ART FOR WORK

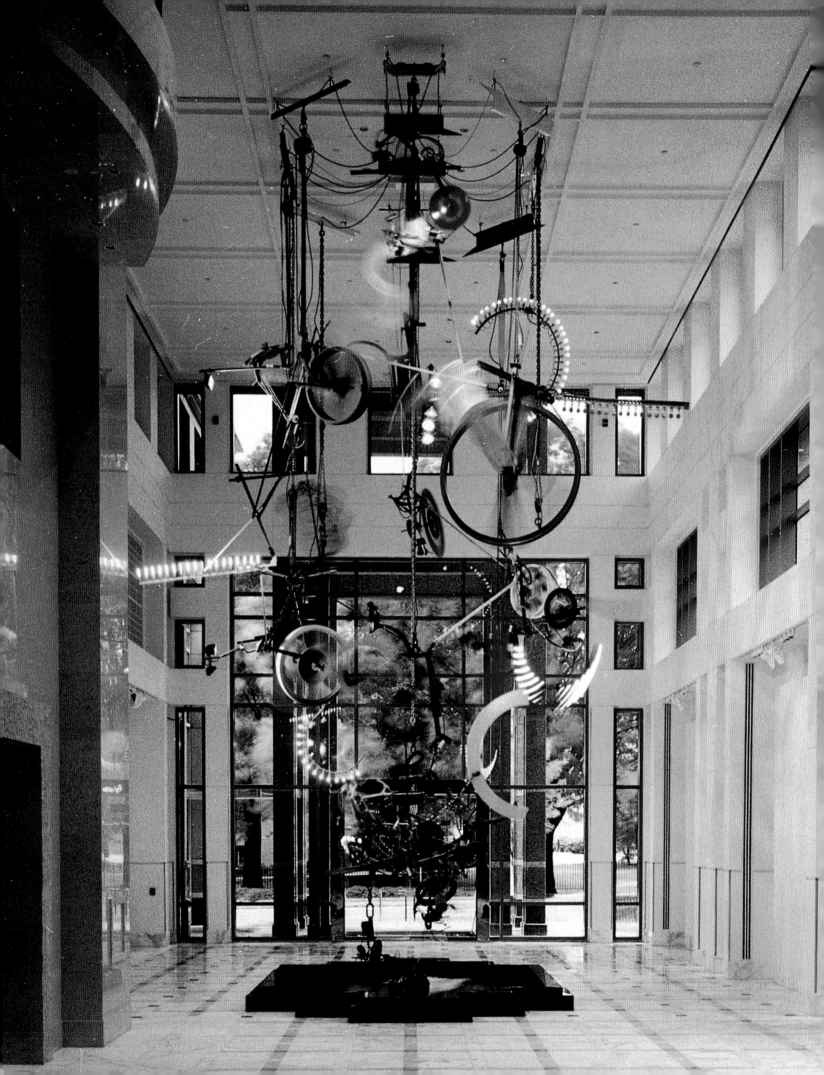

ART FOR WORK

The New Renaissance in Corporate Collecting

Marjory Jacobson

Harvard Business School Press

Boston, Massachusetts

For:

Joe, my dad
Marshall, my guy
Elise, John and Patricia, my kids
Lani, Jed and Greg, my other kids
Kim, my extraordinary administratrix

Each of whom has enriched my world

In the illustration captions, height precedes width.
Dimensions are given first in inches (cm in
parentheses), unless otherwise stated.

Frontispiece: **Jean Tinguely**, *Cascade*, 1991, motorized
kinetic sculpture fountain, $43 \times 15\frac{1}{2} \times 25\frac{1}{2}$
$(1310.6 \times 472.4 \times 777.2)$. Permanent installation in the
main lobby of Carillon, Charlotte, North Carolina.
Collection: Hesta Properties, Inc.

First published in Great Britain by Thames and Hudson, London, 1993
Copyright © 1993 by Marjory Jacobson
97 96 95 94 93 5 4 3 2 1

Printed in Singapore by C. S. Graphics

Library of Congress Cataloging-in-Publication Data

Jacobson, Marjory, 1936–
 Art for work : the new renaissance in corporate collecting / Marjory Jacobson.
 p. cm.
 Simultaneously published: Art and business. London : Thames and Hudson, 1993.
 Includes bibliographical references and index.
 ISBN 0-87584-363-8
 1. Corporations—Art collections. 2. Art patronage. I. Title. N5206.J23 1993
708—dc20 93-18707
 CIP

Contents

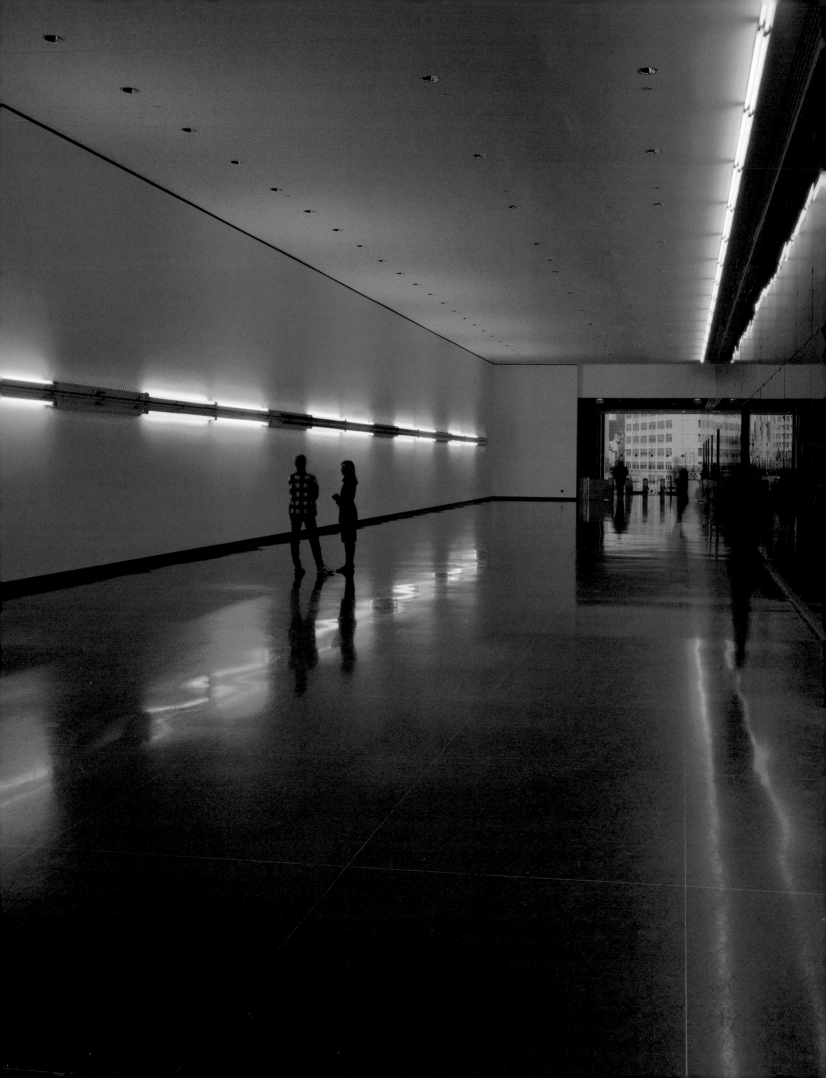

Dan Flavin, *Untitled, (to Tracey Harris)*, 1992,
fluorescent light wall installation, 24 ft (7.3 m) long.
Commission for 4 MetroTech Center, Brooklyn, New
York. Collection: Chase Manhattan Bank, N.A.

PREFACE

As we edge our way toward the twenty-first century, a *fin de siècle* mood prevails, with recriminations against the present and nostalgic yearnings for the good old days. Nevertheless, a vanguard of thinkers, however optimistic, does exist, forecasting a more resolute if not utopian tomorrow. Already the future is prefigured by a dramatically altered geopolitical world order. Economic policy will be the hallmark of this new global constituency. Not since the Italian Renaissance, when the merchant-banker of republican Florence shaped domestic and foreign policy and encouraged social and humanistic reforms, has the business community been so powerfully positioned. The potential influence of the successful international enterprise of the coming age has prompted an enhanced rhetoric of responsibility—commonly articulated in the promotional literature of astute business ventures. Some private-sector entities have channeled that rhetoric into the molding of visual arts programs of profound dimension. Art, as they understand it, does not merely dictate or reflect values. History has taught them that the major artistic achievements of any civilization hold penetrating insights for generations to come.

Still in its early bloom, the 1990's is a watershed decade. Events unfold with dizzying speed as the year 2000 approaches: the dismantling of the Union of Soviet Socialist Republics and the emergence of a quasi-capitalist Russia, the reunification of Germany and the surge towards a market-driven Eastern Europe, the imminent reality of a European Economic Community, the incontrovertible power of Japan and the evidence of an Asian ascendency. As the metamorphosis occurs, a worldwide business culture whose role as a societal force will be wholly redetermined by this new history is already in place.

The status of art and business is at a crossroads, too. Past the traditional notion of building a collection of objects to exhibit in the halls of the highrises, art and its place in the overall business agenda are being reevaluated. Very early on in this project, I talked with Rolf Fehlbaum, the owner of Vitra International in Basel, Switzerland. His company, distinguished as a producer and reproducer of Modernist and contemporary architects' furniture, had just seen the completion of the Vitra Design Museum by architect Frank Gehry at Vitra's factory site in the neighboring hamlet of Weil-am-Rhein, Germany. Fehlbaum began by asking: "Do you have, or is there, a feeling that something interesting is happening when an artistic position and a business position meet?" With that question, the essential framework of this book was succinctly formed.

The ultimate selection of profiles and sketches was hard to finalize. Even though I never intended a full-scale survey, my original plan to include the most aesthetically accomplished corporate programs I could find was refined even further to encompass some larger issues. The model examples became prototypes for particular kinds of patronage where the intersection of contemporary art and present-day culture was vividly portrayed. In other words, the corporations, banks and other businesses small and large that have used the best visual arts of the day as one way to reformulate their corporate strategies and to redefine their work-and-culture ethic, became the central concern. Because of this concentrated focus, many of the admirable projects of my colleagues whose work I respect a great deal are not included. I wish to thank them all, especially Bea Medinger, Janice Oresman, Judy Kay, John Neff and Tressa Miller, for the time and insights they shared with me early on in the process. There were also some appropriate programs I would have liked to feature, but permission was declined for one reason or another. In a few other instances, time ran out for making exploratory site visits. And I am certain that there are many more excellent art undertakings by corporations of which I am simply unaware.

One distinction of this study is the privileged access generously granted to me by many top-ranking professionals in the business and art worlds. Although it was often difficult to gather information on many collections in privately held companies, numerous respected colleagues and friends graciously arranged valuable introductions to other key people. Their faith in my ability to achieve a creditable result allowed me to assemble a working list of the preeminent, and often not generally known, business art patrons worldwide. From this database and my own experience, I was able to expand and contract my horizons. I traveled extensively for one year in Europe, Japan and the United States and personally visited over a hundred of those on my priority list. My sights, as always, were set on the quality of the end product, whether art object, program or process. More and more, I saw myself as a "curauthor," a hybrid curator-author, with text and illustrations at once exhibition and book, neither one preceding the other but rather both emerging simultaneously.

I focused on those standard-bearers who to my mind conveyed a clear message of visionary dimension: that the relationship of art to business in the future is not about entitlement, but enlightenment. In the end, their achievements are not related to affluence or opulence, nor to an unrealistic moral or civic sense of responsibility. They are successful entrepreneurs who have understood the value of experimentation, risk-taking and standard-setting in business, and they are continually looking for new ways to achieve their business goals. Characteristic to their business nature, their art programs are often highly sophisticated management tools geared to stimulating right-brain thinking. Their patronage is enlightened self-interest, and promotes the wellbeing of their societal constituencies.

Whatever their budget, type of business or program goal, the flagship examples chosen had certain guidelines in common: the level of priority that the art program

was assigned; which department was responsible for its administration; who the decision-makers were; and how the program was presented both within the company and to a larger constituency outside. These criteria were invariably held together by the active involvement of the principal-in-charge and by the access of art professionals and/or subordinate personnel directly to that executive.

This book explores many facets of enlightened business patronage of the visual arts from varying vantage points. Many voices are heard—of employer and employee, client and customer, artist and architect, curator, consultant and art dealer—but the rhetoric of the art in its setting is, as it should be, the ultimate arbiter. I have tried to be especially sensitive to the corporate perspective. It is less than satisfying, in my view, to reissue hackneyed platitudes about how art makes the workplace more attractive, and that by osmosis we are somehow uplifted. It is just as tiresome to condemn the entire business world as incapable of a high cultural position because it has an ingrained commercial character. The most forward-thinking corporations take the attitude that the visual arts are seminal—yet only one of many—critical elements of a total business culture. Enlightened executives tend to practice the habits of patronage and sponsorship of the visual arts. Philanthropy is a charitable act, an act of mercy. Patronage and sponsorship of the arts are, in their purest forms, a kind of educational stock with a high-yield cultural return.

For the prescribed purposes of this book, I have not included sponsorship of events, or programs and activities, by business in the cultural institutions where art usually occurs. It goes without saying that this policy mode of patronage, so heavily endorsed by business and its foundations, is one of the mainstays of Western capitalism, and should be strengthened. Instead, I have concentrated on those programs and projects that occur in the businessplace, or in conjunction with government, civic and other partners, at other public sites outside the purview of the traditional cultural institutions. The intent is to suggest a more public forum for the precepts inherent in these programs, to allow for the fertilization of newer concepts and better plans.

As a result, I have become a strong proponent of the notion of forging partnerships, using corporate public spaces for exhibitions and temporary installations, and integrating the arts into the architectural program of new and renovated facilities as particularly valuable and rewarding for art, business and culture today. In this area of interdisciplinary investigation, under informed circumstances, fertile artistic concepts requiring temporary and permanent large-scale environments can generate and be given concrete shape. Enlightened business citizenship with its accompanying reimbursables of goodwill, social action and all the cultural benefits to the business community and public-at-large can take place in the arena of everyday work life.

In the final analysis, this study is not about maintaining a mainstream business attitude toward art, nor about how artists can sell their work to corporations, a phenomenon that has come to be labeled too often, and disparagingly in America particularly, as "corporate art." While the 1980's largely represented the over-saturation of "corporate art" in the office, the decade also carried portents of fresh prospects. I expect the 1990's will be a period in which goals and priorities are reevaluated and a revolutionary model for the partnership of art and business is sought. In my view, the future of these two heretofore antithetical forces lies in the role they both can play in the international cultural landscape of generations to come.

CHAPTER 1
INTRODUCTION
Redefining Art in Business

So well he governed all his trade affair
With bargains and with borrowings and shares
Indeed, he was a worthy man withal
But, sooth to say, his name I can't recall.

Geoffrey Chaucer (ca. 1342–1400)
The Canterbury Tales

Things have changed since Chaucer's day. With the evolution of the corporate organization as a mature participant in the cultural contract has come the potential for business to make its grand mark on civilization. Historically, temporal fame and lasting recognition were reserved for the potentates and the princes, the popes and the priests whose dynastic largess and critical instincts coddled the enduring masterworks of the world. The high patronage of culture by individuals (or their enlightened emissaries) who earned their wealth in the commercial sphere can be traced, along with the roots of early organized business activity, foremost to the Medici family and many other scions of republican Florence. To a lesser but no less illustrious degree, the Etruscan financier Gaius Maecenas (ca. 70–8 BC) and the bankers Fugger of sixteenth-century Augsburg can be cited as great businessmen-patrons of the art of their time. However, the shift from the fortuitous predilections of the individual capitalist to the more seasoned relationship between capitalism and art patronage as a serious substructure of civilization is a late twentieth-century prodigy. Part of the complex equation of the business structure of the future is a new understanding of the world view. Advanced technology has shrunk the universe. Cultures once foreign are now familiar. In a new guise of enlightened self-interest, it has become "the business of business" to support this cultural imperative. Businessmen never had any trouble having their likenesses limned if they could pay the price. But the depiction of true immortality cannot be purchased; it must be earned. Perhaps the time has come for the economic community to have its portrait painted.

It has taken business over three centuries to evolve a new form of patronage of the arts that brings entrepreneurship and enlightened connoisseurship into the kind of balance achieved during the Italian Renaissance, when the Medici and other Florentine merchant bankers patronized the contemporary artists and architects of the new humanism. Along with the advent of modern capitalism, which came of age with the Industrial Revolution in the mid-nineteenth century, business began to court the visual arts again.[1] When the concept of industrialization took hold in America, the scene of unsurpassed capitalist expansion shifted across the sea from Europe to the United States, where land, resources and opportunity for unlimited wealth were available on an unprecedented scale.

The United States

The activity of the patrician art patron before the Civil War was overshadowed by the acquisitive surge of the businessman whose fabulous fortunes were generated when the American frontiers opened up after 1865.[2] The parvenu of the rail, oil and steel cartels developed a gluttonous appetite for "Art" and "Culture" on a scale that was meant to emulate the monarchies of Europe. Instead of the "Golden Age," this was the "Guilded Age," so christened and mercilessly satirized by Mark Twain and Charles Dudley Warner in their novel of that name published in 1873.[3] The American entrepreneur embraced art collecting and sometimes fledgling art patronage as one of the many validators of his newly found nobility. In New York, Chicago and San Francisco, the new plutocracy of railroaders, financiers and industrial conglomerates had in common with Maecenas only their seeming fondness for conspicuous consumption, recalling in their behavior the verse of a Roman poet of the first century BC:

Maecenas is a model host,
Who o'er his viands nice,

Is wont to name each dish and boast
Its quality and price.[4]

As many American businesses federated into organizational entities at the end of the nineteenth century, the notion of the corporation itself as practicing cultural entrepreneurship found some converts. The principal motivation for nascent corporate art programming in America was to provide material for product advertising while simultaneously glorifying the natural resources of the country and the virtues of the democratic process. During the early westward expansion, during the Great Depression, during the Second World War, commissioned artworks were reproduced in calendars, posters, company bulletins and reports and in newspaper advertisements, and the original works were usually exhibited as a group in art museums rather than on corporate premises.

In the 1930's two corporations set modern precedents for American business involvement in the visual arts: the Rockefeller Center real estate development group and International Business Machines (IBM).

The only commercial enterprise interested enough even to entertain the idea of commissioning avant-garde social realism in the art of the day was Rockefeller Center. The Rockefellers, namely John D. Rockefeller, Jr's wife Abby, who was a co-founder of the Museum of Modern Art as well as an advocate of historical and contemporary Mexican art, and their son Nelson, wanted to engage world-class artists in the building's cultural program. Following his one-man show of 150 oils, watercolors, drawings and fresco panels at the Museum of Modern Art in December 1931, when

Craig Wood, *Boardroom Piece*, 1992, water and polythene, 1 × 39⅜ × 281¼ (2.5 × 100 × 714). Continues a series that works with existing architecture (in this case furniture) to determine their format. The site loses its usual function and becomes a viewing place and catalyst for the imagination. Collection: Starkmann Library Services Limited.

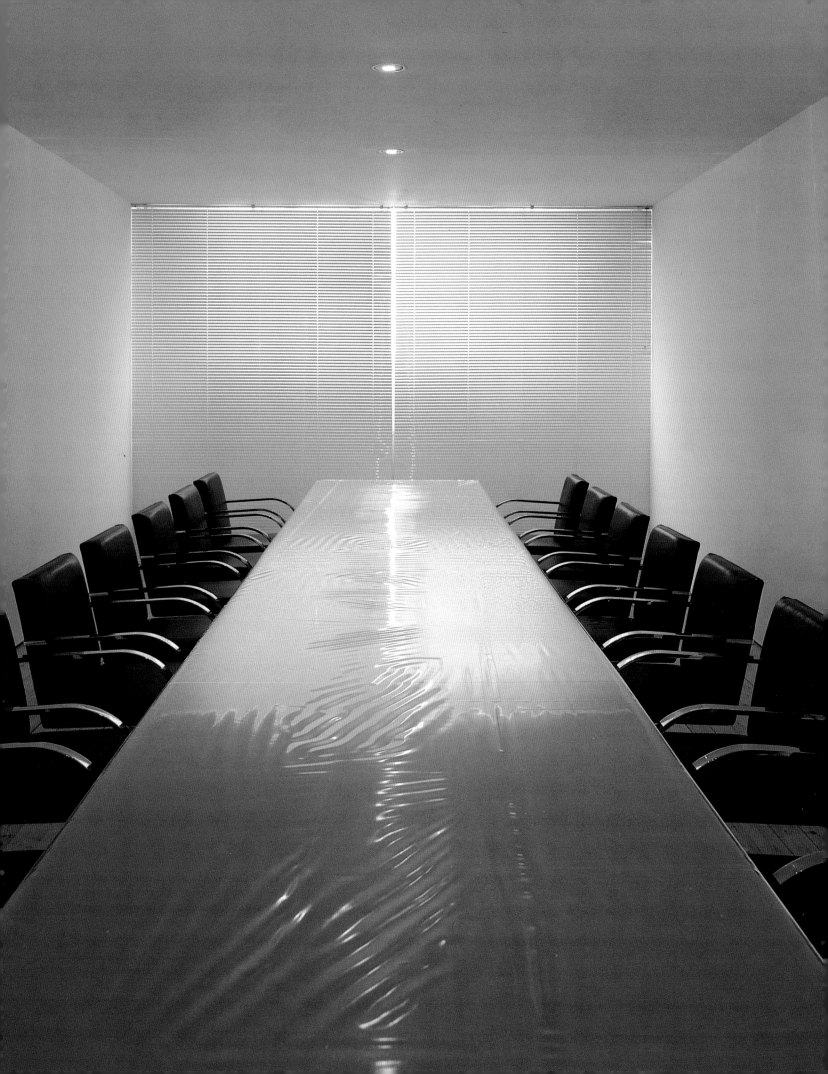

the museum was located on the twelfth floor of the RCA Building, the Mexican Muralist Diego Rivera was asked to propose a mural for the lobby, in competition with Matisse and Picasso. (General Motors had also asked Diego Rivera to paint a mural for its pavilion at the Chicago World's Fair, which he planned to begin in May 1933.)

Within the pattern of established art commissioning practice by church, royalty, state and private patron, the restrictions for this art program were many: the pretentious subject, conceived by a philosophy professor hired to coordinate the thematic threads of the program, was to be "Man at the Crossroads Looking with Hope and High Vision to the Choosing of a New and Better Future;" the colors were specified as black, gray and white; and the murals were to be painted in oil on canvas; "Man" was to be exactly $8\frac{1}{2}$ feet tall, standing at the center foreground; the fee was $300.[5] Both Matisse and Picasso declined, Picasso refusing even to talk to the agents. Rivera accepted the commission after he learned that he would not have to compete, and only with the intermittent mediation of Nelson Rockefeller between the artist and Raymond Hood (the architect most involved) did the project get even as far as it did.[6]

The Rockefeller Center complex was visionary in concept but conservative in taste. The architectural program for the fourteen-building complex, designed by a committee of consulting developers, planners and architects (John R. Todd, Raymond Hood and Wallace K. Harrison), is rooted in tradition, and many of the commissions, doled out by architects to their acquaintances, are predictably bland. Yet, Margaret Bourke-White conceived a giant photomural depicting radio transmission equipment; Gaston Lachaise was commissioned to make sculptures for the exterior piers; and Isamu Noguchi's *News* was cast in relief on the facade of the Associated Press Building.

IBM may not have been the first American corporation to take an interest in art, but the transformation of the accepted mode of art collecting established by nineteenth-century moguls into major company policy was the invention of Thomas J. Watson, Sr., the company's founder. Watson understood that art and business could be mutually beneficial. When the Federal Works Projects Administration (WPA), initiated during the presidency of Franklin D. Roosevelt, was dismantled in 1943, business had already been encouraged to pick up the slack. Watson had been one of Roosevelt's most active arts propaganda emissaries at home and abroad. Partially as a result of its ties to the government, IBM was the first American corporation to practice "enlightened self-interest." From 1937 to 1940, seventy-nine works by artists who were native to the countries in which IBM did business, and over one hundred works by American artists, two from each state and territory, were gathered by IBM as a corporate art collection. The international selection was exhibited in 1939, first at the New York World's Fair and then at the Golden Gate International Exposition in San Francisco (the two fairs overlapped). After the fairs closed, most of the international paintings in the early holdings were donated to institutions, sold or exchanged so that the new company art policy to buy American art could be pursued. The collection was subsequently divided into exhibitions based on specific themes, and from the 1940's to the 1970's these traveled to regional and university museums.[7]

The IBM Gallery of Science and Art represents a wealth of possibilities for the culturally minded corporation, even though its contemporary acquisitions and architecture program poses some serious questions about motivation, audience and responsibility. In *Corporate Philanthropy Report*, Craig Smith, its publisher, commented on an issue much debated behind the scenes, concerning IBM's cultural and community outreach: "It's weird that a company that gives two to

three times as much as any other is still not really counted in the top leadership of corporate philanthropy."[8] The previous year, architecture critic Paul Goldberger had pondered the same issue in regard to IBM's policy of commissioning great architects to build its new facilities: "It's true that no corporation has a track record like IBM's; no corporation has been as rigorous in its determination not to put its name on mediocre buildings ... So what's wrong? The right names are there, but the buildings, by and large, are dull. This is not architecture at the cutting edge of the art, however much it may be architecture at the cutting edge of corporate culture ... it is the architectural equivalent of an art collection with a [Alexander] Calder, a Henry Moore and a [Louise] Nevelson."[9] Perhaps the real question that Goldberger in particular was asking was: "Is this the best we can expect from business which everyone knows has another agenda of first concern?" The cases examined throughout this book suggest that there is another perspective.

Although IBM's gallery represents definition of patronage at a very ambitious level, its programming falls outside the parameters of contemporary art to which this book is addressed. Since the autumn of 1983, when the present IBM Gallery of Science and Art opened in Edward Larabee Barnes' new IBM building, the company has hosted more than seventy-five exhibitions, many with related educational programs such as tours, lectures, films and performances. The exhibitions are free and color brochures are offered as a modest guide to each presentation. Virtually every show is organized from outside, either as a traveling exhibition (sometimes tied in with IBM's sponsorships—when the IBM gallery becomes one of the stops on the itinerary) or by a museum or professional non-profit traveling exhibition service. Almost always drawn from the fields of historic to modernist movements in the fine, decorative, design and graphic arts (with one contemporary architecture and one "computers in art" exhibition, and

one "IBM Collects" show, which included some of the recent art in artchitecture acquisitions), the quality of these exhibitions is uncommonly high, installations and museum technical practices are professionally sound, and attendance substantial.

The gallery is now staffed by a part-time director and registrar, other services being provided by outside contractors as necessary. The budget for the gallery's program and promotion falls within Corporate Communications, under the aegis of the Director of Cultural Programs, Richard Berglund, who has held that title for a decade. By skillfully mediating between corporate culture and corporate cultural affairs, he has been able to hold at bay the skepticism expressed by Paul Goldberger concerning what can really be expected from a corporate sector whose motivations are always measured by its own priorities of consensus. As long as Mr. Berglund sidesteps the controversy of contemporary programming, and while he relies heavily on the best smaller museums, non-profit institutions and foreign cultural attachéships, the politics of corporate operations does not compromise his efforts. He is, after all, IBM's ambassador of culture to the world at large and that is his constituency. Mr. Berglund is a master at his trade, and he understands how to communicate the ultimate value of quality art programming to his superiors.

The IBM gallery's exhibition schedule is heavily geared to promoting smaller institutions in New York and across the country whose holdings are not widely seen. Exposure to a very broad public of the wares held by museums with little exhibition space, or undergoing renovation, often help that institution not only to draw attention to its particular strengths, but to do some fundraising of its own. Many virtually unknown collections that would otherwise not be seen by more than a handful of people come to public notice. Because much of the gallery's programming also creates goodwill for IBM globally, business

contacts are solidified, and the physical space itself serves as an entertainment venue for fostering international relations.

IBM was the first modern multinational corporation to explore the benefits of corporate business and art policy. In the field of corporate *Kunsthallen* the company continues to make one of its greatest and most effective cultural contributions to a public that may rarely visit a museum, to museum-goers unlikely to see the collections exhibited, to school children all over the city, and to IBM staff who would otherwise have little time to spend in museums.[10]

It seems that Watson did sincerely wish to help artists earn their own way in American society, and he was infatuated with the arts.[11] Yet his solution, a simple matter of business common sense, revealed no understanding of the nature of the complexities of artmaking. He was unable to see the artist's plight in terms other than poor salesmanship on the part of a producer who did not understand what his customers wanted. "I believe it is our duty to teach young artists to study the desires and tastes of the public. The reason that some of them cannot sell their paintings is that they are not producing the kind of work that business people want to buy."[12] Yet he himself did not apply his strict code of business behavior when it came to modern art. One biographer commented that when Watson "was misled by someone it was by a person like a painter or a sculptor who did not impinge on business in any way."[13] Art was probably the only indulgence Watson allowed himself. He owned a few works by such masters as Corot, Monet and Turner, but his private collection was mainly one of minor painters. He seemed to boast of his defiantly amateurish dabbling: "I own some pictures that high authorities, perhaps, would not care for, but I like them all."[14]

Congress had passed a law in 1935 allowing up to 5 percent of net income before taxes to be deducted as charitable gifts, but only in the 1960's did corporate contributions to charity continually pass

When Watson bought what he wanted for himself, it was his own affair, of course. But when the head of a business applies the concept of personal taste alone to the art selection policy of the company he directs, and when like Watson he is a rank amateur in the field of art, he runs amok. In all but a few isolated examples where the chief executive officer has extraordinary command of the subject in hand, the general rule of thumb should be to leave the selections to the experts. Once a professional arts program is established it should be managed with the same standards of business behaviour and professional etiquette that are applied to all facets of the company organization.

above 1 percent. A Business Committee for the Arts and National Council on the Arts were instituted in 1964, and the National Foundation on the Arts and Humanities legislated in 1965 did encourage business further to support the arts, but where business was concerned goals were measured in terms of statistical quantity with little attention to standards of quality. Even today there is no universal corporate foundation for the arts dedicated to encouraging and preserving the yields of contemporary cultural expression, although many companies are attempting to establish guidelines and maintain standards of quality in their individual approaches.

By the 1970's, more than in any other country, corporate collecting for the office in America was in full swing. Among the various businesses involved in the activity, the most distinctive were companies like Ciba-Geigy, Prudential, American Republic Insurance, Owens-Corning Fiberglas, Atlantic Richfield Corporation, Security Pacific National Bank, Bank America, First National Bank of Chicago, Forbes Magazine, Gilman Paper Company, Campbell Soup Company, Blount, Inc., Best Products and Steuben Glass.

The 1980's saw a rise in corporate support of the arts in the world at large, but especially in America, that was a reflection of the boom in the world economy. While Europe and Japan were making spectacular capital gains, the United States was living on borrowed money. In America, the 1980's was a time of government deregulation of banking and telecommunications, and speculative maneuvers in securities markets and real estate, and art as commodity. Those businesses that were not latching on to the arts as a fresh image-proviso in a market-driven environment were increasingly attracted to cloaking their headquarters in the art vestments of success and largess obtainable through patronage. Most often in Europe, business, with the same underlying motive of enlightened self-promotion, adopted a more serious art posture in an atmosphere where culture is more widely acknowledged as a necessary ingredient of civilization. The motivations for art collecting simply as just one more commodity in which to invest, with the added potential of tax sheltering, possessed the economically ambitious Japanese in the 1980's. As Fumio Nanjo, a noted Japanese curator, put it: "In a certain way, World War II was a war between Japan's spiritualism and America's materialism ... Because we were defeated by materialism, we may have changed our goal from a spiritual to a material one. But in one sense it was easy to change because the militarist aim ... was: 'you have to be efficient to defeat your enemies: refine production and fight.' After the war, the aim was again: 'refine your production and accomplish economic growth'."[15]

Germany

The ascent of Germany to its position as the international capital of contemporary art was heralded in the Sunday *New York Times* in the fall of 1992.[16] Cologne, not New York, was to reign as the place where the best of the forward-moving could be found. With that august declaration, many heads have turned to the corporate community, which Germany has in great abundance and in vast wealth.

Since the early 1980's a growing number of businesses in Germany that have patronized the arts has surfaced. Although there are no tax advantages for corporate subsidies of cultural projects, positive public relations have become the beneficiaries of their activities. One of the most visible corporate cultural success stories is that of Deutsche Bank. The bank purchased about 180 contemporary artworks between 1984 and 1988, predominantly small works on paper and mostly by German artists, for the public spaces in its corporate office buildings. This collection has a sizeable reputation as a corporate model perpetuated in part by the way in which the bank marketed the features of the program. Almost everyone seems to have heard that Deutsche Bank's Frankfurt headquarters houses much of its collection, one artist to a floor, on descending levels according to the artist's age, and the elevator buttons are inscribed with the artists' names! The collection includes celebrated post-war practitioners like Joseph Beuys, Anselm Kiefer, Gerhard Richter and Sigmar Polke, and younger German Conceptualists like Günther Förg, Georg Herold, Martin Kippenburger and Herbert Keicol. Other notable corporations on the contemporary art scene are Degussa, which concentrates on Frankfurt artists active after the war, IBM Germany, Siemens, BMW and Frankfurt's Jahrhunderthalle financed by the Hoechst Corporation.

After the Second World War, with their country divided and unable to take up arms manufacture or maintain an army, the Germans like the Japanese built up a formidable economic base. The business class in Germany, more than in other countries, was always highly literate, a tradition that originates in their being barred from joining political groups or the military under Bismarck and the Junker caste in the nineteenth century. They took up instead the pursuit of erudition. The German bourgeois businessman became a devotee of culture, and for the individual who was particularly interested, there was plenty of visual art to assimilate. The first public museums had opened in Dresden and Kassel in the early eighteenth century; many German cities, like Dresden, Berlin and Munich, were citadels of world-class art and architecture; and the concept of artistic freedom and a heritage of public patronage of contemporary art had long existed in their *Kunsthallen*[17] and in their liberally funded state arts budget.

Post-war federalization has also shaped the cultural politics of German cities whose pride of place has taken the form of supporting the arts as a way to gain civic stature and tourist dollars. Businessmen in most German metropolises like Frankfurt, Berlin, Cologne, Düsseldorf, Hamburg, Bonn and Stuttgart, and in many smaller towns, have realized the business value of fostering cultural treasuries. In an effort to proclaim the cultural freshness of the new Germany to an international business sector, many corporations have assumed the role of contemporary art patron, in an atmosphere where it is still assumed that it is the obligation of the state to finance culture.

Bayerische Hypotheken- und Wechsel-Bank, known as Hypo-Bank and based in Munich, stands out with its venerable cultural heritage. The bank was founded in 1835 under a royal decree issued by King Ludwig I of Bavaria, and was Germany's first publicly owned joint-stock company. It assembled an estimable collection of Goyas, Bouchers, Fragonards and Guardis, which were placed on permanent loan to Munich's Alte Pinakothek and Neue Pinakothek. In 1975 board member Hans Fey became the director of Hypo-Bank's cultural activities. Fey has been the power behind an extraordinary surge towards a new era of visual arts enlightenment for the bank. In the fall of 1983, he established the Hypo-Kulturstiftung, a cultural foundation with its own independent managing board and a charter that protected it from bank interference. The two main areas of the foundation's activity

are in historic conservation[18] and contemporary art in Germany. One early and innovative activity of the foundation was to establish a museum purchase endowment for the acquisition of contemporary artworks by qualifying German museums and *Kunsthallen*.[19]

After a trip to Japan in 1982, where he was first exposed to the blockbuster-type exhibitions sponsored by Japanese newspapers and department stores, Fey adapted the model for including an art gallery in the restoration program which was under way at Hypo-Bank's Munich headquarters. The exhibition program of the Kunsthalle der Hypo-Kulturstiftung is of a very high standard, professionally staged and ranging from one-man shows by classical moderns like René Magritte, Georges Braque, Joan Miró, Fernand Léger, Marc Chagall and German Expressionist works on paper and less widely exhibited artists like Paul Delvaux, James Ensor and Egon Schiele, to retrospectives of the work of contemporary artists such as Georg Baselitz and crowd-pleasing presentations like the Forbes collection of objects from the workshop of Carl Fabergé and the "Cleopatra" traveling show.

France
In France, the Socialist presidency of François Mitterrand brought energetic government sponsorship of museums, art centers, public commissions, acquisitions funds, art schools and education programs, but the involvement of the private sector has been barely more than a whisper until recently. The Socialist Party's identification of culture as a mainstream element in society, emphasizing a wholehearted commitment to the artistic expressions of our own time, was, and is, a dazzling vision. Perhaps, as some critics have maintained, the French experiment has worked a little too well, with contemporary art centers, staffed by well-trained government-accredited curators, proliferating in towns and cities all over the country. "Today, contemporary art has become a trendy

pastime for the middle classes. Ironically, the rigidity of the French [Socialist] system has created a fuzzy situation that makes it possible for museums and the Regional Endowments to justify buying whatever they please, as long as it is modern or contemporary," was chief curator Bernard Ceysson's assessment when he announced that his acclaimed Museum of Modern Art at Saint-Etienne was "closing for reflection" after it had been open for only two years.[20]

While there is justification for complaints that, despite the pandering to living artists in France, an *ennui* with the obligatory list of internationals has set in, and for the cranky claim that with all that valid and expensive effort no French genius has yet emerged, the real point is far more significant. The French government, right or left, represents a people well informed and respectful of the benefits of culture. The social experience of culture under Socialist policy has been surprisingly free of cant and tract, and operates at a highly respectable, if not monumental, level of accomplishment.

Central to the success of such an experiment is selling the concept of the artist as a practical contributor to the health of the nation. French Minister of Culture Jack Lang may well have applauded the American novelist E.L. Doctorow when the latter testified at a government hearing on the "value" of the artist to the United States' economy: "My work provides employment to others. Painters provide employment to printmakers, publishers, gallery owners and workers, art critics, TV documentarians, museum curators and museum guards. The work of artists in every medium provides jobs and stimulates the economy. All artists are, economically speaking, small businesses. Perhaps we should be testifying before the Small Business Administration."[21] Alain-Dominique Perrin, Chief Executive of Cartier, France, and a member of the Government's Conseil Supérieur du Mécénat Culturel, declares a no-nonsense approach to patronage: "I am a liberal and

I consider that culture must spell liberty ... The State must maintain its role as arbitrator, guardian or partner ... The State must understand that patronage represents for it an intelligent way of liberating itself from a certain amount of expense, and above all dynamizing the art market. Patronage creates employment. The Fondation Cartier employs full-time some forty salaried staff members, and from June 1st to September 30th about a hundred trainees or seasonal workers. And numerous organizations specialized in patronage will soon be born such as data banks, cultural engineering etc."[22]

After a brief hiatus during which François Léotard held the expanded post of Minister of Culture and Communication under the Conservative coalition, Lang was reinstated as Minister of Culture when Mitterrand was re-elected in 1988 and, with superheroic energy, set out to court the business world. Among his top priorities were many items implemented by Léotard at the behest of the business community to foster the joint financing of art projects by government and private funds; to make it easier for corporations to set up foundations for culture and the arts; and to offer tax incentives to corporate patrons.[23]

In 1987, a law was passed permitting businesses to take tax deductions for donations of qualified art to the state. Such donations were to be made within ten years of purchase and were to be of a quality acceptable to national museums or other institutions.[24] Another law permits French companies to offset against taxes over a period of twenty years the purchase of works by living artists only. In both cases, the art must be kept on public display.[25] Also under Lang's proposal, insurance companies would be authorized to form private subsidiaries to invest in art as well as in more traditional kinds of property. Because France's largest insurance company, U.A.P., is nationalized, the government would retain some control over the buying and selling of art investments, for the benefit of the

national heritage. Other institutional investors might be encouraged to invest in the national heritage.

Italy

In Italy, where virtually every building has considerable landmark status, the majority of tax incentives for business cultural affairs are heavily weighted in favor of those corporate benefactors who sponsor restorations and historical exhibitions. Encouragement for advancing contemporary Italian art rests primarily with a small group of entrepreneurial interests in the private sector. Their vision of an ideal partnership between industry and art is one that preserves Italian culture now, and in the future. This contemporary corporate patronage of the visual arts has centered on a handful of widely touted projects, a few of which have won critical certification.

Italy is often seen as a cultural superpower in terms of its rich artistic heritage, if not in its ability to meet the monetary, administrative and technical requirements that go hand in hand with that exalted designation. The Ministry of Culture is described as a bureaucratic morass, tax laws are unclear and often impossible to unravel, and the greatest municipal museums find it difficult to meet the minimum advance payment and security and climate control specifications to host important traveling shows. The loss to Italy of much of Count Panza of Varese's prescient and priceless collection of arte povera[26] and Minimalist art, a story widely covered in the international press, is a consequence of Italy's antiquated tax system.[27]

In Rome, Palaexpo (the Palazzo delle Esposizioni), converted into a mixed-use cultural center with exhibition space, theater, rooftop garden, restaurant and stores, is a joint venture between the city and the Jacorossi Group. The latter is a holding company with interests in the petroleum industry, electronic security, business information systems, publishing and waste management. It is reputed to have a very uneven collection of two

thousand works of twentieth-century Italian art mostly housed at its corporate headquarters in Eur, just outside Rome.[28] The restoration of Palaexpo was supplemented with $12.3 million from Jacorossi in a financial scheme where two-thirds of the outlay would be returned with 8 percent interest in six years, during which time Jacorossi still manage the non-exhibition activities there, market design items and maintain the security system. The municipality remains in charge of cultural programming and collects all admission revenue. Ovidio Jacorossi spearheaded the art initiatives of Jacorossi. The company has concluded similar management agreements with the city of Orvieto and several communities across southern Italy. Thus far the programming and management of Palaexpo has been condemned by the art press as substandard and non-serious. The facility opened with a Rubens exhibition including paintings of dubious authenticity, and future programming was said to include exhibitions of the work of American illustrator Norman Rockwell and John Lennon memorabilia.

Olivetti, the Italian manufacturer of office and information equipment, has focused on promoting exhibitions of contemporary design, namely Ettore Sottsass and Mario Bellini, and high-visibility projects related to world masterpieces of Italian heritage. The company's heroic rescue efforts in Florence after the flood of 1961, and its support of the restoration of Andrea Mantegna's frescoes in the Camera degli Sposi in Mantua and of Leonardo da Vinci's *Last Supper* at Santa Maria delle Grazie in Milan have kept it at the forefront of art patronage in Italy.

For some Italian conglomerates, the intermingling of private and public interests have been advantageous to all. Fiat, for example, Italy's foremost automobile manufacturer and one of the world's largest corporations, has triumphantly sponsored the conversion of the Palazzo Grassi in Venice to a world-class exhibition facility and has supported

its programming. Although the ninety-year-old company has underwritten many cultural activities of note, the Palazzo Grassi is the "jewel in the crown" for Fiat.[29] The Lingotto, a former Fiat assembly plant outside Turin, is another example of industry partnering municipalities to rehabilitate historic structures as cultural facilities. Primarily funded by Fiat, with Turin taxes covering a remaining one-third of the budget, the ambitious conversion plan features an art museum, convention and conference centers, a hotel, an office building, a shopping arcade and a university for advanced technology. The entire facility is expected to be operational by 1995. In 1989, auguring well for the high ambition of the art component of the plan, the first phase of the 6-million-square-foot Lingotto was inaugurated with an historic show of Russian and Soviet Art from 1870 to 1930.

When it was built in 1923 by Fiat engineer Giacomo Matte-Trucco, the Lingotto was admired as the largest and most technically advanced production-line plant in Europe, and for its state-of-the-art reinforced concrete ramps and rooftop auto test track. The plant closed in 1982, and Fiat convened twenty of the world's most respected architects to offer ideas for the mixed-use redevelopment of the landmark factory. Genoa-born Renzo Piano envisioned a reactivation of the building as a symbol of the production culture in which the plant was conceived, and his was the plan that was chosen. Piano, who is probably best known for his design with English architect Richard Rogers of the Centre Pompidou in Paris, likes to preserve old buildings and to celebrate their operational infrastructure. In the case of the Lingotto, he will use the outdated industrial motifs of the building, like the massive chimneys, the old driving ramps, the test track, the pipes and the air conditioning and heating ducts as integral to the design. Piano refers to his work as "a mix of memory and modernity that is much richer than expansion."

Japan

"The Cold War is over, and the Japanese have won" was Chalmers Johnson's terse summary of America's forty-year battle with Communism, and the prevailing theory of a school of highly regarded Japanologists who are labeled revisionist.[30] It is not such a long stretch from revisionism to real estate and to the art and business affairs of Japan.[31] In the last fifteen years, they have become "Japan, Inc.," a nickname coined to stress the fact that Japan is an economic society and that Japanese government functions to "support and guide industry primarily by making sure that corporations have access to safe, inexpensive investment capital."[32]

For most Japanese speculators in the art market, the intrinsic cultural and aesthetic value of artwork by signature Western artists was incidental, if not incomprehensible. Of real consequence was the rapidly rising market value and appreciation of these works, because they served as convenient collateral for tax-free shelter of skyrocketing capital gains. With very few exceptions, the Japanese had been using art as a form of financial engineering, what they call *Zaitech*, a term coined in the 1980's to describe their particular brand of financial speculation. A rapid succession of articles in newspapers, journals and magazines beginning in early 1991 broke sensational stories about such giant super-conglomerates as Yasuda, Itoman, Seibu, Mitsubishi and myriad other businesses of all kinds with intricate networks involving banks, galleries, auction houses and private museums. Many were said to have purchased artworks at lavish prices to avoid paying excessive capital gains taxes on their burgeoning assets.

Much of the art the Japanese acquired was widely acknowledged by Western connoisseurs to be of inferior quality even if by the great Impressionists and Post-Impressionists. And even when the works were deemed to be top rank, as was Van Gogh's *Sunflowers* (1888), bought by Yasuda for $39.9 million (estimated at $10–$15 million), or Van Gogh's *Portrait of Dr. Gachet* (1890) for $82.5 and Renoir's *Au Moulin de la Galette* (1876) for $78.1 million, both acquired by Ryoei Sato in the same week, the selling prices took the world's breath away. The issues involved were primarily economic and political, not aesthetic. However, the barrage of news coverage and exposure has had a positive effect on the cause of contemporary art in Japan and in general. Opportunities have arisen for serious contemporary art critics, curators and artists worldwide to go to Japan as lecturers, panelists and resident fellows. Major exhibitions of contemporary Western art have been launched in Japan, and the small group of Japanese contemporary art specialists that exist has traveled in turn, exposing the West to new Japanese art. If the 1980's were a time of exploitation of Western art in Japan, the decade set the stage for Japan's future relationship with art and its society as a whole.

From the 1960's through the 1980's, the private sector as a collector of art had largely become the Academy of our time, bringing the precedent of the Paris salon to the workplace. Like that famous official institution which had dominated contemporary art affairs in France since the time of Louis XIV, the corporate art collection, reserved and predictable with its own set of acceptable boundaries of taste and style, was a commonplace fixture of American and American-influenced corporate culture. In France, salons were a popular excursion for working citizens, like the office community, which represented a broad mix of social strata, inexperienced with first-hand exposure to so-defined high art. The salon was for the Frenchman the first regular, free, public display of contemporaneous art in a non-art setting, and the workplace too is a public environment where the art object has no hallowed museum status. In both instances, public discomfort and unease expressed itself by providing food for fun-making, and any art that did not conform to prescribed standards of expressions was debunked, derided and dismissed.

And the artists, anxious to please a new audience that was demanding a commodious expressiveness, rarely dared to defy the accepted order: history painting and portraiture fared best if the works were based on classic prototypes and were rendered with exacting detail in carefully modulated volumes built up with coats of cool, dark varnish. In the corporate academy of the 1980's, realism had its taboos—there were to be no nudes or overtly political subject matter and coloration was to be cheerful, eschewing black and white. Abstraction, geometrical or lyrical—the majestic standard bearer of truly American (and therefore universally revered!) modern visual art—has taken its place as the official office style. The real danger was, just as it was for the Paris salon, that the art production became banal, composed for popular consensus and imagination, and invention in the arts did not flourish in or around these workplaces.

Yet, the quality of the "art product" and (in the purest sense) the cultural and promotional value of the visual arts to business have never been explored in depth. With historical precedent and contemporary reality as guides, this book aspires to argue that a significant aspect of future economic and ecumenical growth in the world can be influenced by the kind of programming that the case histories depicted here endorse. As the twenty-first century dawns with the unprecedented worldwide primacy of the culture of economics, the possibilities for business are as awesome as the responsibilities. Education, government checks and balances, and a new awareness of moral obligation are the charge of the next generation of culture makers. "Corporations cannot be the last horizon for collecting art," said Thomas W. Bechtler, Chief Executive Officer of Hesta AG in Zug, Switzerland, "but society as a whole must be the basis for art. Art sponsoring must always be considered as a complementary form of financing art and culture in a society."[33]

CHAPTER 2
MAECENAS, MÉCÉNAT, MÄZENATENTUM
The New Breed of Business Patron

"From now on a company may choose between patronage and sponsoring, like between public relations and publicity. It is solely a problem of strategy. I think that for a company, patronage is a better means of communication than sponsoring, being more intellectual and qualitative since it is linked to culture just by semantics."

Alain-Dominique Perrin, Cartier International[1]

Gaius Maecenas, the Roman patron of poets Virgil and Horace, is duly immortalized in many languages today. From his name, *mécénat*, the French term for patronage, and *Mäzenatentum*, the German, are derived and used generically. In the early 1990's, the Japanese adopted the concept of *mécénat*, and the term; high-powered corporations there, heavily stung by art scandals, are experimenting with this seemingly altruistic approach to cultural comradeship. In modern usage *mécénat*, as distinct from philanthropy or investment, describes a relatively pure form of art support where help is given to the "makers" of culture more to advance, and sometimes access, the creative process rather than for any direct monetary or image-related advantage. Inherent in the term are the properties of excellence and innovation. As the concept of *mécénat* gains currency in the private sector, the message is to include the arts in the corporate platform as enlightened self-interest and as a contribution to societal enrichment. The title of this chapter refers to the new breed of business patrons who are identifying and underwriting some of the best and the brightest talents of our time. Their approach is pioneering, and their curatorial vision—at close range —is promising. Whatever the outcome for generations to come, they have managed to make a bit of magic.

The six *mécénat* programs chosen include two in France and one each in America, Spain, England and Switzerland. It is interesting that three of these businesses, in the Medici tradition, are

financial institutions: First Bank System, Inc., of Minneapolis, Minnesota; La Caixa de Pensions, Madrid and Barcelona; and Caisse des Dépôts et Consignations, Paris. Only one, Cartier International, unapologetically predicated on the principle that patronage of the arts is a highly sophisticated communications tool, has set out to proclaim and promote the business-enhancing values of such an endeavor. One, Hallen für neue Kunst in Schaffhausen, Switzerland, under the direction of Urs Rausmüller, is formulated by a group of businessmen whose efforts are given shape by visionary curatorship. Another, Starkmann Library Services Limited in London, England, is led by a businessman/curator whose passion for art has ingeniously transformed his workplace and captivated the minds and hearts of his staff.

First Bank System, Minneapolis, Minnesota

If it is true, as Lewis Mumford speculated, that "the measure of the progress of civilization is the progress of the people,"[2] then an American project, First Bank System's Visual Arts Program in Minneapolis, Minnesota, may be the paradigm of the kind of progressive thinking to which this book pays tribute. Keeping in touch with some of the most advanced and topical experiments of visual artists, the program sought to elicit independent critical judgment within its office community.

The First Bank Art Program began innocently enough in 1981, as a rather typical art-for-the-office project of no particular distinction when the bank relocated. A move to new headquarters is the most common reason for a business to gather artworks; designated funds, space and the practical need to shape an environment make accountable business logic. Dennis Evans, a former securities analyst, was elected President of First Bank Minneapolis just as the banking industry was being deregulated. When Evans joined, First Bank System's art policy was committed to focusing on

artists who were born, worked in or were inspired by the Midwest, from the turn of the century to the present day. (The majority of business art collections are guided by a regional or community art-support policy—again, a solid business decision.) Evans' major challenge was to guide a banking business accustomed to regulated practices into a highly competitive marketplace. He says that the art program evolved as one of "several ways to help the ship to deregulate, just one piece of the mosaic of change."[3] One can only muse and marvel at how and why Evans made ingenious use of the visual arts, but his perspicacity would eventually set a new industry standard for art in corporations.

The attempt was made to incorporate the visual arts not as investment but as one of several metaphors for challenge and change in his master business plan. "While I hope there will be something for everyone, the real goal of the program lies in a deeper understanding of art's potential gift to us all. If some contemporary art is controversial, it is because it is, by definition, intimately bound up with the life of its time. I hope our collection will come to be understood and appreciated on many levels, but primarily as a stimulus to thought."[4]

A view of Controversy Corridor, First Bank, Minneapolis, with "Talkback" and "About the Art" boxes. Controversy Corridor allowed employees to petition the transfer of a vilified artwork from their work area to the Corridor as long as there was a written statement of reason, accompanied by six or more signatures. The works and petition statements were displayed there, and sometimes re-sited by reverse petition. "Talkback" questionnaires were posted throughout the bank, and responses were published and distributed among employees regularly. "About the Art" pamphlets included such materials as artists' statements and reviews, newspaper articles and letters from employees and customers.

First Bank employees typically pass unusual works in the public accessways, in this case a painting by New York graffiti-artist Kenny Scharf and a sculpture by Englishman Eric Bainbridge.

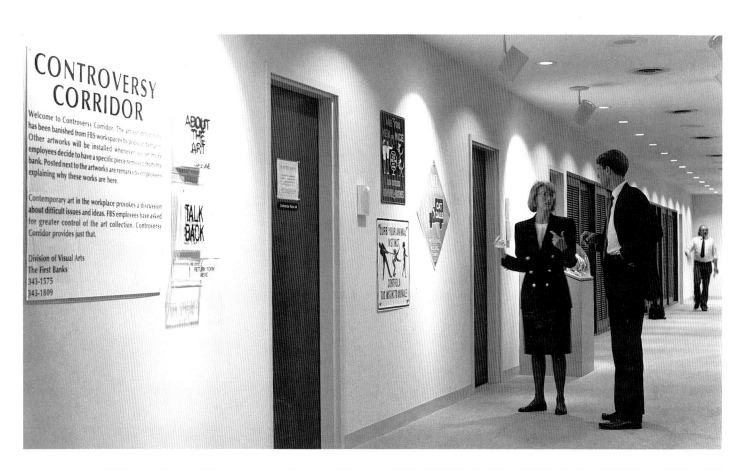

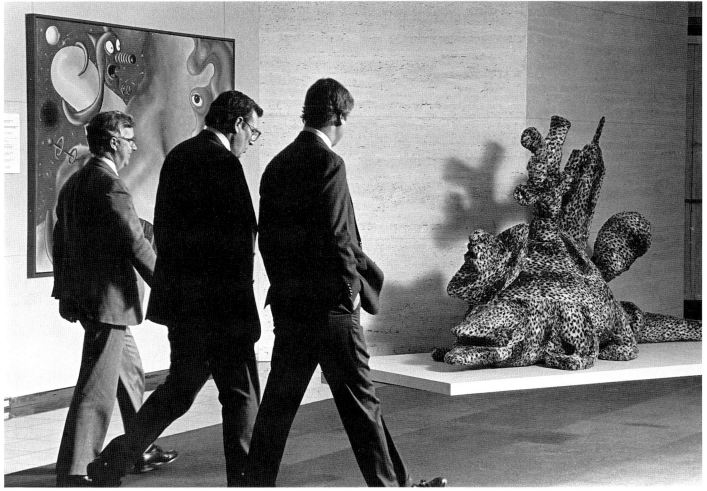

Through 1986, and the giddy rise of commercial bank earnings in the wake of deregulation, the art program evolved into a visual aid mirroring other deified practices singled out to be defied if the business of banking was to enter a newly competitive era. "The challenge for business leaders is to lead, to help people to become better. Art projects can be an important part of that challenge.

"But a business must be at the right point; in a highly competitive situation, it is important to challenge people to think about doing the job, approaching the products and the customer in a different way. Challenge in itself is non-traditional. In our case, as the scope and scale of the art program expanded, and always within the financial boundaries we had established, the whole banking business collapsed."[5] (First Bank earnings went from $202.9 million in 1986 to minus $310 million in 1988, during which time Evans resigned!)

"We did not get too many questions until we began to encourage employee feedback," Evans continued. "We couldn't improve communications until we knew what was on their minds. As we learned, we responded. There was lots of anger in the bank, and we discovered that it had nothing to do with economics. Large businesses pull you into their tradition, their culture and their heritage. It is really hard to turn around on a dime. The farther up you go, the more difficult it is. You can't deal with the edges, you must deal with the middle. I was trying to change this, and we were well on our way. Conversely, the worst time to rock the boat is when things get tough."[6] After the fall, the old banking image that the new management sought to reintroduce was antithetical to the goals of the art program, and that was the end of art in that corporation, and the close of a decade of conspicuous profit and promiscuous consumption in America.

The structure of the Visual Arts Division at First Bank System had a three-fold agenda: acquisitions, educational programming and artist projects. By 1987 the collection had grown from a few hundred to some three thousand works made since 1980 by American and European artists. The collecting activity was, by and large, as aggressive and uncompromising as that of some of the better contemporary art museums and institutes. Very significantly, the acquisition selections were for the most part at the frontier of the field. First Bank was able to compete with more established museums and prime collectors for choice pieces by sought-after artists because it had established a reputation of great stature in its league.

First Bank, Minneapolis, reception area with two works by **Joseph Beuys**.

First Bank, Minneapolis, Skyway Gallery. Exhibition of First Artists portfolio.

Below right: A painting by **David Salle** in a reception area at First Bank, Minneapolis.

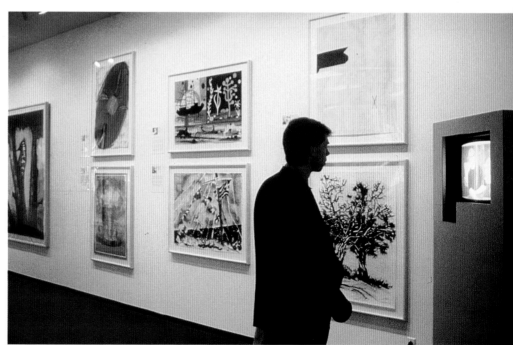

Major works by such internationally recognized names as Anselm Kiefer, Sigmar Polke, George Baselitz, A. R. Penck, Enzo Cucchi, Francesco Clemente, Jannis Kounellis, Joseph Beuys, Gilbert and George, David Salle, Barbara Kruger and Cindy Sherman entered the collection along with some regional talent. Intelligent visual ideas overrode the usual corporate taboos about nudity, politics and sex. Even the most broadminded chief executive officer-curator in a privately held company would have difficulty measuring up to the uncompromising ecumenism of First Bank System's criteria. Nevertheless, once the objectives of the art program were clarified and adopted, Evans' policy was to make every effort to ensure its success as an experimental factor in his grand plan.

Under the curatorial and managerial directorship of Lynne Sowder, at first an independent consultant and then Director and Curator of the Visual Arts Division, ongoing education programs began in the usual manner in the form of wall texts, brochures, catalogues, tours, exhibitions, seminars and films. From the beginning there was an intuitive feeling for turning controversy over particular artworks into educational opportunity. The memos and publications from that art division department used cartoons as a humorous conduit of commentary, poking fun at both the educator/curator and the student/viewer; and, after a time, employees were even asked to write wall labels to accompany those produced by the visual arts staff.

In early 1986, the company adopted a common management strategy using the art program as a tool. An Employee Survey/Seminar Project was conducted not only to "acknowledge and study employee reaction to the art program," but to "create a model structure in which the art [in this case] could act as a catalyst for dissent, discussion and encouragement of alternative operational styles which are vital to the health of the organization."[7] Obvious as it may seem in retrospect, using typical business mechanisms to

integrate an art program into the culture of the workplace had rarely, if ever, been tried before.[8]

With a management philosophy that foreshadowed the tenor of the 1990's, the next few years at First Bank System saw the institution of many art projects that provided "a format for the expression of feelings" and ideas no matter how negatively they characterized the art program. Over a three-year period, more than 350 employees attended special events and openings at museums, galleries and artists' studios. First Bank System's Visual Arts Advisory Team, comprising thirty bank employees and representing various departments, was established to review the Visual Arts Program plan for 1989 and make recommendations. The team's main goal was to advise on how the visual arts programming could achieve excellence in both process (dialogue, participation, innovation) and world-class product, and how as an organizational development tool visual arts programming could act to affirm the best of First Bank System's corporate culture and be an agent of change, a voice of critical self-awareness.

Numerous artists' projects and exhibitions were undertaken whose physical context often encompassed the city and the Midwest region, and whose content delved into the nature of self, community, country, culture and civilization as we experience it: "Artside Out" was a billboard exhibition in Minneapolis of commissions by eight artists—John Baldessari, Robert Fichter, David Goldes, Gary Hallman, Barbara Kruger, Martha Rosler, Cindy Sherman and William Wegman. Installed from May 31 to August 31, 1985, it was a collaboration between Film in the Cities, a non-profit media arts center in Minneapolis, Naegele Outdoor Advertising and First Bank Minneapolis. First Bank concurrently exhibited works by the project artists at its headquarters. Another artist project, *The First Artists Portfolio*, a series of six original graphics produced at Vermillion Editions, was

launched by First Bank as an educational package (including process videotape and informational texts on artists) to be distributed to other corporations and art institutions. Proceeds were to become the first endowment of the First Artists Foundation which would fund public art projects, provide grants for emerging artists and support research to improve adult art education on the job. Profitable in concept, and high in object quality but naive in terms of marketability, the endowment idea failed.[9]

The First Bank Art Program was disbanded in 1990, the objects were sold, and the main players dispersed. It was a decade of tough discourse in which many of the common questions regarding the propriety of "real" art in the workplace typically arose and atypically were confronted instead of quelled. "Art at its best," said Louis Manilow, an ardent and celebrated Chicago patron and collector of the art of our time, "provides a series of images which really speak to a society. Real art comments on and challenges prevailing issues, and occasionally the very best of it anticipates the future."[10] Art activities at First Bank attempted to expose the fundamental properties of "real" art as a catalyst for raising consciousness in the workplace.

Like many revolutions, an extreme position presages a future norm. One did not have to wait long for many of the ideas inherent in the First Bank Visual Arts Program to become comfortable to business leaders in the 1990's. Just a few years into the new decade, corporate rhetoric around the globe speaks of personnel participation, of greater decision-making power for employees, of the imperative to recognize and embrace societal and environmental concerns.

La Caixa de Pensions, Madrid and Barcelona

Spain is the most advanced of the so-called "poor four," the more disadvantaged countries in the European Economic Community in terms of average living standards. (Only Ireland, Portugal and Greece rate lower in per-capita income). Since joining the EEC in 1986, Spain has been adequately able to modernize its economy with EEC funding, and to stimulate considerable growth and prosperity. A flood of foreign investment has put more money into the consumer's pocket. At the same time, the country is experiencing a cultural awakening after its forty-year isolationist slumber under Franco's fascist régime. The re-establishment of democracy in 1976 and the rapid modernization of Spain were fueled by an infusion of artistic energy as well. "More Spanish and more international" was how the manifesto of El Paso (1957–60), a band of Madrid-based visual and literary artists, described what was to be the new Spain.

A sprightly twinkling star, designed by Spanish artist Joan Miró, is the emblem of La Caixa de Pensions savings bank based in Barcelona and Madrid. The logo seems to embody the sentiment of the new Spain. As a leader in the Spanish banking galaxy, La Caixa, like Spain itself, is identified in graphic language as a cosmic sentinel of enlightenment. In deed as well as in symbol, the Fundacio Caixa de Pensions had throughout the 1980's steadily increased its visibility as a dynamic and informed supporter of the visual arts nationally and internationally. Even though Spanish law obliges every savings bank to set aside a percentage of its profits for some sort of cultural or social cause, La Caixa has committed 50 percent of its net earnings to setting up a foundation for the arts and sciences. Josep Vilarasau, Director-General of La Caixa, spearheaded the Fundacio and was also its chief overseer.

When La Caixa established a second headquarters in Madrid in 1982, not long after cultural programming was under way

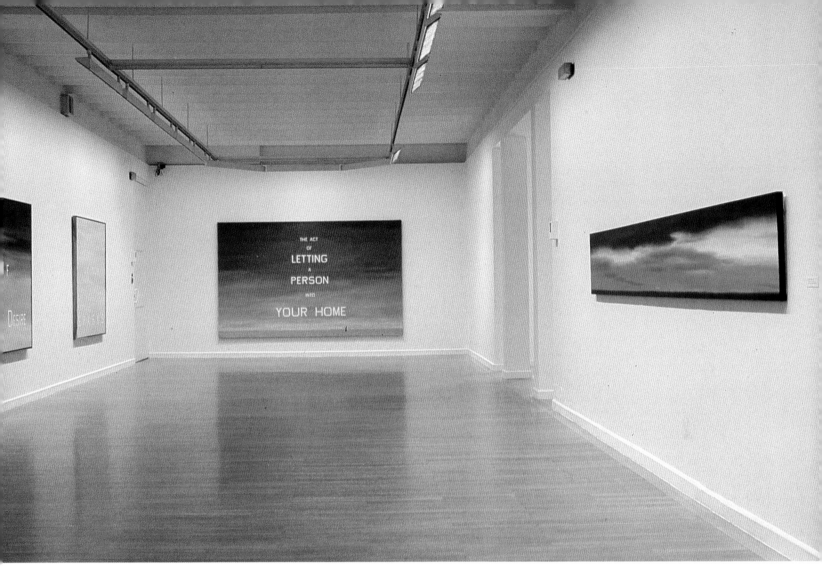

in Barcelona (1981), Vilarasau hired as director María Corral, a Spanish curator who was working at the Fundación Juan March. Corral, a founder of Madrid's Grupo 15 graphics workshop in the 1970's, was especially interested in contemporary visual thinking and in providing a context for airing the latest in art discourse. In 1981, when Spain was still emerging from its long period of cultural insularity, few among the populace had first-hand knowledge of current developments in any of the arts.

In 1990, after ten years at the forefront of arts patronage, this influential savings bank merged with another banking giant, La Caixa de Barcelona, to become La Caixa d'Estalvis i de Pensions de Barcelona. Dubbed "Supercaixa," the new entity is now the premier banking institution in Spain. The merger came in preparation for the influx of new business to Spain as the Single European Market takes shape. The banks' respective foundations were joined under the directorship of Luis Monreal, formerly

director of the Getty Institute of Conservation. La Caixa has the richest endowment in Europe, surpassed only by the Ford, Getty, Kellogg and Macarthur trusts in the United States. Although Vilarasau remains in control, María Corral has left La Caixa to assume the directorship of the Reina Sofía Museum of Contemporary Art. Corral's tenure can be valued as a model *mécénat* venture, well orchestrated to meet the challenge of the time. At this juncture the arts ledger for Supercaixa in the 1990's has yet to be posted.

As with First Bank, Minneapolis, the visual arts strategy at La Caixa reaffirmed the national and global value of business and its cultural activities. Again, the combination of inspired executive leadership and focused directorial vision resulted in a decade of breathtaking arts activity. The program traces a pattern of decision-making where politics and patronage made good roommates, if not ideal bedfellows. Because there were three main exhibition spaces, two in Barcelona

and one in Madrid, La Caixa was able to define the goals of its patronage and to satisfy the requirements of community, country and world citizenship.

In Barcelona, the primary locus is a separate Cultural Center sponsored by La Caixa where concerts and plays are performed, and lectures and art exhibitions held. A second location there supports experimental work mainly by young Spanish artists. The arts at the bank took on standard-setting status with the opening of its Madrid headquarters, and many exhibitions were booked for both Barcelona and Madrid. Although some art shows had been staged in La Caixa Barcelona Cultural Center before 1982, as La Caixa Madrid took shape, one could trace at both locations a major exhibition campaign balancing the historical, the modernist and the avant-garde not only as it was in Spain but in Europe and abroad as well. Though always professionally tended, the Madrid exhibition space was physically underground in La Caixa Madrid's

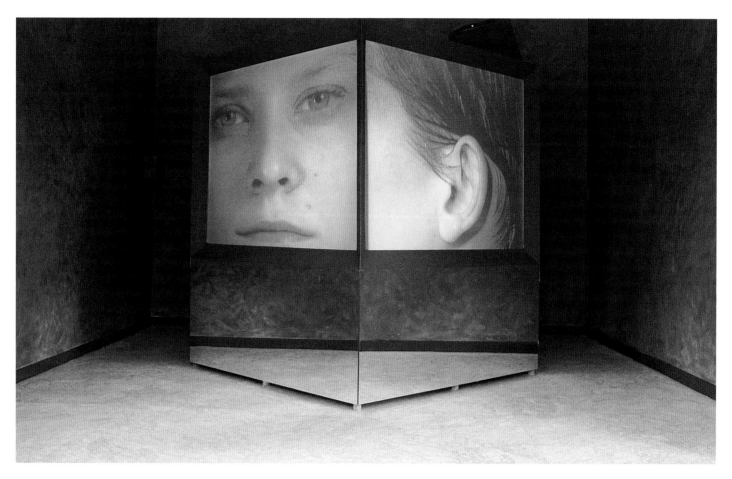

headquarters on Castellana 51. Nevertheless, attendance and acclaim were impressive for major showings including Modigliani, Morandi and Marcel Duchamp, as well as Richard Hamilton, Jannis Kounellis, "American Painting: The Eighties," the Italian Transvanguardia, Walker Evans and David Hockney. Scholarly illustrated publications produced at La Caixa accompanied the shows that were organized in-house.

In 1985 La Caixa renovated a building at Serrano 60 in the center of Madrid. The Sala de Exposiciones de la Fundación Caja de Pensiones was designed as a *Kunsthalle*, more flexible for the presentation of large-scale contemporary art than its low-ceilinged predecessor. Corral's program continued to earn professional respect and popular interest. At the same time, La Caixa began an equally ambitious collection; the Montcada, a small gallery in Barcelona, was opened to promote experimental Spanish art.

La Caixa was one of a very few places in Spain where contemporary art was shown. Thus, from 1986, in any of the three Bank-sponsored spaces in Madrid

and Barcelona exhibitions changing five times a year could be viewed, all free of charge. These exhibitions, made possible by private funds, have consistently rivaled in quality and scope those of the most distinguished parallel public institutions worldwide. They also upheld a level of freedom of artistic expression that kept a healthy distance from inevitable corporate political pressure. The program held sway with a relatively unmarred professional dignity that was the envy of many public institutions. One policy that helped to keep the peace was the ruling that no living Spanish artist would be granted a one-person exhibition, but an examination of any new Spanish sensibility might be undertaken as it emerged. In analytical context, Spaniards like Miguel Barcelo, Susana Solano and Juan Muñoz, who have since achieved international recognition, were offered the opportunity of critical exposure. Just as the highest level of art discourse was supported by the corporation, the corporation was distinguished as a contributor to the highest values of modern civilized life.

Another policy, this time with regard to acquisitions, helped to set the standard of

A video work by **Judith Barry** from "El jardín salvaje" ("The Savage Garden") organized at La Caixa, Madrid, in 1991. The exhibition, curated by Dan Cameron, included new installations by American artists Barbara Bloom, Meyer Vaisman, Meg Webster, Ann Hamilton, Felix Gonzalez-Torres, Charles Ray, Christian Marclay, Mike Kelley, Jessica Diamond and David Ireland.

Installation view of works by **Jeff Koons** – *New Hoover Quadraflex, New Hoover Dimension 900, New Hoover Dimension 1000*, 1986 – and **Peter Halley** – *Rectangular Cell with Underground Sequence*, 1986 – from "El Arte y su Doble" ("Art and its Double") at La Caixa, Madrid, in 1987. The exhibition analyzed avant-garde work produced in New York in the previous few years and also included work by Ashley Bickerton, Sarah Charlesworth, Robert Gober, Jenny Holzer, Barbara Kruger, Louise Lawler, Sherrie Levine, Matt Mullican, Tim Rollins & KOS, Peter Schuyff, Cindy Sherman, Haim Steinbach and Philip Taaffe.

Installation view from "Punt de confluencia: Joseph Beuys, Düsseldorf (1962–1987)" staged at La Caixa, Madrid, in 1988. The exhibition portrayed an aspect of Beuys' activity as an artist and teacher and included thirty of his own works together with those of twenty-one international artists who had been part of his sphere at the Düsseldorf School of Fine Arts. It was a premier showing in Madrid for many of the artists included.

24

excellence. In 1982–83, before there was a real acquisitions program, La Caixa staged "26 Painters/13 Critics," an exhibition of the work of young artists in Spain chosen by thirteen critics from different regions. The exhibition opened in Barcelona, was shown in Madrid, then traveled to banks and other institutions around Europe. La Caixa purchased one painting from each artist. "We bought those twenty-six paintings and then we stopped—never again. We found out that this was not the way to build a serious collection," commented Concha Gómez, a close aide to María Corral. The lesson gleaned— that a purchase program must have clear policy structure—led to the formation of an acquisitions advisory committee. Comprising a carefully selected mix of recognized European art authorities, overseen by Vilarasau and chaired by María Corral, the collection then took on a distinct character.

Although La Caixa's collection has yet to be viewed widely and in its entirety (a selection, accompanied by a catalogue, was shown in Seville at the 1992 World Fair), important exhibitions have been mounted in Madrid and Barcelona.

Robert Gober, *Double Sink*, 1984, stucco, wire, wood, steel, latex and enamel, 36 × 64 × 28 (91.5 × 162.5 × 71), and *Untitled*, 1986, wood, cotton, wool and enamel, 36¼ × 42⅞ × 76¾ (92 × 109 × 195), which were shown in "El Arte y su Doble" ("Art and its Double") at La Caixa, Madrid, in 1987.

Ann Hamilton, *Between Taxonomy and Communion*, a room installation, from "El jardín salvaje" ("The Savage Garden") at La Caixa, Madrid, 1991.

Meyer Vaisman, *Zen Garden (For Walter and Wendy Carlos)*, an environmental work from "El jardín salvaje" ("The Savage Garden") at La Caixa, Madrid, 1991.

La Caisse des Dépôts et Consignations, Paris

La Caisse des Dépôts et Consignations (CDC) was formed in 1816 at the time of the Bourbon restoration to the throne. Today it is a dominant and thriving banking conglomerate. After the defeat of Napoleon, the opportunity for a newly ordained merger between financiers and the court arose. Although there has been no history of business as a distinct entity supporting culture in France, individual bankers and merchants of the stalwart middle class followed the Medician model. It was the middle-class entrepreneurs who, in their private *salons*, encouraged art of the highest standing.

The French, like the Spaniards, were mired in isolationism after the Second World War. But France's quarantine was self-imposed; perhaps partly because of the nation's illustrious traditions in art, French critics and museum directors did not look outside or invite others in. The CDC represents a new attitude. The director of its Visual Arts program, Aline Pujo, is a professional art historian with curatorial and managerial skills. She operates with a clarity of purpose and ideals that can only be realized with direct access to and sanction of Robert Lion, Director-General of the CDC. Pujo, passionate about contemporary art made in France and abroad, understands the importance of fostering a climate of acceptance within the art community and the banking world and among the French public. She is part of the new "inner circle"—a bevy of private- and public-sector administrators, gallerists, critics, artists and curators whose ideas are affecting cultural decentralization policies countrywide and, in like manner, shaping the world's view of French culture today.

Unlike First Bank System and La Caixa de Pensions, whose singular visual arts programs began, peaked and waned during the course of the 1980's, the CDC launched an expansive arts policy reform only in 1989. A stalwart of *mécénat*, the CDC had been acquiring art without particular fanfare until 1988, when it installed in the public space of its Paris headquarters large-scale works by Jean Dubuffet and Roy Lichtenstein, popularly recognized artists of mainstream rank. Then, after the untimely death of Pujo's predecessor, the CDC shifted to a multidimensional approach, and developed a grand plan for what was the beginning of a "state-of-the-visual-arts" *mécénat* posture in France—a level of ambition that was shaped by a very sophisticated pan-national vision of the future.

The arts mission of the CDC is four-pronged. First, it interweaves a strong art component into its building activities so as to develop a contemporary collection of international scope. Omitting the secondary market and auction block, the CDC's buying policy is designed to strengthen the interdependence of artists and their galleries at a primary market level. An exhibition facility provides a showcase not only for its own collection but for other great corporate collections too. Secondly, it built a lending library of prints and photographs for offices. Thirdly, it developed a program to encourage the commercial production of office furniture by French designers. Lastly, the program strives to make the impact of the regional art activities of the CDC as vigorous as those in Paris.

A short period has turned impressive rhetoric into tangible results. As a prime partner in the development of La Grande Arche at La Défense in Paris, France's massive celebration of progress in technology and industry, the CDC experimented with enlightened art-in-architecture theories. While not seminal collaborations between art and architecture as defined in Chapter 6, the three art projects conceived and executed for La Grande Arche function as fresh, intelligent elements of the whole. All were commissioned by the CDC in 1989, under pressure to contribute art when La Défense was near completion. The new conceptual and administrative direction was taken at a time when there could be no mistakes. One of the serious pitfalls of art in architecture is the commonplace *ad hoc* process by which art is introduced into a major architectural program. Not by design in this case but by good fortune, the individuals at the CDC making the decisions at that moment had the combined expertise and intuition to achieve positive results.

The most ambitious project was *La carte du ciel* (1989), an architecturally integrated work by French artist Jean-Pierre Raynaud for the four patios that cap La Grande Arche. (The artwork was funded by SEM Tête-Défense, the development partnership of the CDC, AXA Assurances and the State.) Raynaud, a celebrated figure in contemporary art circles in France, and gaining recognition internationally, is best known for his relentlessly sterile environments constructed with 6–inch white ceramic commercial tiles. Since 1986, when he conceived for a suburb of Lyon an ambitious urban project whose message was impregnated with a strong social consciousness (a rare example of public art in France that has a moral subtext), Raynaud has been involved with large outdoor commissions.[11]

The roof patios at La Grande Arche are particularly interesting adaptations of Raynaud's aesthetic. A French critic observed: "It is his practice to seize upon a seemingly finished situation, a situation characterized by closure, and to attempt to go beyond its borders ...,"[12] and Raynaud, directing the eye upwards, made a map of the heavens on the floors of the *plein-air* patio. Within an overall paved area consisting of modular marble squares into which a granite chart of signs of the zodiac is imposed, the roof becomes a sky garden, a place to contemplate the universe. Raynaud's spaces are always conceptual in nature, without physical amenity or psychological comfort, and the sky patio, like the temple architecture of ancient civilizations, takes on a celestial orientation. Much more than mere adornment of a surface, this linkage forged by an artist's thinking is an example of how art and architecture can interact at a deeper level.

La Grande Arche is also the headquarters of the International Foundation for Human Rights (Fondation l'Arche de la Fraternité) funded by six private-sector sources. The CDC asked the Chilean artist Alfredo Jaar and the American Dennis Adams to make site-specific artworks for permanent installation at the foundation. Using similar (perhaps too similar) formal vocabularies (both employ light boxes, photographs of social plight and even a vertical orientation) as well as comparable political content, the artists came up with equally successful works. This is due in no small measure to the strength of their ideas, and the obviously appropriate context that allows the work to be intellectually and emotionally understood and absorbed. What is troublesome, however, is the lack of any really comfortable place for Jaar's *Paysage* (1989) in the visitors' reception lounge. Moreover, Adams' *Funeral Procession, Soweto, South Africa* (1989) was commissioned for a library that has yet to become functional.

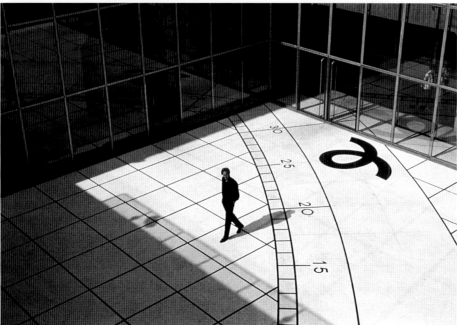

Jean-Pierre Raynaud, *La carte du ciel*, 1989, a bird's eye view of four roof patios at La Grande Arche, La Défense, Paris. White Yugoslavian marble and black granite, each 1320 sq. ft. (400 sq. m). Collection: La Caisse des dépôts, Art and Architecture.

Jean-Pierre Raynaud, *La carte du ciel*, 1989, (detail).

Dennis Adams, *Procession*, 1989, light boxes encased in stained wood, duratrans and fluorescent tubes, $78\frac{3}{4} \times 31\frac{1}{2} \times 23\frac{5}{8}$ ($200 \times 80 \times 60$) at Fondation l'Arche de la Fraternité, Paris. Collection: La Caisse des dépôts.

Alfredo Jaar, *Paysage*, 1989, light boxes, duratrans, fluorescent tubes and mirrors, $39\frac{3}{8} \times 39\frac{3}{8} \times 5\frac{7}{8}$ ($100 \times 100 \times 15$) and $7\frac{1}{2} \times 78\frac{3}{4} \times 7\frac{7}{8}$ ($19 \times 200 \times 20$), at Fondation l'Arche de la Fraternité, Paris. Collection: La Caisse des dépôts.

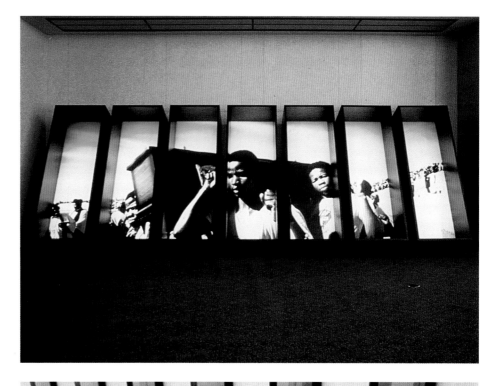

Paysage was Jaar's first permanent public installation, considered important enough for the cover of *Artforum* (April 1990 issue), which featured an article on the artist. The critic commented that "the institutional setting for Jaar's piece ... was ... a shockingly banal lounge where visiting dignitaries meet ... "[13] During my visit, the meeting space was rented out for a textile show and the piece was blocked by commercial display units, much to the consternation of the program head who accompanied me on the tour. This problem is endemic to the siting of work in most public areas. There is no sure remedy, only individual judgments as to the usefulness of the artwork in the particular site. It is impossible to control a public environment all the time. Directives and policy reminders, and liberal communications between space users and management usually go a long way to reduce the problem. All good curators and administrators well know that there are aesthetic and education issues in the presentation of art, and that message should be sent out regularly.

An important part of the success of the CDC's art-in-architecture program is the originality of the selected works as modifiers of their specific environments. Never resorting to a "stock" list of artists whose names have become synonymous with public art, these pieces connect art and place in an imaginative and artful way that is obvious and straightforward yet never naive. Two other enlightened examples, both from 1990, are Patrick Tosani's *Levels*, installed in the elevator lobbies on each floor of a CDC property at 1 Rond-Point des Champs-Elysées, and Louise Lawler's *Birdcalls II*, also in a CDC-owned office building on the Avenue Jean-Jaurès. Tosani's stark photographs of larger-than-life carpenter's levels imbedded in the walls are punning metaphors for the spaces' function, ranging from flattened, dark bubbles in the basement to clearer, lighter, fuller images as one ascends to the top floor.

While Tosani uses linguistics indirectly in a cerebral game of word-play, the American Conceptual artist Louise Lawler's involvement with language incorporates real sound and written text. Reviving a little-known aspect of her work, the main form of which is photography, Lawler employs an audiotape of her own voice "birdcalling" the hallowed roster of male artists who signify the glory of twentieth-century Paris, resounding at half-hourly intervals. The tape is installed in the ceiling of the outdoor atrium of the building, the sound directed toward the ground where a plaque listing the artists' names is imbedded. Within the syntax of art and social behavior, Lawler satirizes a complex male-dominated art industry (culture), where the "voice" of the female (a stand-in for nature) is reduced to reproduction rather than invention. Lawler, an inveterate commentator on the conventions of contemporary museum experience, also refers to habits we are encouraged to perpetuate when we read labels and listen to acoustiguides rather than just look. Sound is an element integral to the site, a busy commercial

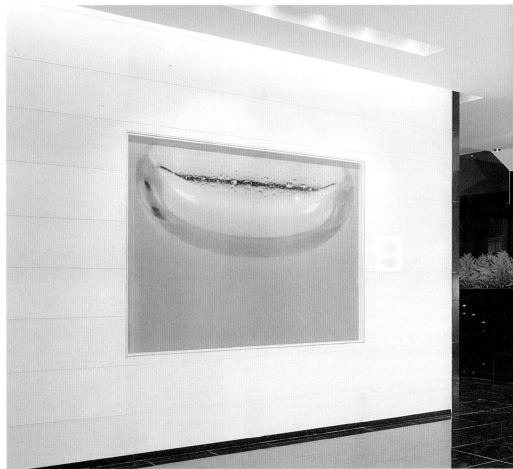

juncture with a music school across the street, and was the instigating factor for the CDC's selecting this particular work by Lawler. It is an original and refreshing choice.

In an attempt to stir up some kind of exchange between Lawler's use of sound and the activities of the adjacent music school, the CDC made some preliminary contacts with the school's administration: it was little prepared to recognize the music in Lawler's piece! Public outreach is a varying aspect of any art program, the ultimate *raison d'être* of a company like Liz Claiborne (see p. 122), for example, which demands a large staff commitment. Although the CDC is sensitive to the possibilities of outreach within the art and architecture program, much of its in-house energy was directed towards building a gallery to exhibit the CDC collection, and the preparation of catalogues permanently to record and, from time to time, critically reevaluate the holdings.[14]

The CDC Gallery, within its headquarters in the rue Jacob in Paris, was completed in the fall of 1991.

Exterior view of the office building at 1 Rond Point des Champs-Elysées, Paris, a building owned by La Caisse des dépôts that houses the installation of Patrick Tosani.

Corridor on the ground floor at 1 Rond Point des Champs-Elysées, Paris, showing **Patrick Tosani's** *Niveau* 0, 1990, Cibachrome on aluminum 61 × 84⅝ (155 × 215). Collection: La Caisse des dépôts, Art and Architecture.

Louise Lawler, *Birdcalls II*, 1990, sound installation in the exterior vestibule of La Caisse des dépôts' office building at 14–34 avenue Jean-Jaurès, Paris. Collection: La Caisse des dépôts, Art and Architecture.

Louise Lawler, *Birdcalls II*, 1990, (detail), plaque. Collection: La Caisse des dépôts, Art and Architecture.

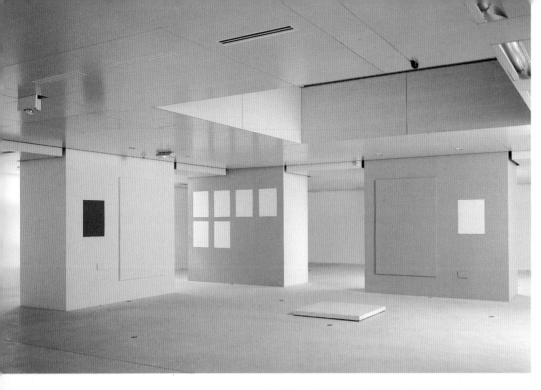

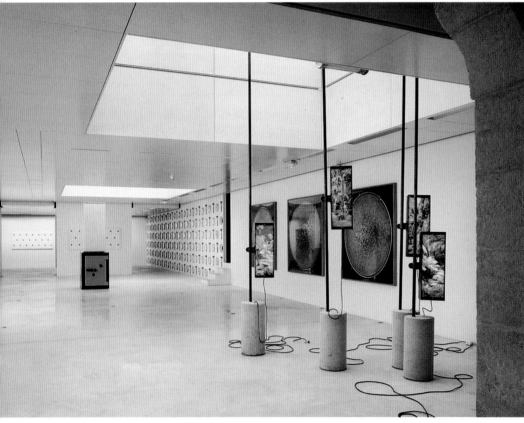

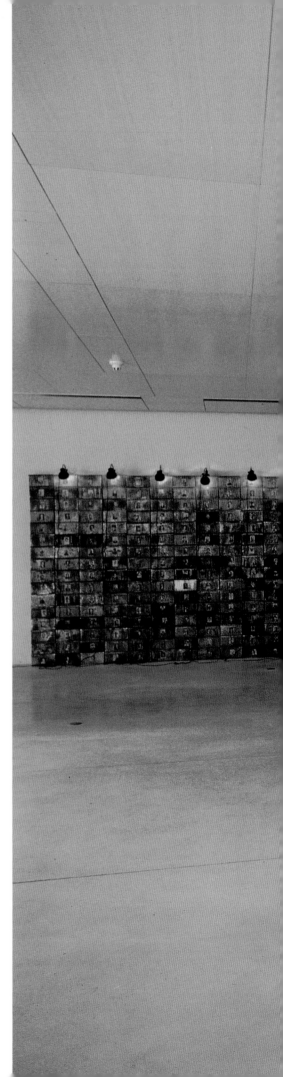

Works from the collection in the gallery at La Caisse des dépots, Paris 1992.
Claude Rutault, *Légendes, Définition/méthode n145,* 1973, *Définition Méthode n34,* 1975; *Définition/méthode n146,* 1975.

Above right, **INFORMATION FICTION PUBLICITE (I.F.P.)**, *Sans titre,* 1991, steel, cement, duratrans, fluorescent tubes, each $157\frac{1}{2} \times 11\frac{3}{4} \times 15\frac{3}{4}$ (400 × 30 × 40); middle ground, **Bertrand Lavier**, *Candy,* 1989, metal and plastic, $78 \times 39\frac{3}{4} \times 31\frac{1}{2}$ (198 × 101 × 80).

From right: **Niele Toroni**, *20 empreintes de pinceau n 40 répétées à intervalles régulières (30 cm),* 1990, acrylic on canvas, $1\frac{1}{2} \times 78\frac{3}{4}$ (80 × 200) and *20 empreintes de pinceau n 50 répétés à intervalles régulières (30 cm),* 1990, dyptich, acrylic on canvas, $78\frac{3}{4} \times 31\frac{1}{2}$ (200 × 80); **Christian Boltanski**, *Archives des suisses morts,* 1990, metal boxes and black and white photographs, fifteen clip-on electric lights, light bulbs, 480 $4\frac{3}{4} \times 9 \times 8\frac{1}{2}$ (12 × 23 × 21.5) and 480 measuring $2\frac{3}{8} \times 2$ (6 × 5).

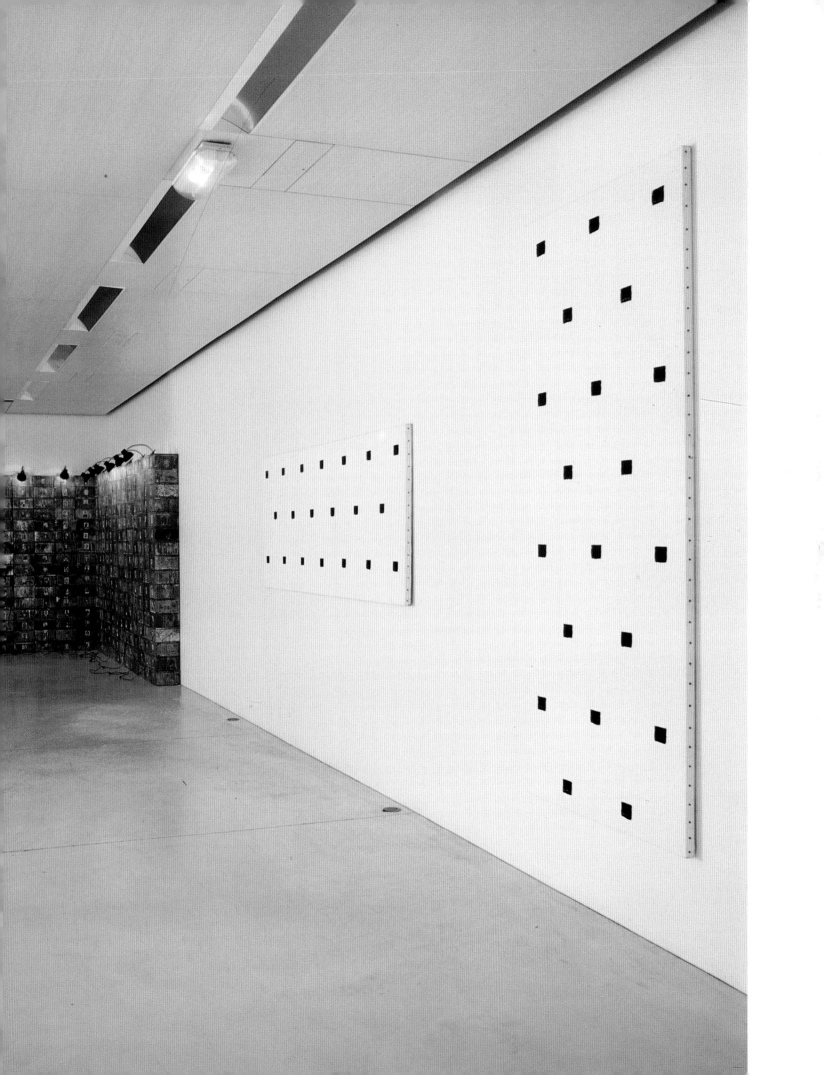

Cartier International, Paris

The author of the corporate *mécénat* strategy put forward in France during the Conservative coalition of 1986–88 was Alain-Dominique Perrin, President of Cartier International. Perrin, himself a former art dealer, was asked to carry out a study for François Léotard (who replaced Jack Lang as Minister of Culture for that two-year period) demonstrating the relationship between the public and private sectors, and to write a report in the language of the businessman. Perrin, a man with entrepreneurial instincts and impeccable taste, is blunt, succinct and shrewd: "It must be understood that patronage is an 'extra strategic' choice ...

Jean-Charles Blais, *Sans Titre*, 1990, outdoor courtyard fresco, Cartier International, Paris.

For example, I chose to help contemporary art by creating a foundation since I wanted to continue giving Cartier the image of a young firm, full of life and dynamic, by associating it with a living art. When the Fondation Cartier organized a much remarked exhibition on the 1960's ["Nos années 60," May 1985], international media repercussions following this event were absolutely fabulous. They correspond to the purchase of about 5 million dollars' worth of advertising space."

Cartier personifies enlightened self-interest. "Cartier's duty is to last and we are always looking to the future. In 1983, we did a survey of the younger generation in five countries asking what the trends were. Seventy-five percent of respondents indicated an interest in contemporary art. So we had a solid business basis for setting up our foundation."[15] Since 1984, the Fondation Cartier pour l'art contemporain has been housed separately from the company's Paris headquarters on a 37-acre estate in the suburb of Jouy-en-Josas, not far from Versailles. The complex is village-like, with a château used as an international conference and meeting center, ten smaller buildings, many of which are studio, living and exhibition quarters for artists-in-residence, a library, restaurants and an exhibition hall surrounding a square. There is even a bunker surviving from the war in which exhibitions are staged. In many ways it is a small-scale Ministry of Culture whose goal is to make an innovative impact on the definition of business patronage of art now.

The strategy of Cartier as a patron of contemporary art hinges on the promotion of culture as a defensible economic policy. The Fondation's budget, said to be FF40 million per year), is constantly justified on grounds of sound business practice. Perrin states very clearly that he sees patronage as public relations, that the international publicity that the Fondation brings Cartier is in itself an advertising campaign on a scale unaffordable and probably unattainable in pure financial

terms, but in this case supported by government ideology and public funding, and deductible in France as a business expense.

In 1986, when the Fondation Cartier was just two years old, Hans Haacke, whose work spotlights various conflict-of-interest situations between art and business, exhibited in Dijon a work entitled *Les Must de Rembrandt*. Haacke declared in the work itself that Cartier was partially owned by Rothmans International, which in turn belonged to the Rembrandt Group, which had a large stake in GENCOR, a major South African gold-mining enterprise. Haacke made the case that when Rothmans' interest in Cartier increased from 21 percent to 46 percent in 1984, it opened the Fondation as a public relations ploy to assuage the bad press. When Cartier offered to buy Haacke's work, the artist refused. Either he thought that Cartier would retire the piece to cold storage, or would display it to the advantage of its corporate justification, and he felt that its impact would be slanted by association. *Les Must de Rembrandt* was again exhibited in a Haacke retrospective at the Centre Pompidou in Paris in 1989, during the time that Cartier was offering to underwrite the popular Andy Warhol retrospective at the same venue. The exhibitions committee at the Centre Pompidou turned Cartier down on the grounds of the latter's South Africa connection.

To Cartier's credit, the Fondation organized its own "Warholfest" concurrently with the Centre Pompidou show. Three exhibitions illuminated aspects of the artist's career and time that the main show did not: the first was the original New York Museum of Modern Art exhibition of eighty-five prints, with a subsequent Cartier-sponsored tour through Czechoslovakia, East Germany (as it then was), Hungary, the former Yugoslavia and Poland; the second was a touring show of Warhol's pre-Pop Art "Success Is a Job in New York;" and the third an exhibition organized by Cartier of

Velvet Underground memorabilia (photographs, films, record covers, T-shirts, handbills and posters), with a reunion party at the Foundation for the Velvet Underground. The Velvet Underground show was a real coup for corporate patronage, demonstrating that the corporate conscience can be cleared when confronted with attacks on its motivations. Even Lou Reed, the rock band's lead musician, was there, brushing aside questions of his loyalty to the South African cause: "I performed at the Nelson Mandela concert in London one or two months ago, so I'm not worried about my credentials."[16] While in many instances the State, the Church and the business establishment have manipulated culture to mask their plunders since time immemorial, a more open mutual relationship between culture and corporation is emerging. Cartier, among many businesses cited here, practices enlightened corporate good citizenship.[17]

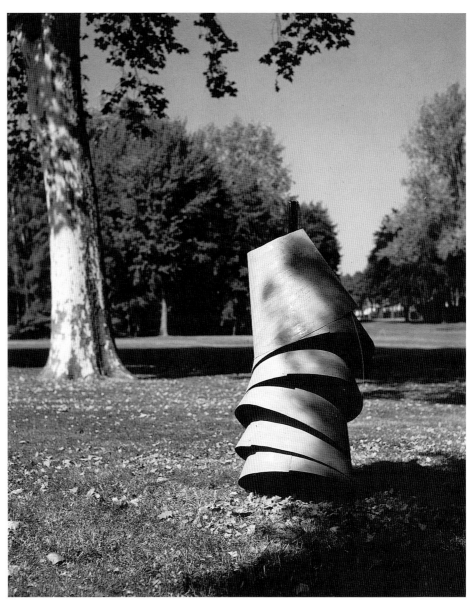

Richard Tuttle, *Terre de Granade*, 1985, 63 × 15¾ (160 × 40). Fondation Cartier pour l'Art contemporain, Jouy-en-Josas.

Ian Hamilton Finlay, *L'ordre présent est le désordre du futur*, 1987, 137¾ × 354⅜ (350 × 900). Fondation Cartier pour l'Art contemporain, Jouy-en-Josas.

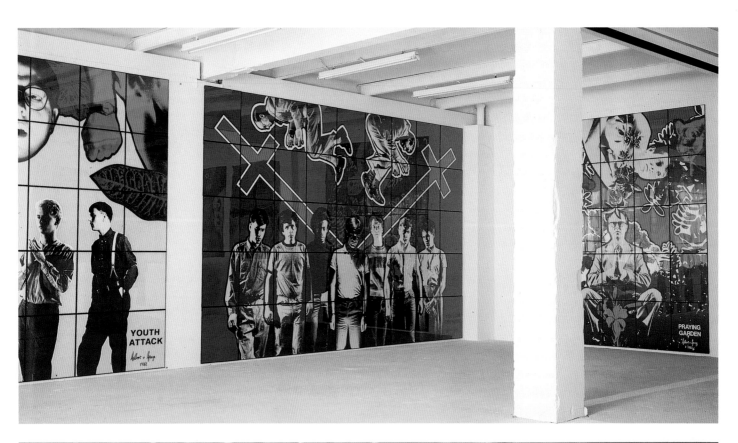

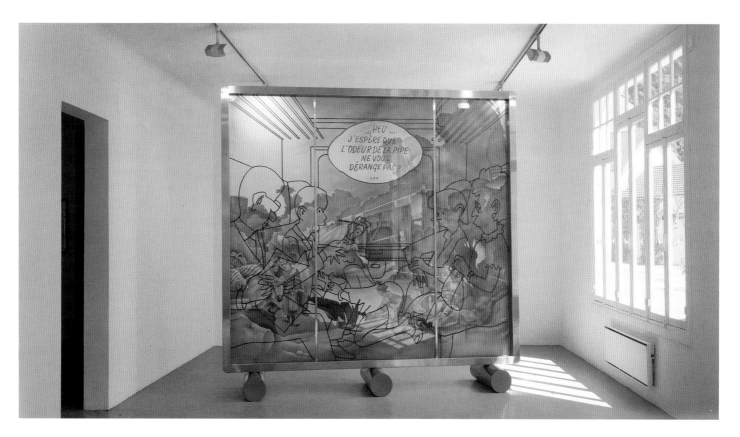

The collection at the Fondation Cartier pour l'Art contemporain is a panoramic sampling of international dimension that includes two hundred works by Absalon, Miguel Barcelo, Ashley Bickerton, Alighiero Boetti, Christian Boltanski, James Lee Byars, Sophie Calle, James Coleman, Tony Cragg, Jan Dibbets, Luciano Fabro, Ian Hamilton Finlay, Fischli & Weiss, Barry Flanagan, Dan Flavin, Ange Leccia, Juan Muñoz, Julian Opie, Giulio Paolini, Marcus Raetz, Thomas Ruff, Hiroshi Sugimoto and James Turrell among them. Other Cartier programming of special note are exhibitions like "Carnet de Voyage" (1990–91), a selection of works by promising young artists from Europe, and the provocative video installation, *The Sleep of Reason* (1990), the first in Europe by American artist Bill Viola.

Opposite, above: **Gilbert & George**, *Yellow Crusade*, 1982, $157\frac{1}{2} \times 118\frac{3}{8}$ (400 × 300) Collection: Cartier International.

Opposite, below: **Edward Allington**, *That Dark Ditch*, 1986, $58\frac{1}{4} \times 78\frac{3}{4}$ (148 × 200). Collection: Cartier International.

Above: **Bernard Bazile**, *J'espère que l'odeur . . .*, 1989, $119\frac{5}{8} \times 116\frac{1}{2} \times 33\frac{1}{2}$ (304 × 296 × 85) Collection: Cartier International.

Left: **Grenville Davey**, *Plain*, 1989, diameter $76\frac{3}{8}$ (194). Collection: Cartier International.

Markus Hansen, *Feature*, 1990, wood paneling, vitrines, metal objects and photographs, variable dimensions. Installation recreated in the small visitors' room at Starkmann Library Services Limited.

Starkmann Library Services, London

In London, business *mécénat* to the purist taste pervades the offices of a modest-looking establishment in Lisson Grove. Owned by Bernhard Starkmann and housed in a converted dairy plant, the firm distributes the latest scientific and some humanities literature published in England, America, Holland and Germany to academic libraries throughout Europe. The facility was renovated by Claudio Silvestrin, a Milanese architect residing in London, whose concept of light and space is perfectly calibrated to the succession of changing site-specific commissions and exhibitions that make up the collection. In the process of inviting artists to install their work in the main workspace "gallery" or encouraging them to look at the total office as a laboratory for creative exploration, Starkmann seems to delight especially in those artists' proposals that "render the boardroom useless for commercial purposes" or "knock the visitors/interview room to bits" in order to realize their invention.

The predisposition of the collector/curator/businessman in this case is toward those artists who pursue new horizons, often absorbing new technology, or at least acknowledging the matter of new science, as it relates to their interest in light, space and especially the passage of time. The mind and the touch of the artist are always intuitively felt, yet often not physically seen. Moreover, the similar and dissimilar interrelationships of media, intentions and visual manifestations here exemplify the kind of exhibition strategy usually accomplished in museums.

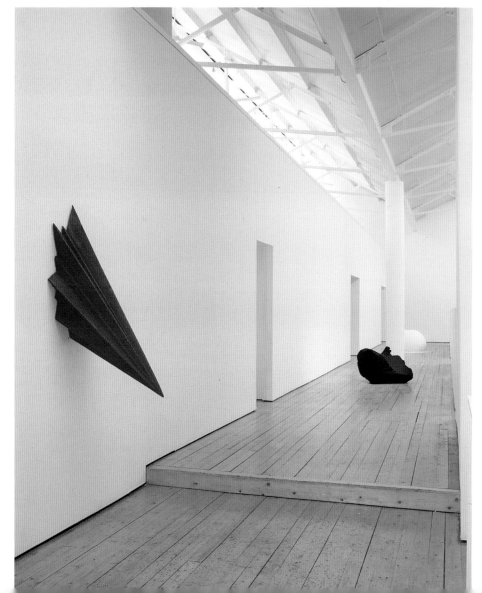

Anish Kapoor, *1000 Names* (white sculpture) 1980–81, wood, gesso and pigment, $27\frac{5}{8} \times$ diameter $51\frac{1}{8}$ ($70 \times$ diameter 130), and *1000 Names* (red sculpture), 1985, wood, gesso and pigment, $49\frac{1}{4} \times 19\frac{5}{8} \times 27\frac{5}{8}$ ($125 \times 50 \times 70$). Collection: Starkmann Library Services Limited.

An interior view of the workspaces at Starkmann Library Services Limited with *What's Said is Seen*, a sound installation by **Angela Bulloch**, 1991, variable dimensions. It consists of a sound-activated light source, tungsten halogen floodlights, a cable, a sound sensor, a light sensor, a variable electronic dimming mechanism and a selection of colored glass plates.

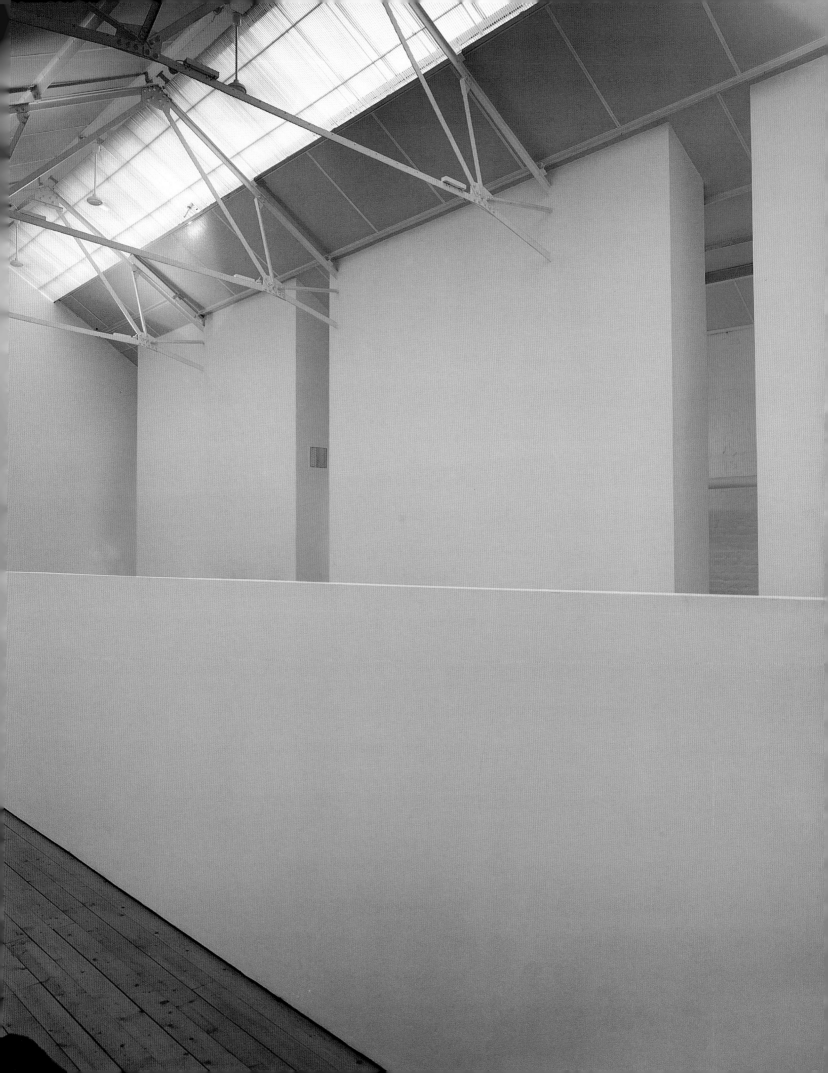

Rodney Graham, *Suide*, Marbais, Belgique, Hiver, 1990, photowork, $34\frac{1}{4} \times 26\frac{3}{8}$ (87 × 67), part of Starkmann Library Services' collection and also used as an advertisement for the firm in a trade journal.

A view of the executive office at Starkmann Library Services Limited, with (left) two *Pollen* works (Buttercup and Moss) by **Wolfgang Laib**, 1981, (right) *Rustic Slate Circle* by **Richard Long**, 1980, diameter $215\frac{3}{4}$ (548) and (on the wall) *Parsifal 1882 to 38,969,735 AD* by **Rodney Graham**, 1990, variable dimensions.

musical passage that was extended to allow time for four landscape canvases to be hauled across the stage thereby denoting the knight's trek. Through the sophisticated manipulation of modern information and acoustic programming technology—consisting of an Apple Macintosh computer, six power amplifiers, twelve speakers and a musical score—Graham, like Parsifal, has succeeded in another "quest" where a lost musical passage is reinvented and electronically programmed to be repeated forever (or at least until AD 38 billion)!

In a variety potentially as infinite as Graham's musical investigation or as nature itself, Richard Long has been making stone circle pieces for interior spaces since 1972. The development of this formalization of the outdoor "walk works" that he began in the early 1970's in walking journeys around the world, represents an artistic distillation of the mental and physical ritual of the trip itself.

Wolfgang Laib, a trained physician turned artist/shaman, lives reclusively outside a small village in southern Germany. In an immaculate and ascetic studio environment, the artist collects by hand different pollens, from hazelnut to dandelion to pine, from the surrounding fields and forests "according to the day or season or weather conditions." "If you put one of these works in a space, the life around, in that space has to be changed," says Laib. "And in public places—we need places for art, not huge architectural monuments which are decorated with some art. For my work [I want] a place with the highest concentration, where the sensibility of the work corresponds to the sensibility of the place and of the people

Many artwork installations are produced expressly for a location in the office chosen by the commissioned artist, and typically are in place for about six months. For the main office space, Angela Bulloch, an emerging English sculptor, has completed *What's Said is Seen* (1991), a sound-activated light environment consisting of tungsten halogen floodlights, cable sound and light sensors, an electronic dimming mechanism and blue glass plates. Craig Wood, another young English artist, covered the boardroom table with polyurethane and the German

Markus Hansen sheathed a small conference room in wood.

For his own office, Starkmann chose three works by more established artists: *Parsifal 1882 to 38.969.364.735 AD* (1990), a complex sound installation by the Canadian artist Rodney Graham, Richard Long's *Rustic Slate Circle* (1980), and two Wolfgang Laib *Pollens* (Buttercup and Moss, 1981). Graham's piece, based on the Transformation Scene in the 1882 premiere of Wagner's opera, where Parsifal climbs to Monsalvat and the Temple of the Holy Grail, focuses on a

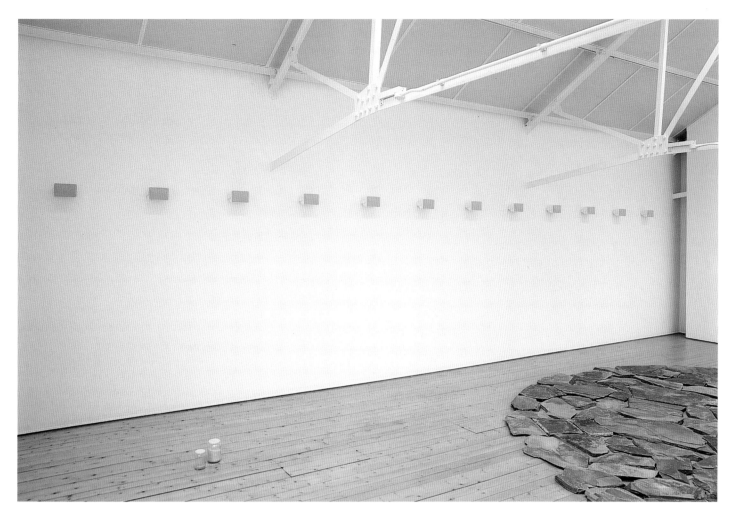

who come there. It is not only a matter of scale, light, floor or walls. Exhibitions in galleries or museums can sometimes be very beautiful, but that cannot be the aim. We need much more."[18]

Starkmann's philosophy is a passionate argument for a better world: "With some imagination, determination and lateral thinking it must be possible to bring the creativity of artists to the boardrooms and to the offices of corporations—not as status symbols but to enrich the daily life of everyone sharing in the enterprise. My small space is looked upon by visitors as a revelation, a rare exception. This must change, since I and my colleagues would enjoy it just as much as my visitors do to enter a space full of surprises, enriched by art and cared for with great concern."[19]

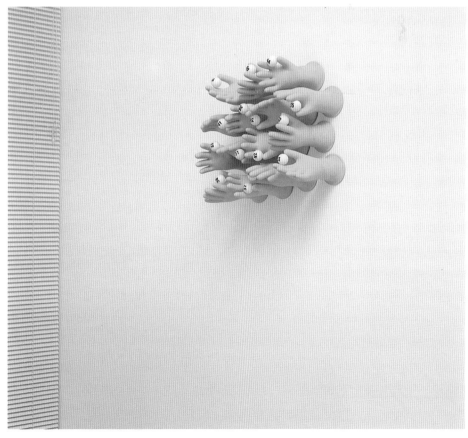

Craig Wood, *Gloves 31–45*, 1990, rubber gloves with white bingo balls, 21⅝ × 21⅝ × 11¾ (55 × 55 × 30), on the wall of a small conference room at Starkmann Library Services Limited.

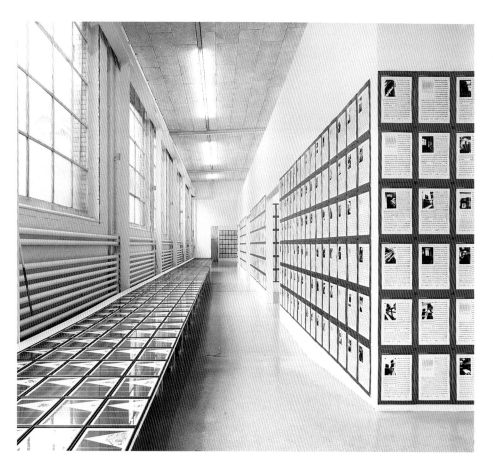

Hallen für neue Kunst, Schaffhausen

In 1974, a group of Zürich businessmen became patrons to an incipient international avant-garde. Under the guidance of Urs Raussmüller, their army buddy who had since become an artist, the businessmen commissioned works which were to be known as the Crex Collection. For ten years exhibitions of the resulting works were staged first (1974–76) in a makeshift gallery in the lobby of Migros Corporation's Zürich headquarters and then (1978–81) at InK, a nearby empty warehouse converted into a *Kunsthalle* and sponsored by Migros. In 1984, the operation moved to the picturesque border village of Schaffhausen. With Raussmüller as the founding director, the exhibition facility, again a converted industrial building, became the Hallen für neue Kunst (Hall for New Art), a place of pilgrimage for contemporary art lovers and a sizeable Mecca for the tourist industry. The Crex Collection is a veritable glossary of many of the most accomplished artists on the international scene who came into full bloom in the 1970's and 1980's. Some of the artists represented at the Hallen für neue Kunst are: Carl Andre, Joseph Beuys, Dan Flavin, Donald Judd, Jannis Kounellis, Sol LeWitt, Richard Long, Robert Mangold, Mario Merz, Bruce Nauman, Robert Ryman and Lawrence Weiner.

Although some works were acquired rather than commissioned, Raussmüller's distinctive concept was to encourage the production of the work of certain artists, and to link their production to their presentation. "There are thousands of people working on the side of presentation," Raussmüller said, "and there are very few, functioning under very hard conditions, on the productive, primary side."[20] The Schaffhausen facility is, in effect, the "spatial continuation" of a number of the large-scale artworks exhibited there. The artists themselves guide many of the installations and the presentation becomes a further ingredient of the artist's conception. This aspect of

artmaking differs from the traditional notion of site-specificity because the work is not usually made for a particular space, but adapted to the site by the artist.

During the 1970's, Raussmüller was also cultural consultant to Migros for the corporation's numerous philanthropic activities in the visual arts, and his innovative pursuits resulted in one of the most accomplished business/art ventures in the world. This unique case study for rethinking art in business had its roots in Raussmüller's work at Migros Corporation and his collaboration with the Swiss businessmen patrons.

The following is taken from an interview with Urs Raussmüller in January 1991, in his office at Schaffhausen:

Marjory Jacobson: Do you think that the future looks hopeful for the possibility of collaboration between business and the visual arts, or are the Hallen für neue Kunst and your work at Migros rare and isolated phenomena?

Urs Rausmüller: I think that we have to understand that every cultural effort needs a very broad base, and without any economical possibilities there is no possibility for the artist to do his work. It is the relationship that exists between society and the artist, and the artist and society. There is a nice example that I might use to illustrate the point. Not far from here there is a monastery, and this monastery belongs to a type where every monk lives in his own house. When we look at this monastery we see that there are thirteen houses, and people must wonder about a monastery where there are thirteen monks doing in a primary way nothing but thinking and writing.

MJ: Either nothing, or everything.

UR: Yes, but working in a field of knowledge or in a field of culture here requires 85 brothers and 270 other people working for that monastery. So, in this illustration, the thirteen monks represent the field of culture. The monks need a force, a production force which is capable of sustaining thirteen people who are not working in the conventional sense. And

this shows you also the relationship that exists between business or commerce or society and the people that make culture. Artists absolutely need the 270 plus 85 to support them. Artists, who are supported by society, also support society by giving it all the spiritual material that is requested to keep society alive. I see the whole problem as a permanent and immediate exchange between commerce, which has the ability to produce a little more than what it needs, and the artist. Through business sponsorship, the artist is allowed to produce the cultural side, which is also needed because without a mental basis for understanding there is no need for a bank, or an insurance company or for any company whatsoever.

MJ: How would you convince the business community at large, after telling this story, of the necessity for getting involved with culture in a serious way? For me it is not only the involvement, but it is the quality of the involvement that is essential for a successful merger of art and business.

UR: Speaking from the top manager's side, he should, because he is a top executive, understand that his institution tends—with him or without him—to institutionalize. That means to do things more easily, and this may lead, if you let it go, to a situation where things are done so easily that the doers fall asleep. The top manager understands that his job is not to keep the institution institutionalizing. He has a totally different task to fulfill. He has to keep his business alive. His employees will keep the institution going. In fact, his real job is to wake them up to ask questions, to disturb what has a tendency to institutionalize. He has to bring in new energies. This is what his role is all about. He has to act when things are difficult. But when things are normal, other people can do it very well.

MJ: Do you think that the world recession means that business must find a new path?

UR: I think that we need more top executives who have the capacity to think differently. New situations always require new approaches and can never be

approached by means of extrapolation from already experienced situations. We need new ideas, creative ideas. At this moment the top executive has a very similar problem that the artist has. He must become creative. Artists can offer him the possibility to understand that being ultimately the only one in his institution who has the final decision, he is the one who has to interface with new ideas. Artists can give him the chance to understand in another field how the creative moments work. He can learn, in the field of culture, that he can find other kinds of creative people, and naturally, he can find creative people in many fields. When he realizes that there is creative behaviorship everywhere, it is his duty to explore it fully. We all depend on him. If he has the right ideas, things go very well. If he hasn't, it may be a catastrophe for thousands of people who are with him in his institution. One of the ways for business to rejuvenate itself is to get involved directly with the creative world where culture is made.

MJ: Is there an argument for business supporting the visual arts over other kinds of art?

UR: I think that there is an argument insofar as certain arts, by definition, have a built-in audience for support. For instance, film requires that there is an audience, music requires an audience. I can hardly think of a theater piece that is played only for the playwright himself. In French we call this *vis-à-vis*, the other side always exists in the thinking. While in the visual arts we do not think of a *vis-à-vis*. For example, Van Gogh did what only Van Gogh had to do. Regardless of the fact that he had no client, or consumer, he did what for him was the true thing he had to do and what he could not escape. The visual arts are for the expression of the individual; the visual arts do not include a third person. Ironically, visual art is about extremely individual moments that tell about a person or a situation.

MJ: Are you saying that the reason for business to patronize the visual arts over any other art form is that in the context of

the workplace, or in a corporate *Kunsthalle* or museum the inception of creativity can be nourished?

UR: That is the point. We have to understand that before there is anything to be conserved, we have to create it. Therefore, where shall the businessman engage the possibilities he has, for example, for his money? I think the best possibility is to put it into creation. Once things are created, there is a lot of time and there are a number of different ways in which to conserve the work, or to make it understandable, or to transform it so that it becomes a cultural fact. We put a lot into the education and the conservation, and we forget that, in fact, before all this can take place, the artwork must be created. This, in fact, is the essential thing.

MJ: So, your point is that the business entity might consider engaging its money in the creation of the work, to make it possible to come into being?

UR: As I said in the beginning, there is the relationship between society, or my monks, and the people who work for them. If the people who work for them do not understand what they are doing, why there are thirteen people who do not work

in the vineyards, if there is no understanding between the two, the situation does not function at all. One must come to the point where there is the understanding that some members of society must be the artists, that they are as important as the others because you cannot do one without the other. This is a total link between society and creative people.

MJ: I visited Migros, and I was thinking about all the wonderful things I saw, and how they are now tucked away in out-of-the way corners of the facility with very little public exposure. How did it all begin?

UR: When I started the Migros program, it was clear that this was an intervention into the creative field. Migros asked me to make an exhibition of my own artwork there in 1976. I did not wish to do this because it did not make sense to me to put some nails in the wall and hang up a decor which then is changed a month later or two months later. I mean, this is not enough. One can do much better by using more or less the same money. So, I suggested to them an idea which would have been my own ideal working situation. It was easy to do this because, as an artist, I knew only too well what I

would like, what exhibition structures existed and how they functioned. I knew how museums operated, how galleries functioned, how foundations gave out money, and I had always felt that with all these many different things, there was not yet an ideal situation. So, my proposal to Migros was for a dream institution, in fact, which was absolutely thought of in terms of the artist. I also knew that as a collector you interfere very late. The work is existing. It's already hung. It's perhaps in a gallery or something. But you come very far and you are very distant from the moment when it takes place. And I knew that one could do much better. One could be much closer to all this. One could take a much more direct action to support the creation of works. When [Joseph] Beuys installed *Das Kapital* here, I did not buy the work but I gave money in order that he could make the work again. [It was first installed at the Venice Biennale in 1980.] Or some other artists came to ask for help and they got money to realize things they were about to produce but couldn't. I understood collecting, in fact, not as going to a gallery and buying what you like. I understood collecting as being as intense and as immediately engaged as possible in the creation and fabrication of the art.

MJ: Why did Migros accept this revolutionary idea of yours?

UR: I wrote it all out as a proposal to the chief executive of Migros. When Pierre Arnold became the chief executive, he engaged a new art director, and she asked me to make the exhibition. Arnold and I developed a relationship of mutual respect. He is a very unusual person. I was a consultant to Migros for the seven years that Mr. Arnold was Chief Executive. As we had very clear ideas about culture, it was very easy to have a policy of behaviorship, a policy that allowed us to say yes, we support, because there were many other things we were doing at the time, or no, we do not support.

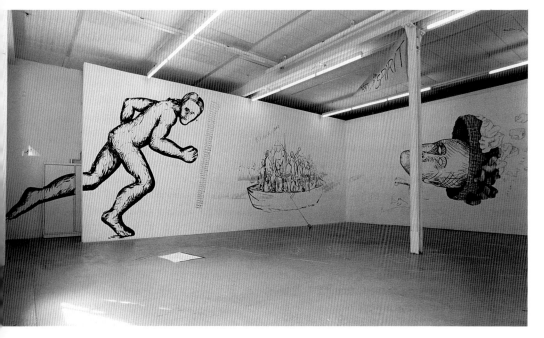

Jonathan Borofsky, installation at InK (Halle für internationale neue Kunst), Zürich, 1979.

I would like to point out here that it is very dangerous to submit the subject of art to a committee. The committee will always do what is the middle of its understanding, and it is impossible that five or three or seven people all have the same understanding. Therefore as soon as you submit anything that is extreme to a committee, it has to be, more or less by definition, rejected. Rather, a committee likes a situation where everybody gets something because everybody will then be pleased. So the constellation of this very strong chief executive and also the power he was able to exercise allowed us to realize something special. This point is extremely important because many times companies are courageous and prepared to take engagements, but they do it the wrong way. One has to keep everything in order. For instance, the chief executive's first priority is to decide whether or not he wants to take on these art engagements. If he wants to take them on, then he has a second decision to make. The second decision is to ask who will do this? And then he has no third decision to take anymore. He can decide to replace the who, but there should be no further decision-making left for him to do. The moment he starts to make decisions on level three, it does not work. He is making decisions where he knows little. If he does this, he is extremely frivolous.

MJ: But it is a very enlightened and sophisticated person who can choose a "who." In our profession, it may not be a person who has the same "taste" you have, but the person must be a responsible and professional and very imaginative "who." And that is very hard, because you know as well as I do that often it is the woman who runs this art organization or the man who runs that art school, etc. The qualifications for and standards of excellence are not well defined in the visual arts. They are the most arbitrary of all the arts. You should get the very best you can after careful research. It is important to be convinced that the people you have are as good as you can get on a professional level, people at the forefront of their fields.

UR: Yes, or it ends with nothing, at nothing. But I would say, if the person in charge is really a top executive in a general sense, I would expect him to have understood what it means being at the helm of an institution, what it means to make decisions. What it means to give responsibility and authority to others and not to interfere. To let it happen.

UR: Before starting InK, in order to get Migros' support, I had to give support to them. And one of the supports we gave was to make exhibitions at the former building entrance hall of the Migros company. And we made exhibitions in this entrance lobby, of the work of artists like Donald Judd and Robert Mangold to people who had never seen this kind of thing. And of course what was even worse was that however you went, you had to pass the exhibitions four times a day. I mean, if I go to the museum it is my free choice to go there, to pay for a ticket and look. But when I do not feel like going to the museum, I do not have to see art. Can you imagine what it means to make this type of exhibition in an entrance lobby where everybody, but really everybody, had to pass through at least four times a day.? This was heavy stuff.

For every exhibition we had announcements and introductions. We made postcards, and on the back side of each postcard was a small text. We found these postcards everywhere in the building. People kept these postcards. When we started InK we stopped doing this and moved to a separate space sponsored by Migros nearby and had plenty to do running the institution. Three months after we had moved, people were still coming over from Migros and asking us why we were not still in the Migros lobby.

MJ: And they didn't like it when it was on their own turf.

UR: Yes, of course. There was a lot of controversy. But when we stopped the program in the lobby, they came and said they realized how much this kept them going. They said they had something to talk about when they went to lunch or for coffee. There was a common ground for engagement. We made about twelve exhibitions in a year in the Migros lobby— Gerhard Richter, Donald Judd, Robert Mangold, Robert Ryman, Gilbert and George, Bernd and Hilla Becher, Sigmar Polke. The works all belonged to the Crex Collection. Then, as an introduction to the artists, we made the Migros lobby exhibition. The problem of art today is the reception of it. You go out in the woods and you shout as loud as you want; if there is no one to listen, you stop shouting. The problem of art today is that the artist makes a proposition; if it goes far you find an institution who will exhibit this, but beyond that there is no reception. And I think that we have to be clear that we need a reception.

MJ: So, let's get back to the beginnings of InK.

UR: InK opened in June of 1978 as an exhibition space and a program to sustain the creation of art. It was a production facility for the artist. Migros provided the space, money and people in order to allow the artist to do something that he might never have been able to do on his own. What happened then was that people could come and look at what had been done, or students from the University could come by and see the works of art for the first time. InK was first a space of creation and second it became a space of exhibition. It was located in Zürich, close

to the Migros headquarters, right opposite the arts and crafts school. It was about 9,000 square feet and about 110 interventions, or exhibitions, took place there in a three-year period. It was not that you could look at the artists at work there, it had nothing to do with that. But it was a mental laboratory. We started it in 1978 and ended in 1981.

MJ: Do you agree that one of the things we've learned from all this is that in the future, when companies consider the support of art, hopefully in a very sophisticated way, one possibility is rather than hang the work all over the building, to create a special space.

UR: I think yes, at the very least, a mental space. Then it is essential for the business to be very demanding in the action of culture, as demanding as it is in its business actions. For example, when IBM does something in the field of IBM, it really tries as hard as it can, to perform the best it can in its own field. The moment corporations do some cultural work, with few exceptions, why don't they ask: "How good is what we do?" "How

efficient is this?" "Can we do better?" The same criteria that they use to run their business should be used in their cultural activities. *How, how.* Not *that* they support cultural activities, every business does something. But *how*? And in what understanding, and aiming at what? Corporations know they have a philosophy for their own business. What is their philosophy in the culture field? It should be close to their real philosophy. It must also be clear that one should never be confused about what is social, and what is cultural.

MJ: Very good distinction.

UR: And this, for instance, becomes a tremendous mess when we look at many corporations that do support the arts. They believe they are doing something for culture and in reality they are providing a social action.

MJ: Well I think maybe the difference needs to be clarified. One is not bad and the other good. They are just different.

UR: I want to point out that we need the social behaviorship as well as the cultural, and when I complain about the

"messing up," I am complaining about many business situations where social work is done in the name of culture, and this results in a replacement of the cultural.

MJ: You must have some new ideas about how to work with business to alter some of the patterns of business behavior towards cultural activity.

UR: Yes. Actually, if you have read Goethe, for instance, in the figure of Faust he says something which I think is really right to say. The moment you say "Do not go on" is the moment you give up the strategy of being alive and of this permanent changing, and of this permanent questioning. When one gives up this moment because he can no longer go on because he got too tired, or because he liked something too much, he is dead. And I think that we should understand that art is that one strategy of behaviorship that is not meant to sit down, and it is not meant to be overly enjoyed. It is meant to be this tremendous question mark to all of us. And we always have to approach it and reapproach it.

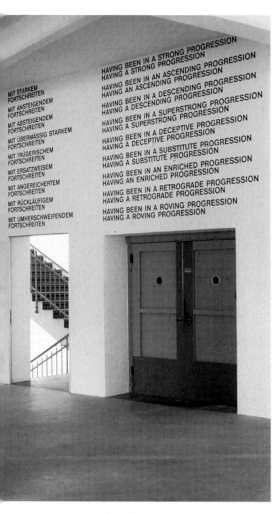

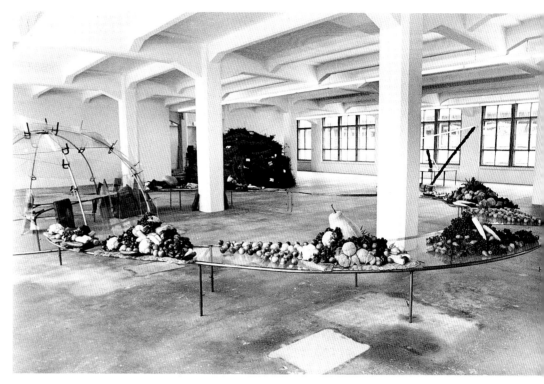

Mario Merz, *Isola della frutta*, 1987, a permanent installation at the Hallen für neue Kunst, Schaffhausen. Crex Collection.

Carl Andre, *37 Pieces of Work*, 1969, a permanent installation at the Hallen für neue Kunst, Schaffhausen. Crex Collection.

Lawrence Weiner, *Having Been in a Strong Progression*, 1973, an installation in the entryway to the Hallen für neue Kunst, Schaffhausen. Crex Collection.

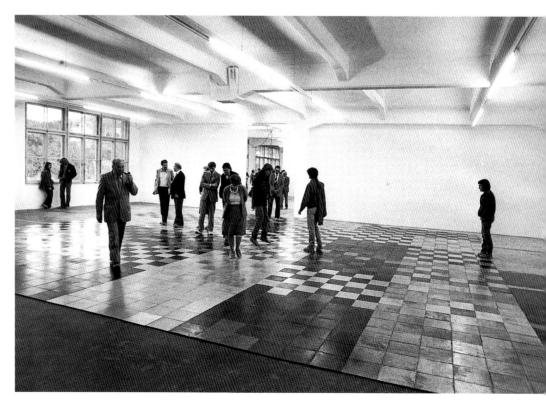

< Hallen für neue Kunst, Schaffhausen, Switzerland.

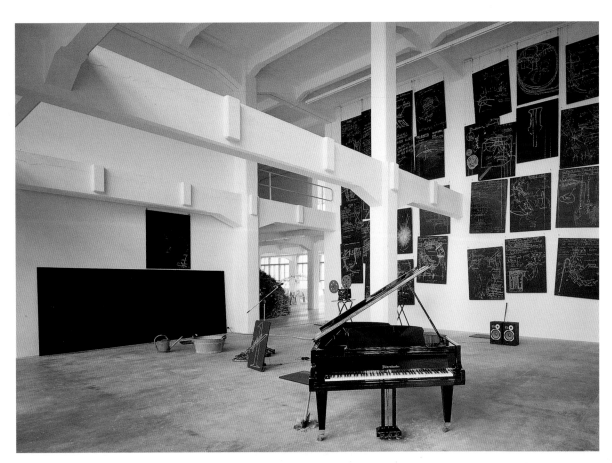

Joseph Beuys, *Das Kapital Raum*, 1970–77, variable dimensions, a permanent space installation at the Hallen für neue Kunst, Schaffhausen.

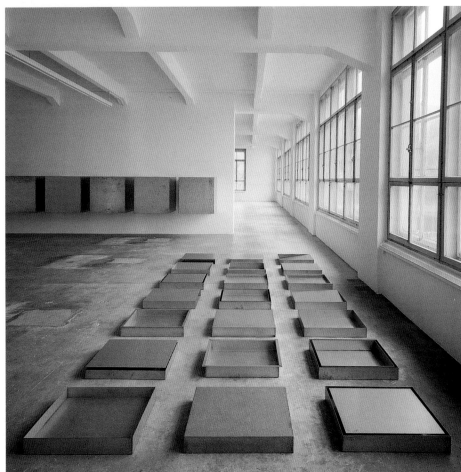

Donald Judd, *21 Sculptures of Galvanized Iron*, 1972–73, each 22⅞ × 26¾ × 4 (58 × 68 × 10.5), a permanent installation at the Hallen für neue Kunst. Crex Collection.

Opposite: **Bruce Nauman**, *Dream Passage*, 1983, two iron tables, two iron chairs and twelve yellow, eight white and eight red neon lights, 472½ × 42 (1200 × 106.5) and 112⅝ × 2 × 97¼ (286 × 5 × 247), a permanent installation at the Hallen für neue Kunst. Crex Collection.

CHAPTER 3
THE PANTHEON
Fruits of Professional Commitment

"We collect art on only one basis, that it is good art. The creative process communicates on its own, so we just started hanging it up around the office."

Donald Marron, Chairman & Chief Executive Officer, PaineWebber, New York[1]

Certain contemporary corporate art collections are only conventional in that they continue the tradition established by major banks and other multinational corporate institutions in richly and liberally covering their walls with artworks. In a wider context, these business patrons are unique in being collectors of the most perceptive and imaginative sort.

This corporate pantheon is not a mausoleum but, on the contrary, a living shrine to the Olympian achievements of three illustrious business entities from around the world, all of which have invested large sums of money and considerable time and passion in developing art collections on an ongoing and highly professional basis. As they would in any department directly related to business growth, the patrons in this pantheon typically hire talented professional curators as senior management staff. Because of their commitment to the visual arts at a senior executive level, they have amassed holdings often of a quality on a par with that of major museums. The high standard of their achievements, and how and why they established and strengthened their accomplishments, are discussed in this chapter.

Chase Manhattan Bank, New York

After over thirty years of consistent buying activity, the Chase Manhattan Bank Art Collection is still the mother of them all. Having veered through three, and now well into its fourth art administration period, and in spite of the fluctuations in the banking business, Chase vigorously pursues its dynamic acquisitions policy. Manuel E. Gonzalez, Vice-President and Executive Director of

the Chase Manhattan Art Program since 1988, is steering the collection into new areas of installation and environmental art as he keeps pace with the leading edge of contemporary developments.

The Chase program, inaugurated in early 1970, was the pioneering example of world-class contemporary art in the workplace that could be seen not only in plazas, boardrooms and conference rooms but in all reception areas and office corridors throughout the building. Dorothy Miller, of the Museum of Modern Art, who along with Katherine Kuh,[2] her colleague at the Art Institute of Chicago, was one of the first serious museum curators to advise a corporation, said that the Chase phenomenon had three distinct ingredients: the clear, neat spaces designed by architects Skidmore, Owings & Merrill; the newly perceived eminence of American art; and David Rockefeller.[3] Another unique aspect of Chase is that the bank has never sold a work from its collection, a fact that makes it a trustworthy place for important art to go, as prestigious and probably safer than many museums.[4]

"I felt that when we were making a major move to the new building, we wanted to change the image of banking," David Rockefeller commented on the new Chase headquarters. "We wanted to get away from the marble columns outside banks and from the image that bankers were glassy-eyed, hardhearted people. So we first determined that we would have a contemporary type of architecture. Then, having crossed that bridge, the interior of a building like this is very severe, because there are none of the friezes and cornices that there are in some of the old buildings. It called for paintings and sculpture that could be thought of as built-in decorative features. The collection would also provide enjoyment and education for members of our staff and visitors and serve as a means to give encouragement to contemporary artists."[5] It should be noted that Mr. Rockefeller's opinions about the place of art in architecture was the orthodoxy of its time; yet to collect

contemporary art on such a scale, by such a professional process and with such egalitarian tenor was sheer heterodoxy in the world of business.

As regards the questionable results of the voracious art-buying practices of many American companies in the 1980's, the Chase Art Committee prototype, amended to address their needs, would have been a much more productive course to follow. Those at the top of the *Fortune* 500 roster would have done infinitely better with their money, image and overall cultural benefits package had they added to their corporate art committees a group of impartial museum professionals to advise on the possible breadth and scope of the art program relative to the financial resources at the disposal of their curatorial staff.

Committees of this kind serve several functions. First, a peer group of art and architecture professionals brings a variety of expert points of view to the table and keeps curators and art program managers up to date; as in science, technology and medicine, it has become impossible for any one person to digest the reams of international information needed to keep abreast of developments. Secondly, the corporate members of the art committee act as support systems for difficult decision-making, whether on aesthetic matters or on purely political issues.

Installation of recent acquisitions at the new SoHo branch of Chase Manhattan Bank, 623 Broadway, New York, in 1990. Artists represented here are (clockwise from left) **Annette Lemieux, Jeff Koons, Thomas Ruff, Barbara Ess, Frank Majore, Jimmy De Sana, Allan McCollum** and **James Welling**. Collection: Chase Manhattan Bank, N.A.

Installation view at the SoHo branch of Chase Manhattan Bank, New York, 1990. Left, **Sarah Charlesworth**, *Rietveld Chair*, 1981, black and white photomural, 67 × 50 (170.2 × 127); right, **Richard Prince**, *Untitled (Three Women Looking in One Direction)*, 1980, Ektachrome print, 40 × 60 (101.6 × 152.4). Collection: Chase Manhattan Bank, N.A.

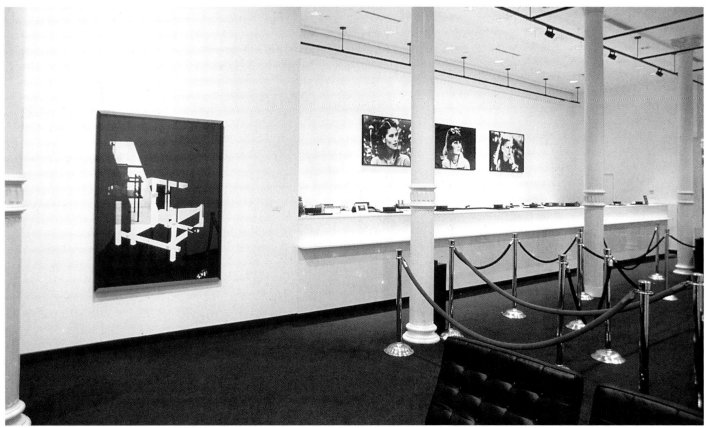

If the effort was Herculean, so was the original budget of $500,000. Rockefeller, himself on the board of the Museum of Modern Art, assembled a stellar art committee of museum professionals to suggest young artists for the bank.[6] This prototype has proved to be highly propitious, and has worked very well with other large on-going or long-range art projects such as Battery Park City (see pp.128–30, 191–92) and Nestlé (see p.141). For about ten years, the Chase committee met monthly or bimonthly, the members proposing work (sometimes as many as 150 per session) for acquisition, after which they voted by secret ballot. Each piece was given a rating of 0 to 3, and any object awarded a total of 11 or more points was acquired. (This voting system could only work, of course, with a group of art experts.)

With art budgets that expand and contract within a seven-figure range according to facility need, Chase's holdings now stand in excess of 13,000 pieces (in number and significance comparable to many world-ranking public art institutions and private foundations) in 400 locations worldwide. Jack Boulton, who was responsible for the purchase of several thousand of them, came to Chase in 1979, remaining there until his death and leaving an impressive curatorial legacy. For a period from 1968 until Boulton's appointment, the program had backed away from the more venturesome tone of the founders and seemed to be settling into a safe and sound middle ground. Boulton re-established the connection with the competitive edge, while never losing sight of the nature of his constituency: "I'm multilingual ... I can speak State Department, I can speak corporate, and I can speak Artforum. Sometimes corporate and Artforum sound a lot alike, come to think of it. At the bank, we never say things like 'art education.' We talk about knowledge base development."[7] What Boulton really did was rely on his installations to make their own point, often juxtaposing radically different objects to encourage people to look. He

was deeply committed to art education in a non-verbal context, "not necessarily to get people to discuss David Salle versus Eric Fischl [two super-artists of that moment] but what it means and how it means."[8]

One of the unique aspects of the art at Chase was Boulton's and architect Michael McCarthy's "SoHo branch gallery" concept. Located on Broadway near Canal Street, the bank's SoHo branch is in the thick of the experimental New York visual arts scene. Boulton suggested that new acquisitions be exhibited there as a way continually to expose Chase's commitment to this constituency, confident not only that he would receive peer support and wide public and media attention before the work was absorbed into the bank's collection, but that it would be a boon for Chase's business in the area. The small branch has been host to approximately three changing exhibitions per year, timed to coincide with Art Committee meetings, as well as some museum shows featuring

works by artists in the permanent collection.[9]

When in April 1988 Gonzalez assumed the post held by Boulton, he inherited the rekindled legacy of avant-gardism. In choosing Gonzalez, Chase made a de facto commitment to strengthening its activities in this direction. Under his guidance, Chase has achieved not only its most ambitious integral art project to date, but embarked on a major episode in the annals of art at work. A trio of electronic sculptural artworks by Americans Bruce Nauman, Dan Flavin and Nam June Paik span the lobby concourse of the Chase facility at MetroTech Center in Brooklyn.[10] Like a narrative exploration of the merging of art and technology at its creative edge, the pieces echo the state-of-the-art banking information and communications systems housed at Chase MetroTech. Nauman, Flavin and Paik are artists of international stature. They have each made seminal contributions to current visual thinking using ready-made industrial lighting hardware or media

Nam June Paik, The Chase Video Matrix, 1992, multi-television set matrix, 60 × 18 ft (18.3 × 5.5 m). Commission for 4 MetroTech Center, Brooklyn, New York. Collection: Chase Manhattan Bank, N.A.

< **Bruce Nauman**, *Read/Reap*, 1986, neon and glass tubing, 78 × 78 (198 × 198), installed in the lobby at 4 MetroTech Center, Brooklyn, New York, in 1992. Collection: Chase Manhattan Bank, N.A.

equipment—Nauman with neon, Flavin with industrial fluorescent lighting, and Paik with computers, television and video. At the Chase complex, not only is each artist represented with a major work, but the relationship of the artist to the user's experience of a public thoroughfare is emphasized. The art project here celebrates the building's function and adds luster to the bank's distinguished legacy as the corporate clarion of up-to-the-minute art patronage. In a second adjacent Chase building at MetroTech, another American artist, R.M. Fischer, has been commissioned to make for the lobby a series of clocks representing different time zones. The design for the installation is inspired by the theme of technology, worldwide networking and corporate imaging.

Gonzalez has also initiated international touring exhibitions illuminating aspects of

the Chase Collection as corporate cultural ambassadors. For example, "Photoplay," over one hundred photographic works from Chase Manhattan Art Collection, was organized to tour five Latin American countries through the end of 1994. A trilingual catalogue (English, Spanish and Portuguese) was produced.

Among Gonzalez's other contributions to the program is a site-specific commission from Peter Halley for the main boardroom on the seventeenth floor of 1 Chase Manhattan Plaza.[11] Halley is a young American painter of geometric abstractions praised for their contemporary social edge. This work harbors the philosophical and physical characteristics Halley experiences in post-industrial culture. In Halley's case, social rhetoric is consistently fused to uncommon visual craft, earning him a reputation as a leading artist of the day.

Installation in the reception area of the executive floor at Chase Manhattan Bank, 410 Park Avenue, New York. Left, **Cy Twombly**, *Untitled (Sappho)*, 1959, oil on canvas, 39 × 59½ (99 × 151); right, **Brice Marden**, *Marble #6*, 1981, oil on marble, 29 × 19¾ × 1 (5.1 × 50.2 × 2.5). Collection: Chase Manhattan Bank, N.A.

A site-specific commission by **Peter Halley**, 1990, day-glo acrylic and acrylic on canvas in three panels, each 50 × 70 (127 × 177.8), for the Chairman's Board Room at 1 Chase Manhattan Plaza, New York. Collection: Chase Manhattan Bank, N.A.

Julian Schnabel, *Untitled*, 1980, oil with plates bonded on wood, 60 × 40 (152.4 × 101.6), in the reception area of the executive floor at Chase Manhattan Bank, 623 Broadway, New York. Collection: Chase Manhattan Bank, N.A.

R. M. Fischer, proposal for Chase Manhattan Bank, Building E lobby, at MetroTech Center, Brooklyn, New York, 1992. The design for the installation is inspired by the theme of technology, worldwide networking and corporate imaging, and the images and forms in the work evoke power and optimism. The reflective floor and walls of the lobby and rear lighting at the elevator entrance area give the installation a jewel-box-like quality, emphasizing the precision and beauty of the mechanical forms. The installation also conveys a sense of the heroic, the humorous and the functional. Rendering by Jeffrey Kamen. >

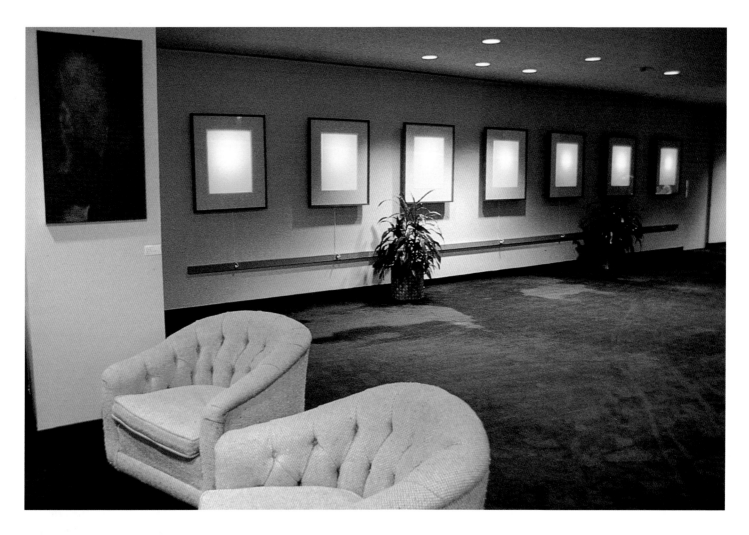

"Art was becoming more and more an arena of connoisseurship ... increasingly divorced from any connection with what I call international or worldwide intellectual social issues. I think that what we do in the visual arts is really only important insofar as it engages issues that are real in society as a whole." On his use of industrial paints, Halley commented in the same interview that he had seen "Roll-a-tex on suburban walls and was fascinated by it, and Day-Glo had always seemed very spooky and unnatural to me." His first paintings were of prisons, but "the more I thought about alienation, the more I thought of telephones, televisions, electricity and things zipping in and out of isolated spaces, and so I felt I had to depict the support system that these isolated cells had. In the real world

they usually come from an underground conduit network feeding into the cells. It's about above-versus below-ground, visible versus hidden, and maybe even the conscious and subconscious. I began to notice, driving down the street, that almost every car or truck with graphics on it (like moving company vans or four-wheel-drive pick-up trucks) uses the same sequencing of yellow, red and orange. I thought I had hit on something that the culture uses as an emblem."[12]

When Jack Boulton first came to Chase he commented that it looked like "the computer had belched Ilya Bolotowsky, Bolotowsky, Bolotowsky [an early American Geometric Abstractionist whose work is commonly collected by corporations for what is seen as placid inoffensiveness]—standard, abstract,

geometric."[13] Peter Halley's boardroom painting for Chase marks the distinction between the generic and the genius, an important addition to the Chase collection and to the discourse on art in the workplace.

"Although you may agree or disagree with our particular choices, I hope you see reflected in them all the values which have always defined the Chase Collection: innovation, quality, scholarship and imagination," Gonzalez said. "Our challenge as a program as we face the twenty-first century is twofold: to maintain the high standards established by David Rockefeller and Alfred Barr thirty years ago and to expand them and keep them flexible for the changes that are sure to mark the future of the bank and the future of art."[14]

PaineWebber Group, Inc., New York
Like David Rockefeller at Chase
Manhattan Bank, Donald Marron,
Chairman of PaineWebber Group, Inc.,
has adeptly woven his personal passion for
the visual arts into his company's business
philosophy. Marron, who has been leaving
his imprint on the investment world since
the late 1960's, is also an esteemed private
collector and for five years was President
of the Board of Trustees at the Museum
of Modern Art. It is not the fact that he
instigated a great art program for his
company so much as the process and
manner of its introduction and evolution
that provide illuminating insights.

PaineWebber Group, Inc. is the parent
company of PaineWebber Incorporated,
one of the leading securities firms in the
United States. Together with
PaineWebber International and Mitchell
Hutchins Asset Management, the group
has a global clientele. The company leased
its present headquarters in the Equitable
Life Building, New York, in 1985 after
Equitable expanded its development
through to 7th Avenue. Although sharing
both physical connections and high-power
arts patronage, the companies' approaches
differ considerably. (See p. 108 et seq for
a detailed discussion of Equitable.)
Equitable is new to arts support;
PaineWebber has been amassing holdings
for nearly twenty-five years. Equitable has
made a virtue of marketing its art and
architecture program; PaineWebber, a
virtue of keeping its collection a very
public secret. Equitable engaged the
consulting services of the Whitney
Museum of American Art and outside
professional advisors to do the job; while
Marron has his own curator in-house, he
is a knowledgeable collector in his own
right. Both Equitable and PaineWebber
have lobby galleries; the Whitney
Museum programmed and administered
the spaces at Equitable with exhibitions
both from their own holdings and from
outside sources; the PaineWebber Gallery
is supported and operated by the company
as a resource for many non-profit arts and
cultural institutions who wish to obtain

It is interesting to note that Marron has
very successfully adapted the museum's
organizational structure to the
relationships and responsibilities of the
PaineWebber curator. Marron is not only
the "director" but also the "head" of the
firm's acquisitions committee. A
hypothetical job description for the post
of PaineWebber curator might be the
ideal model to emulate: the curator
should be fully informed of current
exhibitions, auctions and private sales;
be aware of interesting emerging artists
not yet widely shown; recommend
acquisitions; install the collection in
innovative and instructive ways; take
charge of the administration and
conservation of the collection; conduct
an ongoing verbal education campaign
by maintaining an open dialogue with
the company's staff, promote the
philosophy established by the chairman
and lobby for new ideas. In addition, the
curator should understand the nature of
the business in which he or she
operates and must develop ways to
address the corporate constituency.
Beyond art training, the curator should
communicate with the diverse corporate
community. People visiting a museum
are a captive audience. People who
work in or visit the workplace need to be
captivated. It takes consummate
training, skill and experience to be able
to operate effectively at this level.

exposure for their programs in the urban
community. The PaineWebber Gallery
was designed as part of the renovation
program for the whole Equitable complex
under the aegis of Skidmore, Owings &
Merrill, who built the skyscraper in the
1960's. The open plan and elaborate panel
system devised by the architects make for
an interesting display area. As a serious
art space, to which Mr. Marron would
have been very sympathetic, it does not
work. Both corporations have used their
private dining rooms to show selections
from their collections: PaineWebber

houses on its premises works on paper
accumulated slowly and with individual
connoisseurship; Equitable in some cases
commissioned artists to make a group of
works for a particular room and in others
purchased masterpieces by early American
masters often with the assistance of the
Whitney's curatorial resources.

Currently the PaineWebber Collection
numbers about 550 works and is installed
on all nine floors that the firm inhabits.
Initially, Marron used the services of
outside consultants to help him manage
the collection. Since 1985, the firm has
had a full-time in-house curator: first
Monique Beudert until late 1990, and
currently Jennifer Wells. Both women are
trained art historians and curators who
worked previously at the Museum of
Modern Art in New York.

The following excerpts from an interview
given by Donald Marron in June 1991
provide a rare and revealing perspective
on the intersection of visual arts and
business from the point of view of a man
who has had the opportunity to make
empirical observations at first hand over
the years.

Marjory Jacobson: Is an art program
such as yours good for business? Is it a
good thing for business to get involved in
a serious way in the visual arts?
Donald Marron: My view has obviously
been shaped by my own experience. I
started the collection about twenty-five
years ago, by hanging prints up in my firm
[Mitchell Hutchins]. The reason I did it in
addition to loving it, which is the most
important reason, was because I think
contemporary art in most cases reflects at
the very least the society that creates it. If
you are running a modern business, you
expose your people all the time to the best
of contemporary thinking, and it should be
a benefit to expose them to the best of
contemporary creativity. On the other
side, I think that if you try to do this by
imposing the experience [on the
workforce], or by developing a formula,
then neither is going to work very well. If

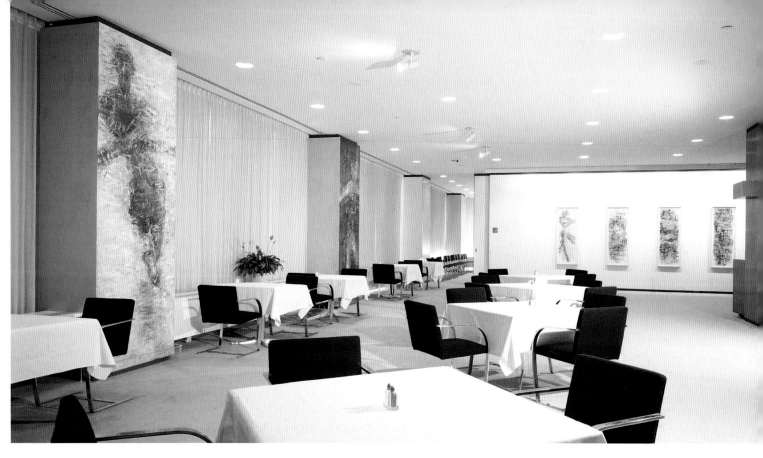

Susan Rothenberg, *1–6*, 1988, oil on wood in six panels, each 126¾ × 46⅜ (322 × 117.2), on the piers in the main executive dining room at PaineWebber Group, Inc., New York. On the far wall are Rothenberg's full-scale preparatory drawings for the project.

you impose the art on people, then you are not really giving art the chance to communicate on its own level. If you do it on a formula basis, the probability of getting to the heart of what is being done is not too high.

MJ: How can you not impose the collection on people if it is in their work spaces?

DM: My approach was, first of all, to install everything, and not explain it. Contemporary art is always subject to explanation as are most things, and I never thought that was right. Truly good art wins its own fans. What we did was to encourage people to put anything they wanted in their offices, but in the public spaces for some period of time we would site work that we chose—six months, nine months—and at the end of that time if it really offended someone, we would take it down. Just like everything in life, you have to give it a chance to see how you feel about it.

MJ: So you think it is something about the universality of great art? That it intuitively speaks to us?

DM: Yes, I think that is the sole purpose of art. The creative process communicates on its own. Art does not come from the artist or curator standing beside it explaining it. We learned this from Mitchell Hutchins where the collection began. That experience gave me the encouragement to develop the program, to keep going and to make a much bigger thing out of it. If it had not worked that way, and at that point almost all the things hanging in the offices were mine, I would have just taken them home. Another thing it did was to start a number of people collecting. At the time I had three of four different collections in the office. One of them I had was a modest collection of American black and white prints. There is also another issue. If what you are trying to accomplish is a sense of quality, and I think everyone is, quality that exists in areas that are not your business is still important. It is important to reinforce the standards of the firm. I think that art in business is very different because you are around it twenty-four hours a day, and it serves not only as a communication device but is the background that sets a certain sensibility.

MJ: Art today is much more overtly political and socially conscious than was the case in the past. Would this phenomenon affect your thinking about putting that work up in your offices?

DM: I think that every decade has addressed these issues. If there is more now, that is fine. We collect art on only one basis—that it is good art. The only thing that we will not collect is work that we regard as offensive to people.

MJ: What do you mean by offensive?

DM: For example, Lucian Freud. He is a great artist. We have a complete set of his etchings since he returned to printmaking in 1982 as well as several drawings. And we have a great new painting. As you know, Freud's work can be pretty explicit. I was offered a few paintings that you might have said were really great. Well, some people would have found them offensive. We have waited to get the Freud that is still at the top level of quality but isn't so explicit. I have found, as a result of being involved with art in the workplace for this length of time, that in the end almost everybody sees in the art something, so there is no need to impose art on somebody for its shock value or because it is extreme.

MJ: What are some of the qualities that having visual art in the workplace encourage, or discourage?

DM: Contemporary art reflects contemporary trends. What you want is for everyone who works for you to be as much in touch with the issues of the day as possible. My own feeling is that for Americans in the 90's what will be one of

the important trends in terms of America's desire to distinguish itself will be education and culture—not split-level houses and washing machines. When you get to education and culture, and I don't necessarily mean high culture—it can be fashion, or graphics or whatever—communicating and appreciating the involvement of art is going to play a continually increasing role. If you want to be a business linked with American trends in thinking, being involved in art in some way or another is a good idea.

MJ: I believe in contemporary culture, having respect for the time that we live in, understanding it a little better and coming to recognize the visual arts as a valuable asset to society.

DM: Art is more integrated into society than it has ever been, from every point of view. So long as it is going to be integrated, for most corporations and for most entities that house lots of people for long periods of time, it is enlightened self-interest to participate in the arts.

If Donald Marron had done nothing at all but commission Susan Rothenberg to make a mural for the executive dining room, he would still have made his mark. It was an inspired choice, and has resulted in what may arguably be Rothenberg's *magnum opus* to date. Marron said: "I had never done commissions before because

you never know what you are going to get. I called up Susan and said, 'What do you think?' and she said that she had never done commissions before either for the same reason. But she came over anyhow. I had my own idea about what to do, but I did not want to tell her what to do. We walked around together. And it went on for weeks, and she wound up doing the last thing she thought she would do and the last thing I thought she would do. I wanted her to take one of those very big walls or alternatively do a room. That was her thinking too for a while. Then she said, 'Those pillars are very interesting.' Oh, God, those pillars were covered with beautiful teak, too!"[15]

Although there is one solid wall in the thirty-eighth-floor dining room (six drawings that Rothenberg began as studies for the paintings now hang here), Rothenberg was ultimately attracted to six piers that interrupt the sweeping fenestration on two sides of the space. Each pilaster measuring $10\frac{1}{2}$ by 4 feet was fitted with a wooden panel of the same size. Entitled *1–6* (1988), the work depicts six whirling figures in different aspects of dizzying rotation. Painted in a complicated palette of brushy abstract strokes, four with a predominantly black ground, and two mainly white, the generalized figures are melded with their atmosphere. The phantom bodies, in

Rothenberg's words "figurative but apersonal imagined body states," are generic in form and rendered in reds and blues. Part of the brilliance of the project is the sensitive incorporation of the architectural features and the implied extension of the atmospheric light, mood and tone of nature viewed from the windows. "I was getting annoyed at the art world, and I wanted to do something in the city for a different bunch of people. And I thought I wanted to be present there, to be available to relate to people in a way that would break the old ivory-tower, stuck-in-studio way of working—you know, be more in the world. And I had originally thought I would paint on site, but that proved to be impossible at PaineWebber. People were eating there. So I realized I had to do the work in my studio in Sag Harbor."[16] Nevertheless the ensemble has the sense of being made on site; the work reestablishes a connection with architectural art (the caryatids of Ancient Greece, the figure reliefs of the buttressed medieval church, the niched saints of Renaissance buildings) and goes beyond to solve the problem of fusing work to site. This set of conditions, under which the corporate entity helps the artist to find new directions, is a notable achievement.

Many of the drawings and prints in the PaineWebber collection are displayed

A typical reception-area installation at PaineWebber Group, Inc., New York, including (left to right) works by **Ashley Bickerton**, **Matt Mullican** and **Christopher Wool**.

An installation in a reception area at PaineWebber Group, Inc., New York, revealing correspondences between works by (left to right) **Vija Celmins**, **John Baldessari**, **Gerhard Richter** and **Richard Artschwager**.

A comprehensive selection of prints by **Jasper Johns** can be viewed together in a private conference room at PaineWebber Group, Inc., New York.

Room N at PaineWebber Group, Inc., New York, where works on paper from the 1950's and 1960's by such artists as Claes Oldenburg, Robert Rauschenberg, Willem de Kooning, Franz Kline, Philip Guston, Robert Motherwell and Cy Twombly are installed.

chronologically or thematically in private dining rooms adjacent to the Rothenberg space. They are literally small drawing and print viewing spaces inhabited by some of the treasures of the collection. Room J, for example, contains a nearly complete body of etchings made by Lucian Freud; Room N houses a compendium of works on paper from the 1950's and 1960's—Claes Oldenburg, Robert Rauschenberg, Willem de Kooning, Franz Kline, Philip Guston, Robert Motherwell and Cy Twombly among them. Other rooms hold drawings by more contemporary masters including Enzo Cucchi and Francesco Clemente, and new additions by Lorna Simpson and Yasumasa Morimura.

Other areas, such as conference rooms and private meeting rooms, provide space for some of PaineWebber's principal print holdings. Two examples are the Jasper Johns conference room on the fourteenth

floor, and an area where the Californian artist Ed Ruscha, supported since the 1960's by Marron, is fully represented in graphic work as well as in drawings and paintings.

Each of the nine floors holds masterpieces and a wide range of the best work of the younger generations, intelligently rehung every so often to reflect various sources and crosscurrents. For instance, an installation on one of the nine floors showed how differently artists such as Gerhard Richter, Andy Warhol and Richard Artschwager and others shaped by the 1960's used mass media and Pop culture.

A more predictable but commanding large-scale work by Frank Stella hangs in the reception area to the executive dining room; and paintings and multimedia works of rare quality by such artists as Jean-Michel Basquiat, Francesco Clemente, Tony Cragg, Enzo Cucchi,

Lucian Freud, Gilbert and George, Philip Guston, Donald Judd, Anselm Kiefer, Jannis Kounellis and Bruce Nauman are other highlights of the collection. Recent acquisitions are by younger innovators around the world as well as imaginative works by more established artists: Ray Smith, Matt Mullican, Christopher Wool, Jonathan Kessler, Brice Marden, Lucian Freud, Jasper Johns, Chuck Close, Robert Gober, Rosemarie Trockel, Jim Shaw, Willem de Kooning, Greg Colson, David Salle and Guillermo Kuitca.

Since his retirement as President of the Board of Trustees of the Museum of Modern Art, Marron has begun an expanded, yet still measured, program of visibility for the collection, including publication of a scholarly catalogue raisonné and some touring exhibitions which will take place by the spring of 1994.

Fukuoka City Bank and Fukuoka Jisho Company, Fukuoka

After a decade of frenzied art purchasing in Japan, which was reported to be $3.4 billion in 1990 alone,[17] the West was still smugly assured as to what it perceived to be the not-so-discreet charm of the parvenu. Yet once again, the West has been proved short-sighted. As one insider observed kindly: "We tended to think that this was some aesthetic naiveté on the part of the Japanese, a perhaps cultural inclination to rely on photographs. But now, it seems, a lot of the Japanese were playing a whole other game than we realized."[18] The complex "game" that in Japan has to do with business, taxes and a host of ingrained cultural and social traits is discussed in greater depth in Chapter 1 (p. 17).

A business-initiated collecting posture that fits the theme of the pantheon class is rarer in Japan than in the Western world, but the example set by the Fukuoka City Bank and the Fukuoka Jisho Company, both owned and managed by the same family interests, has made great strides in the area of corporate art collections. They are also on the very cusp of invention with Nexus, their prophetic experiment in urban housing.

There are many lavish art collections founded by corporations in Japan. Few are contemporary, and only a handful of these are in the highest rank, a fact which makes the Fukuoka City Bank collection and its precepts even more hallowed. Fukuoka, a city of 1.2 million people located on the southwestern Japanese island of Kyushu, is a link to Korea and China and a convenient launching point for the archipelagos of the Pacific Rim, and Australia and New Zealand. Mr. Tsukasa Shishima, President of Fukuoka City Bank Ltd., the parent organization of the family interests, is a second-generation Shishima and the impetus behind the bank's cultural activities. Hifumi Shishima, his father, was of humble origins; in a kind of Horatio Alger tale, people at the bank are fond of citing that the elder Shishima, who once was a fruit

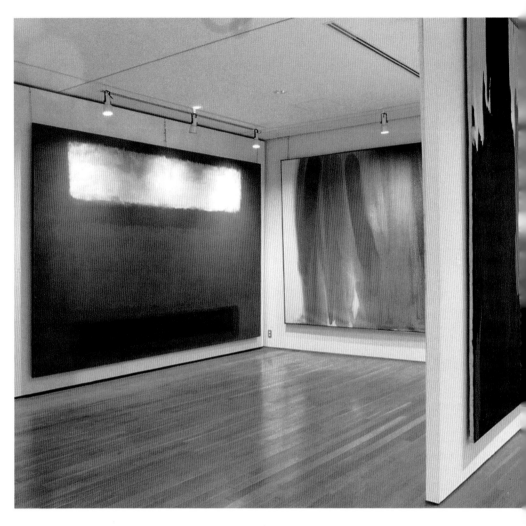

picker in California, returned to Japan and started the Fukuoka Sogo Bank in 1952. The younger Shishima had hired the then-fledgling architect Arata Isozaki in the late 1960's to design Fukuoka Soga branches in Oita and Daimyo and, in 1972, Isozaki completed the new Fukuoka City Bank headquarters in Fukuoka. Isozaki has gone on to become one of the premier architects worldwide, and the banks represent the apex of his early style.

Tsukasa Shishima credits Isozaki with stimulating his interest in contemporary art. Mr. Shishima believes that in general Japanese companies are changing by reaching out to collaborate with the world.[19] He has also made a case for tax reforms which would encourage Japanese corporations to give more funds to culture, providing cultural amenities that

The exhibition room at Fukuoka City Bank Ltd's headquarters, Fukuoka, with (left to right) **Mark Rothko's** *Black Maroons & White*, 1958, oil on canvas, 108 × 156 ft (274.3 × 396.2m); **Morris Louis'** *Nun*, 1959, magna on canvas, 98 × 138 (249 × 350.5); and **Clyfford Still's** *PM-967*, 1956, oil on canvas, 113 × 147 (299.7 × 373.4).

Sam Francis' *Untitled*, 1971, installed in the executive reception area at Fukuoka City Bank Ltd's headquarters, Fukuoka, along with (left) **Louise Nevelson**'s *Royal Night Winds*, 1958–59, 110 × 85 (279.4 × 216).

The boardroom at Fukuoka City Bank Ltd's headquarters, Fukuoka, with **Red Grooms'** enormous installation, *Red's Square*, 1990, poly-flash on aluminum with foamboard, 113¾ × 219¾ × 47⅞ (289.6 × 558.8 × 121.8).

The private reception room at Fukuoka City Bank Ltd, Fukuoka, contains many works by **Lucian Freud**, among them (left to right) *Father and Daughter*, 1949, 43 × 20 (91.5 × 45.7); *Girl on the Quay*, 1941, 16 × 19¾ (40.8 × 50.2); *Wastegrand, Paddington*, 1970, 28 × 28 (71 × 71); and *Girl in a Fur Coat*, 1967, 24 × 24 (61 × 61). All oil on canvas.

Another view of the exhibition room at Fukuoka City Bank Ltd's headquarters, Fukuoka, showing (left to right) **Roy Lichtenstein's** *Figures & Sunset*, 1979, 107 × 167⅓ (272 × 425); **Jean Dubuffet's** *Rue Pitre*, 1971, oil on canvas, 65 × 86⅝ (165 × 220); and **Jasper Johns'** *0 through 9*, 1960, 72 × 54 (183 × 137.2).

would have national as well as international ramifications. Like so many of his compatriots, Mr. Shishima has plans to build a corporate museum in Fukuoka to house his collection. Whatever the loss in tax revenue to the city, Kyushu would reap the financial benefit of having the only tourist-oriented cultural attraction with significant contemporary Western art within easy reach of South Korea, Thailand, Burma and Taiwan.

The Japanese are very keen on developing themes and consistent rationales for their projects. This kind of analytical pre-planning has been a bonus to the great architectural experiment that the Fukuoka Jisho Company underwrote. The wealthy Shishima family has promoted a cultural philosophy unparalleled in its dedication to "integrity-oriented" concerns. Again, the whole concept of enlightened self-interest is at play. The Fukuoka Jisho Company, headed by Shishima's nephew Kazuhiko Enomoto, wished to find alternatives to the bland conformity in Japanese middle-class housing design—an especially conspicuous condition in crowded Japanese cities. The urban environment of the future was the basis of its development plans for Fukuoka. From the beginning, the company declared that it "would produce this project as an artwork, not merely as merchandise, respecting the concept of the designers and our resolution to cooperation."[20] Only after fashioning a clear concept for the project did Fukuoka Jisho ask Isozaki to mastermind the whole operation.[21]

Fukuoka Jisho wanted a breakthrough model of excellence, and was willing to take some risks to attain it. Isozaki, in turn, was in a position to lead a strong campaign for the ultimate professional input because of his revered status and intimate relationship with his long-time client.[22] Fukuoka Jisho began with two buildings in the Seaside Momochi zone slated for redevelopment in a joint venture between the city and several real-estate firms.[23] Michael Graves and Stanley Tigerman, successful American architects

In 1988–1990, **Stanley Tigerman** (right) and **Michael Graves** (left) designed housing at Nexus Seaside Momochi, the first phase of the Fukuoka Jisho Company's redevelopment plan.

of the current garde, each built a condominium core in 1988–90, and in the thick of real-estate mania, the units were snatched up within an hour of being offered. (There were 650 applicants for 22 units!) It was Jisho's first experience with "overseas architects." In the wake of Jisho's inability to reach any kind of *rapprochement* with the city for its radical vision, the company turned to Kashii, a section in the eastern part of the city where it was the sole owner of the land. The project was billed, tellingly, as the new "exhibition" site for Nexus. The planning for Nexus World Kashii began in the fall of 1988 with the selection of an additional five foreign architects and one Japanese. They represented the cream of the rising generation of urban planners and designers: Christian de Portzamparc (France); Rem Koolhaas (Netherlands); Oscar Tusquets (Spain); Steven Holl (USA); Mark Mack (USA), whose design for Nexus won a 1989 Progressive Architecture award; and Osamu Ishiyama (Japan). The plan, slated for completion in 1993, featured a Western-style residential block of 192 units and 16 commercial stores, with two high-rise towers by Isozaki at the center, a commercial building by Andrew MacNair and an open green space by the American landscape artist Martha Schwartz.

While the majority of artists who use earth and horticultural materials are trained in the doctrinaire fine arts disciplines (painting, sculpture, drawing and printmaking) (see pp. 128–30), landscape artist Martha Schwartz has a graduate degree in Landscape Design. She was commissioned by Isozaki in 1990 to design a park for the Kashii-Fukuoka project. The concept was to "unify the diverse architectural statements," as well as to provide outdoor spaces of artistic character and practical function. Schwartz has always worked in the landscape idiom to make places of symbolic and functional demeanor, ever within the boundaries of the visual art discipline. Among her other private-sector projects are the temporary *Turf Parterre Garden* that she contributed

to the "New Urban Landscape" exhibition sponsored by Olympia & York at the World Financial Center, Battery Park City in 1988 (see pp. 191–92), and a master plan for a unified art landscape for various parts of the site and site functions at the Los Angeles Center, an urban renewal project for six downtown city blocks.

In Japan, the elaborate process of developing real-estate projects, like the familiar ritualistic attitude inherent in the culture, is as important as the outcome. What made Nexus World Kashii a critical success was the exceptional rapport between its architects and patron. Isozaki undoubtedly played the all-important role of enlightened producer, but the visionary attitude of Fukuoka Jisho personified in Kazuhiko Enomoto, the company's president, was as important. The architects, all eager experimenters, were treated as hands-on artists and asked to supervise all finishes and details inside as well as out. The high standard of craftsmanship delivered by the contractors, who were respected by the architects as collaborators, expanded the scope of talent for both. Although the Japanese were impressed with all the buildings at Kashii, the work that most intrigued them was that of Rem Koolhaas

whose "vertical stacking of rooms around a courtyard, and the airy atmosphere that resulted was a revelation, representing an important discovery in the history of multi-unit housing."[24]

In the project-descriptions her office issues, Schwartz typically includes the heading "artistic intent." The Kashii project narrative is composed as a metaphor for a painting: "Like a tablecloth underlying the objects in a still life painting, a patterned ground plan is employed ... Architecture and landscape objects combine to provide a richness and spatial character of a still life painting, but at an urban scale ... around the site perimeter unified plantings and paving provide a strong picture frame to complete the metaphor of the still life painting."[25]

Nexus augurs well for the new in city planning, and not only offers an alternative to the dogma of Japanese middle-class urban living but, by nurturing the wider perspective of art and business combined, rewrites some of the traditional formulas for success in real-estate development. Isozaki observed: "The bottom line was not uppermost in the client's mind. He got carried away. I have learned that things never happen unless there is someone who allows himself to get carried away."[26]

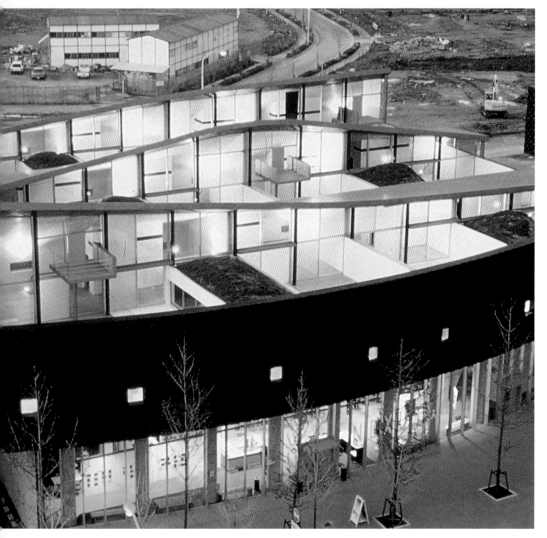

Detail of Austrian-born American **Mark Mack's** building for Nexus World Housing, Fukuoka, 1988–93. The architect's design won a Progressive Architecture award in 1989.

French architect **Christian de Portzamparc** designed figurative buildings likened to a mountain and a tempietto for his thirty-seven condominiums at Nexus World Housing, Fukuoka, 1988–93.

Dutch architect **Rem Koolhaus'** condominium complex for Nexus World Housing, Fukuoka, 1988–93.

Site plan and schematic design showing **Martha Schwartz's** park for Nexus World Housing, Fukuoka, 1990. The elements in the park include a double row of columnar Ginko trees forming the frame and describing the scope of the artwork and a Mound Garden, three sculpted mounds of progressively larger size on a stylized ground place, each mound supporting its own park folly (sleeves for a vase to contain Ikebana arrangements – a base for an "architectural" folly designed by Daniel Liberkind – and a base for a single sculpted Japanese pine tree). The entire ground plane of the mound garden is black asphalt striped with caution-yellow paint. Other trees, benches, bridges and moats connect the garden to the street and adjoining apartment buildings. The caterpillar fountain is a meandering element made of rubble loosely stacked and studded with nozzles that form the "fur" of the caterpillar. The Palm Grove garden consists of thick truncated date palms planted on a slightly depressed grid of gravel ground. Isozaki Plaza, an area between Arata Isozaki's two residential towers, is treated as a single flat field of functioning safety yellow fiberglass drainage grates. Green neon lights glowing under the grates become an "electric viewing garden."

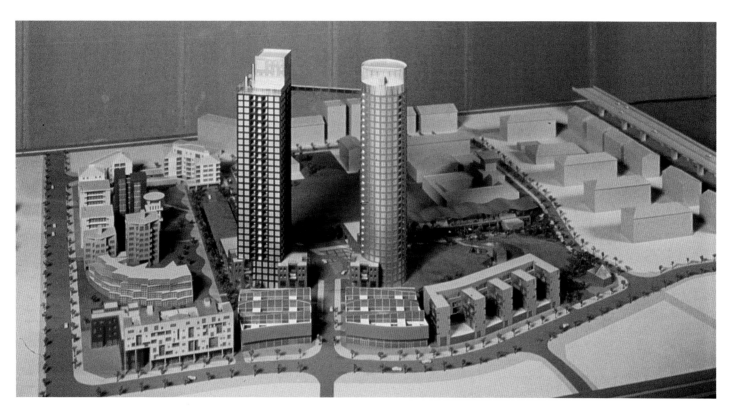

CHAPTER 4
THE NEW MUSEUMS OF THE MAGNATES
Purpose and Performance

The museum and the collection are very connected to what we are doing, and at the same time very independent ... It is a sort of celebration of innovation, and that also gives force to innovative people in our own company as well as having an impact on the public.

Rolf Fehlbaum, Chairman, Vitra International[1]

Why would a business underwrite its own museum? Can a corporation initiate a collecting institution that adequately addresses the challenges of museumship? This chapter is devoted to a selection of museums founded by corporate interests that have met the model with great distinction. They have been chosen because they represent a mosaic of interesting results from the cohabitation of seemingly odd couples.

The Hara Museum of Contemporary Art, Tokyo

Since the mid-1970's Japan has been riding the crest of an economic boom. Upwards of two hundred museums have been established in Japan during this time, of which perhaps 20 percent are owned by business corporations. Virtually all of the noteworthy as well as the notorious contemporary collecting in Japan is done by these corporate museums. It is also commonly known that many of them have sprung up either as a way to circumvent Japan's punitive inheritance taxes or as a Byzantine subterfuge for sheltering taxable capital gains. Either way, during the last decade the combination of soaring real-estate values and low interest rates, the high yields of the stock market and the doubling of the value of the yen against the dollar led to an art-buying binge that boosted the prices of anything by, or like, Monet, Renoir, Modigliani, Chagall, Van Gogh, Picasso and a host of less and least prized Impressionists and Post-Impressionists—as well as paintings and prints by a select group of famous contemporary Americans.

Toshio Hara of Nihon Tochisanrin Company Ltd., a lumber and construction firm, has been a singular missionary voice encouraging the growth of contemporary Japanese talents at home. Unlike the Shishimas of Fukuoka (see p. 62), whose forefather began as an unskilled laborer in California, Mr. Hara's roots trace back to the financial dynasty pioneered by his ancestors during the Meiji Restoration. Toshio Hara's great-grandfather was one of the privileged few who studied abroad at Princeton University and then at the London School of Economics. When he returned to his native land in the late 1800's, the elder Hara founded the Yokohama Shokin Bank (now the Bank of Toyko) and the Daihaku Bank (now Mitsubishi) and eventually became a cultivated collector of traditional Japanese art. Following the family pattern, Toshio Hara himself studied business at Princeton, and developed a strong passion for art, especially Japanese art today.

Hara founded the Hara Museum of Contemporary Art with two ambitions: to create opportunity for younger Japanese artists and to promote quality contemporary East-West cultural exchange on an international level. The museum, located in his grandfather's house in the Tokyo ward of Shinagawa, was opened to the public in 1979 with a collection of one hundred works that Hara had been acquiring. The landmark building, a 1937 design by well-known Japanese Modernist architect Jin Watanabe, was converted into a museum by Arata Isozaki. It was the first museum in Japan, public or private, to focus exclusively on contemporary art. Within a year Toshio Hara had instituted the Hara Annual, a yearly invitational showcase for a dozen or more young Japanese artists, as well as an ongoing acquisitions and international exhibitions program. Another integral part of his program was the establishment of the Hara Museum as a think-tank and cultural exchange center for top Japanese and visiting foreign art critics and curators. Eventually, Hara felt that the grounds of the Tokyo building

were too restricted for the needs of the Hara Annuals, and in 1987 the Hara Museum ARC, also designed by Isozaki, was built in Gumma Prefecture, north of the capital, as an annex of the Hara Museum, Tokyo.[2]

Since its opening, the Hara Museum collection has grown to about five hundred works of sculpture, painting, video art, installation art and photography representing in equal proportion American, European and Japanese artists from mid-century on. A professional staff of fifteen runs the museum. The Americans Jasper Johns, Robert Rauschenberg, Christo, Richard Diebenkorn, Andy Warhol and Tom Wesselman have had one-person shows, and exhibitions have been devoted to new trends in international video art and to a profile of other kinds of art from countries including Taiwan, Australia, Brazil, Argentina, Germany, Switzerland, Norway and Canada. A Japanese public accustomed to thinking of French art as Monet and Picasso was introduced as early as 1981 to Jean-Pierre Raynaud, long before he was shown in America. At that time Hara commissioned the artist to make a room for the permanent collection (see p. 27).

Toshio Hara's efforts to elevate Japanese contemporary art to the level of current critical dialogue was manifested in "A Primal Spirit," an exhibition organized by the Hara and the Los Angeles County Museum of Art (LACMA). Hara invited Howard N. Fox of LACMA to curate the show, which opened at Hara ARC in March 1990 and has traveled to Los Angeles, Chicago, Fort Worth and the National Gallery of Canada in Ottawa. In the introduction to the catalogue Hara said: "The search for a form of expression that acknowledges cultural roots while achieving a certain universality or 'internationalism' has been

Jean-Pierre Raynaud, *L'Espace O*, tile, 85⅜ × 57⅛ × 228¼ (217 × 145 × 580), commissioned artwork executed *in situ* at the Hara Museum of Contemporary Art, Tokyo, in 1981.

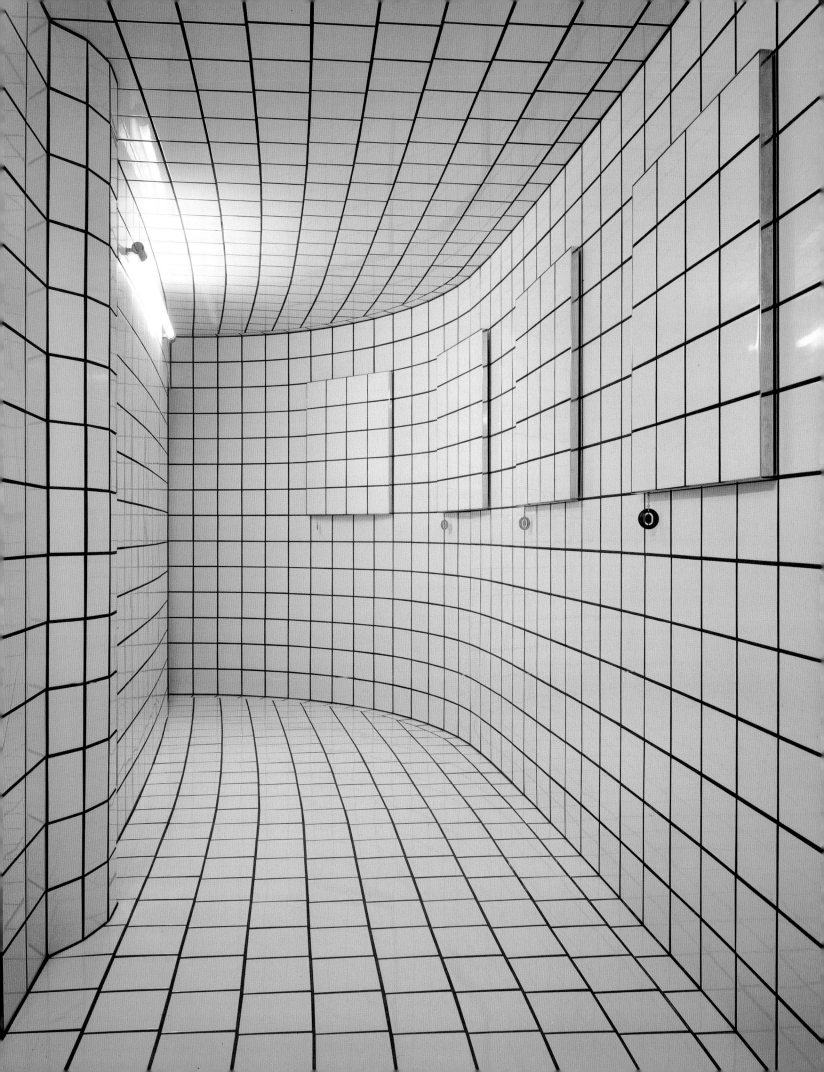

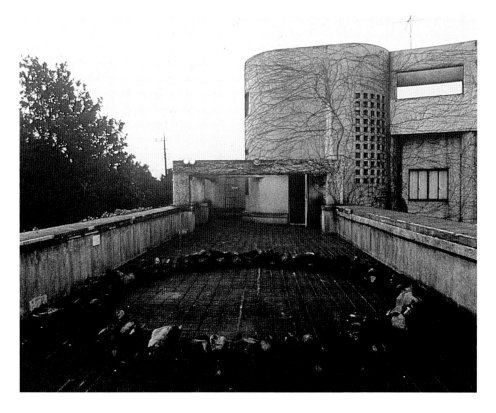

a preoccupation of Japanese artists for
many years ... Until recently most
Western critics have looked for a
japonisme, the exotic flair of the Orient
that is perceived simply as different from
(and therefore marginal to) prevailing
Eurocentric movements ... Now that the
West has openly acknowledged Japan's
challenge to its economic hegemony, the
Western cultural establishment has turned
to Japan with renewed interest."[3]

Hara's conception for "A Primal
Spirit" was nearly five years in its
incubation, a logical outgrowth of
cultivating an understanding of new
Japanese art. Instead of choosing a
Japanese organizer, Hara offered the
project to Fox, who had been coming to
Japan as a participator in the Hara arts
professionals exchange, and who was then
a curator at the Hirshhorn Museum in
Washington, DC. Fox's vision of Japanese
contemporary art at its best level differs
visually and spiritually from "Against
Nature" (see p. 84), perhaps reflecting
Hara's more temperate taste. All the
pieces selected were sculptures or
installations of gigantic scale, abstract and
"primal" in their use of natural materials.
A few of the artists, like Toshikatsu Endo,
Tadashi Kawamata and Shigeo Toya,
have gained varying degrees of recognition
essentially through Documenta in Kassel
and the Venice Biennale, two important
critical contexts for artists exhibiting
globally; most of the others, like
Takamasa Kuniyasu and Emiko
Tokushige, had little exposure outside
Japan. "Against Nature" and "A Primal
Spirit," which were shown concurrently
around the United States, had the
advantage of exposing the American
gallery-going public to a number of
discordant strains developing in Japanese

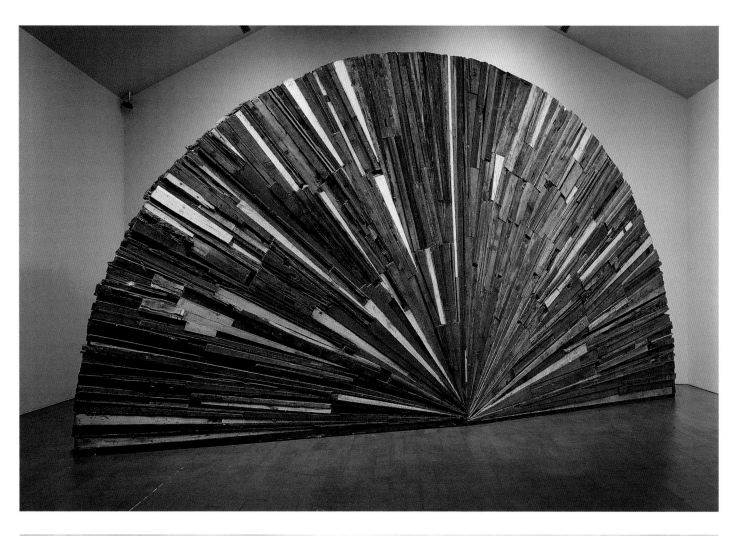

The Kawamura Memorial Museum of Art, Chiba Prefecture, designed by **Ichiro Ebihara** and opened in 1990. In the foreground is a bronze sculpture by **Joel Shapiro**, *Untitled*, 1988–89, 129⅞ × 70⅞ × 82⅝ (330 × 180 × 210).

>

art. However, it has been said that an ultimately Western orientation has dominated both presentations.

What the West learned about contemporary art in Japan might be summed up in the statements of two artists who have radically different physical approaches but who are united by a similar present-day urban *japonisme*. Noboru Tsubaki, whose grotesque, brightly colored *Fresh Gasoline* was exhibited in "Against Nature," was asked when he talked about being in the country, looking up into the sky and weeping: "Oh, did you feel at one with nature?" "No," he replied: "I hate nature. I'm an urban creature. I know nothing about the countryside; in fact it frightens me. This idea of Japanese people being at one with nature, with the purity and wholeness of nature, is nothing I understand. I am very much against that."[4] Tadashi Kawamata participated in Documenta VIII in Kassel in 1987 and in "The New Urban Landscape" exhibition at the World Financial Center, Battery Park City, in 1988 (see pp. 191–92). In contrast to Tsubaki's, Kawamata's work is always site specific, abstract and made of raw or blandly painted lumber scraps, implying a temporal, makeshift formlessness in the process of becoming. In an interview during the installation of his "A Primal Spirit" project at the Los Angeles County Museum of Art, Kawamata said: "I don't walk in the countryside with the idea of making 'Japanese' art although people may see something Japanese in the work. We are not talking Buddhism or Shintoism here. My art comes from a more industrial situation, from a kind of control and artificiality you find in the city ... Japan has always been in contact with other countries. Our problem is to choose from the information ... from outside and thus to choose our identity ... I am looking for those kinds of basic connections."[5]

As Toshio Hara became more involved in the arts, his avocation became his primary professional interest. He now spends most of his time as President and Director of the Hara Museums and as worldwide ambassador of new Japanese art. He is active on the International Council of the Museum of Modern Art in New York and at the Centre Pompidou in Paris. His lobbying efforts are focused on the private sector in Japan. "I hope the government will decide to encourage the business sector to play the role of good art-supporting institutions. After all, private persons are getting richer in Japan, so why not create conditions that will encourage them to do things themselves? Instead of buying outrageously expensive paintings, they should do more to encourage young artists."[6]

As part of his initial concept, Hara was able to establish in 1987 the Foundation Arc-en-Ciel, a non-profit foundation for his art activities. This is a rare occurrence in Japan. Hara explained that, "under the Japanese tax system, corporations that spend money as a part of their public relations, namely art activities, can deduct their expenses. They can finance their exhibition spaces as part of their expenses. While donating money to a foundation is not tax free."[7] So even if a corporation has money and wants to finance its cultural activities based on the non-profit principle, it is too costly. The non-profit foundations are extremely unpopular in this country, especially for modern art-related activities. I think that only Seibu and Hara have instituted them. All the others are just part of the corporation. They can shift money back and forth from their cultural to their commercial activities." And then he adds, revealing a particularly Japanese attitude toward economics: "This is a unique pattern for Japanese systems. When I think about the very rapid growth of Japanese industrial power, I think that this is not necessarily a bad idea. Personally, however, I think things will eventually have to change. If you want to call yourself a museum, you must be at least not for profit. In my understanding, if you are buying and selling, it is not a museum. There is a big conflict of interest and it can never be resolved."[8]

Dainippon Ink and Chemicals/ Kawamura Memorial Museum of Art, Sakura, Tokyo

Dainippon Ink and Chemicals, Incorporated (DIC) is another successful Japanese company with its own museum. Kijuro Kawamura started as a manufacturer of printing ink in 1902; two succeeding generations of Kawamuras have built the business into an international conglomerate in the research technologies and manufacture of the latest graphic art and printing-related processes. Today DIC is a diversified producer of advanced composite materials, including non-metal structural components used in aircraft, cars and trains, and in sports-related engineering.

Located on the campus-like grounds of the DIC Central Research Laboratories, the Kawamura Memorial Museum of Art opened in May 1990, on the eightieth anniversary of the company's foundation. It was designed by Ichiro Ebihara, a mainstream Japanese architect, and as a recent example of a corporate museum facility, was built in the grand manner. The complex is on a 27,634-square-meter wooded site in the country outside the city of Sakura, in Chiba Prefecture, about one hour from Tokyo.

The Kawamura collection represents the taste of the three generations who guided its growth: Kijuro Kawamura, the founder, was interested in traditional Japanese art; Katsumi Kawamura, his son, broadened the scope of the holdings to include some solid work from the European schools; and the youngest Kawamura, Shigekuni, President of DIC, is more involved in contemporary Japanese and American art. "What I find most interesting," he wrote in 1990 (before the strain on the Japanese economy became widespread), "are the works that have been created in these modern times. We at DIC are trying to further internationalize ourselves by aiming to be ranked among the ten largest chemical companies worldwide by the 100th anniversary of the founding of our company. The Kawamura Memorial

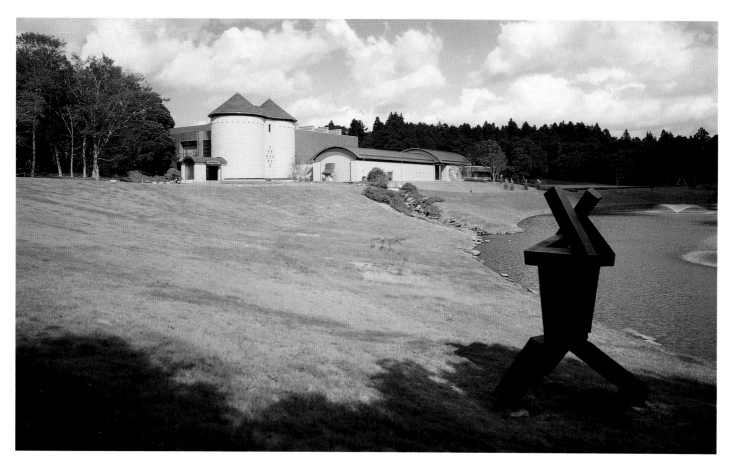

Three of the eleven works by **Frank Stella** owned by the Kawamura Memorial Museum of Art, Chiba Prefecture, all of which are installed together in one room at the museum. Left to right: *Mosport*, 1981, mixed media, 114⅛×126⅜ × 24 (290 × 321 × 61); *Lo Sciocco senze Paura*, 1985, mixed media, 126 × 117¾ × 207⅞ (320 × 299 × 53); and *Sphynx*, 1988, mixed media, 121⅝ × 134¼ × 50 (309 × 341 × 127).

Museum of Art is just in its initial stage though we shall endeavor to make it a more substantial art museum in years to come."[9]

Before the museum opened, Dainippon had been acquiring some major examples of the twentieth-century American artistic ascendency: Jackson Pollock's *Composition on Green Black and Tan* (1951), Morris Louis' *Gimel* (1958) and *Gamma Zeta* (1960), an Ad Reinhardt black painting *Abstract Painting* (1960–66), and Barnett Newman's *Anna's Light* (1968). The company had also collected ten or more Frank Stellas, ranging from the seminal *Tomlinson Court Park* (1959) and *Marquis de Portago* (1960) through signature work of the 1970's and 1980's to the present, and a Joel Shapiro sculpture, *Untitled* (1988–89).

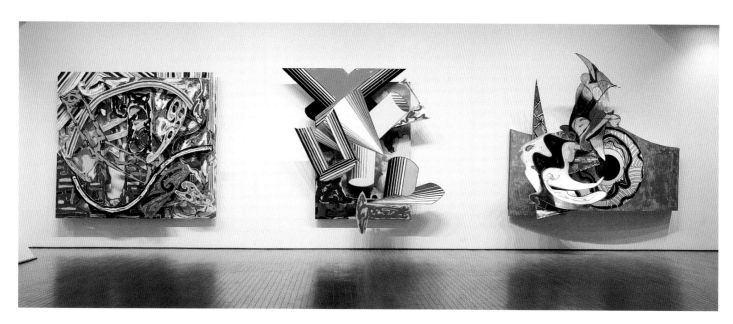

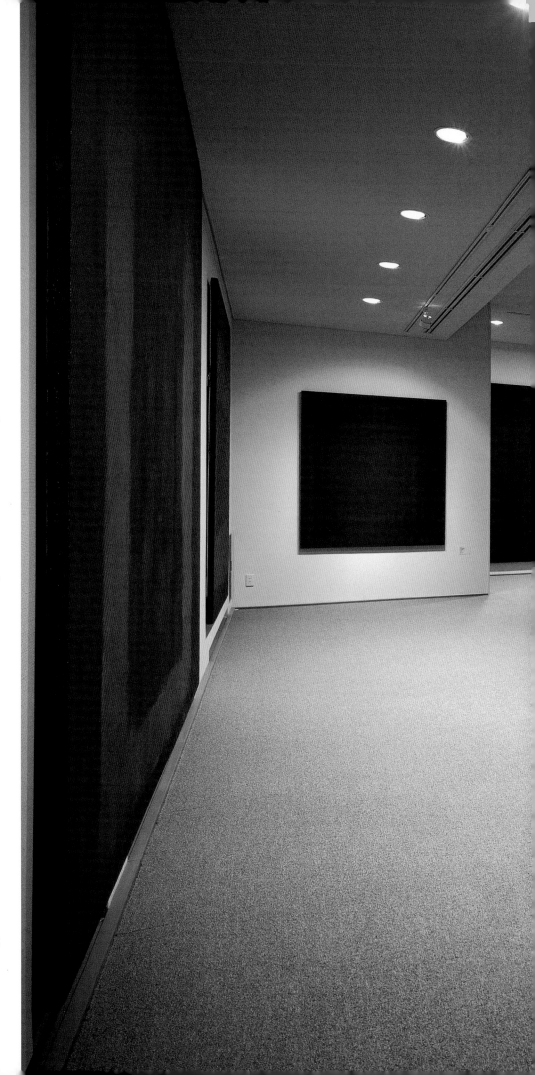

A room at the Kawamura Memorial Museum of Art in which seven paintings by **Mark Rothko** from his Seagram Murals project, 1958–59, are installed as a meditation space in the spirit of Rothko's original intent. Largest painting 105⅝ × 179⅞ (267 × 457).

The treasure of the collection, and one of the greatest achievements in American art, is seven of the Seagram series of paintings by Mark Rothko (1958–59). Rothko was commissioned by Philip Johnson and Phyllis Lambert to make works for the Four Seasons restaurant on the ground floor of the Seagram Building in New York in 1958. The artist had painted forty murals and "sketches" in three series when he withdrew from the project for reasons that remain unclear. Rothko wanted above all the opportunity to create an environment, where people could absorb an atmosphere of art permeated with and unified by his spiritual vision. Looking back, it is hard to understand what intensity of artistic passion could transform an upscale restaurant into a place of pilgrimage, but at the time few artists were presented with opportunities to work on the scale Rothko envisioned.

The Tate Gallery in London had acquired several works from the Seagram series, and in 1988 mounted a new reconstruction of the murals after the curator had come across works in the Rothko estate that went further in providing information about the original installation plan.[10] The Tate reshuffled its presentation again, and six of the works surviving in the Rothko estate, which had been exhibited in 1978 at the Pace Gallery in New York under the title "Second Series," along with one other, were sold to the Kawamura.

With the added benefit of this recent scholarship as a bonus to art scholars, a trip to the outskirts of Tokyo is one of the few places in the world where one can see a Rothko environment close to what the artist envisioned. A Rothko meditation room, of which there are now only four in the entire world (Tate Gallery, London; National Gallery of Art, Washington, DC; Rothko Chapel, Houston, Texas; and the Kawamura), is often likened to the Kaaba, the most sacred sanctuary in the court of the Great Mosque in Mecca. The "Kabba" at the Kawamura is a fascinating record of artistic intent, and a wonder of the art world for travelers, scholars and inhabitants of the Pacific Rim.

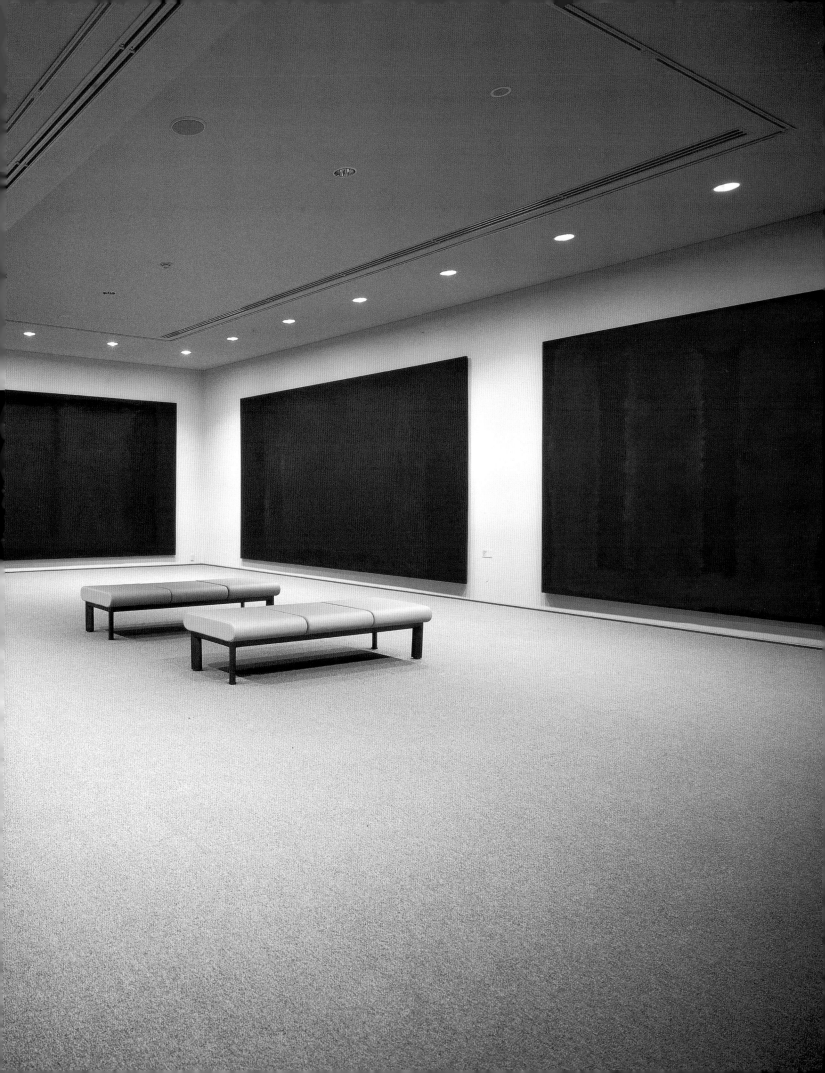

The Vitra Design Museum, by **Frank Gehry**, which opened in 1989 at Vitra International's manufacturing facilities in Weil-am-Rhein. The interior view (right) shows the building's cruciform plan and natural lighting.

Vitra Design Museum, Weil-am-Rhein

Thousands of miles away from Tokyo, in the small German hamlet of Weil-am-Rhein on the Swiss border, is another free-standing company-sponsored museum built close to the company's manufacturing facilities. Here, by contrast to Japan, industry, politics and culture have more distinct boundaries and the motivations for cultural involvement are ostensibly very different. The Vitra Design Museum opened in 1989 as an adjunct to Vitra International, a European manufacturer of classic modern and innovative contemporary furniture. The project, made up of the museum and an adjacent showroom, is the first European commission and the first new art museum designed by Frank Gehry, one of America's vanguard architects. The winner of the coveted Pritzker Prize for Architecture in 1989, Gehry is one of the offbeat practitioners associated with Deconstructivist architecture today.

Vitra was officially chartered in Weil-am-Rhein in 1950 by Willi Fehlbaum, who had built up the business from a shop-fitting firm in Basel, Switzerland, which he had founded in 1934. In the late 1950's, the company was licensed to produce the Herman Miller Collection in Europe, and in 1986 it acquired all rights to Charles and Ray Eames and George Nelson designs for Europe and the Middle East, culminating in the acquisition of a large part of the estate of Charles and Ray Eames in 1988. In the meantime, Vitra established its formidable reputation as promoter of the most innovative design in office furniture. Specializing in chairs, the company collaborated with many of Europe's top designers (Mario Bellini, Antonio Citterio and Philippe Starck) and in 1987 launched Vitra Edition, a small-scale experimental production project which currently manufactures furniture to designs by artists, designers and architects such as Frank Gehry, Richard Artschwager, Ron Arad, Ettore Sottsass, Coop Himmelblau and Shiro Kuramata.

On the occasion of their father's seventieth birthday in 1983, the Fehlbaum family presented him with a monumental sculpture by Claes Oldenburg for the Vitra factory complex. When Oldenburg came to install the sculpture he brought his friend Frank Gehry along for what was to be a fruitful journey for the architect. Rolf Fehlbaum says that if he influenced Gehry at all it was in the exterior surface, which is the architect's first all white building. "At first he found the white in the photographs glaring, but against the grey skies, the wind and the rain of Europe, or spotlit by the sun, it is right for us," was Fehlbaum's conclusion, and Gehry agreed: "It was an agonizing decision to make the buildings all white. Here I saw them green and red against concrete gray. Now I see it has great energy. There is so much movement and animation. Colors would have burnt out."[11] The museum has become a component of the Vitra corporate identity, to use the vernacular of marketing. It was, in retrospect, a challenging commission that provided Gehry with the energy to explore a new design territory.

Rolf Fehlbaum, one of Willi's three sons, is the head of Vitra International and the visionary mastermind behind the concept of the Vitra Design Museum.

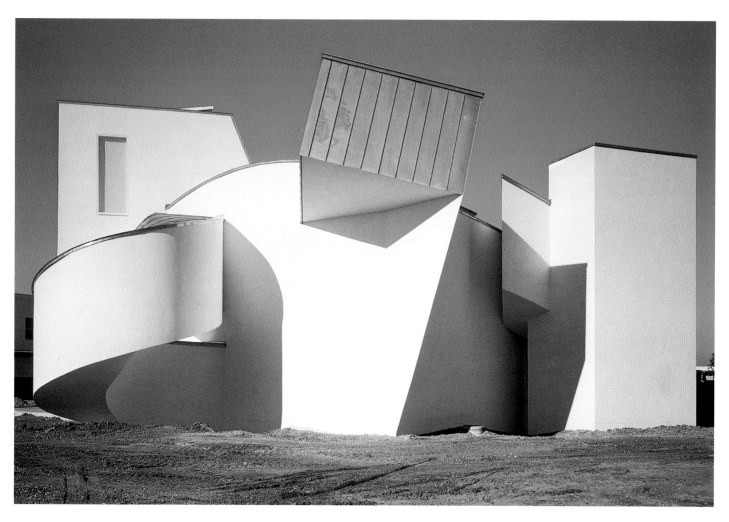

"Growing up with chairs" over the years, he began to buy mass-produced pieces and eventually acquired more than one thousand examples. The collection, however, was an assembly of objects where his personal taste was more the primary motivation for selection than anything resembling a definitive statement of historical types in the industrial age. It seems fair to say that Charles and Ray Eames were vital to the formation of Fehlbaum's profound understanding of art in design. When Ray Eames died in 1988, Fehlbaum acquired important archival material from the estate, with the aim of exploring the creative process not only of the Eameses but of their sources and the roots of industrial design. In the museum as in the business, the challenge is to influence industrial culture. Fehlbaum says: "My aim is to be the inspired end of the mass market."[12]

In an interview given at his office in Basel in January 1991, Fehlbaum expressed his philosophy of art and business:

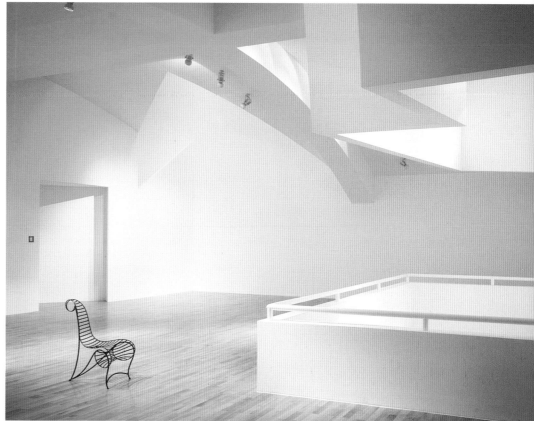

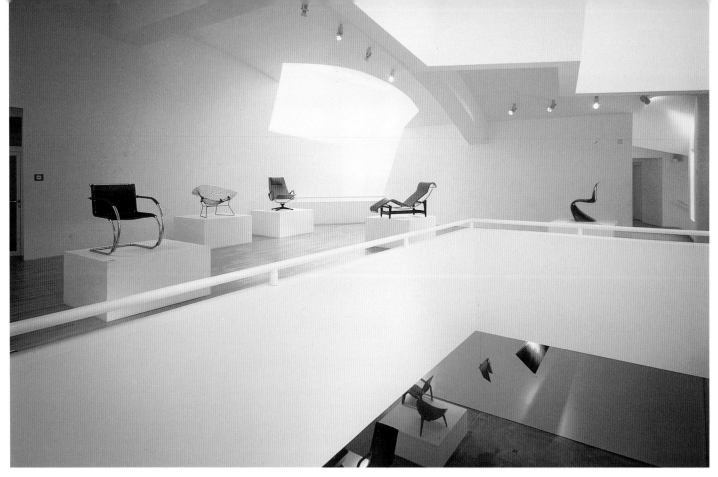

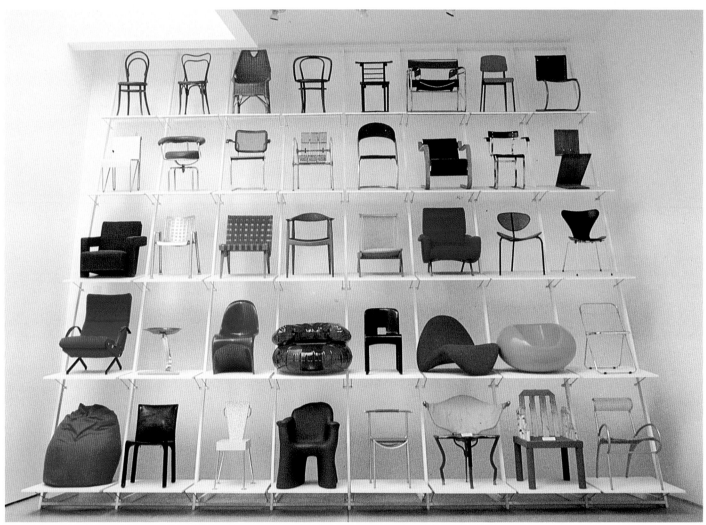

Opposite, above: ''Classics of Furniture Design,'' the first exhibition held at the Vitra Design Museum, Weil-am-Rhein.

Opposite, below: ''Europe – America,'' an exhibition at the Vitra Design Museum, Weil-am-Rhein, 1991, which drew an historical comparison between European and American industrial furniture design 1850–1990.

An interior view of the Vitra Design Museum, Weil-am-Rhein, with **Gerrit Rietveld**'s *Red Blue Chair*, 1918.

Rolf Fehlbaum: I think that the major difference between our company and the typical collecting corporation is that we do not collect, or engage in cultural activities that are outside our direct [field of] competence ... What we are doing is collecting and exposing products that are in our area of expertise. That is, we believe that our field of furniture is a very exciting field, and think that we can contribute to the general understanding of and sensitivity to that area ... a better understanding of the original designs, etc. But always in a field where we have direct concern. It is very different from saying we have an arts program because we think arts are good for business, or the public. Our path is to celebrate, to idealize our own activities. We will do that by celebrating the history, the presence and glances at the future of our discipline. It is a form of self-sponsoring, a less detached but more fully integrated view of the act of sponsoring. It is putting what we do in a greater scope, putting it in perspective with benefit to our own people understanding what they are doing better, or acquiring better judgment of the greatness of certain things—as well as the lesser greatness of others. It is a celebration that should hopefully give force to innovative people in our own company. Of course if it is successful, Vitra's immediate profile and the appreciation of what Vitra is doing gets enhanced. It is important to understand that we are fully aware that we do not want to put the museum and the collection in the direct service of Vitra promotion. As a consequence, we don't have this strange relationship between the artist and the businessman where they are both sniffing at each other; one is the exotic guy and he looks at the company as this semi-corrupt something that is representing other values and always wondering should he (or she) be involved or not. All these hopes also of industry that the artist as an exotic animal will be an inspiration of sorts, that the artist as a free spirit will teach the company bureaucrat something—I don't know. In the corporation there are all these people who are narrow in their goals. However, that dialectic has never come up with us, and I think it's a little boring as a theme anyhow. I feel that what we are doing, generally, is very similar to what the artist is doing. Not in theme, but in attitude, so we never had any sort of fear of art. I think the great designers like Charles Eames, George Nelson and others, attitudinally are not that different.

Marjory Jacobson: Do you consider these designers to be artists?

RF: It is not art to start with because if a designer wants to do art he's bound to fail. But if he does it well, it can become art, like art itself, but only unintentionally. If you say, ''Now I will do that chair as

art," then you're most likely bound to do something terrible. Or you can choose art as a theme for a chair like Scott Burton, for example. He takes the chair as a theme for art. That is a different approach, but in the end, if a great chair is there, then it's like art itself. But Charles Eames did not start by saying, "I'll make art." The special part about our approach is that we're trying to do what we are doing well and may be opening a door to that discipline. Not just to our work, but to that discipline. That is what we do.

MJ: Because you are treating your business as a "discipline" (and that is a term commonly used in the scholarship world) in a serious and thoughtful and respectful manner and opening it up to questions of philosophy as well as profit, you are making an enormous contribution to the culture of yesterday, today and tomorrow. The question is, how do we enrich the meaning of a commodity without deflating its function as a useful product in contemporary culture?

RF: To get back to the issue of the artist and furniture maker, we also started a project with Richard Artschwager, and we started a project with Scott Burton. But it didn't really work with Scott for many reasons. I think Scott did not want to move into the internal laws of something becoming a piece of furniture. That is a very different aspect of the situation. The artist's approach to furniture where he chooses the chair as a theme is very different from making a chair that, even if it is a small-series product, goes through the manufacturing and distribution process. I greatly enjoyed the work with Scott, but I think he did not really want to give up that conceptual purity that makes up his furniture, in comparison to that collective domain that the chair inhabits where there are many aspects involved. And the work of a designer is not just to give a product a shape, the work of a designer is to integrate a number of issues of which shape, beauty, economics, ergonomics, and even ecology lately come into play.

MJ: What about your experience with Richard Artschwager? He used to make furniture.

RF: Yes. Artschwager is a little different from Scott. Before he did art, he did furniture. And so, Artschwager is very knowledgeable, and easy and eager to do a product. Still, this is not a product for mass distribution, but it is very, very well thought out, even in terms of manufacturability, even if it is complex.

MJ: Do you plan to work with other artists in the future?

RF: Up to now I have not really continued on that theme just because there are so many other things to do, but I may take it up again and try other relationships. The museum and the collection have had much more of a determination behind them up to now. This cooperation with the artists was not a major use of my energies. I had not developed it conceptually enough. I would love to work with Bruce Nauman on a project. He is somebody I do admire tremendously. And there are others, of course. The real danger is that designers usually make bad art, or that artists do not understand design. If I look at this new freedom in design, most of it results in something that is both bad product and bad art. It is still sort of a no-man's-land where people think it is possible to be interesting.

MJ: Again, one has to be very careful in how one selects the artist. What his or her motivations are and how they can marry with your product aspirations. And even then, with carefully choosing, if you get one out of ten that is really great, you are doing very well. But to me there is something very exciting about the possibilities.

RF: For sure. When these projects are embraced in the spirit of true research and not in the spirit of the current vogue— only then will good work come out.

MJ: What is the tangible meaning of your museum for your business?

RF: Well, it is not a really tangible one. I suspect that in the end it is a good business decision. The problem is that you do not know this in advance. It now has proven to be a good business

decision because it expresses what is there anyhow but sometimes needs a symbolic statement. It expresses that we are on a search in our design for something which is beyond just making a commercial product. Of course it has to be commercial, too; otherwise we cannot continue. But we try to make products that have an inspiring effect on the environment and we work with inspired people, great designers. We feel that the products that come from that sort of cooperation have great meaning. We believe deeply that what we are doing has meaning. Every product has a message. The message can be good, inspiring or sophisticated, or it can be repressive or boring. We hope that we are on the inspiring side. If all this comes together in the end, not as a crusade, for that would be much too pathetic, but as a movement that the customer relates to, then I think in the end we will have succeeded on many levels. I am sure of that because in the world of objects that surround us, people are looking for more. The design that succeeds is not merely the result of a purely rational process, but also the work of a great personality expressed.

The program for Vitra Museum has been developed by Alexander von Vegesack. There are plans for further additions to the permanent collection, but the museum will concentrate on changing exhibitions that will aim to explore the history and process of industrial engineering in original furniture design. Although the annals of corporate art are filled with examples of companies who have succumbed to the obvious impulse of associating their product with their philanthropy, the Vitra concept sets a new standard in the relationship of culture to a corporation. "Inwardly," Fehlbaum concluded, "the museum motivates the individual employee. It conveys not only the technical know-how from 140 years of furniture design but also adds another dimension to the work of the individual. At the same time it is a design school for us and our sales representatives."[13]

The Hess Collection, Napa, California

The Hess Collection in Napa, California, designates both a winery and a contemporary art collection, both of which are housed in the same facility. The concept of collecting in a museum sense is expanded here by association with the business of building up a choice selection of wines, and the connection between great art and great wine is well placed in the mind of the consumer. So, although the product and the art program are not directly related (as they are, for example, at the Vitra Design Museum), Hess, like Vitra, has combined art and business in an interesting and intelligent manner. The wine and art presentation at Napa is not a crusade but part of a program that Donald Hess, the collector and corporate head, has initiated to persuade the business world to take culture more seriously. "Every product has a message, and I want my customers to feel that this is a company where they can have more heart share. We are off the beaten path. People think twice when it takes them twenty minutes to get to us from the highway. About half the visitors are interested in the wine and half are interested in the art. And we have found out that they often say, 'Well, we really came for one or the other, but we equally enjoyed the experience we did not primarily come for.'"[14]

Donald Hess has been collecting art privately for the past twenty years. He comes from a family who for nine generations were successful brewers in Bern, Switzerland. When he took over the family interests, he expanded Hess's holdings in breweries and hotels into a range of international operations in mineral water, cattle ranching, a trout hatchery, resorts, restaurants and other real estate, including vineyards in Napa, California, in 1978. In 1986, Hess renovated the turn-of-the-century winery on the Napa property and part of the architectural program was to design 15,000 square feet of gallery space specifically to house a major portion of his personal collection.[15]

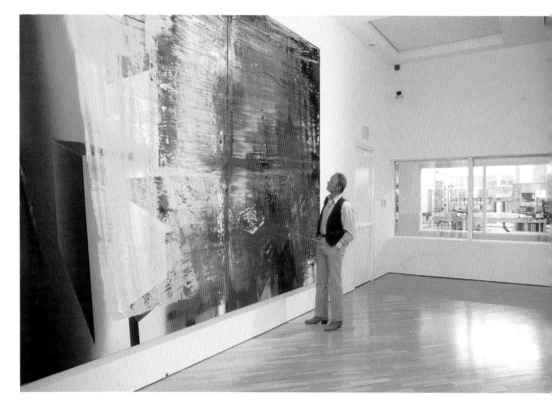

>

What the Hess Collection accomplishes that is progressive is to address the issue of art and business on an egalitarian rather than an epicurean plane. By treating the viewer and the taster as an individual with the same capability for connoisseurship with regard to art and wine, the visitor is open to a process aimed not at the privileged few but at the many who want to experience culture.

It is helpful to understand the collection in terms of the planning strategy that Hess, the businessman, used to make his choices. "In order to feel comfortable as a businessman, I had to find a system for collecting. I found that artists think about things we businessmen never consider, but we should. So I decided to narrow my focus to about twenty artists, and to try to be a friend to all of them. It takes me anything from two to five years until I make my decision to *really* collect an artist. Let us be frank. I am a pretty shrewd businessman, but I cannot see a purpose in only earning money. My company pays me to do good business and I am also a shareholder so I get paid doubly if we do well."[16]

Asked how this art collecting is good business, how it is good for the company to conduct business with the visual arts in the forefront, Donald Hess replied: "I think it makes a lot of sense. I think that culture will be more and more important. Culture has a future. People want to find something to develop another part of themselves. As a businessman you have to be quite specialized in what you do. I find that quite boring. When I go home I shut off my business. Human problems haunt me at home, but rarely business problems. People are at first frightened by my engagement in art. My rule is that I install artworks in the common areas of my workspace but never in the private offices of others.

"I also find that art is an interesting motivator. I think that American people are much easier to motivate than the Europeans. I always thought that the American managers were the best in the world. I used to think that the problem was the American workers. Now that I have been established in the United States for several years, I think the American workforce is absolutely incredible. If only one had the time to motivate them. I think that one of the mistakes of the big universities is that they are too intellectual and that makes a gap. The managers who come out of Harvard aren't used to talking to the workers. They put themselves in a tower and don't really understand what is going on with their own people. There is an incredible lack of motivating ability in America ... I think art is one of the best communicators you can have."[17]

Hess is a prominent supporter of contemporary art in his ancestral town of Bern as well. In 1982 he was one of three prominent citizens to set up Stiftung Kunst heute (Foundation Art Today) to support contemporary Swiss art. The founders were also interested in exploring the purchase politics of other art institutions in the area and of testing the theory that new art has the best chance of recognition when judged by the critical eyes of its own generation. The members of the board of Stiftung Kunst heute set up an acquisitions committee consisting of three people having a maximum tenure of six years. The committee is always of the same generation as the artists whose works it acquires and has complete independence from the board and financial supporters.[18] The foundation's collection was initially housed and intermittently shown in the Olten Art Museum. In 1988, Hess made renovated exhibition space available for it in Hess Holdings, his Bern headquarters, located in the former Steinholzli brewery building in suburban Liebefeld. There the works are on permanent public display.

In 1986, Donald Hess, with other prominent members of the Bern art and business community, was also instrumental in setting up the Stiftung Kunsthalle Bern (Bern Kunsthalle Foundation).[19] The Foundation funds the purchase of artworks primarily chosen by the director of the Kunsthalle from the exhibitions he has assembled,[20] and makes possible the purchases of art by emerging artists on whom most museums cannot take a risk. The Kunsthalle, which does not have an official collection, exhibits the works periodically and the Bern Kunst-

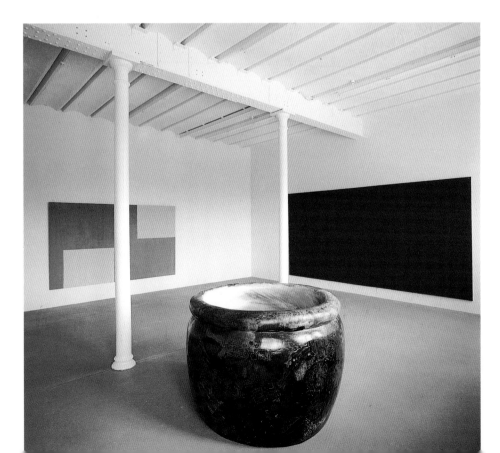

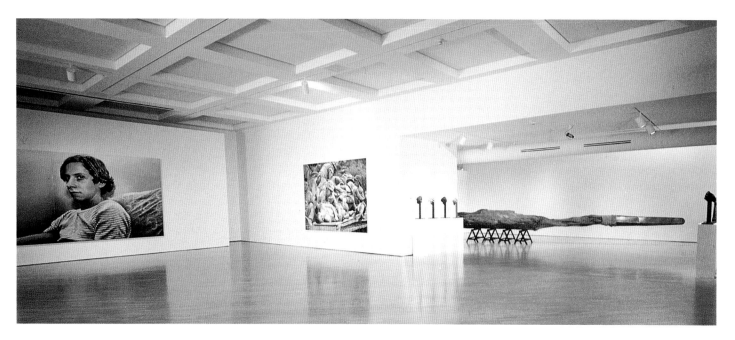

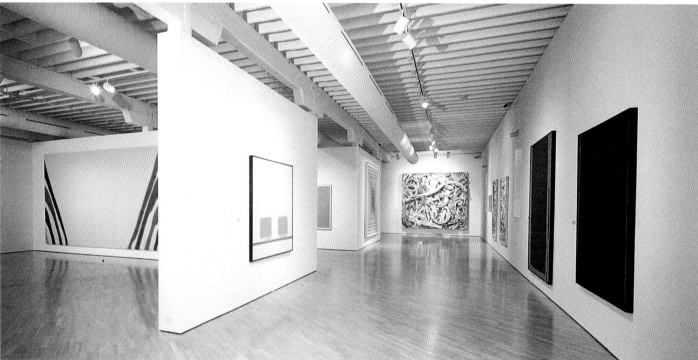

museum may borrow them at any time.

In 1990, Hess established the Napa Contemporary Arts Foundation (NACA) at the Hess Collection in California. Again, the aim is to expose the latest trends in avant-garde art, design and criticism. NACA has instituted a joint venture with San Francisco State University and Sonoma State University for special workshops, seminars and symposiums.

"Over all," Hess concluded, "the process [of involvement in art] has had a profound mental effect on me, and the whole company. The business individual needs to deal with the contradictions and complexity of the times and his ability to be fit for survival is enhanced. As a businessman, you have to try to be logical and you tend to use your left brain more than your right. There are instances where the businessman used his right brain but he never really trusts it. I found that I was tending to make decisions with my right brain, listening to my inner voice. As I became more interested in art I saw that I was more comfortable letting my emotional brain loose."[21]

Opposite: The Hess Collection Winery gallery with (left to right) **Morris Louis**, *Alpha Nu*, 1961, acrylic on canvas, 105 × 179 (266.7 × 454.7); **Theodoros Stamos**, *Very Low Sun-Box*, 1964–65, acrylic and oil on cotton, 56 × 68 (142.2 × 172.7); **Robert Motherwell**, *Open No. 88*, 1969, acrylic on canvas, 54 × 60 (137.2 × 152.4); **Frank Stella**, *Sacramento Moposol No. 5 (Concentric Squares)*, 1978, oil on canvas, 103 × 103 (261.6 × 261.6); **Frank Stella**, *Silverstone II*, 1982, mixed media on aluminum, 111 × 126 × 24 (282 × 320 × 61); and two other Stellas barely visible here.

CHAPTER 5
THE CORPORATE KUNSTHALLEN
Exhibitions and their Influence

"I think that a corporation has an obligation to the community that it is in. The fact that the building is here—we have 800-and-some employees—has made an environmental impact on this town. We therefore have an obligation to deal with these communities in a positive way ... and from a purely selfish point of view, this company has never received the kind of recognition for anything it's ever done at any time, as it has received and is still receiving, because of the involvement with the Whitney [Museum]."

Andrew C. Sigler, Chairman and Chief Executive Officer, Champion International Corporation[1]

The difference between a museum and a *Kunsthalle*, strictly speaking, is basically that the former is a repository for a permanent collection and the latter a space for the presentation of art that is usually on loan. Some corporations have taken up the model of the *Kunsthalle* to assemble their own exhibitions, or host pre-organized shows. The *Kunsthalle* has its roots in Germany and emerged as a phenomenon during the nineteenth century when artists, encouraged by the growing mercantile class and the market for contemporary art, began banding together to display and sell their works in market halls and other kinds of commercial buildings.

Modern *Kunsthallen*, generally no longer commercial cooperatives run by artists, are typically public buildings or spaces chartered through municipal or private funds to program limited-duration loan exhibitions usually of contemporary art, and to provide a social and intellectual center for exploring the issues taken up in the art of the present day. Such municipal *Kunsthallen* are ubiquitous in Germany and Switzerland. In the realm of the *Kunsthalle*-type exhibition space sponsored by the private sector, contemporary art activity is most common in Japan. Corporate *Kunsthallen* managed by professionals in the arts who are either company staff or outside advisors became a viable form of patronage for some art-

conscious businesses such as Nihon Hymo Textile Industries in Nagoya and the Wacoal Corporation in Tokyo; and in the United States, Equitable, Philip Morris, Champion International and IBM have endorsed the model.[2]

In Japan, the *Kunsthalle modus operandi* is as a much-needed outlet for showing new art in a country where isolation from the international as well as the indigenous Japanese avant-garde and the opportunity for adventurous business promotion become curiously compatible. If, through the creation of numerous corporate museums, a Japanese company's stake in contemporary art is primarily a tax-sheltering or cash-producing device (see p. 17), the incentive for a Japanese business to underwrite an exhibition space only is specifically linked to the *mécénat* concept of good corporate citizenship and august name recognition.

Two Japanese business-sponsored exhibition centers, the Institute of Contemporary Art in Nagoya, now closed, and the Wacoal Art Center (Spiral Building) in Tokyo, serve to illustrate the ability of corporate interests to run professionally conceived corporate *Kunsthallen*. Both are the brainstorms of particular Japanese businesses and, typically, are housed in buildings built or converted for the purpose. They established programming profiles in the contemporary arts during the 1980's, in spite of the rampant consumer lust that marked that decade, anticipating and helping to define the tenor of the dawning era when a younger generation of Japanese would want to keep pace culturally as well as economically.

Institute of Contemporary Arts, Nagoya

Under the directorship of Fumio Nanjo, the Institute of Contemporary Arts in Nagoya, Japan, gained recognition for programming exhibitions at the cutting edge of contemporary art. Few people outside Japan realize, however, that the Institute was underwritten by Keitaro Takagi, President of Nihon Hymo Textile

Industries Co. Ltd., and that the Nagoya ICA is a corporate *Kunsthalle*. Over a four-year period, Nanjo's planning encompassed important one-person shows, most presented in Japan for the first time, of the foremost artists of the international avant-garde: Jannis Kounellis, Giulio Paolini, Mario Merz, Ed Rusha, On Kawara, Christian Boltanski and Daniel Buren. Many of them were commissioned to make a new work at the ICA studios, excellent catalogues were produced, and usually the artist and prominent critics from within Japan and abroad were invited to provide an expansive educational context. During this time, the Italian art critic Germano Celant, Kasper König, Director of the Städelschule in Frankfurt, and Jean-Louis Maubant, Director of Le Nouveau Musée in Lyon, France, were visiting lecturers. The ICA also arranged local itineraries for some of its presentations at institutions like Art Tower Mito, a public exhibition and performance space outside Tokyo, and the Touko Museum (now closed), another corporately funded exhibition space in Tokyo.[3]

Takagi and Nanjo were equally determined to support contemporary Japanese art in Japan and abroad. Nanjo had independently arranged several shows of Japanese contemporary art in Europe and the ICA was one of the organizing institutions of "Against Nature: Japanese Art in the Eighties."[4] Takagi had owned the commercial Gallery Takagi in downtown Nagoya for the last twenty years, maintaining a reputation for early representation of adventurous native sons by showing the work of such artists as Tatsuo Miyajima, another rising young international star.

Jannis Kounellis, *Untitled*, iron and wax, an installation exhibited at the Institute of Contemporary Arts, Nagoya, in 1987.

Daniel Buren, *Deux Diagonales pour un lieu*, wood, mirrors and plastic, orange and dark gray painted on white background, $177\frac{1}{8} \times 1275\frac{1}{2} \times$ diameter $665\frac{3}{8}$ ($450 \times 3,420 \times$ diameter 1,691), shown at the Institute of Contemporary Arts, Nagoya, in April 1989.

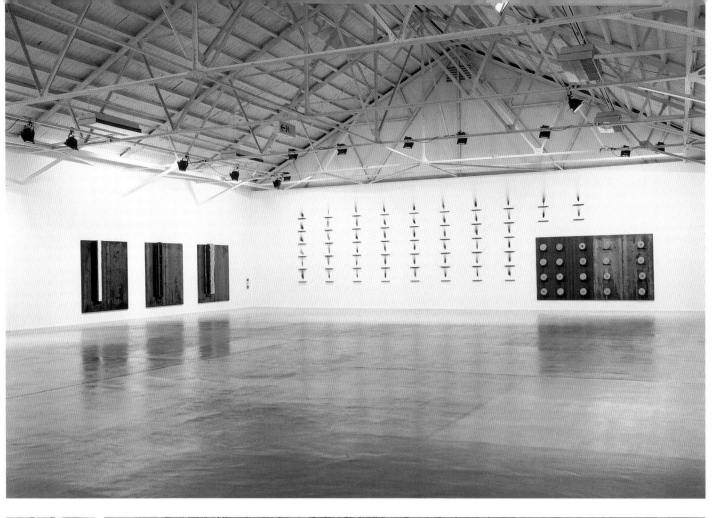

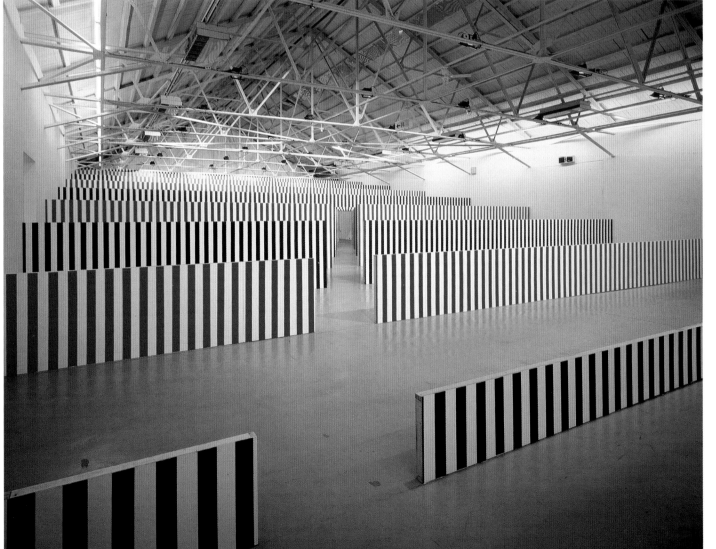

Takagi's family had been in the textile business since 1901. Nihon Hymo Textile Industries Co. Ltd. is a cloth processing and suit manufacturing operation located in nearby Gifu and also in Shanghai, China. Takagi's interest in contemporary art had come from his exposure to galleries and museums that he visited on his extensive business trips. The exhibition spaces, offices and artists' studios of the Institute of Contemporary Arts took up a portion of the old Takagi factory buildings on the outskirts of Nagoya. The remainder of the 4,500-square-meter site housed another of Mr. Takagi's recreational enterprises—a golf shop. Mr. Takagi said that, while his golf business was thriving, the ICA was not a commercial venture. "The idea was to introduce foreign artists to the Japanese market. We wanted to invite artists to Japan and to stay here and make works. If I wanted to make money, I would not get involved with contemporary art. The reason I am doing this is to keep in touch with high-quality artists. As with the Gallery Takagi, which I started eighteen years ago, it was always a problem, because it is very expensive. The ICA is in the same predicament today, but I keep thinking of ways I can keep it going. It was the same with my textile business, which has not been so good for the past two years. We changed our plan and our problem is receding because of the shift to China and the diversification we have embarked on. I attribute this kind of flexibility to my experience with contemporary art over the past twenty years. If I am only doing business all the time, my relationships are very limited, and I cannot create flexible ideas for my business."[5]

The Spiral Building (Wacoal Art Center) by architect **Fumihiko Maki**, which opened in 1986 in the Ayoyama district of Tokyo.

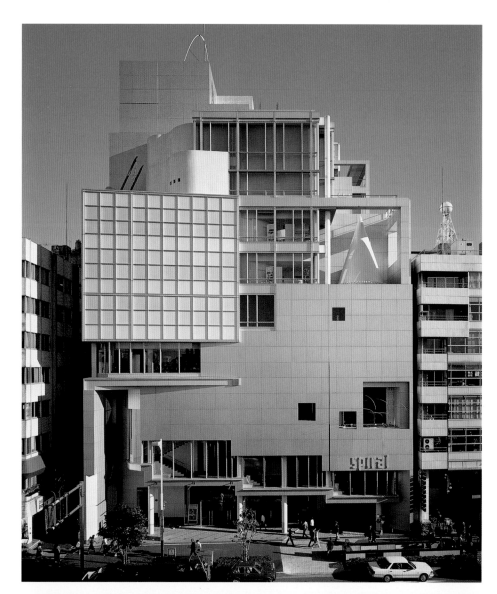

The Spiral Building, Tokyo

Going against the commercial grain, the Wacoal Corporation leaves the corporate logo off its contemporary arts center, opting to make it known as The Spiral Building, so named for its distinctive interior configuration. Since its opening in 1986, this innovative building designed by Fumihiko Maki, a member of the Japanese architectural avant-garde, has been the showcase for a wide variety of advanced international contemporary art, video, performance, music and design.

Established after the Second World War, Wacoal has grown into a leading manufacturer of lingerie and other women's clothing, bed and bath linens and toiletries, with sales and manufacturing divisions in South Korea, Taiwan, Thailand, the United States and other areas throughout Southeast Asia. In 1978, Wacoal's chairman, Koichi Tsukamoto, founded the Kyoto Costume Institute for the collection and historical study of Western clothing. As a product-related endeavor, the institute focused on special exhibitions tracing the history of Western-style underwear design and its relationship to customs and manners through history. Mr. Nobuyuki Ozaki, Executive Director of Spiral, has described Koichi Tsukamoto as a pioneer in the promotion of culture by business. "Recently many Japanese corporations speak for *mécénat*," he says, "but Mr. Tsukamoto was one of the first. He thought that the company should have two wheels—one is the economic and the other is the cultural. Mr. Tsukamoto does not speak in English, but he speaks in spirit." The Spiral Building's statement-of-purpose literature advances the idea that it is committed to function as a testing ground for culture of the future. Koichi Tsukamoto, now in his seventies, described the Spiral Building as a demonstration "to all at home and abroad [of] Wacoal's stance and vision toward the 21st century. Not just in word, but in material form."[6]

Japanese economic analyst Kimindo Kusaka titled his essay for the *Spiral Book*

Dumb Type, *pH*, a performance at Spiral Hall, Tokyo, 1990.

"Toward a New Age of Cultural Enterprise."[7] The key to the underpinnings of the Wacoal project is "cultural enterprise." The cultural operation is set up to be self-supporting. Catering tastefully and seductively to spiritual and physical needs, it is a one-stop culture store where one can eat, see, hear, apply and buy aesthetics for the mind and the body. The building is located in the heart of the upmarket Ayoyama shopping district of Tokyo. In addition to the gallery space, there are several restaurants, a café, a video studio, a large auditorium, a performance space, an unusual gift shop, a state-of-the-art acoustic system for sound and music performance throughout the complex, a members' club, a beauty salon and, probably the most cherished amenity of all, an underground carpark!

Wacoal has adopted the successful money-making gift shop and restaurant tactics employed by many museums and exhibition spaces around the world and developed an impeccable example of fine tuning. "It is rather easy for a corporation to spend a part of its profit while the business is booming, but the cases have shown that in time of economic doldrums cultural contribution spending has been the first to be curtailed or simply given up," says Akiko Mizoguchi of Spiral. "Spiral is an experimental cultural enterprise, [set up] so as to maintain a consistent cultural commitment in good economic times as well as bad."[8] For most of its history, Spiral operated in a healthy economy, with a record of ambitious cultural programming, more than respectable in the eyes of the world and quite remarkable for Japan. This partnership between marketing and *mécénat* breaks new ground in the annals of art facilities.

Because the Spiral exhibition space is open and eccentric, it has been an intriguing receptacle for environmental and interdisciplinary projects. The American artist Judy Pfaff made extraordinary use of the facility in 1985 when she participated in the exhibition "Vernacular Abstraction"[9] with a piece called *Gu Choki Pa* (*Stone, Scissor, Paper*). Pfaff worked at a warehouse provided by Wacoal and equipped with all the materials and tools she requested, and aided by Japanese assistants.

An exhibition of the work of **Nobuo Mitsunashi** at the Spiral Garden, Tokyo, in 1989.

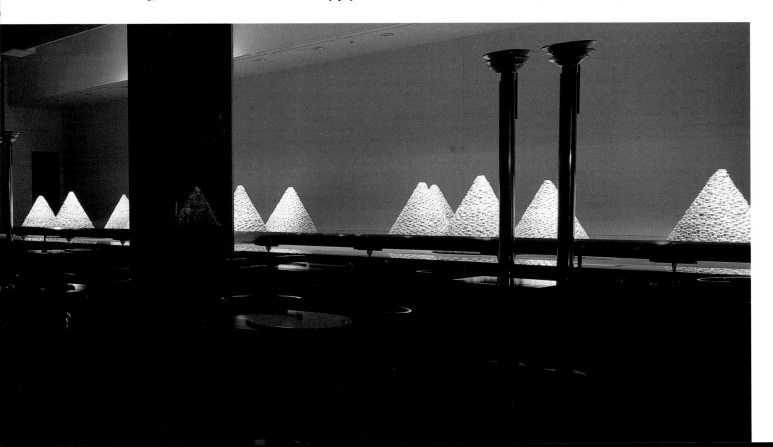

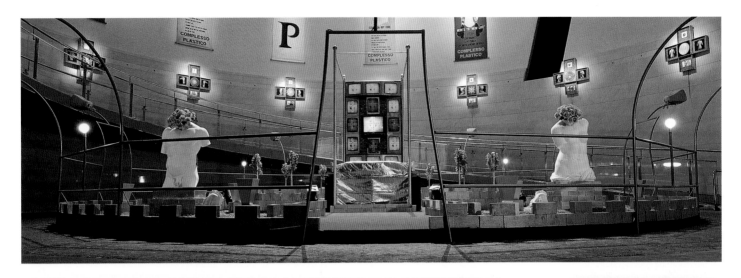

The American critic Roberta Smith saw in Pfaff's experience at the Wacoal *Kunsthalle* a critical juncture in the artist's career. Writing in the catalogue of one of Pfaff's subsequent exhibitions in 1986, Smith commented that *Gu Choki Pa* might "qualify as the first work of Pfaff's maturity ... Unattached to any wall, built from the center out, *Gu Choki Pa* was an achievement of unprecedented clarity and serenity for Pfaff, a series of carefully constructed crystalline suspensions and oppositions ... The piece could be read as an elaborate homage to the various moods and neighborhoods of Tokyo ... there was a fragmentary house-like structure and a wire cone which was inspired by Mt. Fuji. Elements from store signs—a liberal mix

of Japanese characters and Western letters and numbers ... Pfaff also exploited the fact that the piece could be viewed from the top of the ramp, giving much of the installation's ground plane the look of an outsized abstract woodblock print."[10]

Other exhibitions of note at the Spiral Building have included "To the Depth" (1987), with work by South Korean artist Jae Eun Choi; the clay sculptures of Nobuo Mitsunashi (1989); "Metallythm— Dazzling Flotage" (1989), with work by Hideyuki Oda and Complesso Plastico (1989); "Neototem—Twin Sculptures" (1990), with work by Tsubaki Noboru and Sugano Yumiko; and "Dumb-Type Performance" (1990).

An installation by **Complesso Plastico**, which was shown in "Metalythm" at the Spiral Garden, Tokyo, in 1989.

Noburo Tsubaki's *Esthetic Pollution*, 1990, in "Neo Totem – Twin Sculptures" at the Spiral Garden, Tokyo, in 1990.

Judy Pfaff, *Gu Choki Pa (Stone, Scissor, Paper)*, an installation in "Vernacular Abstraction" at the Spiral Garden, Tokyo, in 1985.

90

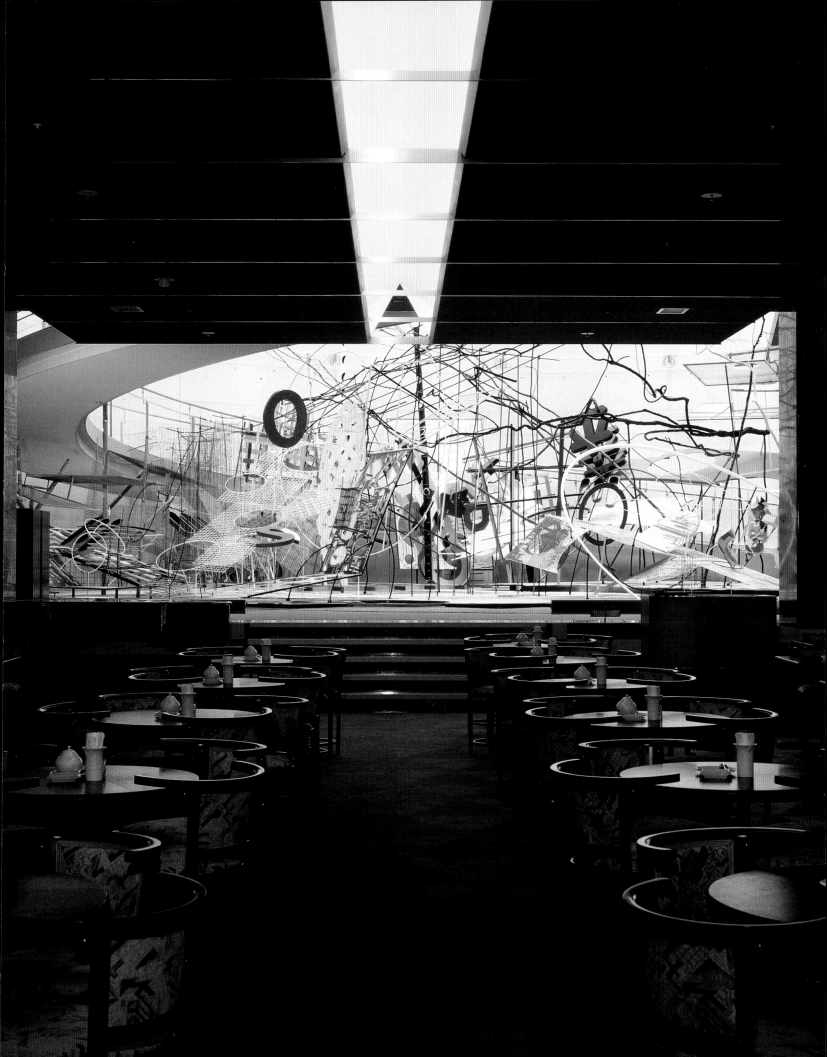

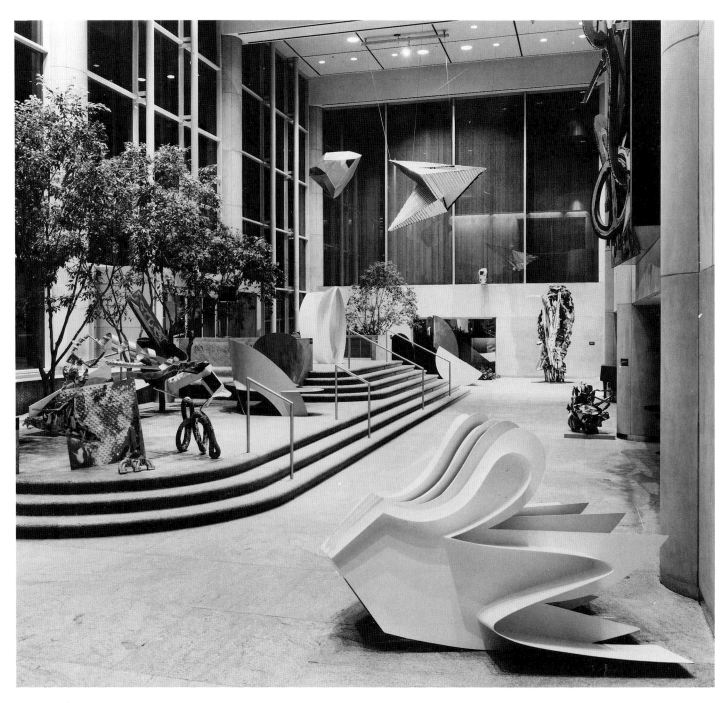

The Whitney Museum of American Art, Branch Museums

The conflict-of-interest issue between the museum world and business had been festering throughout the 1980's when the value of art as a commodity soared and financiers saw more clearly than ever before the value of art not only as investment but as a sophisticated marketing and public relations tool. In its branch museums, the Whitney Museum of American Art developed the concept of peaceful and beneficial coexistence with the corporations who hosted them. The non-profit/for-profit goals of the two sides

were aired and argued; finally, an ideal model of the *Kunsthalle* type was tested. The Whitney branch concept survived the 1980's at two of the four corporate sites the museum inhabited.

In the 1980's, the Whitney Museum entered into partnerships with four businesses and opened exhibition centers on their premises. These so-called branch museums are, strictly speaking, corporate *Kunsthallen* where temporary shows are presented to audiences different from the typical art-museum visitors. The Whitney Museum of American art opened at Philip Morris, New York, in 1983; in Fairfield

County (renamed The Whitney Museum of American Art at Champion) at the Champion International Corporation in Stamford, Connecticut, in 1984; and at Equitable Center, New York, in 1986. The Whitney Downtown Branch, a pilot program throughout the 1970's and 1980's, was reconstituted in 1988 at 2 Federal Reserve Plaza, New York, funded as a joint venture by IBM and Park Tower Realty.

The concept of a museum on the office site could only have functioned when the cards of both sides were all laid on the table. Each entity had clearly defined

< "Painted Forms: Recent Metal Sculpture" at the Whitney Museum of American Art at Philip Morris, New York, December 1990–February 1991, included works by Melvin Edwards, Nancy Graves, Steve Keister, Judy Pfaff, George Sugarman and David Winter.

Suzanne McClelland's environmental *Painting* in the Project Room of the Whitney Museum of American Art at Philip Morris, New York, October 29 to December 31, 1992.

Gary Simmons, *The Garden of Hate*, 1992, in the Project Room of the Whitney Museum of American Art at Philip Morris, New York, May 7 to July 2, 1992.

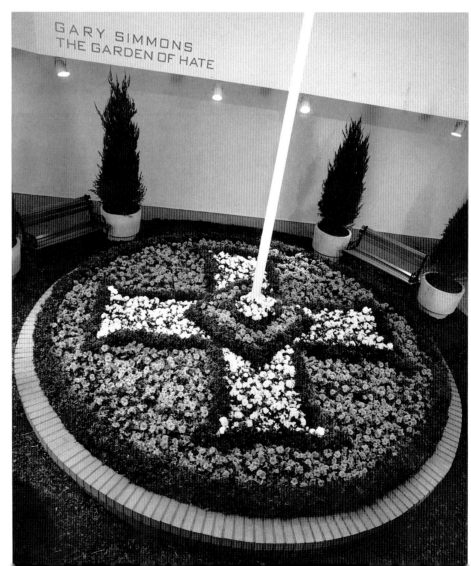

goals: the museum sought wider public exposure for contemporary American art, and the corporations wanted to nurture in their communities a high-profile association with the leading edge of American culture to which they could claim a kinship. Both understood exactly what they could gain from the liaison. The Whitney Museum established and maintained art program guidelines in accordance with their main museum mission, and the corporations accepted the financial and cultural responsibility as an important and rewarding business proposition.

The Whitney Downtown Branch at 2 Federal Reserve Plaza, New York.

The initial Whitney satellite opened in 1973 at 55 Water Street, in the Wall Street neighborhood of Manhattan. The area of the exhibition space was 4,800 square feet, a considerably larger gallery than the later branches, which averaged 3,000 square feet. The concept, the first of its kind, was the brainchild of David Hupert, who had been the head of the Whitney's education department since 1969. From the beginning Hupert's vision wedded the financial community to the Whitney's educational and audience diversification aspirations. Instead of bussing the troops to the main museum, his idea was to bring the quintessential experience of American art and its cultural heritage to America's financial heartland. Hupert promoted the idea of the branch museum as a teaching component of the Whitney Independent Study Program (ISP) (for aspiring art historians, critics and artists) where fellows would organize exhibitions, write criticism and make art. The faculty, staff and student participants and the access to loans from the Whitney Permanent Collection made the endeavor an unparalleled resource for connoisseur and neophyte alike. Hupert funded the program by enlisting the annual financial support of corporate executives in the area and also with matching grants from the National Endowment for the Arts.

The four branch museums operated throughout the decade, staging four to six exhibitions per year. When the Whitney Museum at the Equitable Center opened in 1986 with two galleries, works from the permanent collection were generally shown in the north space and exhibitions curated by students from the ISP program in the south gallery.[11] The 5,200-square-foot lobby at Philip Morris Companies, Inc., along with its function as a public lounge with shops and food service, has served as a sculpture court, and a small separate adjacent gallery space has been designated as a art-project room.

A valuable lesson is inherent in the concept of the Whitney branch museum model. The guidelines and standards for the development of the program were set by a professional body whose primary concern was art and its relationship to contemporary culture. Individual preference, personal taste and the corporate agenda took second place to the notion of art on its own merits, its relation to society and its value to a wider public. A distinction was also made between the hosts' involvement with culture and the support of the museum, and their own corporate art collections.[12]

Pessimists maintain that the diversification of the museum in several locations dilutes the quality of programming and complicates management. They say that corporations are always self-serving at heart, so that the museum branch becomes either the tool of the host business or its Machiavellian surrogate. A more positive evaluation points to a high standard of art education reaching new audiences, mutually benefiting art, audience and corporate host. The branch museum concept places a high priority on educational programming and serves as the base for the innovative Independent Study Program's Curatorial and Critical Studies courses that the Whitney began in 1968 with funding from the Helena Rubinstein Foundation. The Helena Rubinstein Fellows organize two exhibitions, including publications, for the Whitney Museum's branch museums and have the opportunity to collaborate on an in-house fellows' publication. In a manner similar to a teaching hospital, the regular infusion of young ideas keeps the museum and the corporation on the razor's edge of the discipline. The Whitney Independent Study Program has always had a reputation of renown; graduates of the leading universities around the world have attended, and the artists and scholars who teach there are from the "top of their catch."

From the corporation's perspective, the location of a museum on its own premises does spread a professional and educated gospel. The concept elevates the position of art consultancy to the level of informed management consultancy that any leading corporation would seek out. The "I-don't-know-anything-about-art-but-I-know-what-I-like-school" is given the privilege of options, and of exposure to new resources. The company's art component is more closely woven into a general management policy, rather than reflecting the personal serendipity of a particular officer-in-charge. This is the tricky part. Every good art program in the business sector has without exception come into being because of the vision of the person or people at the top. Art and culture ingrained into the corporate, not the individual, psyche as one essential aspect of business is the path less traveled. And that *will* make some, if not all, of the difference.

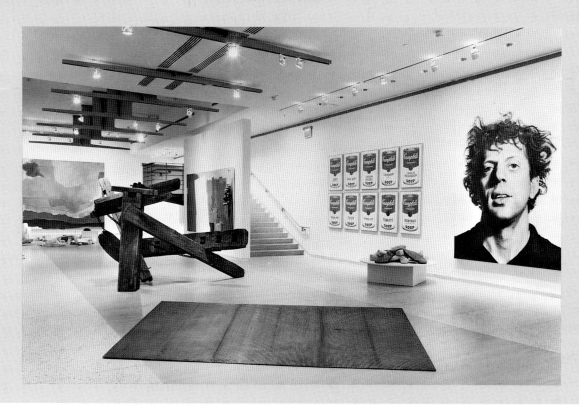

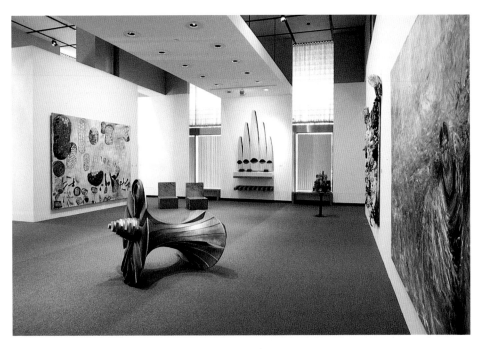

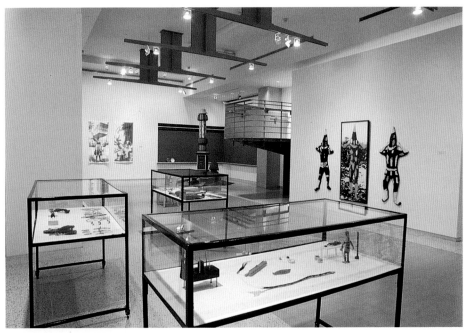

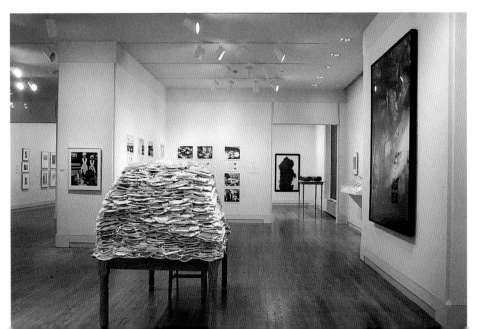

Left, above: "The Eighties in Review: Selections from the Permanent Collection of the Whitney Museum of American Art" included paintings, sculptures, prints, drawings, books and photographs by thirty-one artists. Among them were Susan Rothenberg, Terry Winters and Jean-Michel Basquiat. The exhibition was presented at the Whitney Museum of American Art at Champion, Stamford, Connecticut December 8, 1989 to February 28, 1990.

Left, center: "SITEseeing: Travel and Tourism in Contemporary Art" included photographs, installations and mixed-media sculptures related to travel. It was organized by the 1990–91 Helena Rubinstein Fellows in the Whitney Museum's Independent Studies Program and shown from April to June 1991. The nineteen artists represented included James Luna, Jimmie Durham, Leondro Katz, Renee Green, Elaine Reicheck and Laurie Simmons.

Left, below: "Dirt and Domesticity: Constructions of the Feminine" was the closing exhibition for the Whitney Museum of American Art at the Equitable Center, New York, June 12 to August 14, 1992. Focusing on the portrayal of women as homemakers and housekeepers, the exhibition featured Ann Hamilton's *Still Life*, Lynne Yamamoto's *Ten in One Hour* and Lorna Simpson's *C-Ration*, and works by Carrie Mae Weems, Cindy Sherman and Danielle Gustafson. The presentation was curated by a group of students from the Whitney Independent Studies Program.

Above: Meg Cranston, Mike Kelley, Collier Schorr, Jim Shaw, Gary Simmons and Alexis Smith explored issues of youth through childhood experience in "Songs of Innocence/Songs of Experience" held at the Whitney Museum of American Art at the Equitable Center, New York, in spring 1992.

The Whitney Museum at Champion offers the same quality programming to the suburban audience, and exhibitions originated in one location or two branches together are often restaged at other satellites. Brochures are provided, lectures and performances given and special events and programs frequently staged, all free of charge.

Philip Morris and Champion International have long-standing records of involvement with the Whitney Museum, as major direct sponsors of individual museum exhibitions. Introducing a Whitney Museum branch to their premises was a progressive if risky step. "I've said right from the start I think it's incredibly brave of these corporations," observed Pamela Gruninger Perkins, Head, Branch Museums. "They've invited an essentially known entity with an unknown product into their building to reside on their premises ... but with a real 'hands-off' attitude. And that's been the case at each one of these corporate centers. It is about art, it is about a museum, it is about an educational experience, it is about a lot of constituencies, not just their own employees. You could say that the personal choice they [the branch hosts] made in turning to the Whitney, as opposed to any other museum, was that the Whitney is really about twentieth-century *American* culture. And if they want to present themselves as on the leading edge of American culture, this was the place to turn to."[13]

The conservative's view was summed up by Hilton Kramer, former chief art critic for *The New York Times*, in *The New Criterion*: "From the branches in operation the nature of the Whitney's interest can be easily discerned, and it is not primarily an artistic or museological interest. To a serious experience or understanding of art these branch operations make no contribution whatever. In fact, they aren't in any sense of the word museums at all and shouldn't be called by that name, but are more akin

to boutiques or advertising displays in which token art objects are put on show for the purpose of conferring a spurious 'cultural' image on the host companies. The real function of these branch operations is neither to educate nor to delight, but simply to provide both the Whitney and the sponsoring corporations with a mutually beneficial public relations program. The Whitney looks as if it were performing a service for the public, and the sponsoring corporations look as if they were performing a service for art, whereas in truth both are cynically using art *and* the public as a means of promoting their own respective interests."[14]

The ultimate rebuttal rests in the excellent programming of the branch museums, the numbers of people who saw the exhibitions and performances in diverse settings, the serious reviews that many of the exhibitions received in respected newspapers, the artists' praise of the programming, and the many educational opportunities the program generated.

The Whitney Museum at Equitable closed in August 1992, at the request of the corporation. The reason publicly offered was that Equitable wanted to develop a more ecumenical program, inviting any qualified art institution to submit proposals for programming the gallery spaces on its premises. Equitable has said that it did not plan to cut the budget, but just to distribute it differently.[15] The Whitney Museum at 2 Federal Reserve Plaza, funded by IBM and Park Tower Realty, also closed.

The new Equitable Gallery has assumed a more historical demeanor closer to that of the IBM Gallery (see pp. 12–13) and will serve as host to touring exhibitions organized outside New York and to local art institutions whom the corporation determines would benefit from the midtown exposure.

The corporate entities discussed in these pages have understood the concept of art as visual idea beyond decoration. Perhaps this fact explains why so many of the best collections and programs in the

realm of the visual arts come into being by fiat of the enlightened executive. These innovators have refined the art of cultural patronage and brought the best of it to their co-workers, their stockholders, their clients, their communities, their corporate images, and to the future inter-relationship between art and business.

In pulling Equitable out of the doldrums, incoming chairman Richard Jenrette promised a new cultural image. New, yes, but better? The new system forces professional arts organizations to submit proposals for exhibitions to a corporate art division staff curator. IBM is a proven exception (as Equitable is also likely to be) to a largely undistinguished list of corporate *Kunsthalle* programming where quality is measured by popularity. Yet, IBM and the new Equitable structure are not programs devoted to contemporary issues in the arts. If cultural programming by corporations is measured only by audience ratings (more people supposedly visited the IBM Gallery than went to all the Whitney branches), when it is well known that contemporary art and culture have a smaller following by far, then there will be no corporate patrons for the brave new world of experimentation. If no advisory board of impartial arts professionals keeps watch, the conflict of interest favors the corporate side.

"Immaterial Objects" at the Whitney Museum of American Art at the Equitable Center, New York, September-December, 1991, in which the work of Vito Acconci, Carl Andre, Larry Bell, Mel Bochner, Dan Flavin, Eva Hesse, Richard Serra, Keith Sonnier, George Sugarman, James Turrell and Richard Tuttle were shown.

CHAPTER 6
COLLABORATIONS
Joint Ventures for Public Places

"Contemporary art and contemporary architecture are still seen by many as offensive. This art and architecture provoke uncertainty and changing perceptions. Hypo-Bank knows that it cannot ignore these types of reactions when it wants to develop into the future. Not only in art but also in business it is often difficult to introduce the new. With its openness and its risk-preparedness, art and architecture set up a standard. This standard is also obligatory for anyone who carries the weight of business responsibilities. We are prepared to meet this challenge."

Dr. Eberhard Martini, Manager, Board of Directors, Bayerische Hypotheken- und Wechsel-Bank[1]

Joint ventures involving the interplay of economic, artistic and social forces, with the aim of rethinking and reconfiguring the city and its urban spaces, are viable alternatives for the future metropolis, especially for public places in the corporate domain. Critical understanding of the civic and social responsibility of business patron, artist and architect has radically shifted since Cesar Pelli, the celebrated architect of the World Financial Center at Battery Park City, described his initial response to the equal partnership model of architect and artist in the design of the plaza for the colossal mixed-use landfill complex in Lower Manhattan: "For me, the issue of art had to be carefully worked out because much art today I would call 'anti-public,'" he declared in 1983, "insofar as the artist feels that his or her main role is to make a statement that will somehow shock you or challenge your assumptions about civilized life. I think that in much recent work of both artists and architects there has been little consideration for what makes good social environments."[2]

The problematic distinction between "public" and "private" with regard to artmaking has become an increasingly mainstream issue as visual artists have continued to dissolve the accepted boundaries of where (and when) art can occur. As contemporary culture allows the

artist a more unconventional arena for studio and display site, in other words, a more integrated role in the perceptual shaping of societal structure, the opportunities for artistic intervention have mushroomed. The hierarchy of the museum, the *Kunsthalle* or even the prestigious commercial gallery, the sacrosanct public position of both the monument and art applied to architecture, have all been challenged by new and alluring situations of place. Interventions in rural and urban spaces, from riverbanks, lakes and gardens, courtyards, plazas and alleyways, to office lobbies and warehouses, schools, apartments and houses, temporary and permanent installations have aspired to transform cities into outdoor museums and open spaces into virtual gardens of integrated art.

Inherent in the arena of public investigation is the idea of cooperative or collaborative effort, that is, of something that is of benefit to a community as opposed to an individual. Siah Armajani, the eminent American advocate of rethinking art in public areas, has said that "public art's basic aim is to demystify the concept of creativity. Our intention is to become citizens again ... What is important to us is the mission and the program and the work itself ... One of the fundamental beliefs we share is that public art is non-monumental. It is low, common and near to the people. It's an anomaly in a democracy to celebrate with monuments. A true democracy does not provide heroes as it requires each citizen to participate fully in everyday life, and to contribute to public good."[3]

In the examples described here, the participants have understood the concept of "public" with penetrating insight. In all cases, the success of the projects rested on a comprehension of process, politics, psychology and patronage. The artists are ultimately credited with the achievement, and rightly so, but without the entrepreneurial imagination of the organizational decision-makers to encourage their vision, it is highly unlikely

that the results could have reached such heights.

The idea of artists working as members of a design team to create a public place evolved with two precedent-setting American models, one at the Wiesner Arts and Communications Building at the Massachusetts Institute of Technology (1980–85), and another for the waterfront plaza of the World Financial Center at Battery Park City in Lower Manhattan (1982–87).[4] Fittingly, the model for the Battery Park City project was unveiled at the Whitney Museum of American Art and billed as a collaboration between the center's architect, Cesar Pelli,[5] landscape architect M. Paul Friedberg and artists Siah Armajani and Scott Burton. "We have co-designed the plan itself," Scott Burton claimed at the ceremony. "That is the breakthrough. Normally artists are called in after an architectural project has been designed and given predesigned spaces."[6]

The success of this urban landfill site facing the Statue of Liberty was a miracle of both public- and private-sector collaboration. The instigator was Battery Park City Authority, a government agency organized as a subsidiary of the New York State Urban Development Corporation. The Authority, presided over at the time by Richard Kahan, commissioned the firm of Cooper and Eckstut to execute a complete city-style master plan of housing, office and retail space, streets and parks, a riverfront esplanade and other public areas. Judging from the results, the design guidelines were sufficiently firm without being stifling and architects hired by private developers were obliged to conform to restrictions involving size, shape, placement and facade materials. Pelli designed the 7.5-million-square-foot World Financial Center Complex at Battery Park City, which included four granite- and glass-clad office towers for developers Olympia and York, two nine-story octagonal buildings, and a glass-covered winter garden.

The waterfront plaza, $3\frac{1}{2}$ acres of the total 92-acre domain, leads down to the Hudson River in front of Pelli's towers. From the beginning the plaza was an integral part of the whole complex, and a primary architectural component in Pelli's concept. The artists, landscape designer and architect experimented *as a team* to shape a civic place whose program involved both function and vision. In evaluating Siah Armajani's and Scott Burton's winning scheme, Pelli said: "What Scott and Siah proposed was unlike what an architect would have proposed. Sculptors work within a cultural tradition that draws on different sets of ideas, forms and goals. In Scott and Siah's design there were forms and attitudes that did not come from an architectural tradition. Even when they used architectural elements, they used them as no architect would ... In hindsight, I would conclude that this was probably the best possible point of departure for collaboration, for the very reason that what they had to bring to the project was different from what I brought. They are free in areas that I am not, just as they are constrained in areas where I feel totally free."[7] The ingredients of paving, waterside seating, balustrades, park, garden, fountains, outdoor cafés and linking stairs were blended to meet the visual as well as the physical needs of the public. Although the artists subordinated their personal styles to the overall perceptual unity of the place, those who know their individual work will easily recognize Burton's granite benches, and Armajani's gates and railings inscribed with lines from poems of Walt Whitman and Frank O'Hara (chosen by Burton).

The waterfront plaza at Battery Park City, New York, a collaboration between **Scott Burton** and **Siah Armajani**, 1982–87.

Scott Burton, *Settee, Bench and Balustrade*, black granite, poured concrete and metal pipe, and **Kenneth Noland**, *Atrium Wall*, 1981–85, industrial exterior-grade house paint and steel tile, at the Wiesner Building, Massachusetts Institute of Technology, Cambridge, Massachusetts.

By mid-1983, when Burton and Armajani were in the thick of the waterfront plaza design, Burton, along with Richard Fleischner, Kenneth Noland, James Turrell, Dan Flavin and Alan Shields, had been invited to participate in the design of public spaces inside and outside the Wiesner Building at the Massachusetts Institute of Technology. (Turrell, Flavin and Shields subsequently dropped out.) I.M. Pei & Partners had already generated a scale model and schematic drawings for the project. New ideas about public art were in the air, and artists, architects, administrators and the public were seeking fresh options to humanize the urban environment. It was the artists who were leading the way. They were beginning to call themselves "placemakers," artists like Armajani, Burton, Fleischner and Mary Miss among them. Their individual philosophies varied, but their common will was to nurture an anti-monumental, integrated and collaborative spirit glorifying, if anything at all, the humble user.

In the case of the MIT project, there was no competition and artists were invited directly to integrate their work into specific areas: ultimately Fleischner resolved the $2\frac{1}{2}$-acre outdoor space between the new Pei edifice and the Mitchell/Giurgola Health Sciences Building; Burton took charge of the banquette scheme, the form of the stairwell opening, and the railings; and Noland the interior and exterior skin of the structure. Although Pei's office was in the middle of schematic designs when the final group was assembled, Pei himself affirmed his solidarity with the concept: "This is a collaboration of artists and architects . . . and we're going to be working together on it. We're not going to be dogmatic. We're going to be very open. We'd like to consider this as an experiment."[8]

Richard Fleischner, *MIT Project*, 1981–85, granite inlays and granite stairs, stairs 84 (2560.3) across, at the Wiesner Building, Massachusetts Institute of Technology, Cambridge, Massachusetts.

Becton Dickinson and Company, Franklin Lakes, New Jersey

When Michael McKinnell of the Boston architectural firm of Kallmann, McKinnell & Wood (KMW) was called upon by Becton Dickinson to introduce some major art commissions into the plans his firm was developing for the company's new corporate headquarters in Franklin Lakes, New Jersey, McKinnell only had to cross the Charles River from Boston to Cambridge to see the precedent-setting Wiesner Building as a model example of the melding of contemporary art and architecture. One of the artists on Becton Dickinson's list was Richard Fleischner. McKinnell was familiar with Fleischner's projects in general and, after recommendations from I.M. Pei & Partners and the Massachusetts Institute of Technology, he invited Fleischner to visit the site.

Becton Dickinson is one of the largest manufacturers of health-care products and systems operations in the world. With future growth channeled to the longer-living senior population, its new research, training and purchasing headquarters was built in 1986. Known as a company at the forefront of its area of expertise, Becton Dickinson's drive for excellence permeated the physical plant and public working environment. And, no stranger to the field of contemporary art, Becton Dickinson had already amassed a sizeable collection for its New York premises.

All the principals involved in the new building gave the utmost praise to Wesley J. Howe, Chairman of the Board, and Dr. Wilson Nolen, Vice-President, for their patronage of two cooperative ventures in the visual arts. These leaders set the course for relationships between McKinnell and Fleischner, and between McKinnell and another sculptor, Michael Singer, that have had memorable results. Everyone also lauds Mary Lanier, Becton Dickinson's art advisor for many years, for her effective arts advocacy in making things happen.[9]

Landscape architect Morgan Wheelock had developed a master plan for the site, and the architects, having completed the design, were in the construction phase of the project when Fleischner was first brought in to suggest an environmental plan for two interior atriums. As it turned out, Singer worked in the atriums, and Fleischner, choosing the outdoors, gently reshaped the natural landscape to achieve a brilliant blend of land and place. Singer, too, rose to a new level of authority with his interior environmental settings at Becton Dickinson.

Richard Fleischner is a hands-on formalist, an artist who sees space in perceptual terms. His language consists of words like plane, edge, corner and perimeter. He measures distances and volumes phenomenologically—by getting out into the site and feeling the lay of the land. The built to the natural, the natural to the built was the dialogue of his "place/piece" at Becton Dickinson. To all intents and purposes, Fleischner made a series of three outdoor rooms, a group of exterior destinations where the business of pleasure, relaxation and communion with nature could happen: a terrace area, a stepped green and an inlay in the woods beyond. "I was trying to take some of the built construction, some of the perimeters or edges of the building out onto the ground plane and get to the wood's edge," Fleischner explained. "The birch tree line that we put in was a means of establishing an organic material as an organic wall ... At the stepped green where the grass changes is a rectangle, but its primary function is to set up a sense of scale within that space. These materials are constantly echoing the building—the bay windows, etc. Here are these squares and rectangles described in solid planes with some plantings to set them out. Here you have this constructed frame set within the ground plane of the grass."[10]

When an art component for the project was first contemplated, a more conventional approach was sought for adorning the three prominent atriums, the linchpins of KMW's plan. The architects had already designed and engineered the first atrium with a stepped substructure for a fountain and pedestals for statuary by the time Fleischner was asked to make his suggestions for the space. "I did not think the atrium was the appropriate place for art to occur," Fleischner said. "I did not think it was a good idea to build on the pedestals, to add another vertical plane here. What is most interesting about this is the fact that the architects were operating in an archaic mold—they had designed the space and left the pedestals empty for an artist to fill in ... What I think we did outside was the opposite side of the coin. You walk outside into the landscape, a series of outdoor rooms, some with inlays or perimeters defining scaled ground planes within a context that becomes more and more natural as you move away from the building. As the context becomes more organic, the work becomes more geometric. Contrast within context."[11]

Michael Singer was the artist who ultimately worked in the atriums. As early as 1983, critic and artist Jean Feinberg had noted, "with [these] new sculptures we realize that Singer is no longer looking up, into the atmosphere of the fluctuating landscape. Rather he is looking down at the structure of the earth itself—literally the ground beneath our feet."[12] The Becton Dickinson installations are a mature representation of Singer's turn to gravity and ritual, a shift from the absence of human presence to the man-made in its primordial essence. The word "ritual" appears in all the titles, and the pieces, now resembling altar-like platforms, contain sticks, stones and slabs of slate and granite. In keeping with his reverence for Asian philosophy, Singer's sculpture implies in its architectural format both physical entrance and spiritual passage.

In considering the two rectangular atriums at Becton Dickinson, Singer wanted to make a strong relationship between the two spaces, a kind of narrative. The first atrium, below grade, was already appointed with the substructure for a fountain and plantings, as already noted. "If I work indoors I am very concerned about what that space

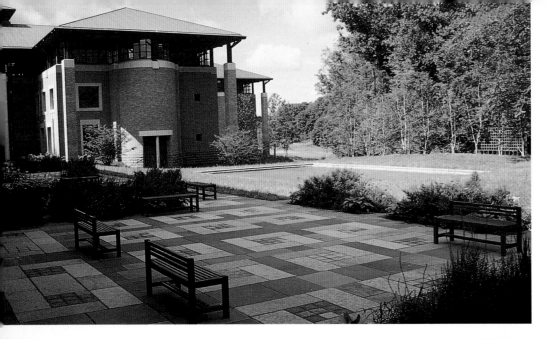

really is, and to have had the Becton Dickinson space to relate to was great."[13] However, Singer, like Fleischner, did not believe that the proper solution was vertical statuary on pre-cast cement pedestals. Instead, Singer proposed to work with the existing conditions in a way that would complement and advance his own concerns with sculpture and site.

"The fact that the first atrium that you go into is actually below the grade was just perfect for me—when you come in and look across through the windows you can see the grounds. Everything I have done is actually below grade, and is literally on the dirt. Below grade is almost the process of going into yourself, and digging out the material inside you."[14] With the first atrium likened to an archaeological dig, the second atrium, built at grade, became the site for display of the excavation finds.

Both Singer and Fleischner are very strict in their usage of the term "collaboration," each preferring to describe their involvement with McKinnell as a cooperation. "I was very skeptical about the architects accepting my theories because I was doing work that was about the ground and going down when they had designed a space where the artist was asked to go up [vertical statuary]. I would say that the cooperative stage began when Michael McKinnell and I started discussing how to edit my work, and I think he is a great editor."[15]

When I spoke with Fleischner and Singer individually, I asked them to define how their input was distinguished from the other design-field experts involved in the conception of a building project. I met

Richard Fleischner's *Becton Dickinson Project*, 1986–87, an integral artwork for a landscape art commission encompassing all aspects of the larger wooded site. Fleischner sculpted a series of three outdoor rooms: a garden terrace area with teak furniture; a sunken grass plane adjacent to the buildings and in front of a line of birch tree; and (opposite) a granite inlay in the woods. Integral artwork.

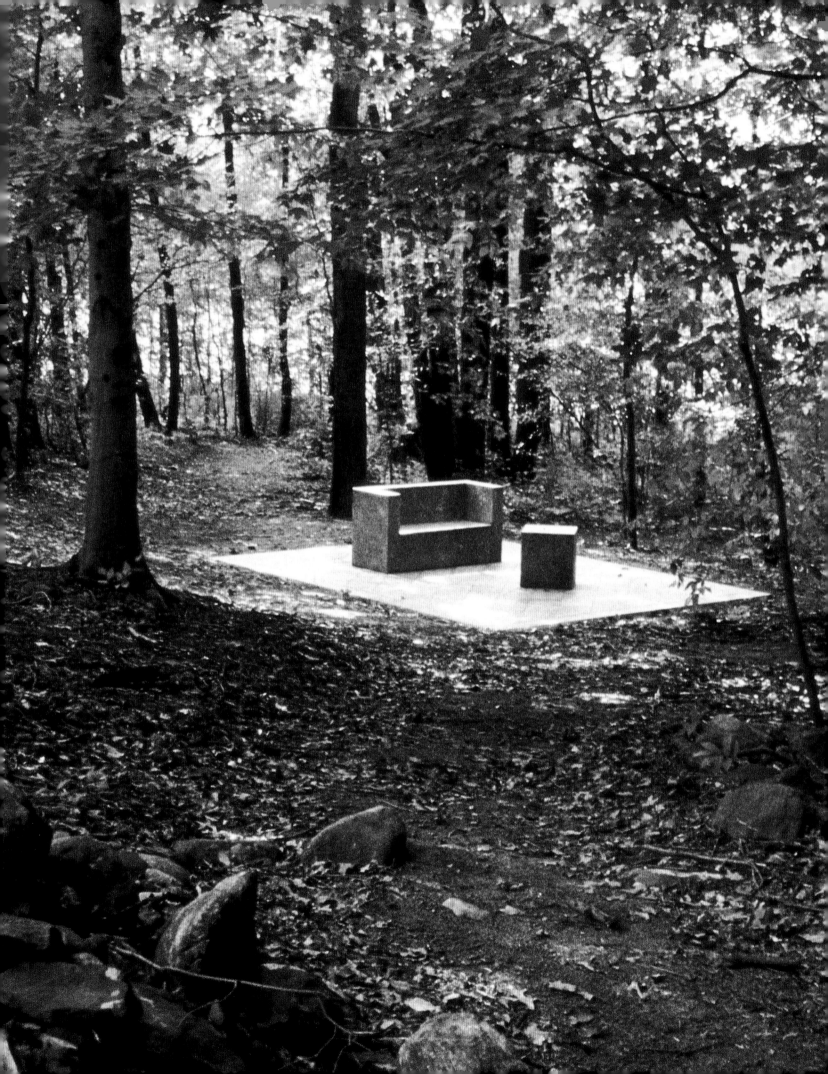

with Fleischner in his Providence, Rhode Island, studio in April, 1991. We discussed the process of collaboration and the breed of artist/placemaker to which he subscribed:

Marjory Jacobson: If you are working as a part of a team with architects and you are conceiving something together in a truly collaborative way, how would you describe your input as an artist as compared to that of the architect? If I were to walk into a space and say, "where's the art?" where would the art be?

Richard Fleischner: I think that there is a very revealing flip-flop of conventional roles taking place. On the one hand, there are prominent architects like Peter Eisenmann, Frank Gehry and Michael Graves who are making objects— buildings that exist independently of their site and context— while on the other hand, there is a small group of artists making places—artists like Mary Miss, Siah Armajani, Bob [Robert] Irwin and myself who are working to integrate the experience within a project's particular context and whose work has as much to do with how a place feels as how it looks. It becomes less and less obvious as to "here's the work of art."

MJ: Yes, but if that is true, why bring an artist into the process in the first place?

RF: I do not think the title of architect, engineer, landscape architect or artist is consequential. What matters is that someone identifies and then resolves the proper issues.

MJ: Is that person an artist?

RF: There is a quote I love by Guy Davenport: "Art is always the replacing of indifference with attention."

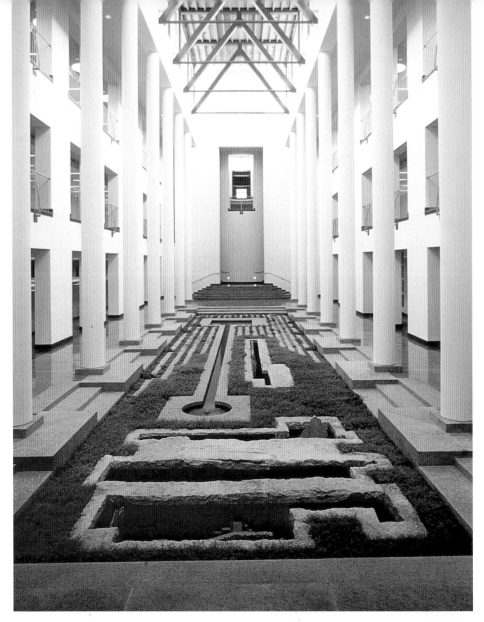

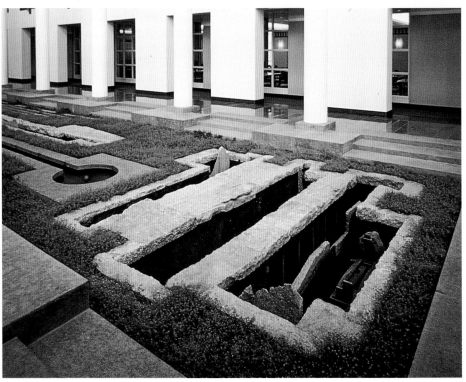

Michael Singer, *Ritual Series*, 1987, wood, stone, copper and steel, (with detail below) an installation in Atrium I at Becton Dickinson and Company, Franklin Lakes, New Jersey.

Also in April 1991, I had a similar conversation with sculptor Michael Singer.

Marjory Jacobson: In terms of art and architecture, what does an artist bring to the collaborative process that is different from what the architect does?

Michael Singer: Artists have a very different process in the way that we "design." Architects need to have a client. Architects must have a defined program that exists in the world. Artists can go into the studio and just work, without a client, and artists create their own programs. So right there an artist is working in the realm of research and questioning and exploration, and the architect is working more in the world of answers to known questions. I am not saying that one is better than the other, but they are so different.

MJ: In these building projects, is it meaningful to include an artist's vision?

MS: Very much. Architects have a special language. They talk in terms of opportunities and constraints. There is a specific process they go through—talking

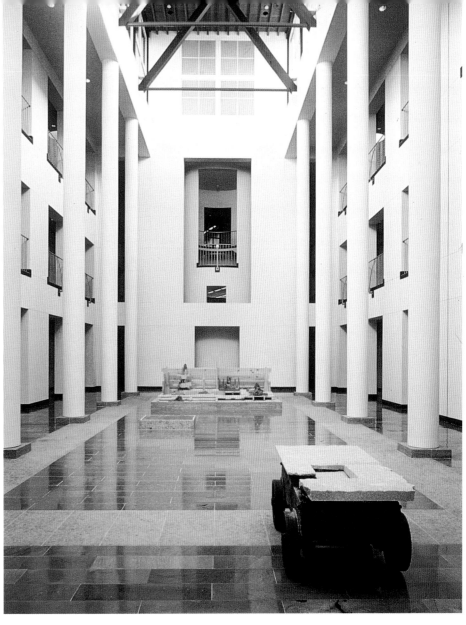

to the client about the program, and then a study identifying the opportunities and constraints of the particular job. For example, a constraint could be engineering, or needing a permit from the city, etc. Artists never think in those terms, artists just think in an "egocentric" way. You walk into your studio and you are a god and you create a world that is a very unreal place. I sometimes think that this way of life often makes us very childish people. When I was invited to participate in an architectural process, and I would say Becton Dickinson was one of the first, the idea that there was reality to work with like "opportunities and constraints" really was a gift. In other words, to be told that your real limitations were really dictated

by your possibilities. Many people do not see it that way. When they learn that they have limitations, they revolt like a child would. On the other side, most architects don't "play." They want to but somewhere along the line the idea of playing and exploration and research is lost in the process. They are dealing with law, liability issues and economics—they are more in the realm of the business world than they are in the creative world. McKinnell is someone who very clearly understands and respects the difference between the two. He has an envy for what an artist does. Probably one of the reasons we work so well together is that I have that envy for what he does just as much.

Michael Singer, *Ritual Series*, 1987, wood, stone, copper and steel, (with detail below) in Atrium II at Becton Dickinson and Company, Franklin Lakes, New Jersey.

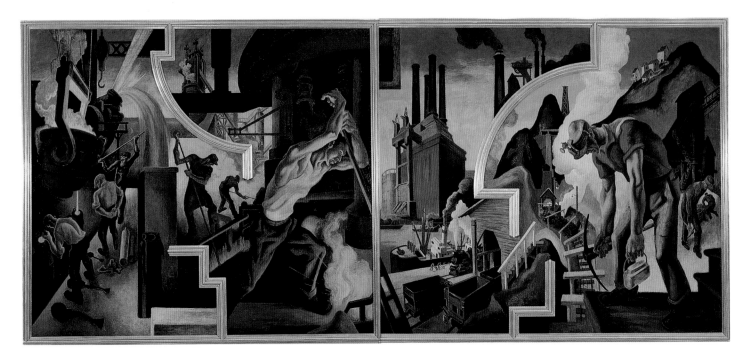

The Equitable Center Art Complex, New York

Given the generous funding and museum guidance lavished on it, the Equitable Center Art Complex in New York was a flawed enterprise, for it did not fulfill its enormous potential. Nevertheless, it remains a noble contribution to the annals of forward-looking collaborative ventures. In this case the venture was between the museum and the corporation. To design the complex, Equitable engaged Edward Larabee Barnes, a noted architect with a record of sympathy towards contemporary art, and it also contracted with the Whitney Museum of American Art to establish a branch at its new headquarters and to act as art advisor to its public art program. Benjamin Holloway, Chief Executive Officer of Equitable's Real Estate Division, took a sound and pragmatic business position publicly heralded as "new, varied and exciting ways to beautify the bottom line." "We are doing these things," he said, "because we think that it will attract and hold tenants, and they will pay us the rents we are looking for."[16]

When Equitable opened the 3-million-square-foot Manhattan headquarters in 1986, Michael Brenson, art critic for *The New York Times*, hailed it as "an event of major artistic importance ... a commitment to art on the part of a prominent American corporation that is as generous and innovative as any before,"[17]

though he added, "The Equitable's Art Program is innovative, but its taste is safe."[18] Ironically, Roger Kimball, writing in *The New Criterion*, the hard-line bastion of "safe" art, found the Equitable a mockery of decorum, a "parody of conventional 'good taste,' an exaggerated, overblown conventionality that spoofs even as it imitates traditional forms of bourgeois elegance."[19]

The Equitable made an enormous patronage effort. The art program included placemakers and objectmakers Scott Burton, Roy Lichtenstein, Sol LeWitt, Barry Flanagan and Sandro Chia, who were given major commissions meant to address the public dominions of the corporation and the city. The Whitney Museum was instrumental in awarding the site-specific commissions, making major acquisitions for a collection that was to be installed in the executive interiors, and organizing its branch museum in the Equitable lobby. An independent art consultant and the in-house curator were on hand to coordinate the administration of the project. The company had also offered reduced rent at the Equitable Center to the New York office of the Archives of American Art and three non-profit arts support groups.

Although no official theme was imposed on the Equitable Center's art program, some of the works constitute a mini-anthology of mural making in our time, beginning with Equitable's highly

publicized purchase in 1984 for $3.4 million of *America Today* (1930) by the American Regionalist Thomas Hart Benton. This ten-panel paean to American industry and culture was made in the aftermath of the Crash of 1929, for the boardroom of the then recently established New School for Social Research. It was Benton's first mural and had been in some disrepair for years. Not only had Benton misunderstood the distemper medium with which he experimented, but the mural had also suffered physical damage because the room in which it was located was turned into a crowded classroom. In 1984, when the New School decided to put the Benton up for sale, former New York City Mayor Edward Koch went to Equitable with the plea for the mural's purchase and conservation so that it could remain in New York as part of the city's great heritage.[20]

Roy Lichtenstein's *Mural with Blue Brushstroke* (1984–85),[21] a colossal 68 feet tall by 32 feet wide and set into the limestone wall of the Equitable Center's lobby, makes no attempt to revive the fresco technique of mural painting, yet his literal reference to the cartoon might be read by some as a wry comment on the method by which the outlines of frescoes were traced on the wall by Renaissance masters. In a thoroughly modern way, it is Lichtenstein's typical work in acrylic on canvas. Lichtenstein, an early and

Three panels from **Thomas Hart Benton's** *America Today*, 1930, installed at the Equitable Center, New York, after their extensive restoration in 1984. Left to right: *Steel*, 92 × 117 (233.7 × 297.2); *Coal*, 92 × 117 (233.7 × 297 × 2); and *Instruments of Power*, 92 × 160 (233.7 × 406.4). All distemper and egg tempera with oil glaze on gessoed linen.

The atrium at the Equitable Center Art Complex, New York, showing commissions by **Roy Lichtenstein** – *Mural with Blue Brushstroke*, 1984–86, acrylic on canvas, 68 × 32 ft (20.7 × 9.7 m) – and **Scott Burton** – *Atrium Furnishment*, a 40-foot-long (12-metre) seating area in marble with onyx light fixtures, semicircular settee and circular table 19 ft (5.79m) in diameter. The pool within the table contains aquatic plants. The atrium floor patterned with red granite and white marble was also designed by Burton. Commissioned by The Equitable.

enduring proponent of popular culture, derived his imagery from such stuff as chewing gum wrappers and comic strips. In the manner of the times, he has made many big paintings. The largest, over 13 feet high by 96 feet long, was executed for a temporary show at Castelli Green Street immediately preceding the Equitable commission in 1983 and then covered over with a false wall. As he usually did, Lichtenstein used black photographer's tape to set the Equitable "drawing" on the canvas.[22] After he had checked the perspective from various vantage points within the building as well as through the archway from across the avenue, Lichtenstein painted *in situ* for five weeks.

Lichtenstein's Equitable mural has many aspects in common with Benton's *America Today*. Both include narrative passages that overlap and interlock in a baroque melding of energy—denoting a simultaneous, not sequential, narrative. Lichtenstein's narrative is at once autobiographical and historiographical, referring to the compendium of image-labels by which he and the titans of modern art are recognized. Saluting his business patron and echoing Benton's theme, Lichtenstein included in the upper left-hand corner a figure lifted from Léger, the early twentieth-century French painter who incorporated the machine ethic into his positivist's view of man in the industrial age. Through their signature motifs Lichtenstein also makes

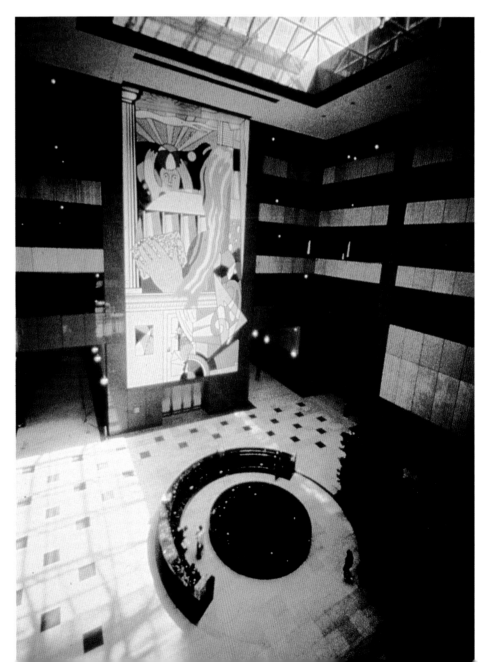

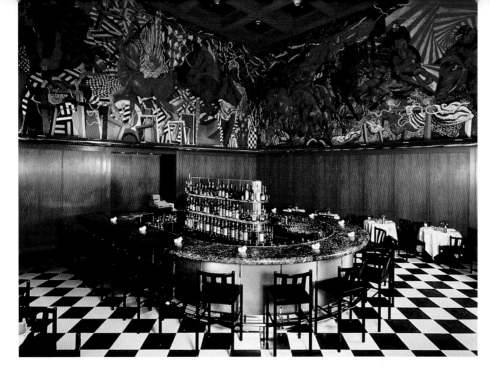

reference to Matisse (cut-outs), Johns (flagstones) and Stella (triangle and French curve). Almost everything else in the mural is a summary of his own image vocabulary: sponge, Swiss cheese, the "perfect" abstract painting, cornices, columns and doors, sunsets, notebooks and, of course, a sweeping brushstroke. Lichtenstein's mural, like Benton's, is "framed." An assortment of framing devices—Doric columns, gilded frame, the classical cornice and a *trompe l'œil* canvas (back and stretcher edge) on the upper right—may refer to the illusory mural (actually an easel painting affixed to the wall).

Palio, **Sandro Chia's** four-part mural depicting the traditional Sienese horse race commissioned in 1985 and installed in the bar at the Palio Restaurant at Equitable Center, New York. Acrylic on canvas, about 162 × 384 (411.5 × 975.4). Commissioned by The Equitable.

A private dining room in the executive area at the Equitable Center, New York, with **Terry Winters'** *Untitled I, II, III*, 1987. Commissioned by The Equitable.

The Galleria, a mall between the Equitable Tower and the PaineWebber building, New York, features two bronze sculptures by **Barry Flanagan**, *Young Elephant*, 1985, and *Hare on Bell*, 1983. **Sol LeWitt's** *Wall Drawing: Bands of Lines in Four Colors and Four Directions, Separated by Gray Bands*, 1985, on the exterior walls of the Galleria were executed in acrylic on limestone as part of the public space artwork plan. Commissioned by The Equitable.

There are other wry allusions to illusion and reality: in the canvas the door to the artist's mind surmounts the doors to the auditorium below the mural; a painted hand wipes a sponge over the surface of the canvas, revealing an image of the atrium lobby fenestration which actually encloses the surrounding space; the brushstroke, the origin of the Abstract Expressionist dictum, doubles as the image of the water that wets the sponge; and the rectangular field of painted sunlight mocks the real shaft of light that enters through the skylit ceiling.

Consultant Emily Braun was hired independently to advise Equitable on the art for the Galleria, which included the wall drawings by Sol LeWitt, two sculptures by the Englishman Barry Flanagan and another mural by Sandro Chia for Palio, Equitable's Italian restaurant. LeWitt updated the mural as a "wall drawing" conceived by the artist in watercolor sketches and then transposed on to the wall by trained assistants using the *secco* technique, in which a water-based paint is applied to dry plaster. *Wall Drawing: Bands of Lines in Four Colors and Four Directions, Separated by Gray*

Bands (1984–85) is composed of six acrylic-on-limestone panels. It was designed for the Galleria, which links the Equitable Tower with the PaineWebber building. The piece is LeWitt's only permanent outdoor mural and his only wall work on display in an open public space in New York.

In the midst of his commitments to Battery Park City and to MIT, Scott Burton was also designing sculpture/seating for three areas in the Equitable Center, his first large-scale commercial project: *Atrium Furnishment* (1986) in the lobby of the Equitable Tower, and *Urban Plazas North* (1985–86) and *South* (1985–86). *Atrium Furnishment* is a congregation area whose flooring, seating, plantings and lighting make a discrete environmental unit planned and executed by the artist. The circular composition is comprised of a high-backed semicircular marble settee (40 feet long) with four onyx cube lamps, a circular table whose center is a pool filled with aquatic plants, an arc of 14-foot-high conifers (*Podocarpus*) and a floor plane of red granite and white marble squares circumscribed by a bronze curve around the settee. On cursory viewing, the

"piece" reads as ornate decor in perfect harmony with its elegant corporate surroundings. But what Burton is really interested in is not how it looks but what it means and how it feels: "It's not for me to say whether it is poetic work, but I certainly know that it comes out of fantasies of Arcadianism where you could live in nature without any walls. The incomplete circle in the floor is like drawing a house in the dirt with a stick. You have the table, but out of it is growing reeds and water chestnut and papyrus. I think there's a love of Classicism in the work—not just of classical architecture, but of the whole idea that nature and civilization can be synthesized."[23]

In the urban plaza environments in the outdoor public space on either side of the PaineWebber building near the Avenue of the Americas (the old Equitable building, now leased to PaineWebber as part of the Equitable Complex), Burton designed two seating areas complete with tables, chairs, planters and landscaping, and even litter bins. The South Plaza at 51st Street is made to function as a picnic area with two regular rows of granite tables and chairs, while the North Plaza has a complicated configuration addressing a multitude of situations of communication and repose.[24] During the 1980's, Burton was preoccupied with a number of public commissions, and his rhetoric became more and more socially self-conscious: "I don't feel the need to establish it as art as much as I feel the need to establish it as furniture ... The social questions interest me more than the art ones. I hope that people will love to eat their lunch there [in the urban plazas]."[25] Scott Burton died on December 29, 1989, at the very close of the decade. He defined for his time the need to merge art with the social experience just as he blazed one trail for showing the way.

Scott Burton, *Urban Plaza North*, granite, 1986, adjoining the PaineWebber building, New York. Commissioned by The Equitable.

Römerbrücke District Power Station, Saarbrücken,
artwork location plan.

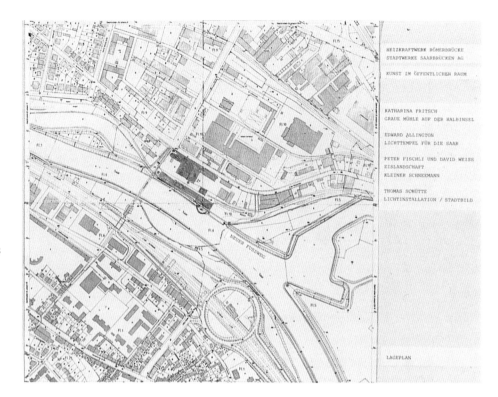

Römerbrücke District Power Station, Saarbrücken

When an addition to the existing Römerbrücke District power station was built in 1985–88 (a public utility situated on the bank of the Saar River, that provides energy for an area of Saarbrücken, Germany), the combined skills of an architect, businessman and arts specialist resulted in a "public monument" appropriate to our times. Rather than working to a pre-set formula, the approach was developed during meetings between architect Jochem Jourdan, of Jourdan/Müller, Frankfurt, and Willy Leonhardt, a physicist, businessman and head of the Saarbrücken Cityworks. The scope of the work expanded to integrate an office building into the complex, and Leonhardt raised the necessary additional funds by bringing together a group of private investors. The art component was introduced as an adjunct to the infusion of private money when Jourdan brought in Kasper König, Director of Portikus Kunsthalle, Frankfurt,[26] and a long-time *agent provocateur* of art and public discourse.

In the case of Saarbrücken, there were paramount historical, political, environmental and economic issues that had a pressing place on the art agenda. Although populated almost entirely by Germans, the Saarland has flipped back and forth between Germany and France, with whom it shares a border, ultimately becoming a German state in 1957. Much of the Saarland's coal and iron resources had been depleted, and the Saar River, which winds through the state and across the French border, where there is a huge French nuclear plant, was heavily polluted with industrial waste. With an architect prepared to try new modes, a public arts pioneer equipped with the models, and a German businessman with a trailblazing ambition to bolster the economy, improve the environment and enhance civic pride, there was every chance of excellence. The new power plant, fused to the original 1960's facility, is at the forefront of economical natural resource technology, a

sober alternative to the French nuclear solution; the river is returning to its unspoiled state; the economy is improving, and the innovative and pan-national art program proclaims Germany's investment in a future European cultural community.

König recommended a group of mid-career artists from different European countries for the project and invited them to attend workshops at the site with the project's principals. On three occasions over several days, two Germans, Katharina Fritsch and Thomas Schütte, the Englishman Edward Allington and the Zürich-based artist-team Peter Fischli and David Weiss met in Saarbrücken with engineers, architect and public utility personnel. The clients stressed the people's love for the Saar as a precious natural community resource and the municipal desire to harmonize the new energy plant with virtuous energy conservation, ecological responsibility and usable public space. From group discussions the idea of the artists somehow utilizing the excess energy discharged from the machinery evolved as a component of the dialogue just as did each artist's choice on siting. Architect Jochem Jourdan commented on the workshops: "In this project in Saarbrücken we learned and managed to work with artists in another way and to

see how art can be integrated into architecture. This was really the main point."[27]

This methodology underscores three commonly underrated process tactics. First, artists selected by invitation of professional arts experts and guided by a mutually understood and respected multidimensional agenda almost always make for a better product. Secondly, themes should evolve as integral to the respondent artistic speculation, rather than preempt the selection of the artists. Thirdly, in the environmental realm, siting is an issue welded to artistic decision-making and the purview of the artist: the more closely linked work is to site, the more fully articulated the artwork. This top-level evaluation process need not be only the option of the rare thinkers; the interdisciplinary crosscurrents are still being experimented with, and a new generation of trained organizers is waiting in the wings.

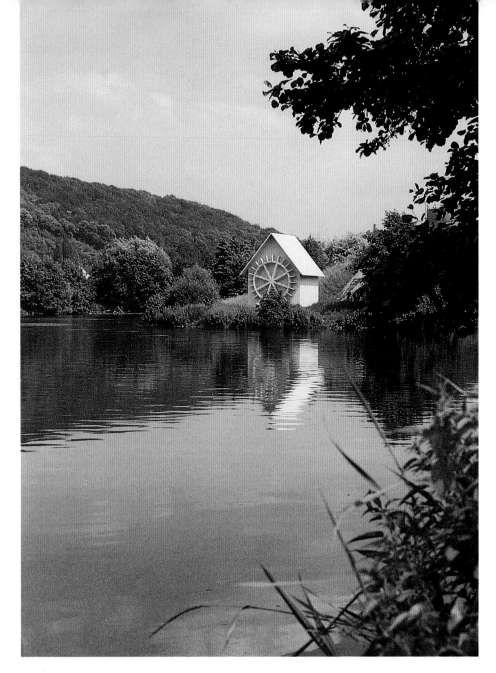

Katharina Fritsch, *Kleine graue Mühle (Small Grey Mill)*, 1988–90, constructed of concrete and wood and painted grey, 23 × 17¾ × 17¾ ft (7.5 × 40 × 5.40m), sits on a small peninsula apart from the utility plant complex. Below is a concept drawing and plan for the artwork.

Katharina Fritsch and Thomas Schütte, especially, have given considerable thought to what it means to make art for public territory. Both are Düsseldorf sculptors who since the early 1980's have shown in international outdoor sculpture exhibitions as well as in galleries and museums, although Fritsch has had considerably more widespread attention. Fritsch's *Kleine graue Mühle (Small Grey Mill)* (1988–90), constructed of concrete and wood and painted grey, sits on a small peninsula apart from the utility complex, acknowledging the land between the two buildings and indirectly establishing it as a usable place. *Kleine graue Mühle* is Fritsch's sole extant public project, and only her second to have been carried past the design stage.[28] This picture-book watermill nestled serenely in the open landscape, the unremarkable image we hold in our mind's eye, seems oddly out of place and scale. The gigantic wheel revolves not in the water but on the front wall of the mill, driven by a motor whose pace has been determined by the artist.[29]

On first impression, Thomas Schütte's *Lichtinstallation (Light Installation)* (1988–90) seems closely allied to architectural decoration. He chose the facade of the original power plant, with its many small windows, for his intervention, developing an "elevation" of house types by adding red light boxes in the shape of pediments or roofs to each opening. The facade reads like a logo for community, a proxy for the district that derives its energy from the city's power plant.

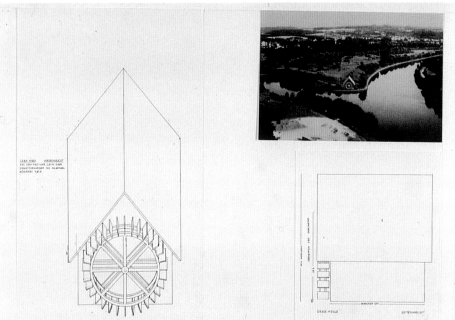

Römerbrücke District Power Station, Saarbrücken, by night, showing integral artworks: **Thomas Schütte's** *Lichtinstallation (Light Installation)*, 1988–90 – twenty-eight windows in a building 14ft 8ins (39m) high – and **Edward Allington's** *Lichttempel (Light Temple)*, 1988–90, 19⅝ × 39⅜ ft (6 × 12m). >

Thomas Schütte, concept drawings for *Lichtinstallation (Light Installation)*. >

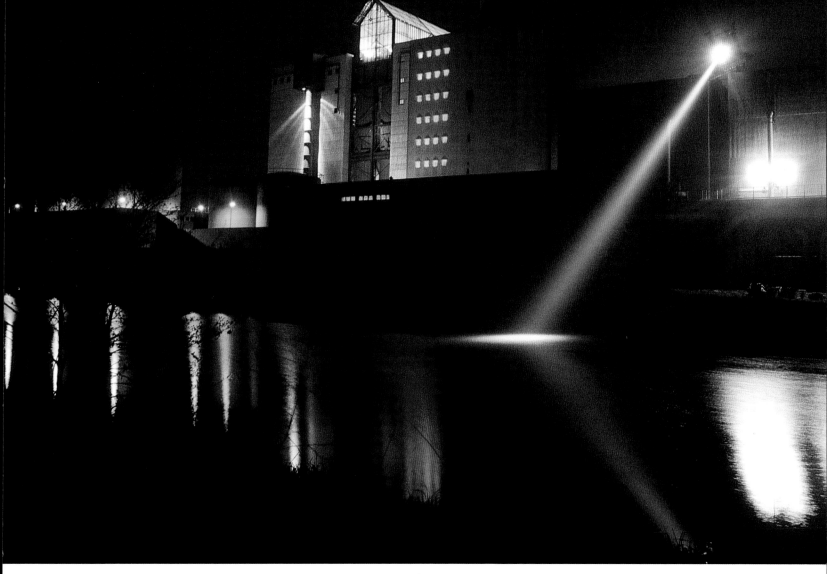

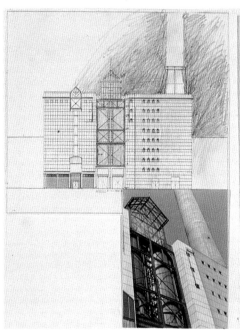

Es wird neu Fenster gebraucht, falls
sich die Fenster öffnen lassen –
die von innen ausgeleuchtet werden.
Warmes oder Neon oder gelbliche
Glühbirne wäre das beste.
Darüber eine Metallkiste 130×40

mit rotem Plexiglas und sehr
hell.
Ein Testfeuerte wäre wünschenswert,
und ein zweites Bund in Saarbrücken.
Bitte behandeln Sie die Zeichnung
gut, sie sind wegen der Größe
sehr empfindlich. Zum Zeigen sind
Fotos davon besser.
Gute Festtage
Gruß
Thomas Schütte

Schütte often refers to architecture, sometimes fully scaled and sometimes in model format, in his sculpture and his prodigious drawing output. He uses architectural models in his work because "it is something everyone understands" and the power plant building with its little windows is an accessible public form of a ready-made model.[30] The most recent development in his œuvre is concerned with the direct influence that a work can have on the design of the area in which it is displayed ... By making a city on the face of the building, Schütte is expressing his own vision of the Römerbrücke District, which becomes another world in which to dwell.[31] Schütte made thirty-five drawings for *Lichtinstallation*, a diary of the artist's thinking process. At one time Schütte thought of rendering the facade with eyes and a meandering blue line to represent the Saar.

Like Fritsch's *Mühle*, *Lichttempel* *(Light Temple)* (1988–90) by the British sculptor Edward Allington reinvents another common building type, the classical tempietto rotunda. Yet, straddling the void between the tops of two cooling towers, the structure can hardly be perceived as it would in a normal surrounding. On one level, the image of a toppling temple may be perceived as a playful chat with the architects whose formal language is the post-modern idiom. From a footbridge across the Saar, the ensemble of buildings and art is a piece of Romantic theater, with Allington's little temple appearing like a vision through the billowing clouds of excess steam pouring from the towers. At night, a light directed from inside the temple door beams onto the river, as if simultaneously targeting the victim of industrial waste and celebrating the clean water campaign under way.

Regarding *Lichttempel*, Allington has said: "[My aim was] to make a breach, a leak in this cathedral to energy [hence temple] in a culture that will do anything for energy. It is our true religion, our theology—witness the bitter disputes between the various lobbies pro or con, and this time there is more than our souls at stake. The source of all the earth's energy, the sun, hence a leak of light, [like] a ship's beacon, into the river ... We must spill energy for art. Art is an essential. A culture that will not produce living culture is not a culture ... Once the greatest expressions of technology went into cathedrals, into temples, now [they go] into power stations, in metal to be a machine. I wanted my temple to be a part of, yet not a part of, the power station, at an angle, fixed, yet perhaps sliding—and also for formal reasons."[32] Allington has used the residue of the power process as a way of, in his own words, "simply showing you your dreams."[33] The temple,

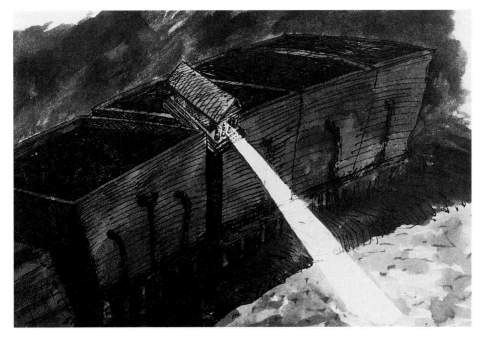

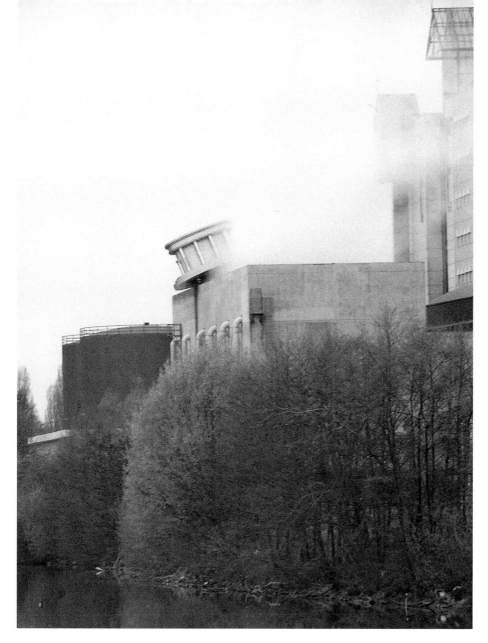

were primarily interested in what the use of these machines was. We decided very early on to do something using the energy that was being produced in the power plant. We had some crazy ideas at first about heating lamps and mushrooms in the cellar, and animals. Strange ideas—I don't remember all of them now. It was because there is something very German about the whole thing, very Nordic. Eventually ice came into the discussion.

MJ: You thought about live animals running around?

F&W: Yes. Like wolves or some animals that bring up the idea of wild energy. Then we thought about symbols, about loading the whole thing with a macho symbol. We talked about bulls—the old-fashioned or traditional way of having one object in front of the factory. More on the idea of a bronze sculpture. We thought, what if we were to do a symbol of a factory, like a graphic symbol? We also thought about a Walt Disney figure—or the inventor, perhaps—an American symbol which is well known here. This character has a little helper, which is a light bulb with legs and arms and it can talk. We thought maybe we could put a creature on top of the whole building like a "Pop symbol." But what was important for us ultimately was that we found out we could use the leftover energy from the cooling tanks. Those tanks are full of water that cannot be used anymore, so it just steams away. We were told that this energy could be used to heat something else, and eventually we decided that this was the direction we would go in. We would turn heat into cold. That was very important for the ice landscape. Underneath the factory itself we would make a small building with a window where one can look inside.

MJ: Like a diorama?

F&W: Yes. Maybe it was also like the icebox in your house. That machine is working twenty-four hours a day the whole year. And when the refrigerator is not working you have a big mess in the kitchen! So the idea came to us of a sculpture where the material, ice, is the fetish, the thing that is there and when the

constructed of galvanized and stainless steel, is not even an historical reproduction. It is industrially constructed, several generations removed, and commonly understood— a metaphor for the cyclical.

Swiss artists Peter Fischli and David Weiss planned two related works for Saarbrücken, *Snowman* and *Ice Landscape*. To date only *Snowman* has been executed. The following are excerpts from an interview held in Zürich in June, 1991.

Marjory Jacobson: How did you come up with your idea for the snowman and snowscape?

Peter Fischli and David Weiss: We visited Saarbrücken twice, first to see the site, and the second time when we already had the idea, to choose the precise place for the work.

MJ: Did you have the idea for both pieces at the same time?

F&W: When we walked around we were attracted on the one hand by the huge tanks where the steam was coming from. But also by a short pathway underneath the whole factory where the support pylons are. The pathway and this useless area underneath the factory were very intriguing to us. We were also interested in the power plant itself and by what a power plant is. And we were thinking that the power plant itself is an artwork. All these machines—a place where they are producing energy to heat the houses. The architects were asked to design an addition to the existing plant and the new part was already under construction when we got involved.

MJ: So you did not really have a chance to collaborate with the architects from the beginning.

F&W: We were not so interested in the formal part of the project anyhow. We

117

Peter Fischli and David Weiss, *Schneeskulptur (Snowman)*, 1988–90, integral artwork for Römerbrücke District Power Station, Saarbrücken, 23⅜ × 23⅜ × 65⅜ (60 × 60 × 166).

F&W: The idea of finding a logo and handling the ice came together to be the snowman as a small sculpture together with the big ice landscape. The snowman has this aspect of a single object. It is the soul of the whole machine. It is an archetype.

MJ: But also in a way an anti-symbol, perhaps. If you wanted to carry it further you could talk about the precarious and transitory nature implied, or dependency, and you could say that the monument, or the idea of monumentality, today is so dependent on the machine that without the machine the symbol does not exist. If something happens to this ice machine, if the power goes, there is nothing left.

F&W: If the power goes, it melts. Then we have to rebuild it. Technically it is like—it is simple and it is not—when cold air mixes with humidity the ice starts to grow. It is the same system that you have in your freezer. Inside it is hollow, and there is a cooling liquid, the same as in your refrigerator. The humidity in the air causes snow to grow. The cooling liquid is inside, and outside is an aluminum mold, and outside that is snow and ice. At a certain point you have to close the refrigerator so the snowman doesn't grow anymore.

MJ: You've sculpted conceptually in a way—that is, with your minds, not with your hands.

F&W: You cannot really control what the ice is doing. You can say stop, don't cool it more or keep going. The ice is coming from the air. When you want it to stop, you don't let any more air come in. You have the box around it and you create an equilibrium. The process stops automatically when the temperature equalizes inside and outside. We did experiments in a cooling house in Switzerland, but they were not scientific tests. The ice only took one or two days to form. Depending on the humidity in the air, it grows more or shrinks. At one point there was too much ice on the nose, and the snowman had to go to the doctor!

MJ: From what I understand the ice landscape is now being worked out technically.

energy is no longer delivered, then the sculpture, or the artwork, disappears. So it was this kind of dependence that intrigued us. We thought of both the snowman and the ice landscape. First we had the idea of transporting ice from a glacier in a big

refrigerator. But it was technically impossible to transport ice and store it in front of the factory. We were still coming from the idea of "the bull."

MJ: Well you did that with the snowman instead.

118

Peter Fischli and **David Weiss**, early prototype experiment for *Ice Landscape*, integral artwork for Römerbrücke District Power Station, Saarbrücken.

F&W: We were told that the ice landscape needed too much energy to operate properly, that two houses or more could be heated with the amount of energy that would be required. For the utility managers it was also a matter of responsibility. If the power authorities always preached, ''Don't use too much energy,'' and then did something like this, it would be very bad for them. Instead, the project has been assigned to some engineers at the university, and they are trying to find a solution that will use less energy. The problem is also that no one has ever done something like this before. The theories are very far apart. Some say it just needs four degrees below zero to stop the ice from growing, which would not use very much energy. Other people say it must be much colder in there.

MJ: How big would the piece be?

F&W: That is also a problem. We want it to be very, very big—500 square feet. At minimum it should be something like a deep space, and really dark like a vision of a flat landscape and not much happening. Just ice and endless dark. You would look at it from the short end, not like a store window. Much more deep than wide. With some light in it so that you can see—artificial light. We think that the Saarbrücken power plant is a very important place for our society.

MJ: So you do have some very strong ideas about public art. This is very different from a gallery exhibition.

F&W: These projects, when we take them on, are a comment on the place where they are to be installed, like the Saarbrücken pieces. When we do an exhibition, it is more a comment on what we are thinking about in a given period of time.

MJ: So part of what makes the public pieces successful is that they add to one's understanding of place.

F&W: Yes. Hopefully one will reflect on the meaning of these places in an unexpected way. We talk a lot about what kind of atmosphere we are working in.

MJ: I feel that there is generally so little contemporary work that is truly defined as ''public,'' that is really saying something new and worthwhile about what the publicness of a particular place is. But I think the snowman and the concept of the ice landscape are perfectly tuned to their environment. What you may be getting at here is a thoroughly contemporary definition of the public monument.

Perhaps the success of Saarbrücken is an extension of that kind of thinking because the artists were shown the whole area and they responded to it intelligently. All of you are artists who cared about the issue of public. Some artists would never care about it, and that is OK, too. Yet, those artists should not be making work in public spaces. Educated choices must be made on the basis of appropriateness as well as genius.

F&W: Yes, it is also a matter of how intelligent the comment on the place is.

MJ: Right. You could make a dumb comment, and it would be a dumb work.

F&W: Yes, site specific but dumb!

delimitation of spaces, the vigor of ancient Rome, the geometry of Romanesque, the classical proportions of the Renaissance ... are closer to my concept of architecture ... [they] seem to convey an inestimable richness of experience, handed down ... by past architecture, not, of course, for me to squander as a catalogue of formal models, but to enable me to recognize in them the manifold metamorphosis of a limited body of images and ideas and make it continually new and different."[35]

Retaining the support pylons of the existing structure, Ungers expanded the interior by raising the inner courtyard and adding a floor. Using the basic vocabulary of Greek and Roman building types traditionally associated with bank architecture, Ungers translated porticoes, forums with colonnaded foyers, inner courtyards with second-story peristyles into twenty-four-hour banking porches, teller cubicles and private offices. LeWitt and Richter, meeting with Ungers, developed their contributions in consort with the agreed-upon spirit of the building (what Ungers calls the *genius loci*), its geometric underpinnings and their individual and personal poetics in the realm of the public place.

Both Lewitt and Richter are now wildly popular in Europe and singled out not only by museums and the private collecting population but by the corporate community, often for commissions. Because both artists are master colorists as well as conceptualists, work in large format and are interested in the physical and psychological attributes of architectural space, they have become a first resource for art planners. Their work has positive implications for both curatorially minded and design-oriented professionals. One of the important aspects of the Hypo-Bank Düsseldorf collaboration is that both artists have managed to shift into a new gear. Putting together the right team for commission and collaboration is much like developing a provocative exhibition installation where the juxtapositioning of objects (substitute "people") makes for a meaningful

Bayerische Hypotheken- und Wechsel-Bank, Düsseldorf

An existing 1950's building, surrounded by other banks, shops, offices, hotels and restaurants in the midst of the Königsallee, the prominent Düsseldorf retail block, had been renovated to meet Hypo-Bank's priority: "to stand out from the competition." Architect O.M. Ungers worked in tandem with artists Sol LeWitt and Gerhard Richter to build the branch bank in Düsseldorf. "In Germany up to this point there existed few examples of the successful collaboration of art and architecture. When we asked the architect and the artists to try it together it was an adventure with an uncertain end. The risk

was worth it. These three met each other not only with trust but with tolerance and because of this the work has an edge but at the same time is not discordant."[34]

In a speech accepting the BDA (Bund Deutsche Architekten) grand prize for 1987, Ungers (also a collector of contemporary art) described his reverence for architecture that embodied an essential geometry. It is no surprise that he was able to work with Richter and LeWitt so effectively: "I don't look for some kind of esthetic content but concentrate on an elementary formal language," he said. "The clarity and unambiguity of geometrical forms, the definite presence of simple volumes and bodies, the limpid

conversation, asks new questions, stimulates fresh ideas and finds a new context. The intelligence of the team effort cannot be overstressed.

In recent years Richter has been employing real mirrors in his work, a practice he has carried to a sublime resolution at Hypo-Bank Düsseldorf. As if in anticipation of this move, critic Anna Tilroe wrote in her catalogue essay on Richter's "18 Oktober" series for the show at the Museum Boymans-van Beuningen, Rotterdam, in 1989: "the subject matter is generalized in Richter's familiar fashion: unfocusedness, glassiness, in combination with close-up or blow-up. Again, like a curtain with varying degrees of transparency, paint and brushstroke hang in front of the representation, creating distance in time and space."[36] In his colored glass and mirrored panel installation for the twenty-four-hour banking vestibule, Richter has re-examined in a new material the issues he addressed in the wry blend of Pop and Minimalism in his *Farbtafeln* (paint color chart blow-ups) of the 1960's. A mirror, like a photo, reflects the given image, creating distance in time and space.[37]

Two views of the square inner courtyard of the Hypo-Bank, Düsseldorf branch. Above: the glass-domed atrium with reflections of the mosaic floor below by **Sol LeWitt** entitled *Wall Drawing #356 A*, 1990–91, an isometric cube composed of alternating black and white marble bands. Below: LeWitt's floor and, through the columns at the back of the inner courtyard, **Gerhard Richter**'s wall of rectangular mirrored panes, 1990–91. In 1990–91, LeWitt also designed a four-part mural in gray and black paint on the ceiling of the main hall of the bank (not shown).

"I'd rather my man
should hit me,
than for him
to jump-up
and quit me."

Is a joke girl-friend

To get help call: 415-864-4555 San Francisco Domestic Violence Consortium

Liz Claiborne, Inc., New York
Under the auspices of Wendy Banks, Senior Vice-President, Marketing, Liz Claiborne, Inc. initiated *Women's Work*, a public art program interlocking the private and public sectors and the visual arts. Claiborne had been searching for a cause-related marketing campaign topic that would have a social function as well as be legitimately tied to the product the company manufactured—clothing for the working woman. Well beyond the object in the workplace, this national program involving women artists, community agencies and their target audiences was to give Claiborne an opportunity to gain a competitive edge in corporate arts patronage. With the ambitious goal of exposing through contemporary art "social issues affecting American women and their families," the pilot launch for 1991–92 involved literacy in Chicago, domestic violence in San Francisco and urban land reclamation in Atlanta (see pp. 131–32). The cities selected were major retail markets for Claiborne and the focus of each project was determined

through research and feedback from respective community constituents.

It is no mean feat that a corporation has been able persuasively to combine an array of agendas in one neat package. Much has been said about the pressure brought to bear on corporations to come to the aid of their communities; praise has been lavished on Claiborne for its creative efforts to benefit the victims of violence, the decay of cities, the erosion of the environment and the effects on the family of mothers in the workforce. One aspect of the equation, less underscored but equally important, is the function of the serious artist in the development of a better world. As a cultural signifier, the artist's role has often been cited. Here, at long last, the artist has the opportunity to be a significant conduit of contribution, a

productive member of the cultural infrastructure. Not as a graphic designer, a social activist or a media consultant, but as an independent visual commentator and interpreter, the artist may be employed directly by a corporate client to interact without censorship in the cause of social progress.

The Liz Claiborne, Inc. San Francisco Domestic Violence Campaign was unveiled in September 1992. After complex networking by Claiborne in the San Francisco public sector and its community at large, it became evident that violence in its many insidious guises was Public Enemy Number One.[38] Claiborne launched a month-long public awareness campaign that addressed the issue through blitz billboard and transit-stop advertising in about two hundred

locations throughout San Francisco and Oakland. Six women artists (one working in partnership with a man) who employ photography as a visual medium were commissioned to generate images for the project. Beforehand, the artists were asked to meet with victims of domestic violence and various support agencies. Ranging from the internationally acclaimed New York artists Barbara Kruger and Carrie Mae Weems to the San Francisco-based Asian American Diane Tani and artist-team Margaret Crane and Jon Winet to the well-known photojournalist Susan Meiselas, all the participants were suited to respond to the program's concept.

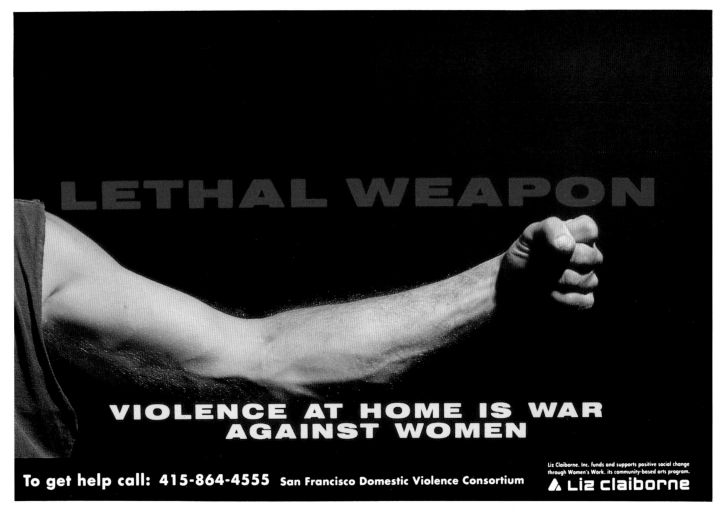

Does a program such as this, where there is a clear connection with the marketing of a product, represent a conflict of interest between culture and commodity? Wendy Banks refers to the endeavor as cause-related marketing and Claiborne's marketing division is the underwriter anticipating a return. "Obviously this can come back to us in a very positive way because it is the women, the educated women, the consumer of better ready-to-wear we would be exposed to. These women are intelligent, thinking human beings and they will respond to an intelligent, worthy program."[39] The more cynical school of artists, critics and scholars refers to the privatization of culture as an extreme conflict of interest and insidious manipulation of the mind.[40] There are certainly innumerable persuasive arguments and examples of the crass use of culture by international conglomerates, which reached a nadir in the 1980's. Through the examples cited in this book, I would argue that the future bodes well for the merging of the visual arts and a business policy of enlightened self-interest (whether through product-related marketing or a good-citizen-of-the-world *mécénat*) as global economic realignments demand new priorities.

An interview with Wendy Banks underscored some of the issues:[41]

Wendy Banks: I would also like to talk to you a little bit about the raising of the consciousness of corporate America. One of the main reasons that we at Liz Claiborne want to do this is that we feel that it is so unique and so right for today's time relative to the lack of funding from the public sector, the lack of funding for women artists, and the prevailing issue of the complexity of women's lives. We are able to encourage changes through art! We will do the road map and we will shame other people into following suit. That is kind of how the "locker room" power happens. *Fortune* 500 companies need to do things like this. Because eventually the old ways will come back to hurt them. If we do not make positive

social change relative to the issue of domestic violence, it is going to hurt the constituency of the work force. If we do not give back to the environment, we are not going to have a place to live. If we do not contribute to the understanding of women's guilt about leaving their children to go to work every morning and helping their children to face their own anxieties, then all of this is eventually going to be a major factor in the demise of American business. Seventy percent of all American women work full-time and they are backbone of a strong corporation.

Marjory Jacobson: I cannot emphasize enough the fact that you are not just going out and getting a bunch of mediocre artists. You are going to the highest possible level. It is not merely a matter of art therapy. If you do not really go to the top rank in the discipline, you do not have an art program, you have a social service program. And that is the difference here.

WB: The reason this program works so well here is that it is totally plugged into the heritage of the company. The market is the women, and the key is giving back to and respecting women. Whether it is in the clothing that they have to wear or in their complex lives of running family, home and job, it is the same issue. There is such synergy because the program is not disparate with the principles of our founding.

MJ: So, the message is that this is not for everyone.

WB: This is not for everyone because it is risky, very loud potentially, and it has a lack of control. Every day I think, what if we don't like this art? What if we say, "Oh my God, and we are putting our name on this!"

One compelling reason that collaborations and cooperation are so important to the future of art and business is their high rate of return in the corporate context compared to conventional acquisition programs. For the most part, the corporate collection per se, for all its good intentions, too often ends up as an accumulation of a few good things and a

preponderance of mediocrity. One is always pandering to the taste of middle ground, and it serves neither artist, business nor culture. There are very few people who, whatever the constraints, can or wish to put together a superior collection of work for a firm that is much more than high decoration. If we have learned anything about the 1980's *vis-à-vis* the arts as we enter the 1990's, we know that, to get the best deal for everyone involved, the scale must tip away from decoration toward discourse. The challenge is to nurture original artistic thought that communicates the intellectual wonder of the creative act without sacrificing its emotional impact.

Transit-stop images by **Diane Tani** (below right and, above, in position) and **Barbara Kruger** (below left) for *Women's Work*, the public art program launched by Liz Claiborne, Inc. in San Francisco, fall 1992.

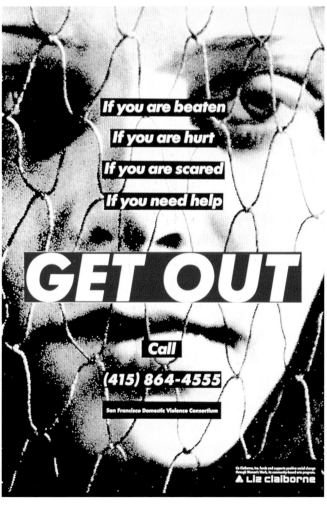

If you are beaten
If you are hurt
If you are scared
If you need help

GET OUT

Call

(415) 864-4555

San Francisco Domestic Violence Consortium

Liz Claiborne, Inc. funds and supports positive social change through Women's Work, its community based arts program.

▲ Liz claiborne

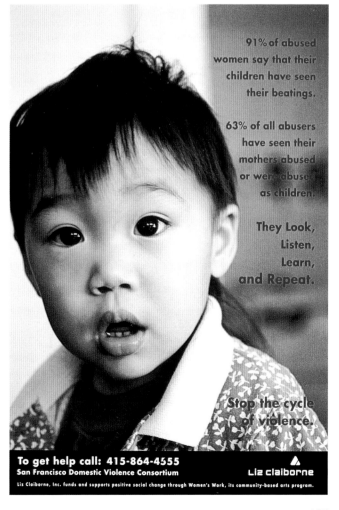

91% of abused women say that their children have seen their beatings.

63% of all abusers have seen their mothers abused or were abused as children.

They Look, Listen, Learn, and Repeat.

Stop the cycle of violence.

To get help call: 415-864-4555
San Francisco Domestic Violence Consortium

▲ Liz claiborne

Liz Claiborne, Inc. funds and supports positive social change through Women's Work, its community-based arts program.

CHAPTER 7
BEYOND THE SCULPTURE GARDENS OF THE TYCOONS
Art Out of Doors

"We are an 'avant' place; we like to be at the front edge of things. I suspect we might have been a little more challenging with the buildings architecturally. Not that they are bad buildings; but they could have been more interesting, which is one of the reasons we wanted to have a sculpture collection in the outside environment."

H. Brewster Atwater, Jr., Chairman of the Board and Chief Executive Officer, General Mills, Inc.[1]

In the business world, the concept of the contemporary sculpture garden has little history. Most classy corporations, because of space and budget limitations, settle for the signature monument at the front door. Because a grand-scale sculpture can't be tucked away at the changing of the guard, it is usually selected safely from the stockpile of well-manicured types, be it work by a famous Modernist like Englishman Henry Moore, Americans Alexander Calder or Louise Nevelson, Frenchman Jean Dubuffet, German Max Bill or Italian Arnoldo Pomodoro. In the urban garden variety, Isamu Noguchi's sunken plaza pool for Chase Manhattan Bank, Wall Street, commissioned in 1963, is a treasured exception.[2] If the budget, or vision, is tight, there are a number of second-, third- and fourth-generation offspring to choose from, and many businesses have taken this academic route.

A small number of corporations, inspired by their rural settings, have assembled collections of large-scale sculpture in the fashion of an outdoor museum or exhibition space. In Japan, where art and leisure have become profitably intertwined, thousands of people spend their free time, and money, at open-air museums in the countryside. Perhaps the best known is the Hakone Open Air Museum owned by the Fujisankei Group, Japan's giant communications conglomerate, where sculptures by accredited masters Rodin, Picasso, Calder, Moore, Ernst and Giacometti, and several hundred less illustrious artists, can be viewed against

the magnificent backdrop of Mount Fuji.[3] In America the most celebrated corporate sculpture park of the beaux-arts type is PepsiCo's in suburban Purchase, New York. As a linkage amenity to a community dubious of the presence of big business, and for cultural ambience, the PepsiCo sculpture collection has proven to be a very good "investment." PepsiCo focuses on a group of internationally established masters like Calder, Dubuffet, Giacometti, David Smith and Louise Nevelson. In the eye of the public, this garden has enormous presence, although there are actually only forty-four works in the entire outdoor collection.

Peering over the horizon, there exists a tiny but select band of visionary capitalists who, either alone or with partners in the public sector, are venturing beyond the traditional sculpture parkscape and searching for new ways to patronize the vanguard artist both as site sculptor and garden maker. A few corporate entities are intrigued by some provocative questions that concern artists exploring the domain of the outdoor environment. How and why should art outdoors relate to its site? Of what value is the artistic transformation of a particular space to the user/viewer's experience of that place? Can a sculpture-like atmosphere be introduced into a landscape without the physical manifestation of the three-dimensional object? How can the monument, the venerated archetype of public art, be returned successfully to the public province?

These questions are posed by documenting the process by which businesses backed four varieties of sculpture gardens. One collection at General Mills in Minneapolis, Minnesota, probes the boundaries between conventional monument, sculpture as edifice and sculptural solutions to issues of direction and access. Another, at Nestlé, SA in Vevey, Switzerland, demonstrates the avant-garde artists' sensitivity to history and context in their commissions for the grounds of this landmark complex on Lake Geneva. A third example of the

neo-garden variety is a visionary garden-as-museum-and-monument conceived for the South Park at Battery Park City in New York. And a plan for urban land reclamation, dubbed an eco-garden in which art, nature and commerce are given a new context, was initiated by Liz Claiborne, Inc. through its *Women's Work* project (see pp. 122–24).

Avant-garde artists have approached the landscape as means and metaphor for coming to terms with modern life. The focus on the art garden today can be traced back to this phenomenon. Particularly in America and England, a movement concerned with earthworks and land sculpture has looked to the natural world as a spiritual and actual medium. The British artists Richard Long and Hamish Fulton have responded to the romantic notion of unspoiled nature in their treks to faraway places. Through text, photographs and organic materials they have translated their experience into contemporary visual language. In America, artists like Robert Smithson, Walter de Maria, Robert Morris and Michael Heizer were, in their early experiments, more concerned with the process of unearthing and reshaping the stuff of primordial nature than in the languid poetics of their English counterparts. As a backlash against the consumerism and impersonality of urban culture of the 1960's and to its visual declaration in the aesthetics of Pop Art and Minimalism, these Americans literally restructured the landscape with vigorous traces of the artist's own presence. The earthworkers reached back to the heroic years of Abstract Expressionism in America when the handmade and the heartfelt were exposed on canvases of gigantic scale. Bulldozers, cranes and dump trucks became surrogates for the gestural abstractions of Jackson Pollock, Franz Kline, Willem de Kooning and Clyfford Still.

Isamu Noguchi, *Water Garden*, 1963, stone and water, diameter 60 ft (18.3 m), at Chase Manhattan Bank, Chase Manhattan Plaza, New York.

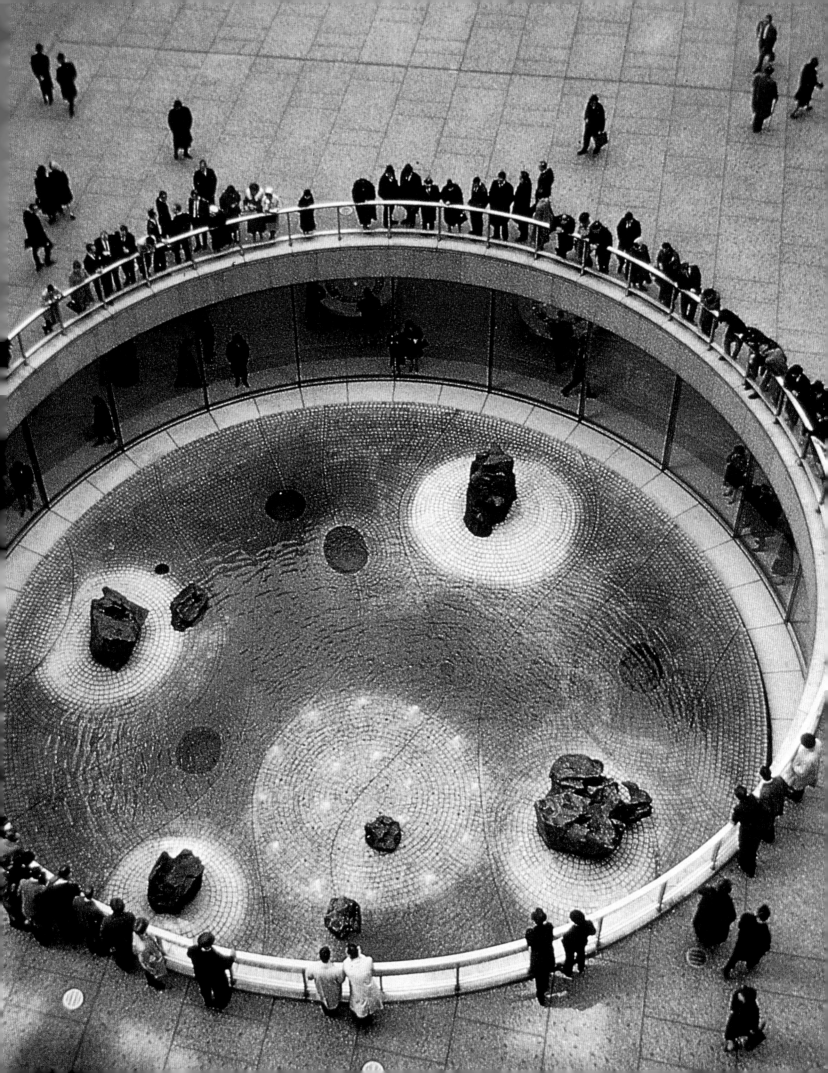

In an ironically personal and original way, the earthwork artists were able to infuse their art with political, philosophical, social and moral imperatives of the period. In protest to art as product, these land artists made their primary interventions in remote landscape settings like Franklin, New Jersey, the Yucatan in Mexico, Great Salt Lake in Utah, the Mojave Desert in California, and Virgin River in Mesa, Nevada, using documentary photography, maps, films and indigenous materials from those locations as "non-site" descriptions. The heirs of their visions today are artists such as James Turrell and Robert Irwin.

The obsessive metamorphosing of a garden into an artist's environment is perhaps most fully realized by Ian Hamilton Finlay, the Scottish poet and editor who began *Little Sparta*, his twenty-year project in Stonypath, Scotland, in 1966. Finlay's ambition was to re-imagine some of the great gardens of history as a zone where Classical motifs, fragments of text and citations of the machinery of modern warfare seem to cohabit benignly with nature. Finlay may be the first contemporary artist to use garden design as a politic—cultural politic, that is. More than an art of implication, the recreated fragments and emblems of different cultures (mainly Classical, French Revolutionary and contemporary) are surrogates for the actuality of those periods. Finlay plays with their relative meanings at different times: "One must understand that weaponry is not being used in a single sort of sense in my work any more than the nude is used in a single sense in art. I mean, Botticelli's use of the nude is very different from Manet's, and so on. There is this funny thing that people at the moment cannot understand war imagery of any kind as being a part of art, any more than Victorians could understand the nude as being part of art ... Anyway, I've put the weapons into Apollo's hands, for example, as simply being the bow updated, because nobody understands a bow any longer as a weapon of war. The

machine gun, the cannon, they can understand."[4] Temples to Apollo, Jupiter, Baucis and Philemon, stones inscribed with Latin and English texts all dwell alongside aircraft-carrier birdbaths, nuclear sails and *panzer* (tank) turtles amid fruit, vegetables, flowers, plants, sundials and benches, in man-made lakes and ponds. "Art which stops short as art is not enough. I think that definition is important," says Finlay.[5]

The South Garden, Battery Park City, New York
Business, art and community had been in sync at Battery Park City until the prospect of an open space as an artist's garden, namely Jennifer Bartlett's and Alex Cooper's proposal for the southernmost tip of the landfill, became the eye of a festering storm. Since its unveiling in 1987, Battery Park City (see pp. 100–1) itself had continued to garner glowing press reports and a favorable reception in the art world, with the influential *New York Times* architecture critic Paul Goldberger leading the bandwagon. In his first major piece on the development project for *The New York Times* in May, 1988, Goldberger pronounced that "the success of this urban landfill was a miracle of both public and private sector collaboration. The system by which this complex has been made recognizes that the private sector is where the money is, but it also recognizes that the public sector is supposed to be where the vision is."[6] The "system" was a powerful intermingling of corporate and civic interests subscribing to a mutually beneficial network of checks and balances.

Battery Park City Authority (BPCA) had strongly backed the public art program and advanced stringent design guidelines earmarked for the public good. "The sense in all of these situations ... is that however much the city's planners may set limits on what real-estate developers can do, it is still the developers who call the tune, since it is their dollars, and not the public's that are creating the public space the city needs and wants. But

at Battery Park City the opposite is true. The BPCA calls the shots. BPCA channels the dollars from private development into public benefits."[7] When things went awry with the South Garden, it was the hue and cry of conciliatory politics and negative public opinion that eclipsed its merit and brought the artwork down.

At Battery Park City's southern tip, a former helipad for Wall Street financiers, the developers planned a 3½-acre public open space adjacent to the Battery itself. Since work began in 1982, the landfill project had already garnered unanimous praise for its utopian blending of the most advanced art with model urban planning and commerce (see pp. 100–1). In keeping with that adventurous spirit, the BPCA Fine Arts Committee selected, after invitational interviews, artist Jennifer Bartlett to make a public artwork in the form of a garden.[8] It was to be community-user oriented, and hopefully an enticing tourist attraction. At the same time, the planners envisioned the garden as an added inducement for private developers to seek out the untapped potential of southernmost edge of the landfill. The garden would also partly pay for itself; to cover maintenance costs, leasing the pavilions for private functions and other events seemed viable. Problems of funding, safety, lighting, feasibility and practicality were being addressed, if not solved, all along the way.

The BPCA Fine Arts Committee was one of the most stellar assemblages of visionary thinkers and doers in American architecture, planning, development, criticism, history and collecting. As the *cognoscenti* of current art thinking, they were familiar with the artists they interviewed and the various prevailing views on visual and public issues. They were well aware that Bartlett was not a horticulturist or a landscape architect. They preferred that her experience with gardens was no more, or less, than that of a multimedia artist who used the motif in a series of paintings, drawings, prints and assemblages to develop a system for narration, exploration and improvisation.

Plan, Phase Four. South Park and Esplanade, a design
for the South Garden, Battery Park City, New York, by
Jennifer Bartlett, **Alexander Cooper**, of Cooper,
Robertson & Partners, and **Nicholas Quennell**, of
Quennell, Rothschild Associates, 1989–90.

Model for The South Garden, Battery Park City, New
York, designed by **Jennifer Bartlett**, **Alexander Cooper**,
of Cooper, Robertson & Partners, and **Nicholas
Quennell**, of Quennell, Rothschild Associates, 1989–90.

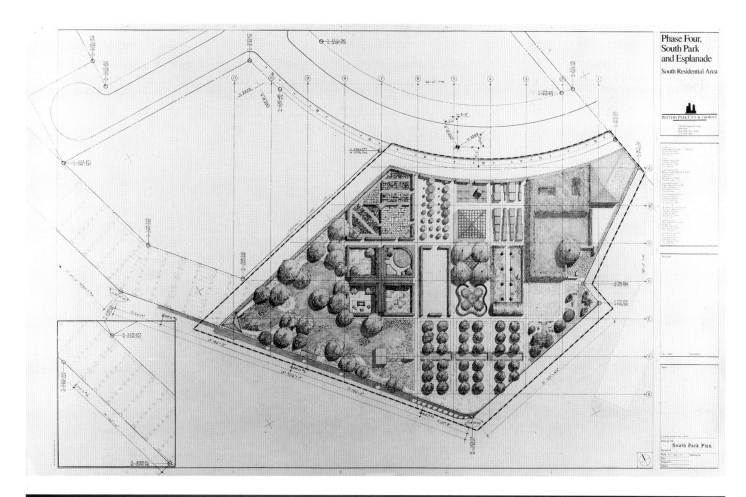

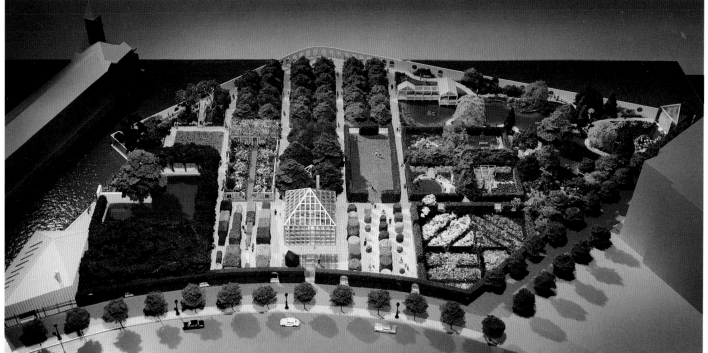

It was a matter of record that Bartlett's signature garden imagery (for her *In the Garden* series) had been taken initially from nature in the tradition of the revered Barbizons and Impressionists—specifically from a view out the window of a French villa she lived in near Nice.[9]

Bartlett's original scheme for the BPCA showed a grid of 50-square-foot garden fields, courts, pavilions and structural elements with themes like fragrance, orchard, color (red, yellow, pink and blue plantings), water play, rose, hedge, ziggurat, maze, beach, fragile, cone, herb, fountain, topiary living room, lily pond and even a secret garden. Alex Cooper called it more a building than a garden, and the BPCA imagined it as a place both for viewers and users. Bartlett saw the garden as a "museum or theater with the lid off."

When Bartlett said: "I have designed a garden not knowing the difference between a rhododendron and a tulip," the landscape architecture community winced. Bartlett was underscoring the art aspect of her project; with no pretense to particular horticultural or architectural knowledge, she was deferring to the architects and landscape experts for the professional know-how to make her garden grow and flourish. Her work had to do with the language of art and not, as her critics had amply pointed out, with the field of horticulture.

An amended version was produced (1989–90) with the welcome expertise of Nicholas Quennell, the new lead landscape architect. When the new proposal was unveiled, Paul Goldberger was able to distill the issue, but unable to still the waters: "the South Garden can be justified only if it is seen as both a piece of public open space and a piece of public art at the same time. If it will not please everyone—some people will surely find the idea of any garden designed by an artist objectionable—no one can deny that the most troubling aspects of the original scheme have been reworked, and modified in the spirit of compromise. So there is no reason not to go ahead at this point."[10]

Bartlett, Cooper and Quennell were all satisfied with the revisions as well. Bartlett especially thought that the new plan was better—more simplified, stronger. But, in retrospect, it was already too late.

What with Bartlett's boldness, the death in 1987 of Victor Ganz, Chairman of the BPCA Fine Arts Committee and linchpin of its Commission, the more conciliatory stance of the new BPCA President and Chief Executive Officer David Emil (after two previous progressive régimes under Richard Kahn, then Meyer Frucher) and a public mood of recessionary despondency, Governor Cuomo canceled Bartlett's garden in October 1991. New York, sliding deeper into the doldrums of its urban plight, was in no mood to listen to an artist preaching that her piece, budgeted at $10 million and with an annual maintenance cost of $400,000, was a museum without a lid, a serious garden that promised a new and exciting experience.

Ironically, Bartlett was reciting the standard humanist dogma in garden planning and offering a public amenity of imagination and wonder: "Open spaces do not always feel open," she said. "Framed views are what I am after … dramatic views. That tradition is dead in landscape architecture, the framed view. I want a serious garden, not one more piece of public sculpture." She had planned to use a host of garden conceits like lawn chairs, greenhouses, water features and bushes shaped like living room furnishings. "It is an incredibly windy spot. No one would go down there between late October and June. But it is right on the water. There were a number of things that I wanted. I wanted a walled garden (with many openings in the surface) for the protection of the plant material and for organizational reasons. I wanted people to be going someplace. I wanted to have one entrance. I wanted to make this three and one-half acre space seem as enormous as I possibly could." Cries of "elitism" greeted the plan, and Bartlett responded: "The garden is open to the public, but the most bitter criticism is that it is elitist. Why?

Because there is only one entrance. Five-hundred people at any given time can go in." And she even introduced the topic of public art and ethics. "This garden will be as influenced by maintenance as by the artist. The City has a responsibility to uphold the work of art."[11]

Later in 1991, after the demise of the Bartlett garden, the BPCA announced alternative plans for the plot. The new team experienced in the design of open spaces included the Boston-based architectural firm of Machado & Silvetti, landscape architects Hanna/Olin from Philadelphia and horticulturist Lynden B. Miller of Manhattan. Absent from the mix was an artist, an omission that the previous design team found puzzling. "The choice of an artist as part of the original design group was something I inherited from a previous administration," said David Emil, reversing the gains of a decade of progressive urban art and architecture planning. "In reviewing our needs, we now felt an architect and landscape architect was most appropriate. That is not to say we won't add an artist later, but initially we wanted a team that had thought a lot about designing open, urban spaces and would give us a powerful plan, one that would work within the context of the park system."[12]

Should Bartlett's plan have been built? In its revised configuration, it met the basic criteria imposed by the commission and the BPCA Fine Arts Advisory Committee standards for public art. It was an artist's environment of such special and unique stature as to do the high level of the entire Battery Park City public art scheme proud. The concept raised the stakes for art in the public domain and likely went too far beyond the established borders of art thinking and the garden. It was a vision ahead of its time, and the role of the artist as public space designer was too radical to be absorbed. This is a case where the commercial developers of Battery Park City missed an opportunity to exercise their authority to promote a world-class collaboration between art and business.

The Atlanta Garden Project, Atlanta, Georgia

The Atlanta Garden Project in Atlanta, Georgia, is another artist's garden in the making. In kindred spirit with the inspiration for the South Garden at Battery Park City, the source of the vision here is also the imagination of the artist rather than the client. While Bartlett's Battery Park City garden scheme was soul-mated with the idea of art as monument—no matter how far it strayed from tradition—the Atlanta Garden is literally art as public place. Initiated in theory by Liz Claiborne, Inc. through the latter's *Women's Work* project, the idea of developing an eco-garden concept was conceived by the participating artist/architect team of Meg Webster and Phil Parker. The commission for the garden plan came to Webster and Parker, by invitation and not competition, from Claiborne as one of its pilot case studies in a high-profile cause-related marketing initiative. Claiborne's *Women's Work: Public Art for Social Change*, an experimental cycle of individual projects involving the corporation, artists and other private- and public-sector partners, is discussed in Chapter 6 (pp. 122–23).

In the Atlanta Garden Project it was the impetus of a corporate sponsor toward a public partner, and not the other way around, that may again reverse the power-politics equation. Paul Goldberger lauded Battery Park City Authority for placing aesthetic demands on businesses who wanted to participate in the new community development. And this time it was a corporation that, through the visual arts, called the shots and initiated the process of interesting other businesses and the city in setting new priorities for urban life.

One problematic aspect of city living that had beset the Atlanta civic groups interviewed by Claiborne's art project management team was how creatively to restyle urban open spaces. When urban land reclamation was settled on as the social priority, Webster and Parker were recommended for the task by Claiborne's

art advisors. After several excursions around Atlanta, the artist team chose to develop four sites concentrated in the Bedford-Pine neighborhood on the periphery of downtown Atlanta. Two public agencies—the Bureau of Parks and the Atlanta Housing Authority—and a private developer, Gibralter Land, Inc., controlled the locales, which together totalled about $6\frac{1}{2}$ acres. It was very important to the artist-team that the area surrounding those locations was widely mixed economically, ethnically and culturally. The full range of amenities in the neighborhood included a science museum, a civic center, a shopping mall, an elementary school, a middle-class residential area and housing for the elderly.

With the assistance of many local partners—government, non-profit groups and horticultural associations—the Atlanta Garden complex has a reasonable chance, at the very least, to argue successfully for innovative urban land reclamation usage.[13] The Atlanta Garden Project is in a sense an artist's laboratory where many aspects of landscape and garden theory and practice are explored aesthetically in combination with science, business and social theories. The common cause is the improvement of the quality of urban life. Perhaps the most challenging position for the art gardenmakers is the philosophy that art can impact tangibly on inner-city problems. Another major aspect of the project is its practical implications. As an educational enterprise, it functions like a botanical museum, where users and visitors can study different species, learn growing processes and experience many different types of open urban space. Classes in horticulture, agriculture and environmental land use are proposed as integral components. As an environment-conscious concept, state-of-the-art fertilizing methods and the selection of ecologically based soil maintenance plantings have been incorporated into the plan. Various possibilities for self-support through the sale of nursery and farm products were also explored.

Parker explained the parameters of the project: "In thinking about the parks and open spaces in this city [Atlanta], and more generally about parks all over America," he said, "they appear to demonstrate two very different uses and spaces typically associated with leisure. One is the park as playfield and court for physical recreation. The other is the open pastoral landscape, which we tend to look at but don't have a great need or desire to enter—like Renaissance Park [in Atlanta] currently, which is seen but not touched. Some like Central Park in New York and Piedmont Park in Atlanta combine these traits; as open spaces they are often places for tremendous public gatherings and have areas for specified uses. Even in these complex parks the various uses are spatially segregated. Our Atlanta Garden project interweaves our different understandings of the ground when it is formed in the farm, garden, park and city. Its uses and spaces are designed to elicit the possibilities in overlooked connections among these very different senses of the ground. The densities of use and material are important. We are bringing the diverse functions and concepts of the ground into one another. We are making a social space where recreational, productive, pastoral and urban impulses intersect."[14]

Complicated in its networking arrangement with city government, non-profit groups and the horticultural and agricultural communities, the Atlanta Garden Project has ambitions to serve the community on a number of levels. Webster and Parker started with a conception of a city garden that would satisfy relevant urban concerns and probe further the issues of their individual work. Asked to describe how their collaboration was better than if either had worked alone, Parker said: "Some of the issues we share have to do with questions of symbolic and formal conditions of an object in art and architecture, also the environment in the natural sense as well as its social meanings. We have each been involved in projects that attempt to bring

other uses into the city. The collaboration is an intensive negotiation, a drawing out of the other's attitudes. Individually, with a singular voice, we and the work would not have been able to do this."[15]

Meg Webster explained what the artist specifically brought to the Atlanta Garden Project. "The idea is that we are making a working garden and a landscape that are both sculpturally and architecturally intriguing—in the way that the land itself rises and falls and the ways your relationship to the earth is established.[16] Your feelings for the ground and your experience with the ground are hopefully significant beyond the fact that it is just a garden. But, the art is also the material and space of the garden as well as the whole community's working of the garden. It is not someone else's place. It is a public working place where the community can experience and create many ways of inhabiting and cultivating their urban ground."[17]

When she was interviewed in 1988 for the BiNATIONAL, an exchange exhibition featuring the work of artists from Germany and America which took place both in Boston and Düsseldorf, Webster expressed her ideas about art, nature and a better quality of urban life: "I'm very interested in care. You can go into a grubby garbage heap, clean it up, take care of things, and you see it change. That's amazing. And I don't mean care in that suburban sense of neat lawns ... So you make something beautiful out of mud. You can take a few sticks and tie them together, and you've got something." She was also incubating a plan which would take tangible form when the opportunity for the Atlanta Garden Project came along: "I'd like to make large forms in the earth. I want to work with some moving water. I'd like to make a stream—pump water and let it run down a bank, creating its own erosion patterns. Then I might come back and shape it a little bit and add rocks, but let the water do the work. And then maybe plant it. I've thought of something like that for downtown Manhattan—I'd study the natural

planting around a stream in a wood, then recreate that place, the feeling of the place, in an urban environment."[18]

Claiborne, after two years of involvement in seeding and start-up negotiations with Atlanta-based agencies and underwriters through its art advisory team, withdrew from the project. The issues raised here regarding the manner of the corporation's withdrawal and the underlying matter of the responsibility of a business toward so public an art project beyond its own bottom-line marketing strategies are serious considerations for any business wishing to undertake patronage of this dimension. The official explanation, given by a spokesperson for the company, was that the artists' timeline did not fit into the company's marketing plan. Claiborne was confident that it had fulfilled its obligation to fund the initial plan. The artists maintain that it was clear from the beginning that Claiborne's commitment and responsibility were not limited to providing money for planning but also included the cost of construction and the operation of the first phase (the Housing Authority site). That was the way its sponsorship as a marketing strategy would make a public relations impact. It seems that a serious change in the focus and direction of the *Women's Work* project occurred[19] and the company decided to redirect its financial and philosophical support. While working diligently on their masterplan, creating impressive models of their somewhat utopian ideal that was applauded by both the Atlanta partners and the art experts who saw them, meeting frequently with many Atlanta organizations and community neighbors to put their plans in motion, these artists were guided only by the art advisory firm and did not have primary access to their patron nor even a binding contract. Again, it is not a question of assigning blame, but of developing professional procedural guidelines to avoid misunderstandings in a newly emerging field. The artists' views were not adequately represented in the sponsor's analysis of the question whether

Renaissance Park Site, an architect's model for the Atlanta Garden Project, Atlanta, Georgia, 1992. The concept of the Renaissance Park site is that of formal gardening. Long rows of raised biodynamic beds produce rich organic soil for growing vegetables, flowers and grains. A dramatic terrace garden room is planted with herbs and edible flowering plants. A hedgerow bisects the site, providing an important habitat and food plants for birds and insects. A bog garden, a spiral earthwork called *Ulysses* planted with indigenous shrubs and flowers, a fragrant cottage garden and a gardener's house complete the site.

or not continue funding the project, and the artists were not fully aware of the implications of the company's change of plans until they were abruptly instructed to cease work.

The process of building the garden with other backing in time for the Atlanta Olympics in 1995 continues. The sheer determination of the artists and the unique quality of the scheme have attracted a new set of supporters and the process of its realization continues in an effort to bring art and nature into a new dynamic relationship.

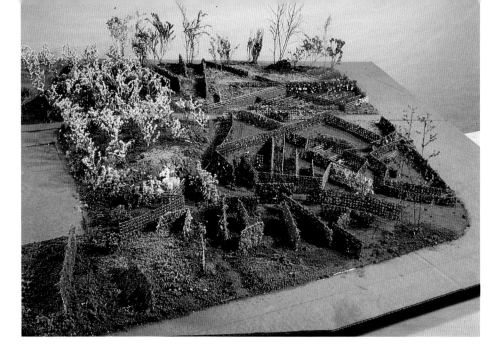

Bedford-Pine Park Site, an architect's model for the Atlanta Garden Project, Atlanta, Georgia, 1992. Across the street at the corner of the Bedford-Pine Park, a maze-like vertical garden is created. Many planted rooms provide space for neighborhood growing of fruits, vegetables and flowers. Varieties of vining crop vines and flowering plants are grown from multi-height fences. Space for sitting and meeting are intertwined with growing places. An orchard and cutting cottage garden are joined by the running trail and small
> basketball court.

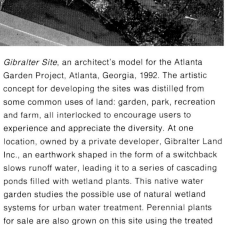

Gibralter Site, an architect's model for the Atlanta Garden Project, Atlanta, Georgia, 1992. The artistic concept for developing the sites was distilled from some common uses of land: garden, park, recreation and farm, all interlocked to encourage users to experience and appreciate the diversity. At one location, owned by a private developer, Gibralter Land Inc., an earthwork shaped in the form of a switchback slows runoff water, leading it to a series of cascading ponds filled with wetland plants. This native water garden studies the possible use of natural wetland systems for urban water treatment. Perennial plants for sale are also grown on this site using the treated water for irrigation. A running trail linking all the sites allows circulation around these features.

Housing Site, an architect's model for the Atlanta Garden Project, Atlanta, Georgia, 1992. The site, owned by the Atlanta Housing Authority and the first one in the project to be developed, will include community garden plots, flower gardens, stands of native trees, an orchard, a long waterwork and series of long ponds, a trellised kitchen and a picnic space. The garden's library and the gardener's office will also be located here.

General Mills Sculpture Garden, Minneapolis, Minnesota

The star attraction of the General Mills art program is the aspiring sculpture collection folded into the campus-like grounds of the company's Minneapolis General Offices (MGO) on the outskirts of Minneapolis, Minnesota. The facility was designed in 1958 by Skidmore, Owings and Merrill and several additions were made as the company grew. The sculpture park, a direct descendant of the "outdoor gallery" type, can now be seen as a stage in the evolution of a new species—the environmental museum. In response to a period of particularly strong developments in the incubation of new breeds of outdoor sculpture, General Mills (America's second-largest producer of cereals and other foods) became an institute for exploring some of the more progressive models in environmental art. These sculpture types are now in the mainstream and most of the artists selected are recognized practitioners. As an appropriate leader in the business-and-art mode, General Mills lends important accreditation to placemaking sculpture as a viable stance for corporate patronage.

The 1980's were a particularly fortuitous time for General Mills to become involved with sculpture. Its corporate art collection had grown to more than 1,500 works, about one third of which are installed throughout the public spaces, mainly indoors. Like most good contemporary corporate art holdings, the collection is a broad depiction of contemporary artmaking in process. Many prominent international artists are represented and there is a liberal inclusion of the best artists from the Minnesota area.

However, the master feat for General Mills was building a sculpture garden that represents not only a progressive stance but an historic contribution to the field of visual culture at a time when environmental sculpture was becoming established as a major facet of the medium's growth. Five years into his position as curator at General Mills, Donald McNeil had become especially

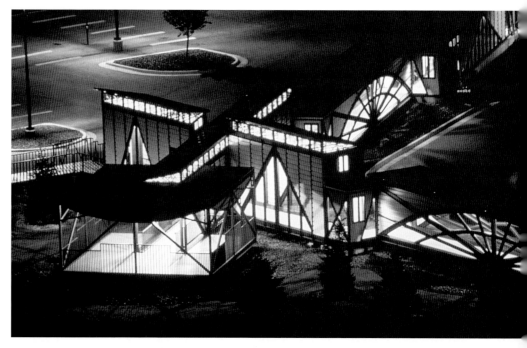

Siah Armajani, *Covered Walkway*, 1989, 700 ft (213.4 m), at General Mills, Minneapolis, Minnesota. The passageway, constructed of a series of offset modular units made of steel, sheet metal, glass and wood, functions as a thoroughfare between the parking lot and the main buildings.

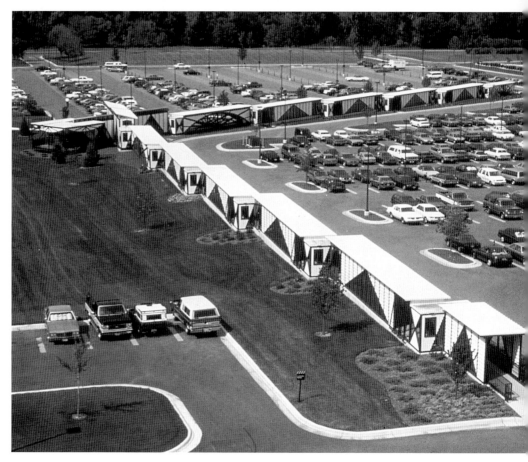

interested in the site-specific approach endorsed by a group of sculptors, and was in a strong position to begin an effective campaign for the grounds art program. In 1982, landscape architect William Rutherford, who had developed an overall plan for a sculpture park at Storm King, began working on a masterplan for General Mills' 85-acre landscape. Soon thereafter, plans for a new highway radically affected the approach to and the orientation of the corporation's buildings. Previously only glimpsed from the road, the company's headquarters could now be seen from the highway; this visibility became a critical aspect of the governing scheme. Part of the cost of the sculpture program was supplemented by land compensation monies from the government, and a generously funded masterplan for landfills, landscaping and outdoor sculpture became a means of improving the site and surroundings and of incorporating the outdoor environment into the overall profile of the company.

The landscaped grounds have become a unique corporate logo for General Mills. Perhaps more than any other image, Jonathan Borofsky's *Man with Briefcase* (1987) came to symbolize for General Mills the *Sturm und Drang* that can occur when art enters the corporate combat zone. First the women in the company protested that the idea of male dominance was personified in the piece as a representation of corporate life, and eventually the men voiced objections to what they perceived as a perverse mimicry of the whole concept of male chauvinism. In fact, Borofsky had begun using the theme of man with briefcase as a portrait of himself carrying his drawings to work (any gallery or museum where he happened to be putting together one of his exhibitions). All Borofsky's output focuses on an emotional and romantic fantasy of his life. He is a modern-day Surrealist whose autobiographical narratives tumble from his unconscious into his art.

Because of the ambiguity of the man/nature juxtaposition implicit in the sculpture, and the loaded cultural content

of the image itself, the staff at General Mills got the point. "It started to percolate in the personnel area," Don McNeil told me. "A lot of people said they did not think we should go ahead with the sculpture. Bruce Atwater [Chairman of the Board and Chief Executive Officer at General Mills] felt we should. I talked to Borofsky a lot about it too. In some real ways it was doing what it was supposed to do. Part of what his work is about is how similar images respond and change in different contexts. Obviously this image in its context has some very significant meaning to a number of people in the corporation. The problem was it was like killing the messenger because you didn't like the message! What is art supposed to do but make us think about and be aware of things like this?" "It also is a wonderful sundial," McNeil added.[20]

In the case of General Mills, the concept of a contemporary art program has been woven fairly seamlessly into the overall corporate culture, without being identified with Atwater or his predecessor, or any other individual. "Whether you like contemporary art or not," Atwater said, "I think people feel good about joining a company that does this kind of thing. Even if they do not like particular works, I think our professional employees are very proud of the art program."[21]

There are many reasons why the General Mills sculpture garden is a notable success story. Yet, without a critical understanding of the process of placemaking by these artists, the project could not have triumphed. Don McNeil, in a masterful understatement, explained why the artists were able to choose their own sites: "I thought I was doing the right thing by saying to them, 'Tell me what you want.'" Very good artists were experimenting with new ways to make their mark on the landscape. Some are hard-headed formalists like Richard Serra and Richard Fleischner, whose perceptual sharpness and spatial envelopments reveal poetic souls. Others, like Siah Armajani and Jackie Ferrara, are master-builders

whose structures are not merely inhabitable but imbued with artistic vision.[22]

With the exception of Richard Serra's *Core* (1987), which was acquired by General Mills and then sited by the artist, all the outdoor sculptures were commissioned specifically for their sites. Fleischner, Armajani and Ferrara have each spent virtually their entire mature careers enlarging the vocabulary of the outdoor site with their place-fixed art. In one guise or another all three owe a debt to Richard Artschwager, who made *Sitting/Stance*, his first public outdoor environment in 1984–88 for the residential quadrant of Battery Park City.[23] No longer on the fringe, Artschwager is respected as an American original. He is the veteran master of the art-as-furniture school who paved the way for the younger generation of placemakers with his historic *Locations* and *BLP's*, and with his fundamental concept of public, the content of all Artschwager's work, what Jean-Christophe Ammann calls "this subversive pact between the intimate and the public." *Oasis*, Artschwager's second outdoor room, measuring 11 by 12 by 20 feet, was commissioned by General Mills and installed in the spring of 1990.[24]

From 1967, when Siah Armajani designed and built his first pedestrian bridges, there was implicit in the work a social or public connotation.[25] *Covered Walkway* (1989) for General Mills is among his few corporate commissions. Here, he transformed the passageway from the employee parking area to the General Mills offices into a magical experience of placemaking at its best.

Overleaf: The campus at General Mills, Minneapolis, Minnesota, with (foreground) **Richard Artschwager's** *Oasis*, 1990, in granite, and (backgound) **Jonathan Borofsky's** *Man with Briefcase*, 1987. The walking path, *The Medusa*, designed by Minneapolis-based artist Philip Larson, is a 5-foot-wide (1.52m) meandering brick trail almost 1 mile (1.6 km) long. The linear element was likened by the artist to the snake-like presence of the Greek mythological character superimposed on the site and allowed to follow the land's existing contours. In another creature-like reference, Larson designed seating areas with benches simulating Medusa's eyes.

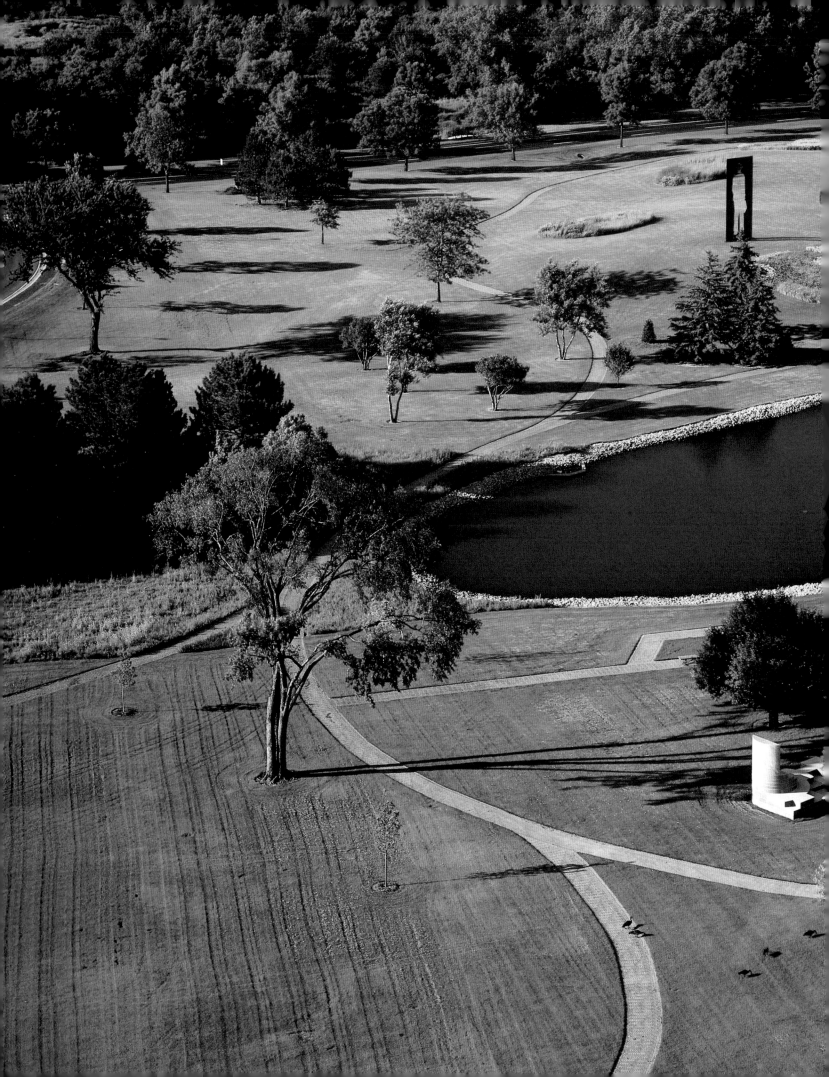

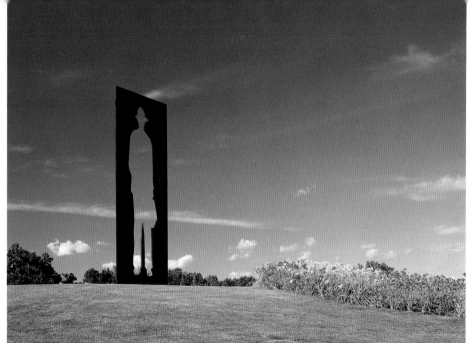

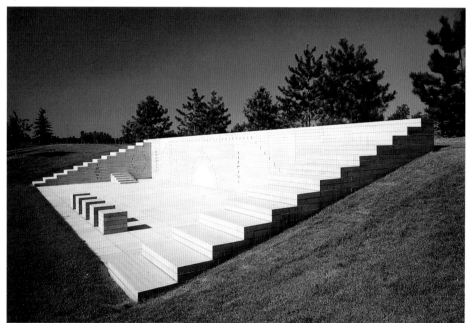

Top: **Jonathan Borofsky**, *Man with Briefcase*, 1987, silhouette image cut out of Cor–ten steel, 30 × 13½ ft (9.1 × 4.1 m), at General Mills, Minneapolis, Minnesota.

Above and below: **Jackie Ferrara**, *Stone Court*, 1988, limestone, 7 × 65 × 24ft (2.1 × 19.8 × 7.3 m), a public gathering place on the General Mills campus, Minneapolis, Minnesota.

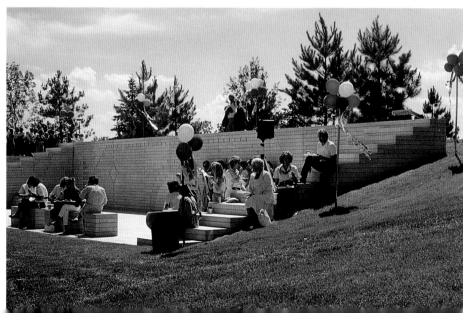

Richard Artschwager, *Oasis*, 1988, granite, 12 × 18 × 11 ft (3.6 × 5.5 × 3.3 m) on the General Mills campus in Minneapolis, Minnesota. The work banters playfully with its surroundings and with the notion of life at the office. Inverting the meaning of "oasis," Artschwager transports the viewer/user from a refuge in the desert to the man-made granite destination in the landscape (or is it a respite from the routine of the job?). Instead of being a relief from the arid desert, the place consists of a granite throned parapet (the seat of power?) whose only organic element is a tree.

Scott Burton, *Public Table*, 1987, cast concrete, base diameter 20 ft × height 28 (6.1 m × 71 cm), top of inverted cone diameter 13 ft (3.9 m), at General Mills, Minneapolis, Minnesota.

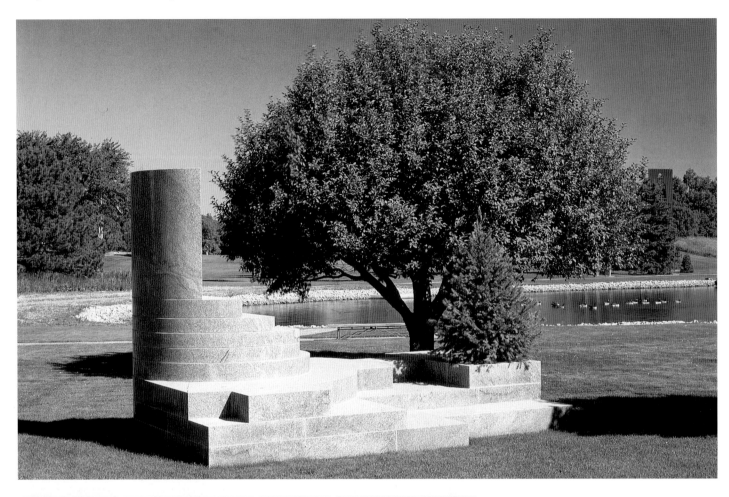

When Jackie Ferrara finished *Stone Court* for General Mills in 1988, she had sculpted for the first time an entire environment for any number of social outdoor activities at the workplace. She had also established a new base for her work, an opportunity to test her theory that art could be monumental and intimate, isolated and socially functional at the same time. Perhaps because *Stone Court*, like her earlier installations in park settings, is not required to negotiate with any surrounding or appended architecture, its resonance within a site the artist chose and helped reconfigure brings it closer to the kind of place/monument that Ferrara strove to build.[26]

The question of public art as social ideology as posed by Scott Burton and Siah Armajani was not the instigating impulse here. Ferrara's instinct was to create a social space for private moments.

As early as 1974 she described her interest in isolation, an attitude that has become antithetical to public placemakers: "My thinking is concerned with sculpture as monument: monument, not in its literal commemorative sense, but more as a pillar, a pyramid, a tower or certain ruins and land formations. A presence exists that, for me, transcends any art style. Certainly hugeness is a common factor, but there is also an isolation that should not be dependent upon sheer size and volume. What interests me is isolation."[27]

In *Stone Court*, Ferrara has succeeded in making a place whose presence elicits the duality of grand monument and private shrine, where introspection and isolation can be experienced as an aspect of social, rather than antisocial, behavior. The artist's choice of indigenous limestone lends the cold stone place a warm, sunny presence, as does the intricate patterning. Facing an artificial pool and wedged into a man-made hill, *Stone Court* beckons the user to taste nature and solitude simultaneously. Even the seating elements reiterate the theme of isolation; five precisely placed square piers, a set of stairs and stepped sides offer a limited number of seats at fixed intervals. Yet the orientation toward the water is the element of enticement. Entering General Mills from the new main accessway, *Stone Court* is in full view; looking out at the site from the building complex, only a 2-foot-high stretch of the back wall is visible.

"I don't think that you end up with 3,000 contemporary art aficionados," said Bruce Atwater in reference to why General Mills has an extensive art program. "I would think that there are quite a few people in this building who would just as soon see a nice landscape with some horses. We had some other comments when we started pushing the dirt around. You know this is prairie land, and the hills you see outside are man-made. The people didn't understand why we were dumping dirt. We had some nice grass and we made hills. The Richard Serra is on a man-made hill and the Jackie

Ferrara terrain was changed somewhat to make the amphitheater. I would say that nobody likes change, but we keep preaching that change is part of the world. We are marketers and we communicate in lots of different ways with our public. I think design excellence is recognized by your average customer. We work hard to make sure that our packages are designed properly. You can see the difference in results you get from good design. There are some reasons in that area to have our employees surrounded with things that challenge their design sense. Then there is the broader issue of challenging a viewpoint. We are in a non-technological business, but we need to continually innovate to be successful. All of our staff, from the research people to the marketing people to the sales people, are very much in tune with what is going on and have the ability to see it from a different view. Art is about getting you to understand that there is more than one viewpoint from which you can see things."[28]

General Mills' policy of arts patronage in general takes into account the fact that the needs of art and culture are not the only problems facing American society today. In 1984 Paul Parker, former Executive Vice-President and Chief Administrative Officer, recapped: "Indeed, I am sure that there are any number of observers and critics who would argue persuasively and forcefully that if American business has any money to give away for worthy causes, it should establish priorities which start with such concerns as education, social services, and civic endeavors. How can we justify the financing of an exhibition of early American painting when money and energies are so desperately needed to help us solve such terrifying problems as mass unemployment of urban youth, teenage pregnancy, soaring crime rates, and inadequate health care. There are surely those who would say that art is undoubtedly something very pleasant, art may indeed be marginally relevant, but art can by no stretch of the imagination be regarded by most of us as a top priority

for private sector philanthropy ... We support the arts in addition to what we do in other areas, not instead of what we do in other areas."[29]

On the questions of seeking professional advice, Paul Parker said: "I submit, sadly but firmly, that if you begin your programs of art support by equating them with public relations, you are well on the road to ruin. One of the safeguards against this insidious influence is to professionalize your own company's corporate art activities ... I suspect that many companies start as we did in the art collection fields—we had a new building that cried out for art and we had a chairman with a legitimate interest and considerable art expertise in providing employees with an attractive and provocative environment ... But because we were new at the game and didn't know any better, we assigned the art curatorial responsibility to an individual whose chief qualification was that he did not have quite enough to do. He was smart enough to realize his limitations and so he gathered around himself a committee of associates whose artistic IQ, even when multiplied by ten, was scarcely sufficient to judge intelligently. I ought to know, I was an early member of this committee. Through the years and almost more by accident than by deliberate action, we did better than we could have expected to do. And then realizing that inevitably our luck would run out, we hired Don McNeil as our full-time curator, and said, in effect, 'Here's your job description and here's your budget. Give us your specific objectives for the year and get cracking.' Don would be the first to deny the fact that he is still subject on occasion to subtle pressure from above, but basically we let him make his own mistakes and judge him as we would any other manager, on the results he achieves. That is the way it is and that is the way it should be."

Nestlé SA, Vevey

After Paul Jolles, the eminent Swiss diplomat and internationally distinguished economist,[30] became chairman of the board of directors of Nestlé SA in 1984, the character of the company's art program began to change perceptibly. For many years Jolles has been a passionate emissary of contemporary art. He is an avid collector and is active at the Kunstmuseum and the Kunsthalle in the city of Bern, where he lives, as well as in several leading contemporary art institutions throughout Switzerland.

While many people associate the name Nestlé with Swiss chocolate, this widely diversified international conglomerate, which began in 1866 as the first condensed milk factory in Europe, also produces foods, pet foods, pharmaceuticals and cosmetics, and recently became involved in a joint marketing venture of breakfast cereal promotion with General Mills. Nestlé had been collecting contemporary art in a typically corporate fashion, modestly and safely, with the decorum more befitting a dowager than a grand dame. Jolles thought Nestlé should begin to fashion a pioneering image that better reflected the company's sweeping global growth. Jolles has been the mastermind behind a remarkable sculpture project and the Fondation Nestlé pour l'Art.

Nestlé's headquarters are located in Vevey, on the shores of Lake Geneva and overlooking the French mountainscape beyond. The main corporate facility is itself a work of art. It is a landmark Modernist-style aluminum building designed in 1959–60 by the Swiss architect Jean Tschumi (1905–62) who was awarded the Reynolds Memorial Prize in 1960 for his creative use of aluminum at Nestlé.[31] One can only applaud Jolles for calling in a committee of recognized authorities to plan the core collection.[32] For all his experience as a collector, Jolles understood the difference between professional curatorship and private collecting. As a businessman, Jolles recognized the value of a committee of

experts in fending off criticism that would surely be levelled at the selections. If they were to be challenging, they were bound to cause some controversy.

Stabile (1963) by the American, Alexander Calder, *Triptych* (1985) by the Spaniard, Eduardo Chillida, and *Troubadours* (1989), a marble piece by the Italian, Luciano Fabro, were among the sculptures directly acquired for Nestlé, and these formed the corollary of the sculpture terrain that was to be choreographed in the commissions. An ensemble by Peter Fischli and David Weiss consisting of plaster figures of women in business suits situated in front of two large glossy photographs of mechanically produced geometric patterns is meant to allude to corporate art as a decorative element in a man's world. The antecedent to the program's whole concept is *Dents du Midi* (1916), a painting by Swiss Modernist Ferdinand Holder, which pictorially relates the Nestlé site to the surrounding mountains and farms, and was acquired for the office of Chairman Helmut Maucher in 1985.

The committee consensus was that the art program at Nestlé take on the challenging task of enveloping city and site through the inquisitive eyes of the chosen artists. The mandate was to form a coherent group, emphasizing the spatial aspect of the site and the diverse origins of the artists whose nationalities would mirror the international character of the company's operations.[33] Between 1989 and 1991, works by the German Ulrich Rückriem, the Dane Per Kirkeby, and the American Ellsworth Kelly were commissioned by Nestlé. Modest in comparison to the sculpture program at General Mills, for example, this plan and the imaginative way in which issues of art and culture are made visible puts Nestlé on the art patronage map of the future.

In the same vein, the Fondation Nestlé pour l'Art, established in 1991 to mark the company's 125th anniversary, promises much with Jolles as its head. The first award went to support the Hospiz project on the Furka mountain pass in

Switzerland where for many years artists have been invited to work *in situ*. Another grant was given to the Medical Hermeneutics, a group of young artists from Moscow, to enable them to render their impressions of Switzerland through art.[34]

At this high level of art discourse, competitions do not usually occur. Artists, clients and art advisors discuss possibilities as peers. Budget constraints, site problems, political or philosophical differences, aesthetic clashes—any number of other obstacles might prevent the actualization of a concept, and red flags appear in one form or another in almost every art process of this nature. The commissioning of art, like any sophisticated negotiation, must involve skilled professionals. A good visual idea, like any imaginative possibility, needs artful nurturing to become reality.

The park on the lake and an area on the streetfront of the Nestlé building were the two locations that most intrigued Ulrich Rückriem, and there he accomplished one of his most daunting feats to date. Consisting of two discrete entities in two separate sites, *Horizontal* and *Vertical* are linked conceptually but not visibly. The works can be said to crystallize the artist's lifelong program of achievement. Ruckriem's art historical contribution lies in the conceptual and physical manner in which he works "on the inside of the volume."[35] The virgin stone is excavated and split according to the artist's plan, chiseled and polished or left untouched and set back together in its original form. "Each sculpture involves one gesture, one act. To make the material larger or to compress it, or to change the way it normally lies in relation to the ground ... People never see how a stonemason really works, how a stone reacts to different kinds of treatment. And I thought it would be interesting to show that."[36]

141

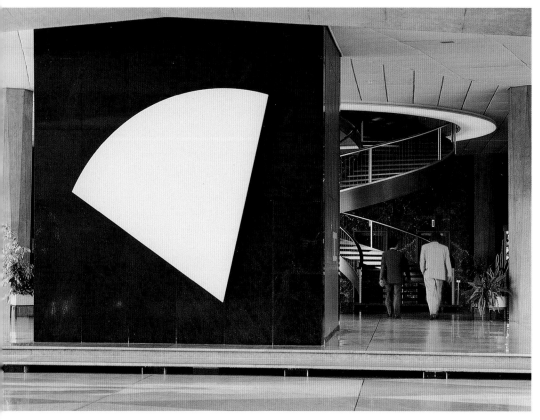

Ellsworth Kelly, *White Curve*, 1991, acrylic enamel on composite materials, 112 × 109 × 2 (284.5 × 276.9 × 5), in the main entrance hall of Nestlé, SA's administration building, Vevey.

has been a client/patron to the artist, making available its own grounds for the performance of radical experiments in visual thinking. "Every time I hear the word 'garden,'" Jennifer Bartlett once told an audience of architects and landscape architects at Harvard, "I break out into a cold sweat and nervous tremors. It is mostly because of working with clients, which is what I guess most of you will have to do at one time or another."[40] Yet, with the encouragement of their corporate sponsors a number of artists have shown innovative capability in the backyards of the landscape architects. To many observers, landscape architecture and design, lagging behind the fine arts, have generally had little success by comparison. Although landscape architects like Peter Walker, Michael van Valkenburgh and George Hargreaves are working either as artists or with artists, their projects do not have the profound nature of those like Fleischner's at Becton Dickinson, Bartlett's for Battery Park City or Meg Webster's with Phil Parker at Atlanta.[41]

Martha Schwartz, a practicing artist who also holds a degree in landscape architecture (see p. 65), put it this way: "I don't think that landscape architecture has ever been involved with modernism … What I do is more of an extension of the ideas in the art world, because I come from the art world. In the time that my ideas were formulating, I was dealing with things way past 'modernism.' The art world has progressed. The people doing the most interesting [work] in the [art] profession are beyond where the earthworks artists are. The next step [for landscape artists] is to get beyond that into manipulation of space. The idea of recreating the picturesque landscapes of another century, by and large, is not tremendously interesting. We all know about what landscape is supposed to be. It's supposed to plug up the space in between the modern buildings. It's supposed to correct all the kind of funky mistakes that are made. It's supposed to be a nice quiet place … It's just not very interesting."[42]

Per Kirkeby is little known for work in the medium of sculpture. Mostly his paintings have been shown, especially in America, and, although he trained as a geologist, Kirkeby is also a filmmaker and author of note. The fact that he turns with ease from one medium to another suggests that all his work has a conceptual origin. The form is not as important as the content. Kirkeby chose to make a work of art, and not a house, on the great south lawn of the Nestlé building facing Lake Geneva. Simply titled *Construction*, the piece was executed at the site in 1991. It consists of five arches, precisely crafted portals in Danish brick, that are enterable, imply shelter and are of human scale. Like Kirkeby's Bremen tower,[37] this piece mediates between function and symbol. The structure rests on a bed of white gravel implanted on the sweeping carpet

of green grass, echoing the glistening aluminum of Tschumi's building. Hovering somewhere between architecture and sculpture, between functional and artful, between craft and art, how does his work define the essence of things? Kirkeby concludes: "Sometimes I think that the only true reality is that which people create in images."[38]

Ellsworth Kelly literally and optically confounds the distinction between painting and sculpture. Kelly's work—abstract, pure, non-objective geometry—has a European ancestry yet yields a truly American sensibility.[39] At Nestlé in 1991, the artist situated *White Curve*, enamel on board in relief, on the side of a polished black marble elevator cube in the entrance hall to the administration building. It is quintessential Kelly.

It comes as something of a surprise to realize that the corporate sector, the bastion of conservatism and a place where the profit incentive all but forbids largess,

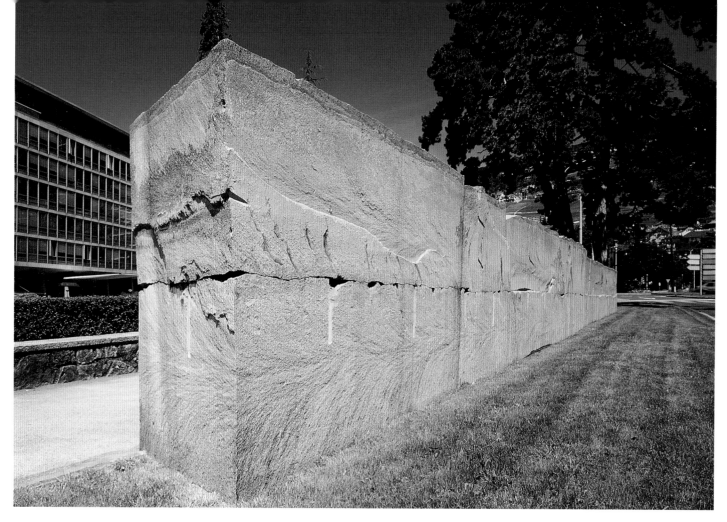

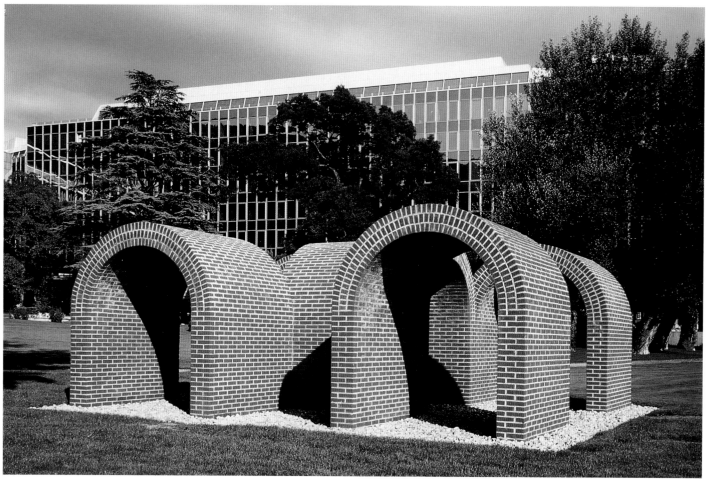

143

CHAPTER 8
NOT JUST ANOTHER CANVAS ON THE WALL
Character and Quality in Art at the Office

Buying art for the office is the most widespread form of art support by business. Typically, art collections in workspaces are there because the company head, managing partner or some senior executive simply likes the idea. The collections discussed in this chapter represent notable achievements. They reflect a range of possibilities where unusual character and quality have been elicited. Art education, when it is formalized, comes in the guise of art catalogues published by the company and not by extensive art-related activities. The primary learning tool is the work itself, and simple identification labels, artwork location guides and occasionally wall texts are the preferred educational supplements.

The businesses described in this chapter are as eclectic as their approaches to art and include a variety of manufacturers, financial service companies and a law firm. From them certain important precepts about art in the workplace can be extracted. The standard of quality they uphold was achieved and maintained within a comfortable rather than conspicuously large budget. It is interesting to note that many of these collections were formed with the help of outside arts professionals, in some cases gallerists, whose skills were always successfully matched with the expertise of designated company staff. When the program was managed from within, a curator was hired for the specific job and not recruited from an unrelated area in the company. Always, in the matter of acquisition selections, the curator reported directly to the company head, or was that individual. In all cases it was clear that art in the workplace, along with

medical and life insurance, had become a coveted cultural company benefit.

Gruppo Max Mara, Reggio Emilia
Whereas the Agnelli and the Rivetti of Turin, the Pecci of Prato and Count Panza of Varese are well known as patrons of contemporary art in Italy, Achille Maramotti of Reggio Emilia has been quietly developing one of the most discerning collections of post-war Italian and current international art in the country. The most recent acquisitions are housed in the Reggio Emilia headquarters of Max Mara, the family business. With the curatorial counsel of Mario Diacono,[2] a highly regarded critic and gallerist, Maramotti is assembling a serious portfolio of artworks that are the contemporary core of his future private regional museum collection of twentieth-century art. Maramotti's concept is to portray the process of new art as it emerges in Italy and internationally with

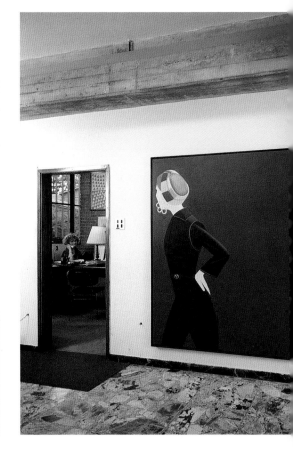

one or two seminal works each by major figures and an in-depth collection of Jannis Kounellis and Enzo Cucchi.

Right: **Georg Baselitz**, *Zwei Frauen im Zimmer (Two Women in a Room)*, 1985, oil on linen, 98 × 98 (249 × 249). Collection: Max Mara.

Below, left to right: **Richmond Burton**, *Vertical Space*, 1989, oil on linen, 96 × 60 (243.8 × 152.4); **David Salle**, *The Mystical Master*, 1989–90, acrylic and oil on canvas, 122 × 96 (310 × 243.8); **Enzo Cucci**, *Untitled*, 1988, oil and iron on canvas, 98½ × 237 (250.2 × 601.9). Collection: Max Mara.

Alex Katz, *Ursula*, 1988, oil on canvas, 72 × 96 (183 × 243.8). Collection: Max Mara.

Ray Smith, *La Pimpinela*, 1988, oil on wood, 96 × 144 (243.8 × 365.8), and (left) **Gerhard Merz**, *Revolutionary/ Classical/Rational/Superior/Aristocratic/Reactionary*, 1988–89, mineral pigment on canvas and wooden frame, 52 × 292 (132 × 741.7). Collection: Max Mara.

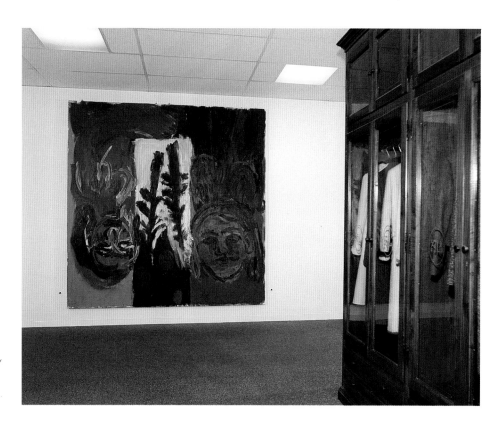

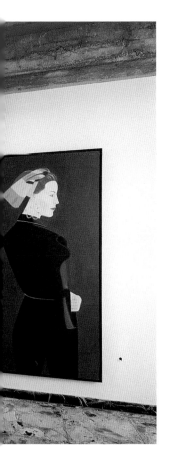

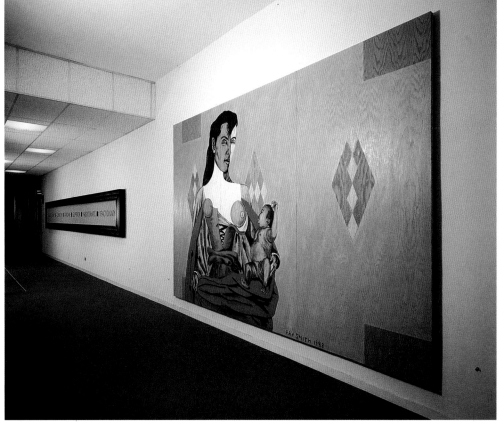

Achille Maramotti is the *pater familias* of Gruppo Max Mara, the Italian designer fashion house. After completing a law degree in 1951, Maramotti became a clothier instead.[3] It was a heady time in Italy for any ambitious entrepreneur as the country was belatedly catapulted into the industrial age and the opportunities offered by mass-production technology. While Italy's avant-garde art community balked at their country's infatuation with style, decor and the aesthetics of commercial design, Maramotti capitalized on the trend by becoming the first Italian impresario to make affordable, fashionable ready-to-wear clothing for the newly career-minded Italian woman.

By the late 1950's, Maramotti, who counted the Milanese artistic avant-garde among his friends, was slowly acquiring some important works of Novecento masters Giorgio Morandi, Giorgio de Chirico, Mario Sironi and Carlo Carra. More presciently, in the 1960's, he was also collecting the work of innovative painters of his own generation like Lucio Fontana, Giulio Paolini, Piero Manzoni, Pino Pascali and even Cy Twombly, the

American expatriate who had settled in Rome.

Much as Maramotti enjoys living with his art at the office, he believes that art in the work environment is an important stimulus to the imagination, especially of the design staff. "We create fashion as a business that is highly attuned to the changes of the times. You are always at a border. You must develop an attitude of getting accustomed to seeing what happens. Art represents the ultimate in this thinking ... With the heavy concentration of creative people here, I have always tried seriously to educate their eye. I expose them to what is new. The physical presence of the art embodies the attitude I want here."[4] The works in Max Mara's headquarters are not compromised in the least by their situation amid wardrobes, fabric cuttings, advertising campaign materials and other normal trappings of the working environment.

Maramotti's office is a comfortable blend of old and new furnishing and decor, and the art changes often. In one view important small sculptures by the Novecento masters Arturo Martini (1889–

1947) and Fausto Melotti (1901–86) representing two stylistic attitudes of the time—the figurative and the abstract—casually coexist with fabric samples on a table. Martini's terracotta *Vittoria Alata (Winged Victory)* (1932) is an historic example from the period in the 1930's when he was the leader of the "Etruscan revival" and realized a series of monumental terracotta sculptures. Although Melotti's *La Casa degli Antenati (The Ancestors' House)* was executed in 1962, when his non-objective work took on a lyrical, kinetic stance, the piece exhibits Melotti's life-long interest in the cultural politics of European avant-garde abstraction that began with his protests against the social realism of the Fascist regime.

In perhaps unconscious yet notable companionship, the paintings on the walls carry on the discourse between the figurative and the geometric. David Bowes and Richmond Burton are young Americans who have made interesting work. Bowes, a native of New England who has lived in Naples, has shown affinities with the Italian branch of the 1980's trans-avantgarde movement. *Fata*

Morgana, an oddly tormented rendition of the legendary Morgan le Fay, sorceress sister and nemesis of King Arthur, provides literary source material for Bowes' intimate exploration. At the other end of the spectrum, Richmond Burton, architecturally trained, manages to probe new formal territory and meaning in his geometric abstraction *Vertical Space*.

Another view of Maramotti's office shows works by Georg Baselitz, Moira Dryer and Philip Taaffe installed above a piece by Sherrie Levine. Taaffe and Levine, both Americans, have been at the forefront of the appropriation movement of the 1980's and have converged at the juncture of architectural decoration, as stressed by the juxtaposition of these two works. Like her mentor Elizabeth Murray, Moira Dryer (1957–92) takes her direction from the painting as construction. Dryer's *Wild One* undulates like a musical composition and evokes a compendium of Modernist to contemporary thought from Man Ray to Yves Klein to Lucio Fontana to Ross Bleckner.

The Reba and Dave Williams Collection at Alliance Capital Management Corporation, L.P., New York

For some visitors to Alliance Capital Management in New York, the Reba and Dave Williams collection may seem, at first glance, an unusual type of office decor, as the black and white prints of which it consists are a dramatic visual experience. To enter Alliance is to step into a unique environment. The office is the repository of over 1,500 original prints from one of the most comprehensive collections of its kind, ranking alongside the holdings of the Metropolitan Museum of Art and Smithsonian Institution in the United States, and the British Museum in London. Far from being pretentious and offputting, the collection adds distinction to the company's image and the atmosphere is informal and inviting. In place of a glossy catalogue, the guide, *ART AT ... Alliance Capital*, though it is a complete catalogue raisonné of the collection, is a modest 100-page Xeroxed list, arranged in a user-friendly fashion, and in viewing sequence corresponding to

location, with brief descriptions of each print. The cover page bears a chatty greeting, belying the intensely academic thrust of the material: "Welcome to the offices of Alliance Capital Management Corporation. You might like to look at the art collection located on our walls. If you would like to view the pictures, follow the guide on the attached pages. You are welcome to enter any office where the door is open."

Alliance Capital Management, an international fund-management firm headquartered in Manhattan, was founded in 1962. In 1977, when Dave H. Williams left PaineWebber to become chairman of Alliance, he brought with him not only his business expertise but a cultivated interest in art, no doubt influenced by Donald Marron's remarkable avocation (see p. 57). Williams and his wife Reba had evolved a scholarly and specialized acquisitions strategy with the specific intention of making the new offices of Alliance the repository of their private purchases. Three quarters of their collection, which alone comprises over 2,500 prints, are

installed in the reception areas, corridors, conference rooms, dining facilities and private offices at Alliance in New York. Parts of the holdings are also shown at Alliance's premises in San Francisco and London.[5]

The original selections concentrated on the best of pre-Second World War American printmaking with a particular focus on work by artists employed by the federal government work relief programs of the 1930's and 1940's, like the Works Progress Administration (WPA). The Williamses started buying in this area when a choice selection was available at affordable prices. In time they expanded to take in printmaking by the Mexican Muralists and their circle, whose period was relevant to the main body of the collection. After the Williamses became more thoroughly conversant in the field, they began to collect color woodcuts from the Provincetown Group, a nucleus of printmakers, many of whom were women, who were active on Cape Cod in the 1920's and 1930's. In order to update their archive so as to obtain a comprehensive overview of all American artists who have made prints up to the

present, they enlarged their scope to include black and white screenprints made after 1960, floral and garden prints that span the century, and other contemporary aspects of the medium.

When Alliance moved its headquarters from lower Manhattan to Avenue of the Americas and 51st Street, the Williamses made the installation of the burgeoning collection a priority of the office design. The goal was to achieve optimal viewing, lighting and conservation conditions within the parameters of a work setting: the wall materials and carpeting were to be neutral in color and texture; the workstations alike, designed to hide desk clutter and form long vistas so that the larger prints could be seen from a distance; and all works were to be framed in welded aluminum so as to minimize distraction from the images.

Williams and his wife originally decided to collect prints rather than other kinds of art not for investment but because they were affordable. "Any investment horizons would be at least ten years. That is not our purpose."[6] By the time the economic incentives of the 1970's had diminished, they were inexorably

A temporary exhibition held in the main reception area at Alliance Capital Management Corporation, New York, fall 1990, of prints by Mexican and American artists of the 1930's-1940's, showing the influence of the Mexicans on their northern neighbors. On the far right, above, is **Jackson Pollock's** *Coal Mine–West Virginia*, 1936, lithograph; far right below, **Blanche Grambs'** *Going into the Mine*, 1937, etching and aquatint; far left, **David Siqueiros'** *Zapata*, 1930, lithograph; third from left, **Diego Rivera's** *Zapata*, 1932, lithograph. Collection of Reba and Dave Williams.

involved. "A large majority of prints in our collection cost in the hundreds of dollars, not thousands. That's because most are by lesser-known artists. Some of the bigger names—George Bellows, Thomas Hart Benton, Charles Sheeler, Reginald Marsh, John Sloan—are multithousand dollar prints but American prints aren't collected worldwide yet."[7] Williams says he was literally inspired by the prospect of all the empty walls he could fill when he changed jobs in 1977, and decided to take the collection in the direction of breadth, to "define an age." Beyond their attraction to the print medium, the Williamses are interested in the scholarly research possibilities available to them in a field that is

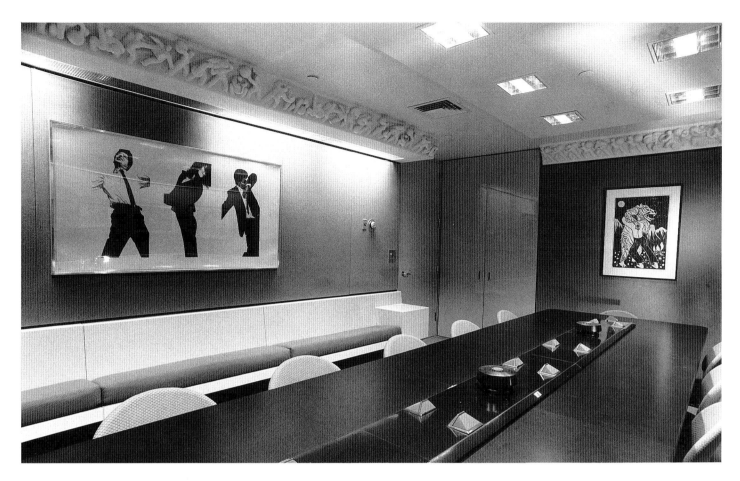

A plaster frieze by **Tom Otterness** commissioned for the teleconference room at Alliance Capital Management Corporation, New York. Other works in the meeting space include (left) **Robert Longo's** *Jules/ Gretchen/Mark*, 1983, lithograph, and (right) **Richard**

Bosman's *Adversaries*, 1982, woodcut. Collection of Reba and Dave Williams.

A typical office artwork installation at Alliance Capital Management Corporation, New York, showing (left, far

distance) **Alex Katz's,** *The Swimmer*, 1974, aquatint, (right) **Philip Guston's** *The Street*, 1970, lithograph, and (on the wall, left foreground) **Adolph Dehn's** *Swinging at the Savoy*, 1941, and *Big Hearted Girls*, 1932. Collection of Reba and Dave Williams.

comparatively uncharted territory to art historians, a natural inclination since they had been doing research as professional security analysts for years. "We've been able to 'rediscover' artists—bring work to light that's been lost for a few decades."[8]

In terms of the number of prints on permanent display, Alliance has become the "largest print museum in the world" and a vital resource for students, scholars and museum print clubs, and anyone interested in the field. The Williamses like to have people come to Alliance to see the collection "because we learn from our visitors ... We have a large number of visitors to the office, looking at the pictures, mostly people who are genuinely interested in prints or art. Some of the artists who made these prints in the 1930's and 40's, like Raphael Soyer and Will Barnett, have come to see them. We've had lots of museum groups, such as from the Museum of Modern Art, the Archives of American Art, the New Museum, the Toledo Museum, the Cleveland Museum, in to see the prints. The Metropolitan Museum has over one million prints in its collection, but typically they have only a few on display at any point in time. There is no such thing as a museum just dedicated to prints that displays a large number of them. So our collection is unique ..."[9]

The works fill 35,000 square feet of wall space on two floors and are a remarkable and specialized visual portrait of American culture as it evolved, artistically, historically and socially, from the late nineteenth century to the present. Among the masterpieces are Winslow Homer's coveted *Eight Bells* (1887), George Bellows' *A Stag at Sharkey's* (1917), Charles Sheeler's *Yachts* (1924), Abraham Walkowitz's *New York Abstraction (City of the Future)* (1926), Jackson Pollock's early *Coal Mine—West Virginia* (c. 1936), Andy Warhol's *"Black" Marilyn* (1967), Harry Sternberg's *Riveter* (1935), Jasper Johns' *Target* (1974), Edward Hopper's *American Landscape* (1920), Robert Gwathmey's color screenprint *Rural Home Front* (1942) and *The Lion Gardner House,*

Easthampton (1928) by Childe Hassam.

The art program at Alliance has followed in the American tradition of collecting as a nationalist support endeavor. The Williamses were drawn to American prints not only because of their relative availability, but because "the images are familiar, and evoke positive feelings in us."[10] Dave Williams has organized exhibitions not only to make the collection more public, but as a means of obtaining new business. "We want to be investors in Mexico. And we want to show how much Mexico has given to America in terms of artistic inspiration. Since my wife and I have been interested in the prints of the Mexican Muralists and many are installed on our corporate office walls, we thought it would be a good overture to Mexico to do an exhibition. So we curated 'Mexican Muralists and Prints' at the Spanish Institute as part of New York's citywide celebration in September 1990. We also opened our headquarters as a mini-museum. This concept is just another example of linking commerce and art. The President of Mexico and his wife came to see the show, and it was an introduction to people who are prominent there."[11]

Another exhibition, a selection of black and white screenprints organized partly for business reasons, was sponsored by the United States Embassy, which arranged for it to travel to various museums in Japan, where clients of Alliance were invited to previews and press publicity was considerable. The breadth of knowledge that the Williamses have aquired in the area of the origins and developments of screenprinting (which formed the basis for the show's accompanying catalogue and for previous articles by them in *Print Quarterly,* the scholarly print journal sponsored by the Getty Museum) is an example of active cultural entrepreneurship. If the Williamses had not been the experts they are, they would have engaged a professional advisor. Their business and curatorial expertise are the ideal combination for enlightened self-interest in business and art.

Fried, Frank, Harris, Shriver & Jacobson, New York

Another American business that has distinguished itself as a notable collector of prints is Fried, Frank, Harris, Shriver & Jacobson, a prominent New York law practice. When the firm moved to new headquarters in 1979, there was already a base collection of some of the best prints of the time. Arthur Fleischer, Chairman of the Art Committee and a known print collector, hired the New York art dealers Paula Cooper and Brooke Alexander as consultants. "Few people would have the audacity to use dealers as advisors," says Fleischer, "but I had so much confidence in them ... and I knew that most of what we would acquire would be prints and works on paper."[12] It is true, however, that a great many collections put together by dealers are hopelessly parochial largely because dealers (and many art advisors as well) are motivated primarily by the impulse to sell. Cooper and Alexander, like Mario Diacono (see p. 144) and Marian Goodman (see p. 156), are distinguished as gallerists in that they bring a curatorial and intellectual as much as a commercial approach to building a collection.

Fried, Frank had established a clearly defined acquisitions program, which was also flexible enough to change as the collection grew and as the practice expanded to premises in Washington, DC and Los Angeles.[13] As is normally the case, the art budget was related originally to the move to new headquarters in 1981. Ten years later, Fleischer commented: "Remember, the eighties were very good years. I just do not think the firm should allocate money for art when the financial situation in the world is so difficult." But, by that time, he had become an avid private collector, to the distinct benefit of the office environment, because he had to respond to the changing economic climate: "However, I continue to acquire with my own money and hang the works in the firm."[14] The artwork in the New York office generally represents the 1980's in their most classical and cerebral guise,

Robert Longo, *Edmund*, 1985, lithograph, 68 × 39 (172.7 × 99), an installation at Fried, Frank, Harris, Shriver & Jacobson, Washington, DC.

Matt Mullican, *Untitled (14, 19, 21, 22, 23, 32, 48)*, 1983, gouache on paper, each 25 × 19 (63.5 × 48.3), an installation at Fried, Frank, Harris, Shriver & Jacobson, Los Angeles.

when the Minimalists of the 1970's and their Formalist-oriented successors, well represented by Paula Cooper in sculpture, painting and drawing, and by Brooke Alexander in prints, were widely admired and encouraged.

One of the most impressive aspects of the Fried, Frank, New York collection is the focus on print series and portfolios. "I happen to think that this is a brilliant space for a corporate art collection. First, the halls are wider than usual. Second, the use of secretarial clusters provides an unobstructed view down the halls. You are not subjected to the clutter you may see in an ordinary office. I believe that this is a case where financial and aesthetic considerations coincide. The opportunity to examine so many portfolios is quite extraordinary. You see the artists' works in the way they were intended; you understand better and enjoy what the artists are doing."[15]

The Washington office focuses more on sculpture, sculptural objects and sculptors' drawings, and prints by artists who have worked in the environment. Acquisitions of the late 1980's reflect the shift of younger artists' interests to social and public issues. Examples include Robert Cumming, Lothar Baumgarten, Louise Lawler and Rosemarie Trockel. The subject matter that intrigued this new generation of artmakers provoked some challenging dilemmas for many businesses collecting art, including Fried, Frank. In this case, Fleischer chose his battleground: "You consciously edit out certain things that you obviously wouldn't have in the office ... You are not going to have explicit political statements. You are not going to have nudes. We had a Robert Longo drawing and people thought it was too harsh. It is about the urban nightmare. I thought that if I had it next to my office that was one thing. Why should I assault another partner with it? I changed that idea when I went into PaineWebber and Donald Marron had a Longo hanging in his reception area. I said that if an investment banking firm can do that, my firm can do it too. I think

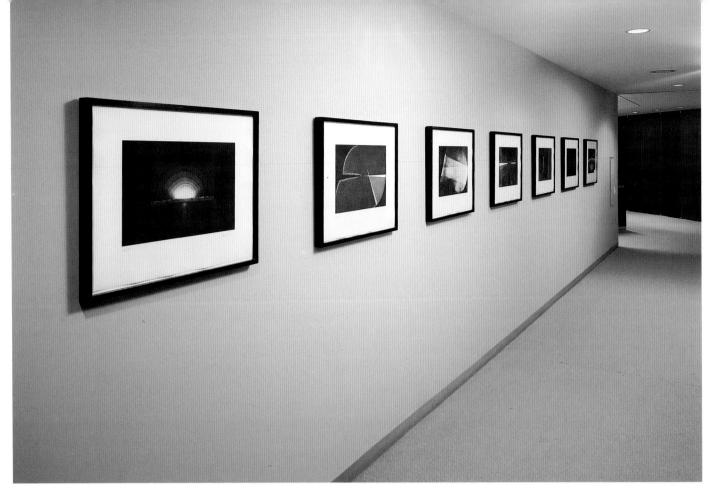

we are strong enough to be able to handle it." Another situation involved an educational approach: "We have a John Ahearn sculpture in Washington. It became very controversial, because certain attorneys thought it was demeaning to African Americans. They thought that the piece had a tinge of stereotyping. We gathered a lot of information about Ahearn, who, as you know, works in the South Bronx and uses his neighbors as models. When this material was circulated people developed a completely different attitude. Indeed, we bought another

Ahearn and the two works now hang together. I believe that the racial concerns that people expressed have disappeared. The works are now seen by most as studies of individuals. I am sensitive to these kinds of issues and I would probably act if I was told that I had stepped over the line. On the other hand, when I receive complaints like 'That's certainly not a Vermeer," we have a different kind of statement. Those remarks are made by people who are not going to respond to an environment like this and their views will not affect the collection.[16]

In their sensitivity to office politics, manners and mores, Fleischer's remarks are typical of those of most executives in charge of smaller businesses and partnerships. But he has managed to instill in his firm's environment an extremely sophisticated collection that maintains high standards and a respectful relationship with its inter-office community, without resorting to the foibles of consensus pandering. Anyone who has ever worked in a law firm knows what an achievement that is.

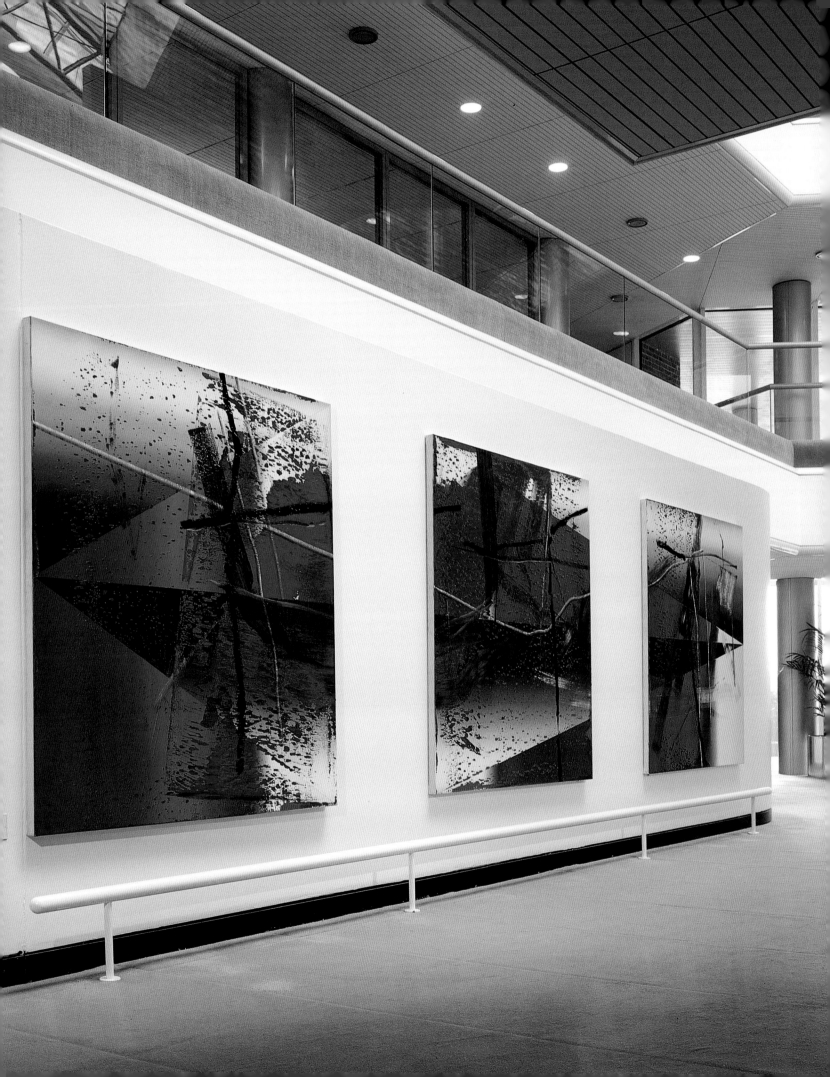

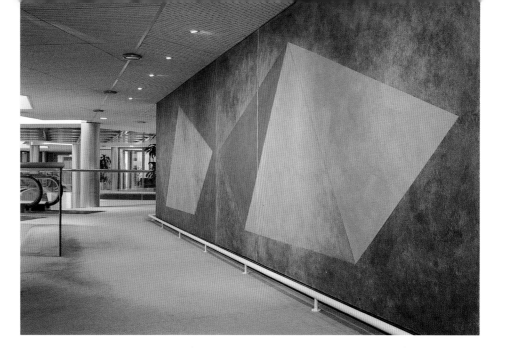

The BOC Group, Windlesham, Surrey

The cover of the 1987 issue of the *BOC Group Management Magazine* featured wall murals by the American artist Sol LeWitt that had just been installed at the company's new headquarters on the outskirts of London. The lead article was entitled "Gaining the Competitive Advantage." Twenty-seven top executives from BOC's worldwide operations had convened to debate the problem of developing competitive differentials in multinational companies. "There is enormous pressure both to squeeze costs continuously and raise standards," they were told by E. Kirby Warren, a world authority on strategic thinking from Columbia Business School. "This leads to many different organizational conflicts that can only be resolved by ensuring that different views and solutions are known and objectively examined." Warren is an exponent of "contention management," the theory that contest is better than consensus when dealing with important strategic issues. "Seek different inputs," he argued. "Manage conflicts; they may contain the keys to success."[17] Obviously, no one could prove that a cutting-edge rather than a consensus-derived art program could singlehandedly solve the problem, but it was hard not to make the assumption that the cover and the cover story had something pertinent in common.

From Aruba to Zimbabwe and in over forty countries between, the BOC Group has become one of the world's largest providers of gases for myriad applications in the fields of electronics and food, and in the environmental, chemical, steel, research and medical industries. BOC also owns companies that supply products and services for hospital and home care.

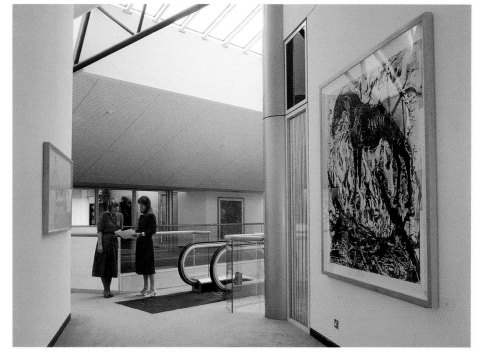

Opposite: **Gerhard Richter**, commission for the BOC Group.

Top right: **Sol LeWitt**, *Wall Drawing #451*, 1985, color ink wash, two walls each 92 × 360 (230 × 900), double two-part drawings on two walls of a room. Commission for the BOC Group.

Anselm Kiefer, commission for the BOC Group.

Gilbert and George and **Ger van Elk**, commissions for the BOC Group.

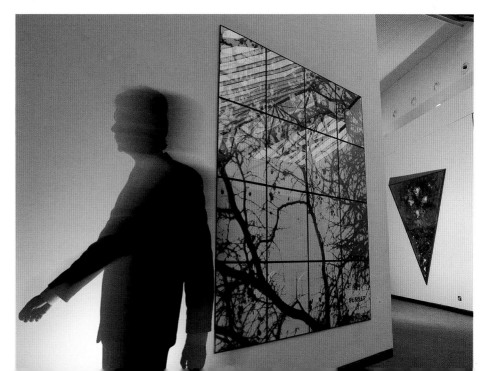

During the course of the 1980's, BOC's profits soared, and in 1985 the company moved to new headquarters on a 50-acre rural site in Surrey. It had hired as architects the GMW Partnership to build a low-level, sprawling building consisting of a central hub with radiating wings whose curved glass walls and skylights opened up the interior to vistas of the surrounding countryside. Only ten of the fifty acres were developed. The remaining land has been preserved as a natural park and two new lakes were built to attract wildlife.

Comfortable as the architecture is, the real adventure of the building is the art. The BOC project is one of the few important contemporary collections curated entirely by a dealer of note. It is commonly known that, in such instances where there is no private advisor, most selections of art for the office involve a dealer coaching the wings. BOC's two-hundred-piece collection was chosen by the American gallerist Marian Goodman, founder of Multiples and the Marian Goodman Gallery, who began her career in 1965 as one of the seminal figures in contemporary print publishing in America. Since then, she has been identified with many of the progressive art idioms as they have emerged. One of Goodman's continuing strengths is that she always maintained a business relationship with each elder generation she showed as she simultaneously focused discerningly on the next wave of practitioners appearing on the scene.[18]

When Goodman was asked to assemble the BOC collection, she had established, in addition to the American stable of the 1960's and 1970's with whom she had worked, an international following including Tony Cragg, Art & Language, Gerhard Richter, Ger van Elk, Giulio Paolini, Richard Deacon, Giuseppe Penone, Richard Long and Lothar Baumgarten. She has acquired for BOC some major pieces by these artists. Outdoor commissions by the prominent English sculptors Tony Cragg and Richard Deacon, and the Italian Giuseppe Penone are among these artists' best achievements. Sol LeWitt and Gerhard Richter made large murals in the main reception hub. Although LeWitt's and Richter's contributions here are more predictable (in terms of the artists' own development) by comparison to other commissions they have undertaken, the paintings are classical examples of their mature production and look quite dazzling in this context. (Another project executed by these two artists for Hypo-Bank Düsseldorf is discussed on p. 120.) Roaming along the corridors and into many of the private offices, the knowledgeable visitor can identify works by many of the best internationally known

Richard Deacon, *When the Land Masses First Appeared*, 1986, wood and steel, 157½ × 295¼ × 255⅞ (400 × 750 × 650). Collection: The BOC Group.

The BOC Group

contemporary artists. For the casual visitor, there is a sense of the company's energy and devotion to the art of our times. There exists here, too, an engaging encounter with the personality of the curator, a kind of retrospective glimpse, as it were, of her full career.

For anyone interested in digging deeper, the sculptures by Tony Cragg and Richard Deacon provide insights into how some important artists are sensitized to contemporary life. Both works, while opposite in visual manifestation, confront the age-old issues of nature and culture from the perspective of the artist in post-industrial society.

Deacon's *When the Land Masses First Appeared* (1986) and Cragg's *Fossils* (1987), handsome and commanding in their own right, are spectacularly situated in BOC's grounds. Although consciously and sensitively placed, neither was commissioned specifically for the site in the manner defined elsewhere in this book (see pp. 134–40). Deacon's piece is abstract. It consists of a spoked basket-like enclosure with a sinuous loop of laminated wood unevenly woven through its rungs. The piece rests directly on the ground in self-reflexive counterpoise to the pergola structure visible across the water. Fragile, elegant, open to the elements yet replete with the implications of enclosure, the work, although fabricated with industrial materials, is in perfect harmony with the lush surrounding countryside.

More familiar in its statue-like demeanor and its use of recognizable though distorted imagery, Cragg's cast iron tubular objects sit, almost conventionally by comparison, on a rough-hewn granite pedestal. Although his earlier work was composed of bits of discarded plastic, Cragg has recently begun to investigate the possibilities of more traditional sculptor's materials— stone, bronze and cast iron—within the framework of their Post-Modern industrial meaning. The BOC piece is a full-bodied visual manifestation of some of the many issues Cragg has spent his career investigating. *Fossils* consists of four cast-iron objects resembling atrophied trumpets, or test tubes and other vessels (as well as human sexual parts) set on a base. Paradoxically imbued with organic (body organs), scientific (laboratory equipment) and pre-industrial (cast bronze) associations, the sculpture, with its cast elements set on a stone pedestal, also appears monumentally Classical.

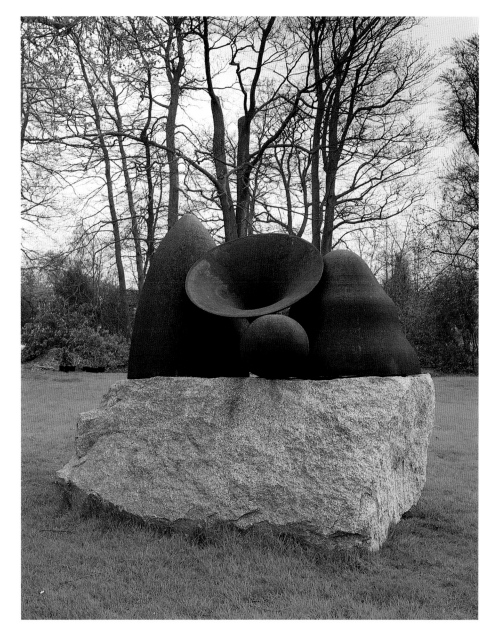

Tony Cragg, *Fossils*, 1987, cast iron on granite plinth. Collection: The BOC Group.

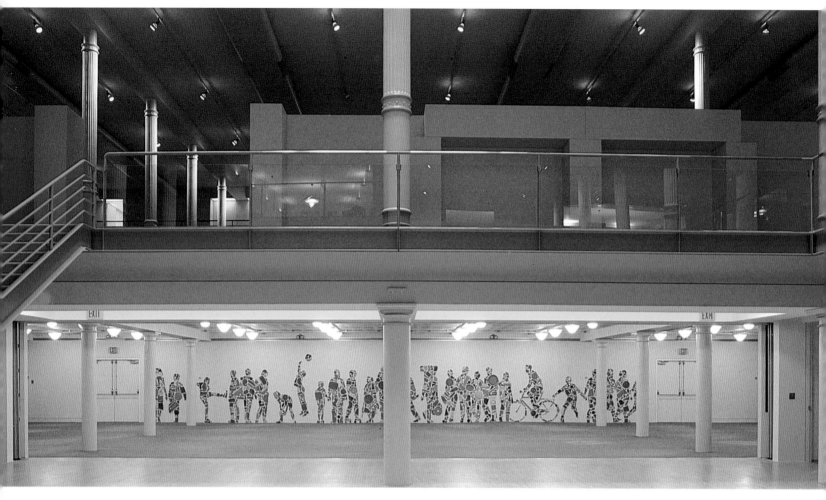

Tony Cragg, *A Day in Central Park*, 1986, found plastic fragments, glued and nailed to wall surface, 7 ft 5 in × 65 ft (2.261 × 19.812 m), one of the highlights of Hasbro, Inc's New York showroom. This monumental mural in the cafeteria is shown here before any furniture was put in place. On his use of plastic as a material for art, Cragg has said: "It's necessary to discriminate carefully because . . . I don't want to glorify plastic. It's an interesting material because it is in many ways so far away from the organic, natural world that it actually underlines very strongly the problem of all man-made substances . . . I don't want nostalgia. I don't want to make an art that sort of sticks, bogged down, hanging onto a natural world that we've lost our grip on anyway. But equally I don't want to make an art which has a horrible futuristic quality about it." (Interview with Lynne Cooke, *Tony Cragg*, Hayward Gallery South Bank Centre, London, Arts Council of Great Britain, 1987, p. 16.) Collection: Hasbro, Inc., New York.

Hasbro, Inc., Pawtucket, Rhode Island, New York, and London

The 1980's were heady times for Hasbro, Inc. The Rhode Island company, a publicly traded family venture known primarily for manufacturing and marketing such toys as the Cabbage Patch Kids, My Little Pony, Hulk Hogan and GI Joe, experienced an enormous growth spurt that took it to the *Fortune* 500 list. With corporate acquisitions and international expansion going hand in hand, Milton Bradley games and puzzles, Playskool toy and baby products and, most recently, Kenner-Parker-Tonka have been added to the conglomerate. Until his untimely death in 1989, Stephen Hassenfeld forged that expansion and shaped the philosophy and the image of Hasbro, Inc. The baton of leadership passed to his younger brother Alan, who has consolidated the company's prevailing vision, and charted his own course for the 1990's.

When the decision was made to expand internationally, the visual arts and design became a central element of the company's identity. Three major projects were conceived by Stephen Hassenfeld: in 1985–86, he moved Hasbro's New York offices and showroom to a 70,000-square-foot two-level space in a landmark cast iron building on 23rd Street in Manhattan. At almost the same time (1986–88), the nineteenth-century textile mill that for forty years had been the home base of Hasbro in Pawtucket, Rhode Island, was undergoing major renovations; and in 1988, Hasbro moved into offices at Stockley Park, near London's Heathrow Airport.

Although several architectural firms were involved, the interior finishes, signage concepts and art components for all the projects were assigned to Sussman/ Prejza, Inc. of Los Angeles, who developed the ambient design, and to Nancy Rosen, an independent consultant who advised Hassenfeld on the art. Lesser-known and well-established artists whose lighthearted, but not lightweight, aesthetic bore out the concept of serious fun predominated in the selections in keeping with the company's product base

The offices of Hasbro, Inc, New York, with (left to right) **Robert Mangold's** *Four Color Frame Painting, # 10D*, 1985, acrylic and pencil on canvas, 9 ft 2 ins × 6 ft 8 ins (279.5 × 203.2) overall, **Richard Artschwager's** *Exclamation Point*, 1980, wood with black latex paint, 27 × 6¼ × 5¼ (68.6 × 15.2), and **Barbara Kruger's** *We Will No Longer Be Seen and Not Heard*, 1985, nine lithographs, each 20½ × 20½ (52 × 52). Collection: Hasbro, Inc., New York.

Jay Coogan, *Prelude to Civilization*, 1987, six elements, painted aluminium, variable dimensions. The sculptor made a menagerie of zany biomorphic figures to inhabit one of the terminal points of a central circulation corridor in the research and development area of Hasbro, Inc., Rhode Island.

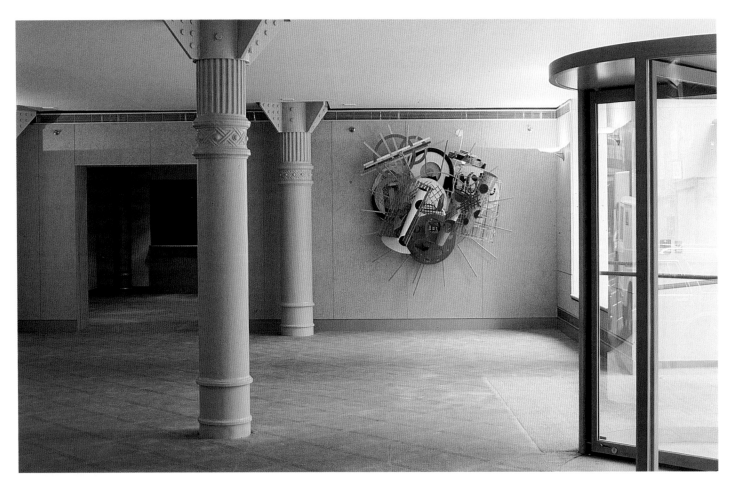

and projected image. As in the great children's classics, *Alice in Wonderland* or *Winnie the Pooh*, there is a challenging subtext to be gleaned from Hasbro's selections. Whether acquired directly or commissioned, the work was chosen in most cases with specific locations in mind. Rosen gathered a number of objects and proposals from a large pool of artists and walked a committee headed by Stephen Hassenfeld (and including his corporate design director and often a facility executive in charge) through an informative selection session. Always aware of the works' formal and contextual relationships both to each other and to the business function of a given area within the company, Rosen guided the process to a winsome end.

When Michael Craig-Martin, Irish-born and a long-time London resident,[19] exhibited in the Projects Room at the Museum of Modern Art in New York in 1991, the critic Roberta Smith described his works as "so sincere and wholesome, it's easy to imagine them on the walls of a school lobby, where they would undoubtedly make children excited about

learning."[20] Three years before, Craig-Martin had already executed a major commission for Hasbro, England at Stockley Park. In many ways, the educational spirit of *Hasbro Bradley Wall Drawing* (1988) typifies the ambitions of the entire collection. Intelligent, conceptually based but ultimately accessible in the most positive sense, the work is fresh and delightfully provocative without talking down to the viewer.

Like Craig-Martin, Nancy Dwyer, a young American artist, also works with "pop" imagery. For her diptych *Over Here; No, Over Here* (1987) at Hasbro, Rhode Island, the artist used twin reception cubicles flanking the drum-shaped auditorium to make a tongue-in-cheek reference to the particular place as well as to direct playful comments at the standardization of office interiors and often of office life itself.

Judy Pfaff, *Full Moon*, 1986, mixed media, 86 × 76 × 31 (218.4 × 193 × 78.7). Collection: Hasbro, Inc., New York.

Nancy Dwyer, *Over Here* and *No, Over Here*, 1987, acrylic on canvas, each 70 × 102 × 3 diameter (177.8 × 259.1 × 7.6). Collection: Hasbro, Inc., Rhode Island.

Michael Craig-Martin, *Hasbro Bradley Wall Drawing*, 1988, three colors, paint on drywall. Everyday objects – books, umbrellas, a light bulb, a bicycle and a table – cavort like mythical creatures from Classical temple reliefs in a frieze-like assemblage across a stark white convex wall. The images are first conceived as simplified line drawings made by hand and are permanently fixed by tracing the outlines on to plastic with architectural drafting tape. After Craig-Martin has accumulated a number of drawings, he finalizes the composition by combining and clustering images, overlapping and transposing them into the desired format, reproducing the piece in slide and projecting it on to a wall. The final artwork is then executed *in situ* with wider architectural tape. Collection: Hasbro, Inc., London.

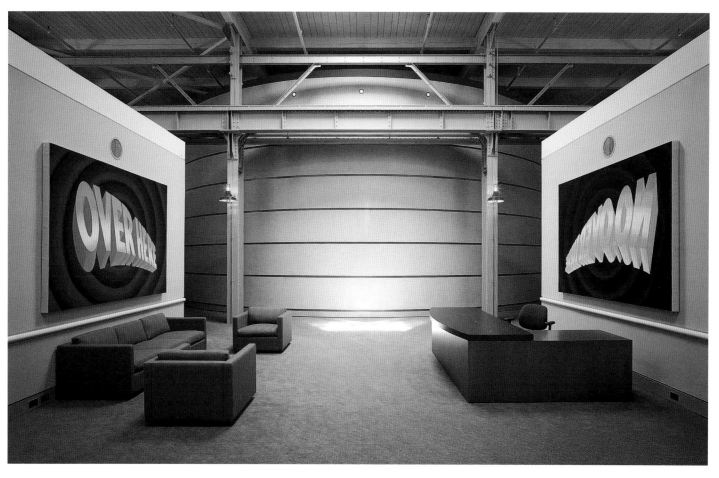

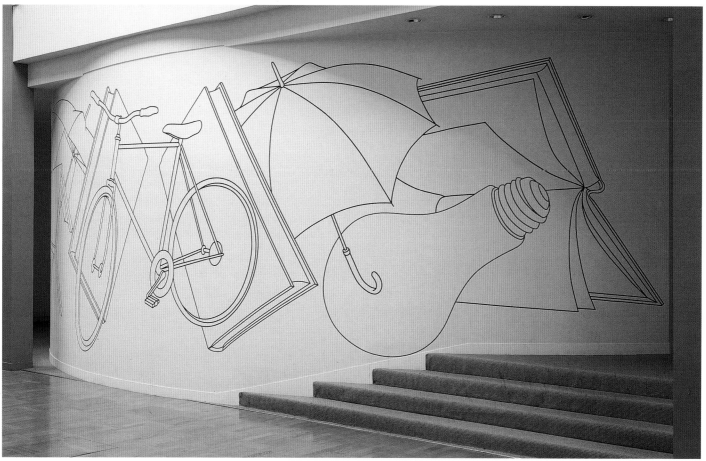

Refco Group Ltd., Chicago and New York

"Risk is everywhere, that's why you need Refco." The advertising campaign of this financial risk management firm appropriates illustrations of works in Refco's contemporary art collection to explicate not only its advertisements but its attitude. Refco Group, Ltd. is an American brokerage operation in futures and options with additional services in the foreign exchange market, securities, equities, precious metals and fund management. Refco's clients include pension funds, banks, insurance companies, commercial enterprises, multinational corporations and sovereign entities. The group's headquarters are in Chicago and New York and there are many smaller offices in other countries.

The force behind Refco's art collecting activities is Frances Dittmer, wife of Thomas Dittmer, Chairman of the Board. She has instituted an extensive and valuable art program at the corporation, sits on the Board of Trustees of the Museum of Contemporary Art in Chicago and is an avid and incisive private collector. Frances Dittmer hired Adam Brooks, a practicing artist, to manage Refco's art affairs, and with the participation of her husband has engaged in an active education program to enable the collection to work both for the company and the community.

Daniel Buren, *Frieze, Situated Work*, 1987, acrylic on 132 sheets of plexiglas, each 3 × 3 ft (.91 × .91 m), installed 8ft 3in × 186 ft × 53ft (2.5 × 57 × 16.1 m) overall, in Refco Group Ltd's New York trading room.

Hans Haacke, *Alcoa: We Can't Wait for Tomorrow*, 1979, mirror-polished aluminum letters on square aluminum tubing, 9 × 192 × 4½ (23 × 487.7 × 11.4). Collection: Refco Group Ltd, New York.

Donald Lipski, *Xalupax*, 1985, mixed media installation, variable dimensions. Collection: Refco Group Ltd, New York.

Business could hold art exhibitions to tell its own story William B. Renner, President, Alcoa

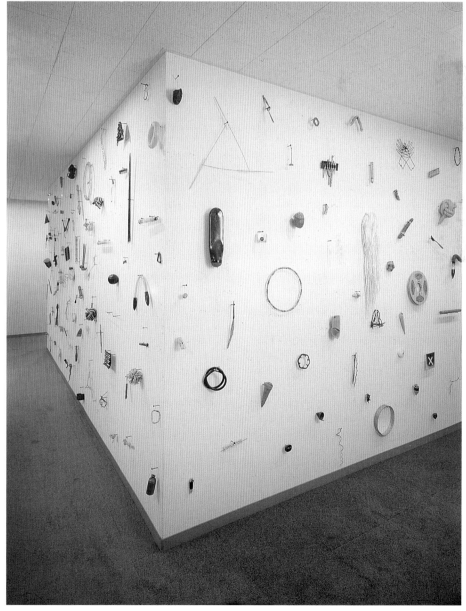

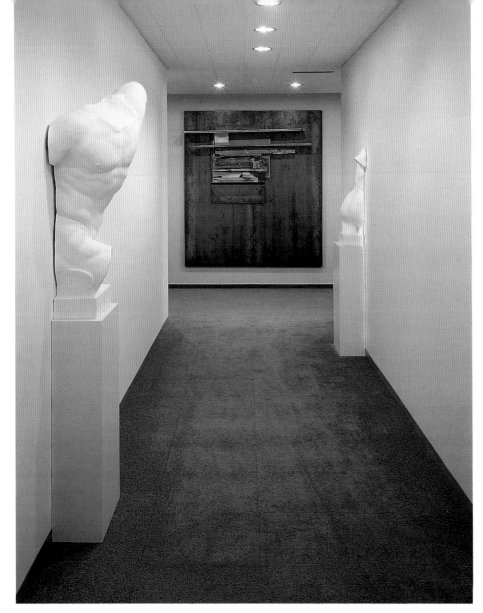

Foreground, **Giulio Paolini**, *Intervallo*, 1974, plaster, two units each 38½ × 21 × 4 (97.8 × 53.3 × 10.2) and, background, **Jannis Kounellis**, *Untitled*, 1987, steel, wood, wax, nails, 70 × 71 (177.8 × 180.3). Collection: Refco Group Ltd, New York.

to the development of international art of the post-1960's are prominently represented, some of whom rarely appear in the annals of American corporate art: Carl Andre, Lothar Baumgarten, Jo Baer, Richard Prince, Marcel Broodthaers, Dan Flavin, Eva Hesse, Philip Guston in his late period, Rebecca Horn, Komar and Melamid, Martin Puryear, Wolfgang Laib, Annette Lemieux, Sherrie Levine, Blinky Palermo, Sigmar Polke, Charles Ray, Haim Steinbach and Juan Usle.

One articulate spokesman for the collection is Phillip Bennett, Refco's Chief Financial Officer, who is based in the New York office. Formerly an employee of Chase Manhattan Bank, Bennett has been with Refco for eighteen years. The 51,000-square-foot New York headquarters opened in 1986. "I have developed a penchant for art that I certainly did not have ten years ago," Bennett said. "For me it has been a tremendously rewarding experience. This is something you do not generally do in your place of work. Normally, when you have a hobby it is extracurricular. I think people are trying to evaluate qualitatively as well as quantavely how they work, the levels of stress associated with that work, how difficult it is to get to and from work, the feeling of the environment while they are at work. And I also feel that people have made a much more conscious decision to trade off the traditional values that were principally monetary, in an effort to achieve some of the more qualitative values. Now, I would suggest that art will find its place in making a qualitative difference to people's decision-making process in the same way that architecture does. And perhaps as we compete for people of quality, I imagine that from a purely practical point of view those things will become more important. If we can believe what we read, then the role of art in the office environment generally may help someone make what is becoming a more qualitative decision about where they want to spend most of their waking hours."[23]

"The way it is done," says Thomas Dittmer, "is that we have groups of people in here all the time. I am actually surprised at how many do come. We have nights for employees when they can bring their families about once or twice a year. We break the crowd down into three or four parties and my wife, Adam [Brooks] and someone else from the Museum of Contemporary Art lead tours. Each time up to a hundred people show up. This is better than advertising in the newspapers. We do not advertise in the conventional sense. We bought the art and we published a catalogue. We consider this part of our education program. We have instructors who teach options trading, etc. and we consider that our advertising. Advertising has always taken the form of education here. Advertising is bringing new customers in and educating them whether it is our own employees, or the art education. We spend only about $50,000 per year on traditional advertising." Thomas Dittmer channeled his interest in capitalism in Russia by visionary means. In another unorthodox example of merging education, advertising and good business sense, Refco sponsored the resuscitation of *Commersant*, a Soviet business weekly published in English by a Russian staff in Moscow.[21] Refco's "risk is everywhere" advertisements have appeared in its pages.

For Refco, 1990 was a watershed year. Hailed as one of the largest futures brokers in the world, the company had expanded to offices in twenty-eight cities in Europe and the United States, and the art collection had become a familiar and prominent workday amenity with over 250 works installed primarily in Chicago and New York. A handsome color-illustrated catalogue of the collection was published; its orientation was toward a more sophisticated art audience of which Refco employees were considered to have become members.[22] Many artists seminal

Eva Hesse, *Sans II*, 1968, polyester resin, 38 × 86 × 6
(96.5 × 218.4 × 15.2). Collection: Refco Group Ltd,
Chicago.

Carl Andre, *Aluminum-Copper Alloy Square*, 1969,
aluminum and copper, 100 units, each $\frac{1}{4} \times 7\frac{7}{8} \times 7\frac{7}{8}$
$(.6 \times 20 \times 20)$; $\frac{1}{4} \times 78\frac{3}{4} \times 78\frac{3}{4}$ $(.6 \times 200 \times 200)$ overall.
Collection: Refco Group Ltd, Chicago.

Matuschka Gruppe, Munich

Matuschka Gruppe, a comparatively small international financial services organization headquartered in Munich, did not have an art program, but Werner Döttinger, one of its former managing partners, is a knowledgeable private collector who made a formidable impact on the workplace as the curator/advisor of the company art activities.

In 1985, Matuschka expanded to a nondescript office structure dating from the 1960's. Instead of building a conventional entrance lobby, Döttinger suggested that Gerhard Merz, a Munich artist who had been steadily attracting critical attention, offer a plan to give the building a distinctive identity. "I showed the building to Gerhard Merz, whose work I have known and valued for years. He does not see his painting as limited to canvas, but rather as a coherent part of the actual space given. He liked the stairwell and was attracted by the idea of producing in it something which museums and galleries cannot normally make possible for an artist."[24] Prompted by the immediate environment of Barer Strasse (where there are historic classical buildings), Merz developed the idea of using his art to make the values of Classicism more recognizable in the present day.

The result is *Tivoli*, a multipart environment which extends through the lobby, up the stairwells and along the landings of four stories. Ascending or descending the staircase is like traversing an architectural elevation in three dimensions, or even a stage set. The walls on every floor have been brushed with a single pigment which, in ascending order, changes from blue to red to gray to yellow. The monochromatic setting provides a theatrical background for a framed canvas on the far wall of each floor. On the first three landings the canvas, like the walls, is a framed field of color, mechanically rendered without evidence of the artist's hand. On each wall the name of the color used appears in the label and "top" of the artwork. At the

uppermost level is a square-framed tondo, a screenprint taken from an old photograph of the waterfalls at Tivoli. Here the word "Tivoli" is affixed to the large wooden frame.

Merz has responded to a given architectural scheme where the prominent design element is the stairwell. In the course of developing the artwork environment, the artist was able to engage in a dialogue with the space, and with the user. An otherwise pedestrian interior was

invigorated with a new range of associations, thoughts and questions: the exchange between a generic abstract notion of the Classical and its understanding by the nineteenth-century German Romantics who so eagerly made their pilgrimages to Tivoli; the paradox of the painterliness of the walls and the framed canvas where there is no evidence of gesture; the provocation of questions on the relevance of art to the working environment.

Gerhard Merz, *Tivoli*, 1985, second floor: *Steingrau*, pigment on wall, $228\frac{3}{8} \times 492\frac{1}{8}$ (580 × 1250) and *Blu Oltremare Scuro*, pigment on canvas, $66\frac{7}{8} \times 145\frac{5}{8}$ (170 × 370).

Gerhard Merz, *Tivoli*, 1985, first floor: *Arancio di Marti*, pigment on wall, $228\frac{3}{8} \times 492\frac{1}{8}$ (580 × 1250) and *Arancio di Cromo*, pigment on canvas, $66\frac{7}{8} \times 145\frac{5}{8}$ (170 × 370).

Gerhard Merz, *Tivoli*, 1985, ground floor: *Blu Oltremare Scuro*, pigment on wall, $228\frac{3}{8} \times 492\frac{1}{8}$ (580 × 1250), and *Giallo di Cadmio Limone*, pigment on canvas, $66\frac{7}{8} \times 145\frac{5}{8}$ (170 × 370).

167

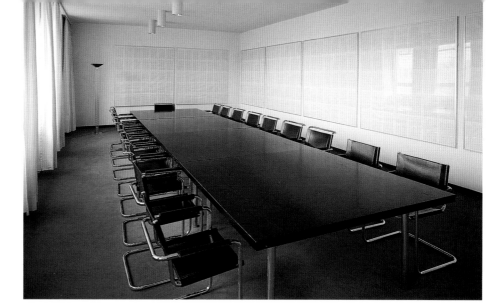

< **Gerhard Merz**, *Tivoli*, 1985, ground floor and stairs to first floor.

Hanne Darboven, *7 Tafeln – keine Worte mehr* (*Seven Panels—No More Words*), 1972–73, pencil on paper, 7 panels of 35 leaves, plus one index of 21 leaves, each leaf 13½ × 9⅞ (34.5 × 25), installed in the boardroom at Matuschka Gruppe, Munich. Collection: Werner Döttinger.

Thomas Ruff, *Portrait (Girl)*, color photograph 79½ × 61⅞ (202 × 157) and *Houses No. 12 II Niederrheinisches Stahlkontor*, color photograph, 67¾ × 108¼ (172 × 275), corridor installation at Matuschka Gruppe, Munich. Collection: Werner Döttinger.

Cy Twombly, *Six Latin Writers and Poets*, 1976, collage, chalk and pencil on paper, each 27⅛ × 34¼ (69 × 87), installed in a small conference room at Matuschka Gruppe, Munich. Collection: Werner Döttinger.

Less dramatic, perhaps, but no less significant is Hanne Darboven's drawing *7 Tafeln—keine Worte mehr* (*Seven Panels— No More Words*, 1972–73) in a main conference room, and Cy Twombly's *Six Latin Writers and Poets* (1976) in another meeting room. Bernd and Hilla Becher and their student Thomas Ruff are represented by signature photographic portraits of buildings and people.[25]

The emphasis in the Matuschka selections is one of contrapuntal rhythms of the mechanically produced and the expressively rendered, of the Classical past and its German Romantic remanifestations and reinterpretations from the nineteenth century to the present. The skillful choice of American and German artists reveals the personality of the selector, the nature of the company, the spirit of the country, and the temper of our times.

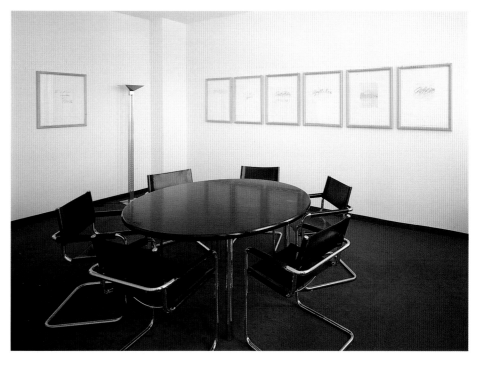

CHAPTER 9
ENTREPRENEURSHIP AND CULTURE
Expanding the Company Benefits Package

"Today more and more corporations are looking for managers with an understanding for the wholeness of the world, managers who are capable of placing the rational system of the business world in a larger context ... From this perspective we believe that art can be of considerable importance for management."

Dr. Thomas W. Bechtler, Vice-Chairman and Chief Executive Officer, Hesta AG, Zug[1]

Some visionaries in the field of management have expanded the concept of art at the office to include the public spaces in and around their buildings. Contributions to the enterprise of culture have taken the form of a kind of specialized stock option not only in terms of the image of goodwill that is ultimately of financial benefit to their investors, but as an immediate advantage to the community at large. Not only the workforce and visitors to their premises, but broader segments of the public have had the opportunity to experience their largess in the form of temporary and permanent art projects.

Hesta, AG, Zug, and Hesta Properties, Charlotte, North Carolina

Hesta, AG, an international network of diversified business holdings headquartered in Zug, Switzerland, is owned by the Bechtler family of Zürich. Hesta comprises Schiesser, Zellweger Uster and Luwa, three companies whose fields of operation include textiles, electronics and industrial engineering.[2] The original enterprise was founded in 1933 as Luwa by the brothers Hans C. and Walter A. Bechtler. As business prospered, the Bechtlers made the visual arts their special field of interest and set an estimable standard of cultural responsibility as an integral aspect of good citizenship. The Bechtlers are known in Switzerland as generous benefactors and important collectors of contemporary art. In the 1950's they each began to assemble collections ranging from classical modern to avant-garde works of their own

generation. Both brothers encouraged the activity of collecting by serving on the committees of many museums and art societies in Zürich. And in their sons they instilled not only a great reverence for the creative process, but the ability to distinguish quality from mediocrity, an awareness of the contemporary cultural imperative of the visual arts, and the business benefits of promoting art at work.

As the next generation succeeded their fathers in the business, Thomas Bechtler, Walter's son, now Vice-Chairman and Chief Executive Officer of Hesta, has assumed the mantle of patron-in-charge and set the cultural tone for the future of the company. Andreas Bechtler, son of Hans, heads up Hesta Properties, Inc., a real estate venture headquartered in Charlotte, North Carolina, where he has implemented an ambitious art program.

Thomas Bechtler, who has been chairman of the Zürich Kunsthaus since 1987, has written professionally on the intersection of art and business. Bechtler summarized his views on business management and art-making: "Management is a practice; it is not a science. There are problems where the analytical approach leads to one and only one solution. But there are other problems, where analysis may shed light on a problem situation, but is not conducive to reaching a decision. Usually the rational and analytical aspect of management is stressed and overstressed and at the same time the importance of intuition for managerial decisions is underestimated or overlooked. In many instances, intuition plays a crucial role:
—in leading people and in selecting employees
—in areas of creativity, as in product development
—when one makes decisions with long-term implications, for example strategy or investment decisions
—in situations where one has to act with extreme uncertainty or under time pressure, as in crisis management or negotiations

—where the sense of timing for action is of importance.

"In all these open and very complex problem situations, the analytical approach is important but has to be supplemented by intuition. It is clear that a professional management team always has to contain both aspects of management: the rational as well as the intuitive. If one analyzes what intuition does, one sees that it is a mechanism of processing complicated information streams from various sources. In this regard it is comparable to the work of an artist who also tries to represent in his work a condensed view of the complex world. A work of art is always a condensation of the complex reality. So, art can be a means through which one learns to perceive an intricate situation through a simplified image."[3]

Bechtler again explored the value of art to business in a speech he made at the opening of the Basel Art Fair in June 1989. *Entrepreneurs and Artists in Dialogue: Quality through Competence and Engagement* was his attempt to clarify the issue of cultural standards and quality control when art and business are intermingled. "The main question is what function art in business in general should fulfill—expression of ideal concerns, self-representation or self-glorification or finally decoration? Usually it is a mix with different weights of importance ... Only through the achievement of a delicate balance between different favorable conditions is the chance highest that the work will develop into something we will experience as quality work. The contract-giver must be responsible for providing the artist with optimal conditions.

Sol LeWitt, *Wall Drawing #683. A tilted form with color, ink washes superimposed,* color ink wash, 1991, 43 × 37 ft (13.106 × 11.278 m), a permanent installation in the main lobby of Carillon, Charlotte, North Carolina. The background is yellow, yellow, yellow; the top plane, gray, gray, gray; the left plane, gray, red, red, gray; the right plane, blue, gray, gray, blue. Drawn by Mark W. Brantley, Gary Drennan, David Higginbotham, Elizabeth Sacre and varnished by John Hogan. Collection: Hesta Properties, Inc.

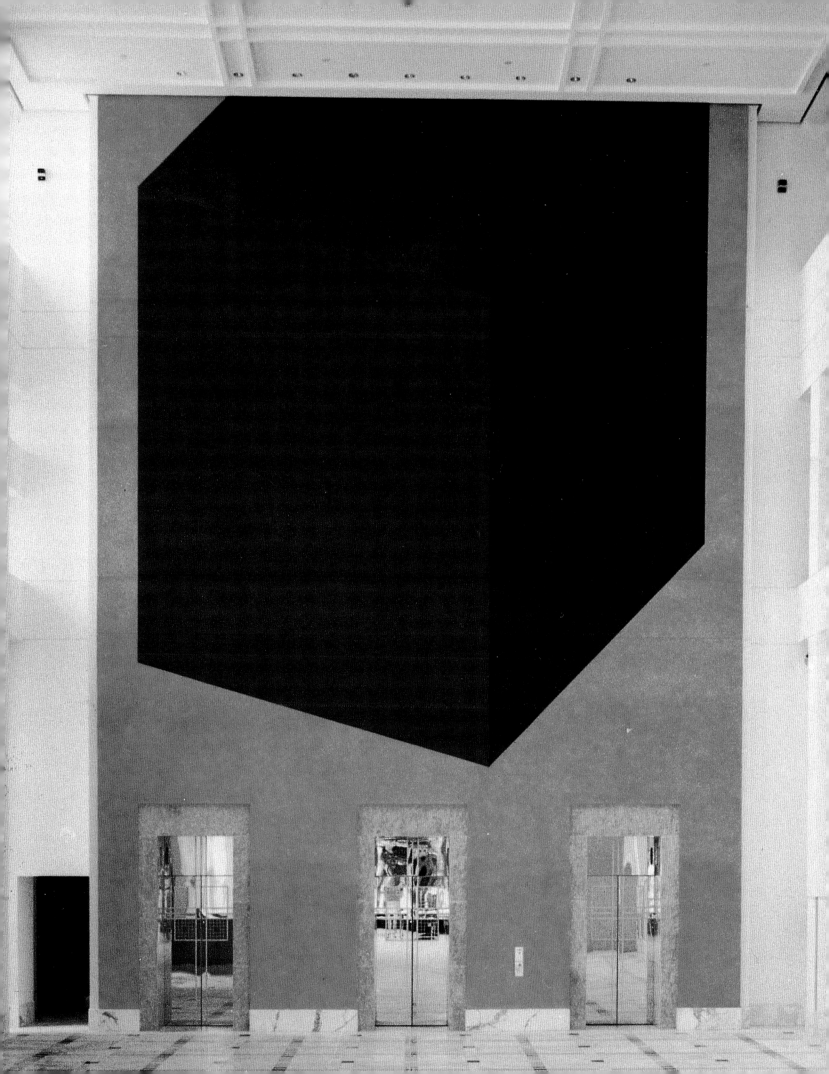

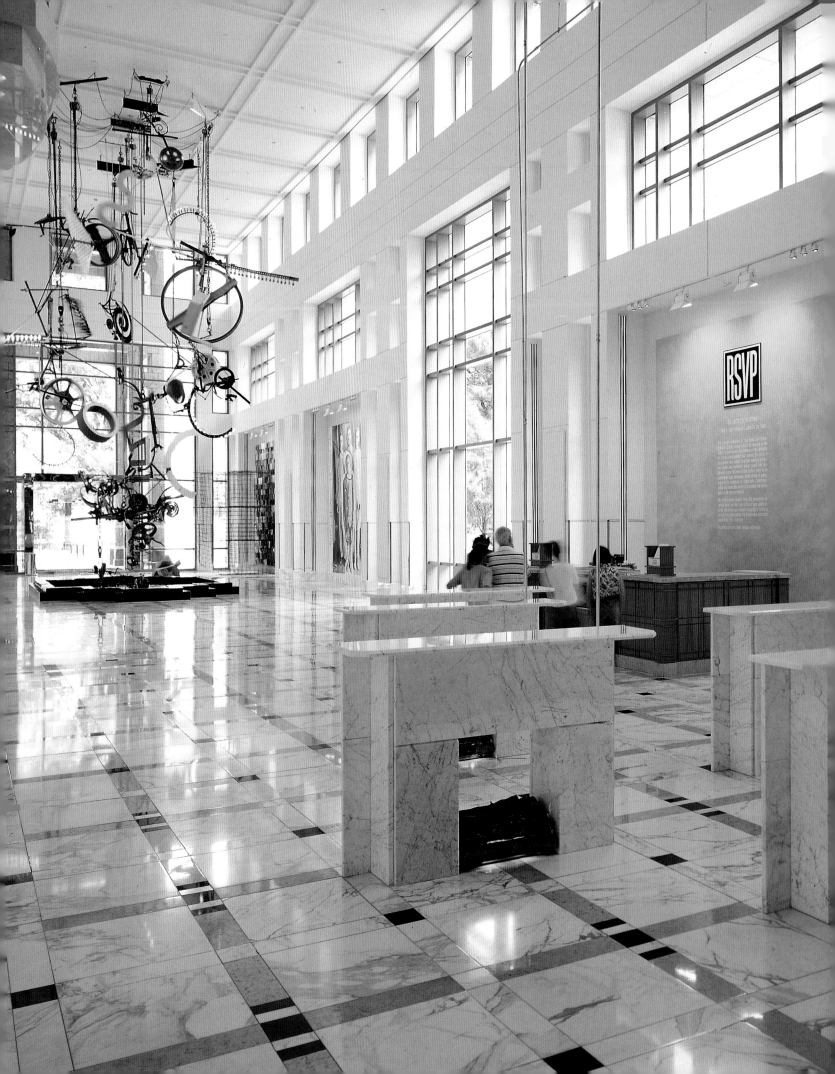

Malcolm Cochran, *Five Hearths for Charlotte*, 1992, mixed media, 15½ × 19 ft (4.7 × 5.8 m), a temporary installation on the floor area for "RSVP: Six Artists Respond" at the H. and W. Bechtler Gallery, Carillon, Hesta Properties, Charlotte, North Carolina, 1992–93.

A Carillon, Hesta Properties, Inc. address label with reproduction of a drawing by Jean Tinguely.

CARILLON

Hesta Properties Inc.
129 West Trade Street
Suite 1106
Charlotte, North Carolina 28202

Everything else is secondary. The contract-giver's freedom is limited to the questions of whether he wants to do something, when, where and with whom. One of the most important questions ... is the choice of the artists or the determining of the procedure for the choice of the artists."

A quintessential example of "quality," "competence" and "engagement" as Thomas Bechtler understands them is the commission the family offered to Jean Tinguely for Hesta Properties' flagship development of Carillon, an office complex in downtown Charlotte, North Carolina, in 1990-91. Andreas Bechtler is himself a practicing artist who has shown quite extensively in Europe. Under his direction, public scale works by Jean Tinguely and Sol LeWitt were commissioned for the lobby of the Carillon complex.

Tinguely's *Cascade* (1991) is a gigantic motorized indoor fountain, full of the verve, wit and whimsy that catapulted this Swiss sculptor to global prominence. Tinguely was among the first to elevate Kineticism to the status of high art, paving the way for its subsequent usage by many important contemporary artists. *Cascade* is Tinguely's last major piece, and ranks with the best efforts of his long career.[4] The work of Tinguely is rarely seen in America and this significant piece

on public display is in itself a unique cultural amenity.

Sol LeWitt, whose work the Bechtlers have also been collecting for a number of years, was commissioned to make *Wall Drawing # 683*, a piece that counts among his most distinguished achievements. LeWitt, a seminal practitioner of American Minimalism since the 1970's, has become the contemporary equivalent of the Renaissance fresco master, sought after the world over. He has developed several methods of integrating drawings with wall surfaces that have made his imagery particularly appealing for architectural commissions. Because LeWitt is in such demand, his corporate projects can easily slip into a more formulaic, decorative mode. In the more conceptual tone of this wall drawing, it is possible to discern the enlightened assurance of the client/patron (bearing out Bechtler's belief) that "without the personal engagement of the highest level of management, a bureaucratic mentality quickly replaces the necessary '*feu sacré*.'"[5]

Although many corporate lobbies have been used by businesses to mount changing exhibitions, Hesta Properties has set its sights a cut above the usual with an imaginative and professional usage plan. Lobbies are not generally destinations but thoroughfares. Therefore, lobby galleries

173

Temporary installations for ''RSVP: Six Artists Respond'' at the H. and W. Bechtler Gallery, Carillon, Hesta Properties, Inc., Charlotte, North Carolina, 1992–93.
Right: **Pat Ward Williams**, *I Remember It Well*, 1992, mixed media, 16 × 14 ft (4.8 × 4.2 m) and (left) **J. Paul Sires**, *Tides of Knowledge from the Past Fragments Future Knowledge* series, 1992, mixed media, 16 × 14 × 16 ft (4.9 × 4.3 × 4.9 m).

Below: **Steven Siegel**, *Holocene*, 1992, newspaper and mixed media, 14 × 16 × 2 ft (4.2 × 4.8 × .6 m).

Opposite: **Karin Broker**, *Trouble in Paradise*, 1992, mixed media, 16 × 14 ft (4.8 × 4.2).

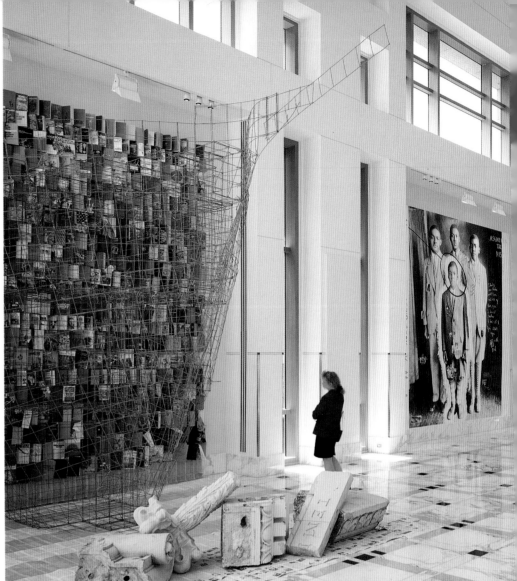

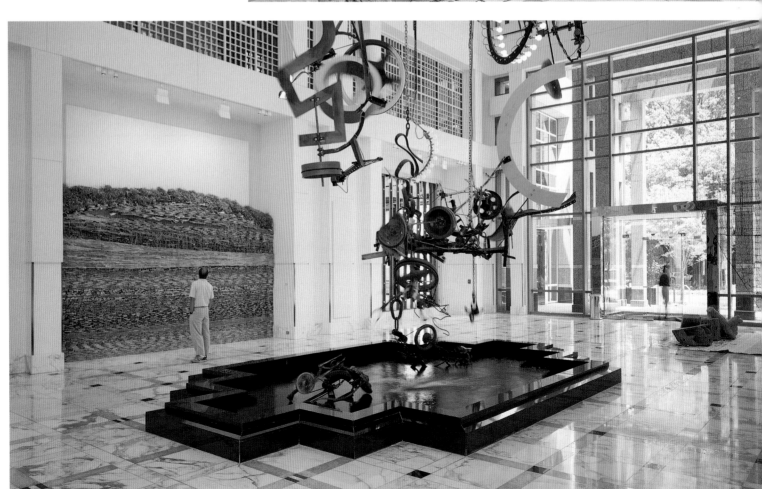

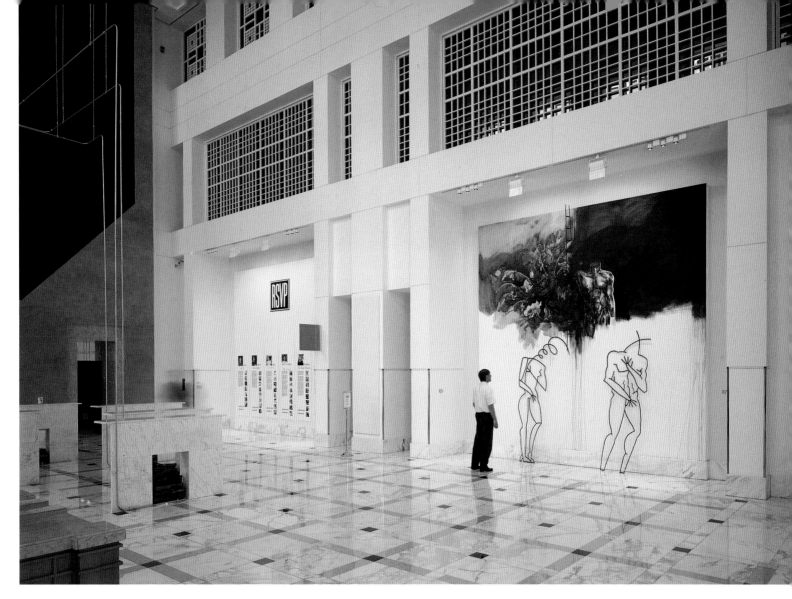

often end up looking like makeshift bazaars where art exhibitions, rather than beckoning, are subsumed into the main function of the space (see IBM Japan, pp. 189–90). Without carving out a separate place for art, virtually the entire main concourse where the Tinguely and LeWitt are on permanent display is designated as the H. and W. Bechtler Gallery. Because the area was always planned as a gallery, 14-foot-square wall niches with appropriate art lighting were designed for the ongoing exhibition activity.

Andreas Bechtler and his team (which included Michael Verruto, Hesta Properties' Vice-President, and a trained architect with great enthusiasm for contemporary art) clearly defined their aim to continue the Bechtler family legacy of patronage by creating a climate where "works of first importance" have an opportunity to develop and eventually be "integrated into society."[6] They have planned an ongoing program of acquisitions, exhibitions and education.

The initial Bechtler Gallery presentations were organized by Curators' Forum, a team of former professional museum personnel based in Charlotte. Fully illustrated catalogues with essays by independent critics of note were published and a series of free lectures were given.[7] The first presentation, "LeWitt, Tinguely, Peart: Counterbalance,"[8] (September 6, 1991 to March 20, 1992) was devoted to introducing these artists to the public. LeWitt's assistants executed two of his early wall drawings that had never been publicly shown before, and models and drawings for the Tinguely fountain elaborated on the featured works.[9]

The second presentation (May 1, 1992 to January 24, 1993) was "RSVP: Six Artists Respond," a group exhibition of temporary installations by young artists whose concept suggested a dialogue with the LeWitt and Tinguely. Proposal requests were directed to a list of eighty artists culled from a national search

conducted by Curators' Forum. Of the thirty responses, principals from Hesta and Curators' Forum chose six entries. Rather than avoiding the unknown, the company challenged the commonly held belief that art and risk are incompatible in the corporate domain. The result was an intelligent assemblage of installations by promising young artists, all of whom work within the expanded vernacular of today, using sound, photography, impermanent and unorthodox materials and site specificity, to explore a range of concepts including women's issues, personal and local histories and ecological concerns. Lou Mallozzi, a promising Chicago sound artist who employs digital audio playback units, contributed *The Continuing History of Rain: Triptych*, one of the most challenging pieces in the exhibition.

Mallozzi explained his own response to the space, the LeWitt and the Tinguely: "What started to evolve was the notion of utilizing the Tinguely in two basic ways. One, to possibly record it or use some

[Score — Part 1, Sections 6 and 7]

TOTAL TIME 1'15" / SECTION TIME 0 — 1'20" — 1'25" — 1'30"

TEXT	YOU ASKED ME IF I NOTICED THAT THE TRAIN'S	RUMBLING WAS GETTING MORE ARHYTHMIC.
BACKGROUND	RAIN / TINGUELY	RAIN / TINGUELY
SAMPLES	#1 HARPSICHORD / #2 SCRATCHES / #3 TONE	

TOTAL TIME 1'30" / SECTION TIME 0 — 1'35" — 1'40" — 1'45"

TEXT	I NODDED AND REMINDED YOU THAT YOU AND I HAD	BEEN HERE TOGETHER LONG AGO IN THE RAIN.
BACKGROUND	RAIN / TINGUELY	RAIN / TINGUELY
SAMPLES	#1 HARPSICHORD / #2 SCRATCHES / #3 TONE	

sonic material derived from it. The second thing was to think about how the Tinguely defined that space acoustically. It is *the* defining factor in that gallery in acoustic terms. And it's one of the things that helps to differentiate acoustically that gallery from the parking garages that are on the other side of those elevators. With the LeWitt, it started to become more about the notion of systems and for me to return to using some kind of very strict rational systems to order the piece: imposing a kind of grid on to a composition in time ... Once I fabricated the fictional basis for these texts, then it was pretty straightforward. It was a question of listening to all the recordings I made while in Charlotte and trying them against the texts and seeing which ones seemed the most interesting sonically. What I ended up using was a recording made of Tinguely under water. I put a contact microphone into the fountain, under the surface of the water, which has mechanical sounds ... melodic, mechanical sounds. The other recording in Charlotte was of my hotel window being hit by rain. Again, I used a contact microphone, which picks up the vibrations in solid objects rather than the vibrations in the air ... It also has nice train whistles in the background, which I was hearing the whole time I was in Charlotte."[10]

Thomas Bechtler expanded on his philosophy of the interface between contemporary art and business culture.

Marjory Jacobson: How can the visual arts as just one element in the workplace change the way the workplace functions?
Thomas Bechtler: The starting point is a deep belief in the visual arts—that the visual arts are a very important form of communication—that is, a way of making yourself clear about the time you live in.
MJ: How does that translate into your business life?
TB: Any business is involved in the future, makes commitments for the future. The point I want to make is that we are not doing anything in the field of art so as to have a monetary return in our business dealings. We have an old-fashioned Maecenas concept with regard to the visual arts. We make a strong distinction between maecenatism [patronage] and sponsoring. We are purely interested in the art, and we want to do something for the arts.
MJ: What kinds of returns are you referring to? There must be some reason to put art in offices.
TB: The topic of art falls into the broader field of corporate culture. We are convinced that culture as well as art is

something you cannot produce, you cannot fabricate with a managed device but need personalities at the top of the company who live this concept. You can only live it with your model and *Vorbild*, the pattern that you follow with your own personality, to be credible. That is also why we are quite skeptical with companies who are building up large art departments or hiring art consultants. We do not believe this has a profound impact in the long term.
MJ: I think it all depends on a number of players in the drama—not only the interest, enthusiasm and sensibility of the company head—to create a very professional program. It also takes unusual artists, curators and imagination to orchestrate the standard.
TB: The family-run company has a particularly opportune possibility to be a model, to embody such cultural values and cultural concepts morally in a way that a public company cannot.
MJ: A public company has another kind of responsibility. Do you feel that with a publicly owned company it is more necessary to have an established curator in place?
TB: It is very rare that the head of a large public company has the competence and expertise that are necessary to run a professional art program, but I suppose it

Hesta understood and accepted that the initial proposals would change as the works progressed and encouraged, rather than dismissed, this evolutionary process. In any installation work, the process of "installing" is as important as the finished product and one of the most effective ways to understand the creative mind. Emphasizing the artistic process is a form of art education and a logical occurrence with LeWitt's master assistants, and Tinguely on the premises constructing more than supervising the installations. The curators chose artists who would not only make their work *in situ,* but who would discuss the progress and process of their work at informal lunchtime lectures. Visitors and employees passing through public thoroughfares had glimpses, fleeting or fixed, as the work developed.

is not impossible. Being exposed to the scrutiny of the public requires a different procedure in the field of art compared to the family company. Decisions must be objectively justified. In a public company you have to convince a larger audience of the correctness of your decisions. Then you need certain legitimizing mechanisms to follow. You choose the experts, but sometimes this is not necessary for the quality of your decision but necessary to "sell" your decision.

MJ: What is the primary benefit to having an adventurous art collection in the office?

TB: It is very important, if you are hanging art in corporations, aside from corporate culture and the special climate you can create, to open the question of how reality is being perceived. The most important thing is to realize that there is nothing like an objective reality. The fabrication of reality in one's mind depends upon where you stand and what your background is, and your history. I think art shows this to

the employees. It is an indirect positive effect of art in the office environment, leading to more tolerance, more flexibility and adaptability because one abandons the concept of a fixed, unchanging idea of truth.

MJ: Those are abstract psychological and philosophical observations, but what about practicality? Do you see any benefits that are more concrete, or direct? For example, would the majority of top executives be convinced by your arguments?

TB: You know, this for me, and also for the executives, is one of the most important things. In German you have "the theory of reason." How do you perceive reality? What is your concept of the truth? What kind of problems are you dealing with? It is crucial for executives to know this.

Art comes in here because art opens your eyes to the changing perception of reality, the relativity of what you believe.

Chiat/Day/Mojo, Venice, California

Jay Chiat, founding chairman of Chiat/Day/Mojo (C/D/M), is a private collector whose presence on the art scene had become more apparent since the late 1980's. Because he is in the advertising business and is a devotee of the avant-garde, Chiat has been likened to Charles Saatchi, the London advertising mogul who was one of the flamboyant personalities in the recent art market of the 1980's.[11] Chiat's personal fascination with contemporary art has spilled over into his businessplace and has shaped the way he runs his operation: "We had discovered earlier that we couldn't demand creativity. Instead we had to devise an opportunity for our people to excel. By combining the architectural environment with a very clear set of intellectual requirements, we created a new management technique—Environmental Management."[12]

Architect Frank Gehry was asked to design C/D/M's new headquarters and Claes Oldenburg and Coosje van Bruggen worked with him to integrate the sculpture component. Chiat had been one of Gehry's earliest and most steadfast patrons. He owned several of Gehry's furniture and fixture pieces, and had commissioned from him both the C/D/M temporary warehouse headquarters, also in Venice, and the firm's Toronto branch office. Chiat invited twelve California-based artists to propose major site-specific interventions during the design phase.[13] In spite of the economic reversals endemic in the late 1980's, the building was completed; unfortunately, the art commissions never passed the proposal stage because, Chiat lamented, of the impact of the complicated recession psychology on the workforce. Nevertheless, in the completed building and in the process and spirit of the art plan, there exists the challenging impulse to forge new relationships between art and business.

C/D/M's West Coast headquarters in Venice, California, which opened in 1991, consists of three discrete and seemingly disengaged elements: a horizontal "ship" wing sheathed in a separate metal screening; a vertical copper-coated "forest" building, its name derived from the tree-like columns; and a functional sculpture by Claes Oldenburg and Coosje van Bruggen in the form of binoculars signifying entry, serving as the gateway to the underground car park and containing conference rooms. "This is not the typical situation of an artist being called in to decorate a building once the planning stages have been completed. It is a total symbiosis of art and architecture," Oldenburg commented. "Coosje and I do a lot of large works that stand in front of buildings, but they are virtually independent. Here's an example of a sculpture becoming an integrated part of the building ... that's a first, and big, development for us."[14]

Not programmatically a collaboration (the sculpture was not initially conceived for the building), but more a collaborative mind-set between artists and architect who are in the habit of thinking in each others' fields, the genesis of this precedent-setting development is a typical story of how innovation and imagination are sparked, and the role that the businessman/client plays in the equation of creativity. Gehry and Oldenburg had known each other since the 1960's when Oldenburg became one of the signature artists of American Pop Art, his hallmark work involving ordinary images transformed into large-scale sculptures made of canvas, rubber, plastic and other soft materials. Gehry himself had often used common building materials in unorthodox combinations to shape his architecture and in his furnishing designs. Often drawing on the shapes of fish and snakes to make structures and furniture, Gehry's sensibility is close in spirit to that of Oldenburg.

In a previous situation where Gehry, Oldenburg and van Bruggen did actually collaborate—on the production of *Il Corso del Coltello* (*The Course of the Knife*), a mixed-media performance funded by Gruppo GFT (see p. 182) and staged at the Campo dell'Arsenale, Venice, in 1985—one of the projects developed was the binoculars building. Back in America, the trio did some sketches together and had a model built in Gehry's workshop. Gehry had invited Richard Serra to make a sculpture for the forecourt of C/D/M's building (see Gehry's earlier fantasy collaboration with Richard Serra, Chapter 6, note 4). When Serra's involvement did not materialize, and literally on impulse in a meeting with Chiat, Gehry placed the scale model of the binoculars he had in his office in the center of the model.[15] Chiat and Gehry were both enchanted, and after several consultations with the artists, the binoculars were incorporated into the design.

Claes Oldenburg, detail from *Design for a Theater Library in the Form of Binoculars and Coltello Ship in Three Stages*, 1984, pencil, colored pencil, watercolor, 30 × 40 (76.2 × 101.6).

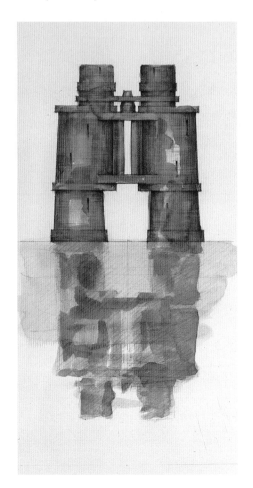

The offices of Chiat/Day/Mojo in Main Street, Venice, California, designed by **Frank Gehry**, with binoculars sculpture by **Claes Oldenburg** and **Coosje van Bruggen**, 1991.

Although Chiat/Day/Mojo had a fair amount of artwork sprinkled throughout its public spaces in many of its regional offices (Toronto, New York and London) and in its Los Angeles headquarters, the planning of the facility in Venice, California, with site-specific art projects brought Chiat to a new level of commitment and engagement. A few of the artists' proposals were charged with a level of vision worthy of the building; one, Mike Kelley's, was later realized by the artist in an adapted form and shown in the exhibition "Helter Skelter: L.A. Art in the 1990's," organized by Paul Schimmel at the Los Angeles Museum of Contemporary Art in 1991.[16]

In a letter to the project architect at Gehry's office in May 1990, Kelley proposed to cover a group of six conference rooms and a copy room in the new headquarters with blow-ups of idle-time office doodles and scribbles. "Generally in my work," he wrote, "I concern myself with the lowest strata of aesthetic production in a particular instance. Office cartoons interest me greatly in that they have nothing to do with job production but are done for the workers' own pleasure, often at the expense of the company. My intention is to use these drawings as the main design motifs in the areas of importance, shifting them from their normal peripheral position. Conference rooms generally are minimally designed or designed to convey a sense of purpose or power. I want to work against this given."[17]

The work planned for C/D/M would have been the agitprop of all times, cutting deeply into the psyche of office culture. Kelley's idea was extremely well

179

thought out, and went into the minute detail that is imperative for a successful site-specific commission: "My proposal is to execute wall murals directly onto, or secure prepainted panels to, the walls of the conference rooms, completely covering them floor to ceiling. The wall paintings are blow-ups of office cartoons of the type usually found in secretarial cubicles or pinned up next to the copier or fax machine. This is the reason for my choice of this particular block of conference rooms containing the copy room … To accentuate the feeling of being surrounded by the cartoons the doors entering into the conference rooms will be solid, no windows, and will themselves be covered by the wall paintings. However, I want to work against the normal isolation of one conference room from the next. To do this, I would like to cut a small window in each conference room to reveal the conference room next to it … The progression of windows, as I see it now, will be a window looking from copy room into conference room … Opening a window into it from the main conference room links the office cartoon super-graphics back to the copy room and will be a nice contrast to the clean treatment of the conference room."[18]

Mike Kelley, proposal for an artist's intervention in a group of conference rooms and a copy room at Chiat/Day/Mojo, Venice, California, May 1990.

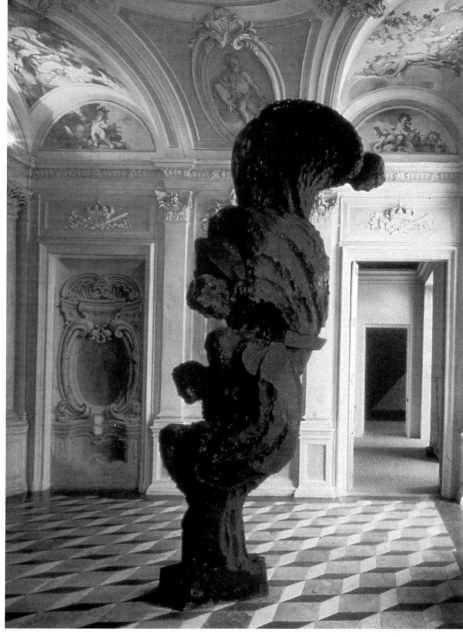

Michelangelo Pistoletto, *Persone Nere*, 1984, in the Museo d'Arte Contemporanea, Castello di Rivoli. Collection: Castello di Rivoli.

Gruppo GFT, Turin

With its financial and managerial support of the Castello di Rivoli-Museo d'Arte Contemporanea, Gruppo GFT, the giant fashion conglomerate, has arguably done more than any other Italian mega-corporation to implant the mechanisms of a healthy international contemporary art scene in Italy. Gruppo GFT is the holding company for ready-to-wear collections of European designer fashion houses such as Armani, Cardin, Ungaro, Abboud and Montana. The company, founded by the Rivetti family, began modestly in the 1950's in Turin. In the early 1980's, Marco Rivetti, son of the founder, Carlos Rivetti, and an avid private collector, took over the business and developed an aggressive international expansion plan with some fifty divisions in Europe, North America and the Far East. The appearance of contemporary art and culture in the company profile became a conspicuous aspect of Gruppo GFT's image.

Castello di Rivoli, converted into the Museo d'Arte Contemporanea in 1984.

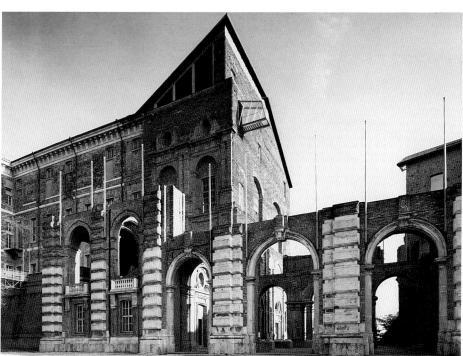

In 1984, the Castello di Rivoli, an eighteenth-century castle outside Turin, was converted into a museum of contemporary art largely with municipal funds from Regione Piemonte. In 1986 another building close by, the seventeenth-century Manica Lunga, initially built to house the art collection of Duke Carlo Emanuele, was also renovated and made part of the museum.[19] When the renovation was completed, a complicated committee structure was devised to operate the museum involving Regione Piemonte and three commercial sponsors: Fiat, Banca CRT, and Gruppo GFT as the main player. Marco Rivetti became the museum's president. In 1985, Rudi Fuchs, a knowledgeable Dutch curator of contemporary art, was appointed first director of the Castello di Rivoli, and under his tutelage the Castello became a repository for the art with which

181

Casa Aurora, Gruppo GFT's headquarters in Turin, designed by **Aldo Rossi** in 1984.

Gilberto Zorio, *Canoa*, 1987, installed on the fourth floor of Casa Aurora, Turin. Collection: Fondo Rivetti per L'Arte.

he and Rivetti were most sympathetic: arte povera, American Minimalism and Conceptual art. An active acquisitions program brought into the permanent collection major works by Joseph Beuys, Donald Judd, Mario Merz, Gilbert Zorio, Luciano Fabro and Giovanni Anselmo. In the twenty-seven temporary exhibitions Fuchs organized during his tenure, a more catholic range of activity was evident:

presentations of Joan Miró and Alberto Giacometti, Lucio Fontana, Arnulf Ranier, Per Kirkeby, Carl Andre, Günther Förg, Alan Charlton and Barbara Kruger revealed the strategy of an institution trying to internationalize its scope, bring to Italy some established Modernists and introduce a younger generation to a public who had had little exposure to these artists. Fuchs also

continued to promote the work of arte povera artists, especially Giulio Paolini, Nicola de Maria and Jannis Kounellis. Embattled by deficits and impeded by political infighting, Fuchs left at the expiration of his first contract, leaving behind an important legacy as the first director of "the first truly contemporary art museum in Italy."[20]

The Casa Aurora, GFT's headquarters designed by Aldo Rossi in 1984, is an act of high architectural patronage in itself. Rossi, the celebrated Milanese architect, described the building as a design project involving "precise interpretations of Turin's architecture ... visible in the plan which follows the Roman block, in the grid, in the materials [brick and local stone] and in a new architectural culture."[21] He concluded with the ultimate oxymoron: "GFT wants to give Turin a modern, traditional building."[22]

Since 1984, art purchased by the Rivettis and by Gruppo GFT has been sited at Casa Aurora. The collection centers on many first-generation Italian arte povera artists and their international counterparts. In 1987, the Rivetti family established the Fondo Rivetti per l'Arte, for funding its contemporary art activities. From time to time, works from Rivetti's private collection were installed in the Turin offices of Gruppo GFT and its international divisions with others bought by the company. Gruppo GFT itself was buying mostly more recent Italian art *ad hoc*, expressly for its public spaces.

Through the foundation, Gruppo GFT and the Rivetti family opened Percorso in 1992, an exhibition space for showing works in the collection on a rotating basis. The foundation has also been instrumental in helping to disseminate the ideas of Italy's arte povera artists through purchase of their works, funding seminal exhibitions exploring the movement and supporting the publication of major multilingual monographs for distribution worldwide. Among specific contemporary projects underwritten by the foundation was *Il Corso del Coltello* (see p. 178).

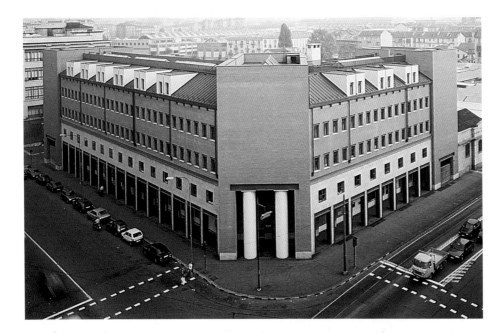

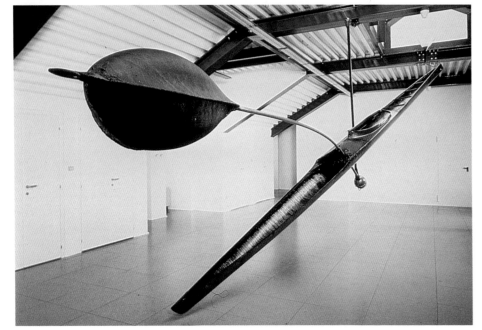

Installations at Percorso, 1991–92, Fondo Rivetti per l'Arte, Turin. Above: right, middle ground, **Haim Steinbach**, *Coat of Arms*, 1988, and, left, middle ground, *Gelded Eyes*, 1987–90; foreground, **Richard Long**, *Pietra di Luserna Circle*, 1991; in far room, **Tony Cragg**, *Linen Divisa*, 1989. Collection: Fondo Rivetti per l'Arte. Left: **Giuseppe Penone**, *Soffio di Fogile*, 1982; on the wall, **Ettore Spalletti**, *Baci*, 1987; **Mario Merz**, *Architettura fondata dal tempo, Architettura sfondata dal tempo*, 1981.

Norwest Corporation, Minneapolis, Minnesota

Minneapolis may well be a Mecca for devotees of progressive business patronage of the visual arts. Some of the landmark models of "support at the summit" exist here: the sculpture garden at General Mills (see pp. 134–35); the experimental undertaking on behalf of art as agent for more enlightened employee relations in the businessplace under Dennis Evans' tenure at First Bank System (see pp. 18–20); and the Modernism arts program at Norwest Corporation.

Norwest, established in 1929 as Northwestern National Bank, is today an influential international financial services corporation, operating commercial banks throughout the upper Midwest. After a fire in 1982 demolished its downtown Minneapolis headquarters (a typically opulent example of Art Deco style by the Chicago firm of Graham Anderson Probst & White), architect Cesar Pelli (see p. 100), designed an entirely new fifty-seven-story office complex on the site.

Norwest, not only physically rejuvenated but enormously successful financially in the wake of banking deregulation, had set in place by the time of its 1989 re-inauguration a specialized variant of arts programming in the area of Modernist functional and decorative arts. Of the handful of American businesses that have delved into this area of theme collecting—the Campbell Soup Company's tureen collection, Domino's Pizza's Frank Lloyd Wright furniture and objects, Forbes, Inc.'s Fabergé eggs and Corning's Museum of Glass (to name a few of the most prominent)—Norwest is unique in having taken the activity to a new level of cultural correspondence. Norwest's program covers an international selection of ceramics, furniture and works on paper from around 1875 to 1945, a period when new technology and progressive ideas combined to established the foundations of twentieth-century models. At the same time, the American Midwest produced a distinctive and advanced interpretation of Modernism in

design and architecture, a phenomenon Norwest has capitalized on with attentive professionalism.

How did Norwest arrive at this enlightened stance? First, in 1987 the corporation hired David Ryan, a former museum curator and director to help it define its goals. Lloyd P. Johnson, then Chairman of Norwest, convened a meeting with a group of prominent Minneapolis businessmen, museum principals and other individuals (including Michael Winton, on the board of directors of the Walker Art Center, and Bruce Atwater, Chief Executive Officer of General Mills among them) to work with Ryan in fleshing out an arts component for the next phase of bank operations. Certainly aware of First Bank System's art program, which had by that time become aggressively public (and of the existence as well of some thirty corporate collections within the Twin Cities, such as Honeywell and 3M), Norwest opted for a program perhaps more modest in size but with a broad scholarly base in Modernism. The movement included architects and designers Louis Sullivan, Joseph Urban, Eliel Saarinen, Raymond Hood, Buckminster Fuller, Frederick Carder, Peter Pfisterer, Josef Hoffmann and Walter Gropius, whose work had been internationally assimilated.[23] There were still objects to collect, undervalued in the marketplace and under-researched in the archives, an opportunity for an institution to make an original contribution to the field and to stand out in the community it served. In the inaugural brochure "commemorating the debut of the new corporate art collection" Norwest's chairman, Lloyd P. Johnson, said, "Through a fortunate coincidence of good timing, community support, curatorial expertise and sheer diligence, Norwest is pleased to unveil among the first (if not the first) corporate art collections focusing on Modernism."[24]

Exhibition vitrines in the grand lobby concourse, Norwest Center, Minneapolis, Minnesota.

There is a world of difference between art as decoration and the "decorative arts." The fine arts are generally understood to denote a higher order of significance. Traditionally including painting, sculpture and limited-edition prints, the definition has been expanded in recent years to include any visual art that has a content where significant ideas are embedded in the visual format. Serious art can, and does, perform a decorative function by virtue of the fact that it is visual. But art that is exclusively decorative is usually deemed to be of a lesser importance. In this book, the decorative arts as a category have been omitted, except for Norwest's Modernist collection. Most good corporate collections of decorative arts are in the pre-Modernist periods and do not fall within the parameters of this book. The Norwest collection embodies the culture of Modernism and treats the decorative arts with scholarly invention. In essence, the advent of the modern age brought a new respect and significance to the decorative arts in general. We should be seeing more collections of twentieth-century decorative art and design forming as the serious evaluation of these fields becomes more mainstream.

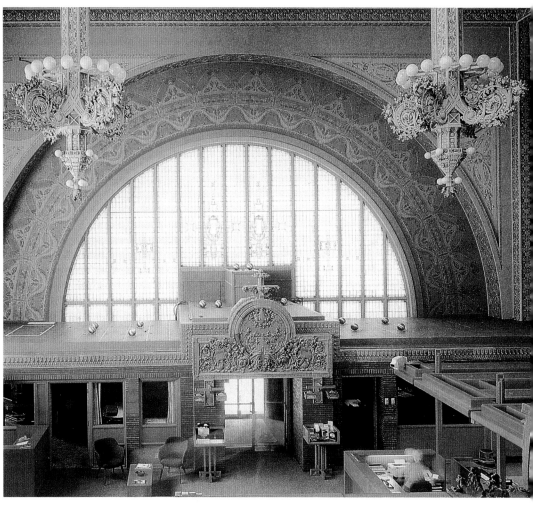

Interior of the National Farmer's Bank in Owatonna, Minnesota, American architect Louis Sullivan's first regional bank commission (1906–08). The main block was restored by Norwest Corporation in 1982–83 and renamed Norwest Bank Owatonna.

Before it had formulated an art program proper, Norwest had already acquired and carefully restored one of America's great architectural monuments: Louis Sullivan's (1856–1924) first regional bank commission,[25] the National Farmer's Bank in Owatonna, Minnesota (1906–8).[26] Renamed Norwest Bank Owatonna, the facility is considered to have been faithfully and successfully restored, and signals Norwest's extraordinary commitment to doing the job properly.[27]

Norwest's holdings, about four hundred works to date, are shown in a variety of ways both *in situ* and in temporary exhibition vitrines. The grand lobby concourse was designed to feature sixteen showcase niches especially fitted to hold three-dimensional objects. Additionally, six floor-to-ceiling vitrines were built as transparent wall-divider displays on the third and fourth floors of the building, and a professionally fitted gallery with wide-plank maple flooring doubles as an unusual reception area for visitors to the fourth floor executive wing. Four functioning private dining rooms have been designed and furnished in different period styles as elements of the art program.

Exhibitions culled from Norwest's collection, such as "Modernist Ceramics," "Modernist Lighting" and "Women in Modernist Design," have been installed in the ground floor vitrines. The concourse space is open to the public year-round and informative brochures and labels supplement the displays. Films, tours and lectures, open to the public as well as to Norwest's employees, have enhanced the programming, and many local academic institutions have used the collection for graduate research and general study purposes.

Norwest has made a significant contribution to the understanding of the roots of Modernism and its Art Moderne subtext that flourished in the Midwest, as well as to the enlightened patronage of contemporary art and culture by business.

A dining room at Norwest Corporation headquarters in Minneapolis, furnished with a buffet/sideboard, table and chairs designed in 1902 by Louis Majorelle (1859–1926). Entitled *Chicorée*, the suite is a hallmark example of the French Art Nouveau style with its emphasis on luxury, rich woods and sinuous floral motifs in gilt-bronze. Other Art Nouveau objects, produced at the turn of the century in Europe, are the table lamp, chocolatière set and vases.

This dining space at Norwest Corporation headquarters in Minneapolis is fitted out entirely with a suite of furniture designed by Josef Hoffmann (1870–1956). The internationally renowned Austrian architect designed the dining room suite in 1913–14 for Swiss artist Ferdinand Holder's Geneva house. Although he was celebrated for his work in the Palais Stoclet in Brussels, Hoffmann's design genius has only recently reached a wide public audience. Hoffmann was the master designer at the Wiener Werkstätte (Vienna Workshop), an influential production studio that predated the aesthetic principles of de Stijl and the Bauhaus. Especially revered today for his *Gitterwerk* (latticework), a series of products manufactured from sheet metal perforated with a grid pattern, Hoffmann has become a precursor of modern, geometric design. Work by other members of the Wiener Werkstätte are included in the furnishings here.

Views of the fourth-floor gallery at Norwest Corporation, Minneapolis.

From left: posters/lithographs by **Kees van der Laan**, *Graf-Spee Landing*, 1932, **Lucian Bernhard**, *Adler Typewriter*, 1908, and **William Bradley**, *Chapbook*, 1894–95. In the foreground are Roycroft Shops' *Side Chair*, 1905, American white oak, and *Pedestal*, c.1912, oak, and a tapestry design by Carl Otto Czeschka.

The famous *Egg* rocking chair, c.1922, polished beech and cane, and **J. Kuykens'** *Floor Lamp*, 1930. On the wall, building plans by **Frank Lloyd Wright**, 1893–1909, reprinted by Horizon Press, New York, 1963.

E.A. Taylor, Display Cabinet, c.1898, mahogany decorated with marquetry, and wallpaper sheets by **William Morris**, c.1864–92.

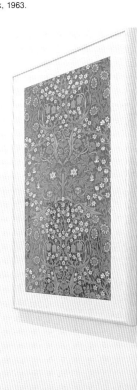

Continuing the theme of specialized stocks, the following case studies focus on some shining moments when a business has sponsored an unusual art project. For a month in the fall of 1990, any guest taking Zimmer 152, a luxury suite at the venerable Steigenberger Hof in Frankfurt, would be inhabiting a space transformed by German artist Carl Emanuel Wolff. The temporary photography event staged by Japanese artist Hiroshi Sugimoto at IBM Tokyo is an episode of high rank. The Canadian developer Olympia & York sponsored the "New Urban Landscape" exhibition in the unfinished lobby spaces and exterior of the World Financial Center at Battery Park City in 1988 to celebrate the opening of the complex. In another venerable but shaky example of art and real estate development bridges, Dara Birnbaum was commissioned by Ackerman & Company to make the first outdoor video art wall for the Rio Shopping and Entertainment Center— only to see the artwork all but come tumbling down.

Steigenberger Frankfurter Hof, Zimmer 152, Frankfurt

Not at the office but in the world-class Frankfurter Hof, the owners became patrons of a young artist whose dream was to use a hotel as the site of his work. When Bernd O. Ludwig, manager of the Steigenberger Frankfurter Hof in Frankfurt, Germany, was first approached to consider the artistic reassembling of Suite 152, he was justifiably dubious: "When we first heard of the project 'Frankfurter Hof Zimmer 152' we were naturally irritated … We have a certain kind of ambience that we have created intentionally … but the delegation of doers from Portikus [Kasper König] and the gallery [Galerie Luis Campaña, Frankfurt] and above all the artist himself convinced us."[28]

From October 10 through November 10, 1990, Suite 152 at the Steigenberger Frankfurter Hof could be "sold" as an artistic event to anyone willing to pay the price. The normal rate was raised for the

privilege of the experience. Conversely, the room could not be "visited" as one would a normal exhibition.[29] It was Ludwig's idea: "We shocked the people who understand art with this mercantile idea: to give art as a gift? NO. For that reason, the price for a night costs DM750, even though the regular rate was DM350! Art has its price and the enjoyment of art in Zimmer 152 must cost the person staying there something extra. The preparations together with the organizers was very enjoyable and we had a lot of fun. Management and employees are proud to accommodate 'Art Room 152' within the walls of the landmark Steigenberger Frankfurter Hof."[30]

Carl Emanuel Wolff, a young artist from Düsseldorf, had been experimenting with stretching the look of functional objects in the direction of fantasy.[31] Wolff was asking some provocative artistic questions about the issues of public versus private exhibition strategies, the interpretation of reality and fantasy, the

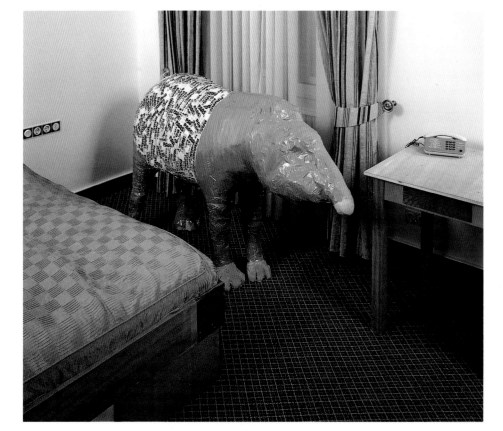

Installation by **Carl Emanuel Wolff**, *Frankfurter Hof Zimmer 152*, 1990. At first glance, all Wolff's objects seem to have the basic properties of their functional counterparts. Most of the pieces – furniture and other normal hotel furnishings – appear to belong. The exception, of course, is the life-size tapir sitting on a side table. (Wolff said it looked like his girlfriend!) Instead of serving a jolt, the artist gently edges perception a few steps to right or left. The impression, perhaps embodied by the presence of the exotic animal, is a very personal experience.

Wolff's ''sculptures'' are made of scraps of wood and other cast-off odds and ends that blend into their elegant surroundings. At their best, his environments alter the way objects are perceived and transport the ordinary into the world of art.

IBM Japan, Tokyo

A project funded by IBM Japan and installed simultaneously at the new IBM Tokyo headquarters and at the Carnegie Museum of Art in Pittsburgh, Pennsylvania, as part of the 1991 Carnegie International, demonstrates one of the more catholic arts patronage possibilities involving the corporate public space and the art institution. The process by which the project came into being had less to do with IBM Japan's existing art programming structure, which was to show work in the lobby of its headquarters, than with an imaginative solution proposed by the artist and endorsed by the company.

When Hiroshi Sugimoto was asked to participate in the Carnegie International and also invited to exhibit at IBM Japan, he decided to show a series of fifty photographs of seascapes he had been taking around the world over the last eleven years. Sugimoto transformed his body of work—consisting of extended black and white exposures of images of sea, air and water, exquisite variations on the theme of the passage of time and the nature of eternity—into a project entitled *Time Exposed*. The catalyst for the idea was a waterfall wall that was part of the outdoor plaza at IBM's Tokyo headquarters. Sugimoto encased each photograph in an especially designed waterproof plastic box, and affixed the boxes to a fountain wall under cascading water. Taped to the back of each frame was information giving the place of the exposure and the location and dates on which the exposure began and ended.

Sugimoto split the project into two parts for two different sites and showed the work in similar settings in both locations simultaneously. A water wall was built in the Carnegie Museum sculpture garden to duplicate the exhibiting conditions at IBM Tokyo. The artist explained, "This show is entitled 'Time Exposed,' not 'Time Exposure.'[33] The piece illustrates the concept that images keep fading the same as all the other matter in the world. It may take twenty

function of and psychological conditioning to objects in different spaces—all of which caught the imagination of Kasper König: "The everyday game of change between imagination and reality is determined by the context of where it is. Leaving the museum exhibition room, for example, has nothing to do with the etiquette of the unusual. The so-called public realm has been long reclaimed by the artist. In this context, the hotel room takes on a hybrid position. It is a public room in the literal sense of the word. It is available to anyone for whom it is necessary to stay for a certain period. In this time, the hotel room changes itself, due to the presence of the user, into a private room. Wolff's integration of his sculptures into this functional context covers an additional tension but, through this, the appropriation is taken away through an anonymous public ... The interesting aspect that comes out of this is the possibility of scrutinizing the function and reception of the works as part of the 'quasi'-private sphere of the viewer or observer."[32]

years or one hundred years, but I hope to exhibit the project continuously until it is completely gone. The exhibitions at the Carnegie and at IBM will last for four months. I would then like to send them to some other institutions, not necessarily a museum, perhaps in a desert country. I just want them to be outside. After that I would like to have them placed under three or four inches of water. Conceptually, the work can be anywhere. I have fifty images all together that will just keep traveling, even after I die."[34]

Sugimoto explained the genesis of the IBM commission. Particularly revealing was the way in which the artist was able to incorporate the existing water feature in the IBM Tokyo plaza into his own agenda:[35]

Hiroshi Sugimoto: When the new IBM building was designed a space was created for art shows and art support activities on the ground floor near the entrance way and I was offered the use of this particular space. It is not a good space. It is not professionally designed. It is not a clearly defined gallery but more like a hallway or entranceway to the business. No one wants to have a show in a commercial building entrance, so I was quite negative when this was offered to me. Instead I found the courtyard and I proposed to IBM that I use that instead.

Marjory Jacobson: One of the things it seems to me that you are doing is defying the scale of outdoor pictures. When I think of the out-of-doors, I think of billboards. I think of things that are very large but you are maintaining an intimate scale.

HS: The nature of my photographs is that I am dealing with a texture and a nuance of air. I am just photographing air and water, and texture is the major issue. So if I enlarge the photo, it just becomes dots. I am also using a large-format camera, 8 by 10 inches, and so if I blow it up to a big size I lose the definite authority of my images. To me the physical scale is not that important. It is more the way I am presenting the work, that is important—time exposed, a kind of past tense.

MJ: Would you say that is a particularly Eastern perspective?

HS: It sounds funny to me when some people call me a "haiku artist." It is too easy to stereotype people that way.

HS: That is what I found so interesting about "Against Nature" [see p. 84]. The exhibition defied the stereotype of the Japanese artist and "A Primal Spirit" [see pp. 68–72] transformed that notion into twentieth-century terms. I think your work bridges those two worlds on some important level.

Sugimoto left Japan at the age of twenty-two and, although he spends a good deal of time traveling, considers New York his home base. He is known to the museum world as an authority on traditional Japanese art but declares that had he stayed in Japan he could not have clarified his relationship to his origins: "To review yourself," he said, "you have to go out and look from some high point."[36]

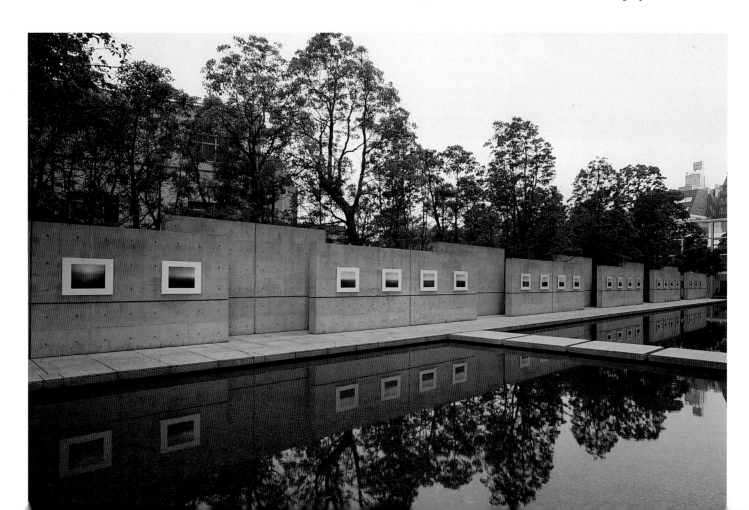

World Financial Center Art and Events Program, Battery Park City, New York

In 1988, before the World Financial Center's corporate office and retail spaces were complete and occupied, "The New Urban Landscape," an exhibition of twenty-eight projects by architects, artists and designers examining the concept of the city today, was held there. Occupying both raw and finished interior spaces, the exterior facades, outdoor areas around the periphery, and any other neighboring sites of the artist's choosing, the show helped celebrate the opening of 300,000 square feet of public spaces in the complex.

To launch the newsworthy landfill site at the southernmost tip of Manhattan with an exhibition of serious art that just as often criticized as celebrated the contemporary urban experience was a brazen move for its developer-patron, Olympia & York, and tenants American Express and Merrill Lynch. But the visual arts are only one avant-garde aspect of the World Financial Center Arts and Events Program directed by Anita Contini.

Contini had been a long-time advocate of bringing all the arts to alternative places. As the former director of Creative Time, a non-profit experimental visual arts and performance support organization, she was known for embracing new artistic concepts whose audience and site were also experimental. Ironically, one of her long-standing projects was "Art on the Beach," a summertime program on the very site that was to become Battery Park City. "Many of our old works were covered over in sand during construction. So we feel that art is the foundation of the World Financial Center. This is an alternative space, too," Contini continued. "Public areas are becoming more and more alive as artists are increasingly moving into the public arena. It's more accepted to have interaction between audiences and performers."[37]

The World Financial Center's Arts and Events Program was unveiled in 1988, one year after Contini had been recruited to develop the plan. The Winter Garden and the extended outdoor plaza space, designed by Cesar Pelli in collaboration with landscape architect Paul Friedberg, and artists Scott Burton and Siah Armajani (see pp. 100–1), were to be the primary sites for the program, which was to have a performance orientation. "Working in a corporate setting is different from running a non-profit arts organization. For one thing, Creative Time was very directed to art audiences … But I took the job here, where the programming is geared to general audiences, to give *them* an increased awareness of the arts."[38]

Major operating funds were provided by American Express, Merrill Lynch and Olympia & York (the annual budget was more than $1 million). Some of the performances remain mainstream, but often a stretch toward the experimental can be discerned.[39] With regard to the visual arts, rather than adopting the strategies used by Equitable (see p. 108) or confining art to the museum, the public art collection or the exhibition space,

Olympia & York, as one piece of its attempt to breathe new life into the genre of generating cultural goodwill, established the precedent of considering all the public spaces in and around the complex as an environmental *Kunsthalle*. "The New Urban Landscape", staged in the spirit of the progressive policies of the whole Battery Park City development (see pp. 100–1), brought together some of the best curatorial and organizational talent available.[40]

What was meant by "The New Urban Landscape"? To Joel Otterson, in his work *The Cage (The Living Room)*, the meaning was contained in 12-by-14-foot twin towers (the World Trade Center Twin Towers), made of copper plumbing pipe. Perhaps a symbol of the dichotomy between corporate fantasy and real public housing needs, the building contained a floor laid with antique Dutch ceramic tiles and Italian porcelain lamps, and was inhabited by live barnyard chickens. In the mind of Vito Acconci, who piled up real cars in mirror-like reflection either side of the glass wall separating outdoors from lobby, the usual humanizing amenities of nature are inappropriately sited. Encrusted with gray concrete like an excavation from Pompeii, the entombed vehicles spouted water and sprouted plants from various hoods, trunks and windows. The functioning transit stop at the corner was the site of Dennis Adams' and Andrea Blum's collaborative piece *Landfill: Bus Station*, where commuters had no choice but to gaze at a color photograph of a Soweto funeral procession. The direct political implication of corporations investing in South Africa made particularly powerful sense in the transitory destination place—a new type of public service advertisement for one's waiting thoughts.

Writing in *Art in America* in 1989, Allan Schwartzman blamed the corporation for his view that the art, although for the most part addressing the problem issues of real estate development, corporate dominance and resulting displacement and loss of power, was impotent because it was "absurd to critique the corporation while residing within it."[41] Another view might be construed: for better or for worse, the exhibition offered an all-too-rare forum for public discourse, for asking questions, for offering alternatives. The risks were considerable but if the art failed to deliver it was not because the corporation muzzled freedom of expression.

"Cross Section," a second presentation held in the summer of 1992, showed seventy-five large-scale works from the permanent collections of nineteen New York museums including the Whitney Museum of American Art, the Grey Art Gallery and El Museo del Barrio, in public spaces throughout the buildings and grounds of the complex. Although billed as a survey of post-1940's sculpture, the exhibition actually took an intelligent glimpse at some of the less frequently shown large-scale works owned by New York cultural institutions; it was a model example of a corporation bringing a museum and its high standards to the community environment.

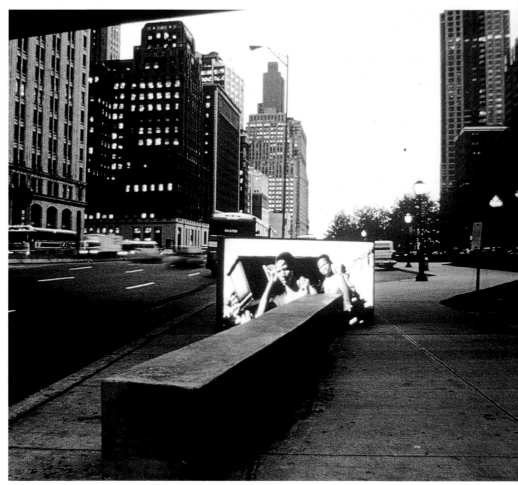

Vito Acconci, *Garden with Fountain*, 1988, junk cars, concrete, water and plants, at "The New Urban Landscape," World Financial Center, Battery Park City, New York, 1988.

Dan Graham, *Triangular Structure with Two-Way Mirror Sliding Door*, 1988, aluminum, plexiglas, two-way mirror plexiglas, 9 × 6 ft (2.7 × 1.8), at "The New Urban Landscape," World Financial Center, Battery Park City, New York, 1988.

Dennis Adams and Andrea Blum, *Landfill: Bus Station*, 1988, concrete, steel, fluorescent light, plexiglas, duratrans, 4 × 8 × 25 ft (1.2 × 2.4 × 7.6 m), at "The New Urban Landscape," World Financial Center, Battery Park City, New York, 1988.

Exhibited in "Cross Section," World Financial Center, Battery Park City. New York, 1992: Pepon Osorio, *La Cama (The Bed)*, 1987, installation, mixed media with bed, 75 × 67 × 78 (190.5 × 170.2 × 198) from El Museo del Barrio.

Left to right: Alice Aycock, *Greased Lightning*, 1984, steel motors and theatrical lighting, 56 × 72 × 72 (142.2 × 183 × 183), from the Jewish Museum; Melvin Edwards, *Cotton Hang-up*, 1966, welded steel, 26 × 30 × 20 (66 × 76.2 × 50.8), from The Studio Museum of Harlem; Willard Beopple *Eleanor, at 7:15*, 1977, Corten steel, 49 × 35 × 45 (124.5 × 89 × 114.3), from The Metropolitan Museum of Art; and Maren Hassinger, *Weeds # 1*, 1985, wire, earth, concrete, variable dimensions, from The Studio Museum of Harlem.

Rio Shopping Complex, Atlanta, Georgia

Dara Birnbaum is a New York-based artist and independent producer who exhibits video pieces internationally and is respected as one of the most original practitioners in the medium. In 1989 she was the winner of an international open competition to develop a permanent large-scale outdoor video installation, the first in the United States, to be located at the Rio Shopping and Entertainment Complex in Atlanta, Georgia. Because some of the funding was public, the center's art component fell under the jurisdiction of government support for art, so that a proportion of the funds and the selection panel were provided by the National Endowment for the Arts' Art in Public Places Program. The award of the commission to Birnbaum was based on highly professional criteria and could not have been more appropriate given the intent of the developer to be part-patron to an entirely original art venture in thé form of a video wall.

The shopping center itself was funded through a limited partnership composed of a non-profit community organization, a semi-private civic body and the private real estate development firm of Ackerman & Company. Rio, in midtown Atlanta, is part of a large land reclamation effort in the city (see p. 131) that provides incentives to developers. Some of the resulting profits are funneled into community services and physical neighborhood improvements. The area had become mixed racially and economically, with public-, middle- and upper-income housing. The new shopping center was the next step. As the developer of the complex, Charles Ackerman envisioned a new kind of shopping mall/ entertainment center and he had hired Arquitectonica, a Miami architecture firm noted for its "new age" modernism, to design the complex. All in all, Ackerman seemed to be the appropriate person to endorse what was to be the "first permanent video art installation in the United States commissioned by a commercial venture."

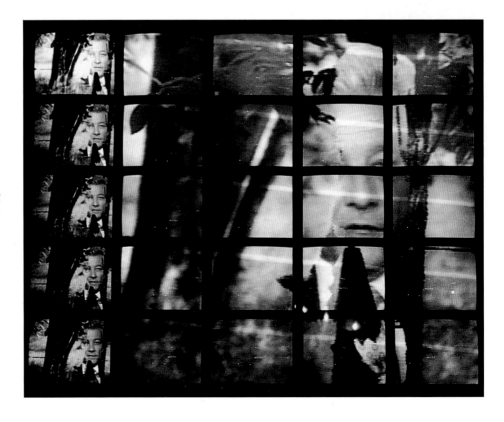

Dara Birnbaum, *Rio Videowall*, a digital video wall
comprised of twenty-five 27-inch television monitors
arranged in a grid. Two different sets of imagery/
information are displayed: one comes live from
current broadcast or news cable; the other is pre-
recorded from landscape images shot at the site in
May 1987, before its construction. There is also a
switcher with a pre-set video key, which provides a
live interactive element.

The following excerpts from an interview between Birnbaum and the author reveal the artist's thinking and underscore some of the generic problems artists encounter in their interface with business.

Marjory Jacobson: It is very unusual for an artist of your stature to enter an open competition. What motivated you to participate?

Dara Birnbaum: The real issue for me was one of accepting a challenge. I think that my entry into the competition was more a response to caring that things were done well because this was to be the first introduction of a large-scale video artwork into a public space. I naturally thought that precedents would be set. I had the grandiose notion that if I didn't at least make an effort, it could so easily turn into a video water fountain, video garden or something like that and there would be no sense of [artistic] integrity.

MJ: Why do you think that you won the competition, since your proposal was conceptually and visually so sophisticated?

DB: I think that Charles Ackerman had some foresight. He is a corporate developer and his mind works very much that way. He has an eye for event and if he talked about corporate sponsorship of things looking toward the future, his goal would be to be there first—whether it was a statue from Tibet or a video wall. That kind of catering to and use of the arts in an old sense of the avant-garde is breaking-forward territory, that is the realm of the building developer.

MJ: Did he see himself, or did somebody point out to him, that you could be the ground-breaker he was looking for?

DB: The architect [Arquitectonica] also had a kind of enthusiasm for what's new, what's different, this century, right now, what's great! The group would talk about things like microcosms of the city, all inside a plaza, and so forth. They decided that this new kind of entertainment area should not have a traditional anchor store, but that something could replace that. They had no idea what that something was other than "we need something contemporary, something that is about this generation now." They decided that the thing that represents a contemporary, youth-like population, which they were calling the "young gentry" at the time, would be electronic. Electronic eventually came down to video. I think their approach was very correct for that time. It is already happening without being labeled as such. Look at Japan. You can see art as you shop. It symbolizes our perverse future now.

MJ: I think this is a very American approach as opposed to a European one. If this were done in Italy or France, for example, it may have been understood differently.

DB: In Atlanta it was a big thing to find anyone who would be willing to take on the project. And eventually even that individual thought in a very corporate manner. This was supposed to be the perfect marriage—the breakthrough in merging corporate and non-profit. What happened, at least what my experience of it was, was that all of the arts agencies involved in the project were very weak in relationship to the corporation.

MJ: There are very few people in the non-profit arts community who understand the profit motivation.

DB: The scale of the project represented a new sense of dynamics. It was a $500,000 commitment. If you realize that the largest exhibition institutions in America were still offering a token honorarium of maybe $1,000 for a show, and if you realize that for video and its sponsorship to raise even $30,000 was a great feat, then you begin to understand the problem. At the beginning Ackerman & Co. wanted two installations at $35,000 each, and $35,000 was more than had ever been offered to most of us.

Of course, I was trying to think how I could work a much more critical edge into the piece. It was a good challenge. How does one use the material of video in a public space without it becoming the kind of direct solutions we have seen before, such as an interactive piece showing off the technology in closed-circuit TV, or pieces that are wonderfully spectacular in new events of visual language? No matter how spectacular that is, it's undercut by the fact that it can become like video wallpaper. That was always how it had been approached and the project here was to get away from that. No one understood what I was trying to do and no one was supportive of it. Everyone tried to talk me into backing down, and for various reasons—the art world because they thought it would be easier on me in a way, Ackerman because he knew what he was doing to me, and if he could reduce me to a software pack, I had less control over the project. My feeling was that it was better to have tried even if I failed. I was basically interested in the new advances in the understanding of the public space whether it was through television or a physical site such as Rio. The reason I started in video in 1977 was that it was the common language of America. I think that what Ackerman and Arquitectonica saw in it was the way they would, forgive me, beat out the competition.

MJ: Why is that bad?

DB: Because to me, when that is the sole intention of the client, when there is no other agenda, it is simply manipulation. As long as it is a human space, as long as there is pedestrian space, I thought, OK. I tried to integrate into that design a component that would yield a different sense of public in that space. Instead of just engagement at the bar, out in the open plaza, far out there in the shopping center, what else could be stated? And what else would engage people without the "tricks" that are usually involved in video.

MJ: When working on a specific business project, the artist is expected to recognize the needs of the client. The dialogue works both ways. The thing that is less often understood by the business world is that if a client is going to introduce an artist's point of view into any kind of

commercial venture, there is an obligation honestly to examine the motivation behind it. One is enjoined to comprehend, if not what the artist brings that no one else can, at the very least, that there is a distinct point of view that belongs to the artist, and that can be modified, but the artistic principle cannot be violated. If it is, there is no justification for introducing an art component.

DB: When I was at the site doing tests and edits and rough cuts on the video wall, people would come around. I was amazed

because I had been wondering with whom I was communicating. What sense of this public do I know? This was a black neighborhood the developer was trying to gentrify. I felt a little bit better that 25 percent of the entire project had to be maintained, by local legislation, as inside the black community. I had also asked myself, can a medium such as video be in a public space to act or engage with the public in any way other than spectacle? Beyond spectacle, and without devoiding it of any kind of representational meaning

with regard to the imagery used, I tried to look at how to do that.

The video wall was built, but when it is functioning at all (which seems to be rarely), it runs commercially produced programming rather than the one Birnbaum designed for the project. Part of the problem is that the shopping center is a retail failure, and the priority of bringing in more business has affected the art. This story is one of sometimes difficult communication between art and business.

Afterword

Interviewer: Do you hope your buildings and, perhaps, your name will last forever?

Architect: Gaining immortality through building doesn't interest me all that much. I'm more interested in the relationship with what's going on now. I'm concerned with the intellectual questions of what we are, why we're here, what we're supposed to leave, what is good to do, all that. I'm very interested in where we fit into the scheme of things and what we should be doing. I feel like we're doing it all wrong, and that we don't understand the big picture—we think we do, but we don't. We may all just be breathing air so that something we can't see yet can survive.[42]

CHAPTER 10
LAUNCHING AN ART PROGRAM
A Practical Guide

A business that launches a meaningful art program today is both taking a risk and breaking new ground. Buying objects of quality from eras past is a costly affair, neither practical nor financially feasible for most corporate concerns. The best a company can normally do within a reasonable budget is to find art of historical curiosity; the museum is the rightful repository for the authentic relics of the past. For these reasons, a corporate patron is often drawn to artwork produced by younger living artists knowing that there is no assurance either of its future market value or of its aesthetic endurance. In the realm of contemporary art programming, the enlightened business accepts, instead, the progressive stance of cultural entrepreneurship.

This section summarizes some of the issues and guidelines that have governed the cultural behavior of the patrons, curators and facilities planners discussed in previous chapters. Whether merchants, bankers, manufacturers or services providers, from mega-international conglomerates and publicly traded companies to small federations of business associates and family or individually owned concerns—no matter how the individual plan of a given entity is imprinted, certain ground rules are commonly shared.

First and foremost these individuals recognize, acknowledge and value the inexorable link of contemporary art to present-day life. The visual arts, especially today, are a cultural barometer monitoring how artists seek to modulate their position between the fringe and the mainstream of the modern world. During the sixteenth and seventeenth centuries in the most powerful countries in Europe, the Church and the monarchy introduced painters, sculptors, musicians, writers and poets into the upper strata of society, expanding the concept initiated by the Medici in the early years of the Renaissance in Italy. Although they have the historical distinction of being the first notable business patrons of the arts, the Medici themselves were a hybrid dynasty of princes and businessmen, and the artist, still considered a mere artisan, was only beginning to be understood as an important messenger of ideas in the manner of his humanist peers. Subsequently, business patronage was again eclipsed by royal families, the nobility and eventually the State, which continued the process of elevating the artist to honorable status. Along with their bestowal of recognition, they established through official academies and salons a constrictive system of preconceived rules and regulations until, by the close of the nineteenth century, the generation of new ideas was seriously inhibited.

Now, after a century of the ascension of business itself to credible citizenship, the new liaison between business and art brings an opportunity to set a positive agenda for creative art patronage. In no previous era have the artist and the businessman been so well positioned to work together at the level of cultural leadership outlined in this book. Various ways in which the arts can be approached with the *direct* involvement of business include:

1. Establishing a contemporary corporate art collection on the premises.
2. Instituting an exhibition program in the office.
3. Introducing an informal arts-knowledge atmosphere into the office by employing the visual arts in the management strategies and other aspects of business life: office ambience, corporate retreats, company seminars, annual reports, advertising, cause-related marketing, lectures, catalogues, wall texts and film series.
4. Organizing an artist-in-residency program tailored to company needs.
5. Organizing occasional art exhibitions and projects in and around the office.
6. Building a company museum or exhibition center.
7. Constructing a sculpture garden or court.
8. Working with architects and public partners to introduce art and art-related events into public spaces and the non-art places that are part of the larger community.

This list does not include such indirect support of the arts as:
1. Donations to museums and other cultural institutions.
2. Underwriting of exhibitions in museums and other cultural institutions.
3. Employee perks at museums and other cultural institutions (such as free membership, discounts at bookstores, etc.).

Basic Guidelines

Throughout the text of this book, passages relating to practical aspects of actual art programs have been highlighted. There are other basic guidelines:

Art can be decorative, but it is not decoration. It is a form of cultural experience.

Art is about enlightenment, not entitlement.

Serious art can also be a pleasurable experience.

Education comes in many guises—through the written word, through exposure to and participation in the artistic process—through good interior and graphic design.

Quality, not money, is the hallmark of a successful art program.

Art is a cultural investment, rarely a commodity investment. With contemporary art there is no such thing as sure appreciation.
In order to like contemporary art, one has to like and respect one's own times.

Treat an art program like any other segment of the business plan.

Remember your child could not really do that, and that, tasteful as you are in the fine art of living, you are not a professional art arbiter.

Always seek professional advice; whether you are a seasoned private collector, or a principal with no knowledge of the visual arts, you need professional expertise to make your program work. Every collector consults authorities—dealers, museum people, professional advisors. And don't let your emotions interfere with your business judgment when you are dealing with the arts.

Do not relax your standards; if anything, make them more stringent.

If you decide you want to use art as decorative enhancement alone, find an interior designer or an art consultant with taste that matches your own to do the job.

If you want to set up a program to patronize art in your region for the purpose of endorsement itself, find someone whose priority is local arts support.

If you want to identify with special-interest community groups and you wish to use art events as a social activity, work with community organizations to that end.

But if your goal is to set up a professional visual arts program of visionary dimension, and these other considerations are of significant but lesser importance, you can achieve the standards that meet the mark in some of the following ways.

The initial step for the individual businessman or organization considering a contemporary visual arts program is to determine clearly what the objective is and how the visual arts are the vehicle for realizing that aim. The possibilities are many, ranging from implementing a highly developed form of *mécénat* (as in the case of Thomas Bechtler, of Hesta in Zug), or a sophisticated cause-related marketing strategy (like that of Liz Claiborne, Inc. in the United States), to acting as an agent of culture in the community (General Mills of Minneapolis), forming a partnership between art, architecture and the public place (Römerbrücke District Power Station, Saarbrücken), or making a host of gestures whose returns can be measured in increased innovation and productivity in the workplace, increased business in the marketplace, increased goodwill in the public place, and increased awareness of the place of modern culture in our lives.

There are two cardinal rules:

1. Do not even think about a visual arts program if you do not have the vaguest interest in the arts.
2. Be the boss. You cannot delegate to your staff the setting of policy. Your consultants, whether in-house or from outside, must have direct access to you.

 If you are an avid collector and knowledgeable art expert in your own right, or have a background in or extensive familiarity with the contemporary art scene at its highest level, be your own curator (or at least director). You are in the league of PaineWebber.

 If you are like the majority of chief executive officers of a medium-to-large-size publicly traded business, in financial services, information technology or a for-profit utility provider, and the arts are not your area of expertise, hire a professional advisor and/or establish a committee of arts professionals to make the art and artists' selections and to develop the process by which the art program is managed. Decision-making with regard to artist and artwork selection cannot be made by a lay committee. The job of a committee is to legitimize the authority of the selections and to pave the way for the program to become a success within the *modus operandi* of a particular company.

Choosing a Consultant

The advice you get is only as good as the people who give it. The interface of art and business is a new discipline. Too few people are qualified to meet the demand, and there is no one resource to consult to make the task easier. *The International Directory of Corporate Art Collections* (write to *ARTnews*, 48 West 38th Street, New York, NY 10018) gives a comprehensive listing of companies that have art programs, but does not include any ranking system. There are organizations of professionals that do attempt to develop qualifications for accreditation and standards for correct business behavior in the field of art consultancy, and most countries have their own business councils on the arts. The Association of Professional Art Advisors (2150 West 29th Avenue, Suite 310, Denver, Colorado 80211) is an organization with some 50 members who are either freelance or in-house art consultants. This group is just one option. Local museum directors and other arts professionals in the community have access to the best information on who the reliable art consultants are, and can be consulted.

SAMPLE SCOPE-OF-WORK PLAN

This scope-of-work plan is based upon the acquisition of the following approximate numbers of artworks:

4–6 Integral and site-specific works of art
580 Major and minor portable works of art

Scope of work

I Phase One: Orientation and Concept

 A. Site visit and analysis. Thorough introduction to context, and site plan, architectural character and components.

 B. Define and amplify general goals of the art program.

 C. Identify all prospective locations for artworks: commissioned, site-specific works for selected areas prioritized.

 D. Establish and distribute total program budget, including integral and portable art acquisitions (including sales tax) and all support services.

 E. Provide a written program accompanied by illustrative materials for the above.

 F. Initial "concept" presentations to Corporate Art Committee (CAC).

 G. Follow-up meetings with CAC or designee.

II Phase Two: Program Development

 A. Research and develop long list of artists to be considered for 4–6 integral works.

 B. Research and develop long list of artists to be considered for major portable works.

 C. Research and develop long list of prototypical works for direct acquisition for other portable artwork locations.

 D. On-going meetings and conferences with company designee.

 E. Presentations and conferences with CAC when timely and appropriate.

 F. Write a program for each integral artwork. Interface with building architects as required for input and technical support.

 G. With company designee, develop a short list of artists for each integral artwork. Rank up to three choices for each location. Contact artists to determine their availability, interest, and schedule.

 H. Final selection of participating artists and contingency choices.

 I. Presentations to CAC.

 J. If commissions, assist company in drafting a contract with each artist,

including programmatic, architectural and technical guidelines, budget and terms, time frame and deadlines. Contract to outline a phased presentation schedule for each artist, with specific payments linked to progressive phases, leaving the artist adequately compensated for each phase of work, while protecting company and establishing a mechanism whereby company can opt not to proceed beyond a given phase. Contracts for integral art will be through company with fine arts consultant acting as advisor or liaison.

K. Schedule and manage presentations of artists' schematic proposals for integral artwork to CAC, as required. Presentations to include renderings and other support materials, as necessary.

L. Develop a complete set of recommendations for all portable artwork locations.

M. Conferences and meetings with company designee with regard to these locations and recommendations. Submission of formal documentation to CAC, as required.

N. Presentation to CAC with regard to portable artwork locations and curatorial recommendations.

O. Final negotiations with artwork vendors with regard to availability and final net prices. Commitments to respective vendors.

P. Maintain flow-through billing system.

Q. Prepare inventory sheets for each acquired artwork. Each sheet will include any particular maintenance and conservation instructions. Arrange for documentary photograph of each artwork, to be affixed to inventory sheet. Please note that documentary photographs shall be in the form of Polaroid snapshots taken by fine arts consultant. Polaroids of commissions shall be taken after installation.

R. Arrange for necessary fine arts insurance for all artworks while in transit, in storage and/or at the framer. All fine arts insurance costs are billed directly to company.

S. Furnish appropriate designee with documentation required to secure fine arts insurance for all integral and portable artworks once at the site.

T. On-going monitoring of program budget, with monthly accounting summaries submitted to company designee.

U. Arrange for accredited storage of all acquired artworks in a timely and responsible manner, if necessary.

V. Arrange for professional fine arts handlers to transport all acquired artworks to fine arts advisor-designated framer(s) and/or storage.

W. Curatorial check of all artworks at framer(s).

X. Review each acquisition with framer and specify a custom frame and archival (museum-standard) mount/mat/hinge/float, as is appropriate, on a per-piece basis. Specify hardware in anticipation of hanging system. Specify sculpture mounts if required.

Y. Specify and arrange for the design and production of wall labels and (selected) texts as required.

Z. On-going monitoring of the evolution of the commissioned artworks. Meetings and conferences with participating artists. Reports and conferences with company designee with regard to progress of each commissioned work.

AA. Review lighting plan for all artwork locations and advise company on recommended modifications and additions. This will be done with the participation of artists for major spaces.

III Phase Three: Program Completion

A. On-going monitoring of commissioned works, as they evolve.

B. On-going communications with company designee with regard to the progress of the integral works.

C. Coordinate with company designee and architects (if required) with regard to final installation schedule for each integral work. Supervise installation of each integral work.

D. Schedule (staged) shipping and delivery to site of all portable works. Coordinate with company designee.

E. Arrange for professional fine arts installation team to install each portable work, supervised by fine arts consultant.

F. Supervise the installation of each wall label.

G. After job is completed, conduct final curatorial check.

SAMPLE FIXED–FEE PROPOSAL FOR THE SERVICES OF A PROFESSIONAL ART ADVISOR

I. Business Practices

The advisor works exclusively on an hourly basis or for a pre-negotiated fixed fee. The arts advisory firm does not represent any artists, galleries, dealers, artists' estates, artists' representatives or vendors of technical services, nor stocks a collection of artworks. Any discounts, commissions or courtesies on art and related services that advisor is able to negotiate are passed on directly to the client with no mark-up.

II. Fee Proposal Terms

The fixed fee for fine arts services for the art program is determined by the projected number of principal and staff hours required to do the job, office overhead, and supplies and services. First Principals chargeable to the project are: ____

The rate schedule and projected number of hours are:

	Rate	Hours	Amount	% of Fee
First Principal				
Staff				

The average staff hourly rate is determined by the following hourly rates and multiplier of 3.5:

Research Associate × 3.5 =
Administrative Associate × 3.5 =
Secretarial Services × 3.5 =

The fixed fee is based upon a start-up date of _____ and a projected completion date of _____.

Partial payments on account of the Fixed Fee shall be made to the Consultant upon company acceptance and approval of individual portions of the work in accordance with the following schedule:

Description of work

AMOUNT

Contract Execution
Corporate Art Committee
Concept Approval
April 1, _____
July 1, _____
October 1, _____
Completion of Project
(with no additions to Scope-of-Work)
anticipated [date]
not to exceed [date]

TOTAL FEE:

III. Artwork Acquisition Scope

The fee is based upon the ultimate acquisition of approximately _____ integral works of art, _____ major portable works of art, and _____ portable corridor works of art for office building corridor spaces.

IV. Preliminary Program Schedule

The preliminary program schedule will correspond to the tasks and time distribution as detailed in the *Preliminary Task and Time Distribution* so that installations may be completed in a timely manner prior to occupancy.

Installation schedule

The consultant will be guided by the installation schedule of portable artworks as detailed above, provided that the approval process is carried out in a reasonable and timely fashion. However, the Consultant anticipates that the installation of integral *commissioned* artworks may not be completed by assigned occupancy dates, as the time frame may be unrealistic for the development, implementation and/or fabrication of such large-scale works.

Sample Project Plans

(All examples given are from the business files of the author and represent actual projects) Organizing an art program, no matter what the budget, should include a structure for a pro-forma arts-policy plan.

SAMPLE BUDGET AND BUDGET DISTRIBUTION

TOTAL RECOMMENDED BUDGET:
TIME PERIOD:
NUMBER OF ARTWORKS:

Summary

			SUBTOTALS	TOTALS
I	Art			
	1.0	Integral/Site-Specific (includes artists' fees and expenses, fabrication and sales tax. *Note:* Unusual site preparation expenses not addressed here.)		
		1.1 # works @ _____ each		
		1.2 # works @ _____ each		
	2.0	Portable Art Acquisitions (including sales tax)		
		2.1 # @ _____ net		
		2.2 # @ _____ net		
	3.0	Shipping and Delivery		
		3.1 Presentation of prototypical artworks to corporate art committee		
		3.2 From vendor to framer and/or storage		
		3.3 From framer and/or storage to site		
	4.0	Framing (includes museum-standard framing materials, hardware, and/or sculpture bases and hardware if required) _____ units; average _____ per unit		
	5.0	Storage 5.1 Warehousing at authorized fine arts facility until installation		
	6.0	Fine Arts Insurance 6.1 At storage facility 6.2 In transit		
	7.0	Installation 7.1 Installer time (_____ installers @ _____ per hr. each × 8 hrs. × _____ days) 7.2 Installer travel		
II	Reimbursables			
	1.0	Out-of-city travel and subsistence		
	2.0	Long-distance phone		
	3.0	Local travel		
	4.0	Presentation services and materials for integral art		
	5.0	Wall labels and texts		
	6.0	Messenger and express mail services		
	7.0	Polaroid film		
III	Fees			
	1.0	Principal's time FIXED FEE		
	2.0	Research, associate, administrative and secretarial time, office overhead and supplies TOTAL BUDGET		

Corporate Art–Collection Policy: A Case Study

A major telecommunications company contracted a consultant to review its corporate art-collection policy and procedures, and its management and programming with regard to the future, and to make recommendations for future revisions of the structure of its art collection. The company, whose established acquisition program has been in existence for more than fifteen years, was considering various options for restructuring its art program, which had been corporately owned and managed since its inception. The alternatives proposed were:

1. What is the most efficient way to manage the assets of a corporate art collection whose holdings are as large as those of a major metropolitan museum of contemporary art yet housed in several far-flung locations?

2. Should the corporate art collection continue to operate as a centrally managed, corporately owned and corporately planned entity, should other options ranging from total to partial decentralization to the various business units be considered or should the program be disbanded and works deaccessioned?

The consultant made the following recommendations:

"Telecommunications have become central to the development of a global economy. What petrochemicals have been to this century up to now, telecommunications will be to the end of the century and the next."
David Gillick, Telecommunications Regulatory Affairs Specialist, PA Consulting Group, London, England (from the International Herald Tribune, October 7, 1991, Special Report on Telecommunications).

As international deregulation gathers momentum, this telecommunications company has a valuable marketing asset in its corporate art-collecting know-how that can translate into a potential set point over tough competition. The company's cultural profile is at its highest in the fields of modern dance and museum exhibition sponsorship. The public perception of the company's contemporary corporate art collection ranks somewhat behind but is still one of the pillars of American business art collecting. Although other utility companies in Europe and Japan have made their mark in the arts (for example, Japan's NTT, recently privatized, is experimenting with fax and phone art, Fujitsu has its famous open air museums and P.T.T., in the Netherlands, collects), none have carved out the territory of the work environment with anything near the bravado of this company.

The partnership between the arts and the private sector is entering a new phase. Various expressions of art as culture, not decoration, are an increasingly significant component of the business plan of any company seeking a serious market share in the international economic arena. For solidifying goodwill, for presenting an image of progressive management, for fostering a sense of global responsibility, for understanding the creative experience, and simply for setting oneself apart from the crowd, the continued maintenance of the company's art collection as a corporately owned and managed asset is a viable policy structure for any company whose goal is to have a first-class corporate art collection.

The recommendation is based on the premise that [COMPANY], in keeping with its image of excellence as a telecommunications giant, is committed to a world-class level of art collecting for the work environment, well beyond the notion of art as decoration. When it comes to judging art, an area where everyone thinks his or her opinion is a virtual right of birth rather than a matter of hard-earned professional expertise, central corporate management and controls are the best way to maintain standards integral to the development of an estimable collection.

History continually tells us that all professionally praised successful contemporary art-collecting programs run by corporations are centrally controlled and managed. By definition, "successful" means those art collections that function in the corporate environment as a manifestation of enlightened self-interest both with regard to the business and the art. It is widely acknowledged that the success of any credible visual arts program, or indeed any cultural patronage undertaken by business, is effective in direct relationship to the authority of the mastermind behind the program.

In addition, decentralization of assets leads to decentralization of control. Special professional acquisition and conservation procedures, as well as the introduction of appropriate learning strategies, are becoming as important to the proper functioning of art in the workplace as instruction in the latest computer technology is to office efficiency. The material objects that are the receptacles of ideas and skill in the visual field are as essential to understanding the world as are other artforms such as film, literature, poetry, music and dance, in their own particular formats. Art and culture cannot be designated the same bureaucratic purchasing and maintenance procedures that apply to the service and repair of furniture and furnishings, for example. The mechanisms of corporate processing systems have up to now been unable to adapt to the specialized management of art in the workplace.

Finally, it is important to note that virtually all the most prestigious art programs in the [COMPANY] league subscribe to central arts policy, asset management and program control. Two prominent examples are Chase Manhattan Bank and PaineWebber.

HOW ART AND BUSINESS INTERACT

As the world looks to a future of global business ventures, those corporations that are embarking on, or continuing, successful corporate art collections are drawn to a new understanding of the arts in relation to their business goals. Visual expression is no longer merely another pretty picture on the wall but a potent way to offer to the community, regional and international, a model of responsible business conduct.

Contrary to the current wave of thinking that separates corporate art patronage from the main concern of doing business, ostensibly to keep business away from the enticing possibility of reducing art to product or service advertising, it is more important to allow art and business to interact on equal ground. Real patronage by business suggests that art support is a cultural asset and not a charitable act.

PROCEDURES TO CONSIDER

1. Establish a Fine Arts Advisory Policy Board

of Directors who are internationally acknowledged and prestigious leaders in the field of contemporary art. Although the Policy Board should not be involved in curatorial matters, it should be kept informed of major acquisitions. One of the main functions of the Policy Board should be to pave the way for the integration of the arts into the [COMPANY] structure, and not to act as a censor. The board composition should be reshuffled every four years in order to keep up with new ideas. The general areas of competence represented should include: a museum director; the director of an outside arts foundation; an outside curator; an architect; the chief executive officer or board director of another leading corporation involved in the arts; an artist; a manager from within the company; the company art curator; a recognized authority on art in public places.

2. Establish a Fine Arts Curatorial Advisory Committee, rotated every four years, to provide input to the company's curator of collections on the selection and purchase of artworks costing over $7,000 as well as advise on the development of concepts for commissions and acquisitions for major public spaces, interior or exterior.

Develop a masterplan for a carefully formulated marketing campaign to promote the association of the company with the visual arts as a tool for learning, innovation and tolerance. Mutually enlightened self interest is the key to this concept. It is important for each side to understand that art is good for business and business good for art. The ground rules of sound business behavior and the artist's freedom of creative practice must be honored and carefully monitored.

While artists' rights are not often sufficiently respected, most businesses know that inflammatory political, religious and sexual subjects can be among the dangers of introducing art into the workplace. The artist, on the other hand, is equally wary of the motives and morals of the corporation. A task force should be instituted to discuss the boundaries of the propriety of art in the workplace and to explore attitudes as to what is appropriate for public spaces. Artists, by the same token, should be educated to understand that economics and evil do not necessarily go hand in hand. It is important, however, that the two camps maintain a healthy skepticism.

One way to respond to the present and the future with regard to mutually enlightened self-interest is to start a cause-related marketing campaign using the visual arts as a vehicle to indicate awareness and willingness to become involved. The reason that the arts are an especially effective way to do this is that some of the most interesting young artistic expression of our time involves the challenges we all face in the present climate: the environment, civil rights, sexual politics, overpopulation, minority expressions, domestic violence and illiteracy.

However, it is important to remember to play to the strength of the visual expression emerging at any given moment. If a corporation follows that rule, always exploring subjects and themes that are of current interest to the artists working most creatively at the time, it is bound to develop an interesting assemblage of work that allows it to capitalize effectively on its broad interest in the current state of the world. Conversely, if the company manufactures dog food and commissions artists to make work relating to animals, or looks for a collection of dog art, it will be missing the point. That particular company will have amassed many product-related artifacts, some of which may be of cultural interest, but it is unlikely to have acquired anything of any lasting artistic value.

Best of luck!

Temporary Art Installation Series: A Case Study

[COMPANY] is in the process of distinguishing itself as a business of the future. In the fields of health care, government relations, corporate and financial services and real-estate law, [COMPANY] is demonstrating an entrepreneurial strategy that promises to make it a model interdisciplinary law institution.

[COMPANY] did not adopt this visionary attitude overnight. The philosophy of its founding fathers is the backbone of the firm and the values and responsibilities they imparted are being adapted to meet the challenges of the marketplace of tomorrow. In demonstrating its social and cultural responsibilities, [COMPANY] has responded to many community needs, always on the most enlightened and professional level.

The goal of the [COMPANY's] art program has always been to reflect the values of the firm. As the company enlarges its scope of services and readjusts its long-range priorities to meet the realities of a changing world, it is proposed that the art program be divided into two separate projects:

1. The Art Collection.
2. Art and Meaning at [COMPANY]: A Temporary Changing Installation Series designed to enhance the cultural dimension of the workplace.

Why? Because these are serious times. Along with the world at large, creative thinkers in many fields are asking questions about the physical and moral circumstances of our society. In the visual arts, some of our most promising talents are tackling current issues with the kind of energy and aesthetic success that rivals the didactic power of the Mexican Muralists. This is an unusual situation for the visual arts because, although artists have always been concerned with the ideas embodied in their work as well with its appearance, so-called socially conscious art has rarely, in history, achieved the synthesis of form and content that marks the difference between the mundane and the masterful. This new art program component will further define [COMPANY's] model of tomorrow's workplace.

A changing art installation series would accomplish the following:

1. Reflect the overall image of [COMPANY] as a firm of distinctive and distinguished ideas and people.
2. Create a forum of exchange where ideas that are of concern can be aired intelligently and creatively.
3. Allow for contemporary topics to be addressed without making permanent commitments to acquisitions.
4. Provide a ''cultural benefits'' campaign to be used in public relations efforts to define [COMPANY] as an enlightened business citizen and patron of cultural activities.

It is proposed that an experimental situation be set up with a series of works by artists who are either native to the region or are resident there. The works should include some installation aspect as opposed to being a single

painting or objects. To keep costs down the company might consider direct acquisitions rather than special commissions. The works might address a particular concern that is either of specific interest to the [COMPANY] community or of general concern to all. The works should be selected by the [COMPANY] Art Committee from a list of artists suggested by its art advisor. The works should remain in the workplace for a minimum of two months, during which time a series of events could take place. These might include an informal talk with the artist; desk-top-generated information handouts for employees and visitors, offering basic information on the pieces and the artists and giving further references, and a lunch-time open forum to monitor the process and elicit feedback.

SAMPLE BUDGET

1. Artist's fees (including lecture)
2. Artist's reimbursables (shipping, special materials, etc. associated with adapting the work for installation in the workplace).
3. Miscellaneous reimbursables (desk-top publishing, etc.) in-kind from [COMPANY].

4. Fine Arts Advisory fees (includes principal and staff time, overhead and reimbursables to be billed at current hourly fees of:
 Principal Time _____ per hour
 Assistant Time _____ per hour
 Office Administrative Expenses _____ percentage of fees
 Authorized reimbursables

SUGGESTED PILOT PROJECT ARTIST

[ARTIST] has been the recipient of several grants from the local Council on the Arts and Humanities. [ARTIST] has just won two coveted and highly competitive prizes.

Although [ARTIST] lives in [city where COMPANY is located], he/she is now in a residency program and has just completed an installation that will be exhibited there. In addition to the enclosed list of works that would be available for loan to [COMPANY], this new piece could be borrowed. Entitled *Intervention and Revision*, it explores invented history and consists of a computer printer, a paper shredder and text, among other objects. Slides and catalogues are enclosed.

Sample Educational Program

[COMPANY] has expressed an interest in stressing the cultural aspect of placing art in the corporate environment. This important function of an art program can be achieved in a number of ways ranging from the simple addition of selected informational wall texts to the staging of exhibitions in the corporate environment.

However, the workplace is not a museum. Any educational tools that are used should be low-key and provide an enjoyable pause in the business day. As part of the scope-of-work, fine arts advisors can introduce a number of ideas for the effective development of an educational program. Among them are:

1. Selected informational wall labels describing major commissions or acquisitions.
2. Theme acquisitions for particular divisions.
3. Master planning for a series of corporate art exhibitions for the building lobby (or other designated space).
4. Exploring the development of a loan program with area art institutions and galleries.
5. Setting up an "art information corner" where employees can obtain current listings of art events of interest.

NOTES

Chapter 1 Introduction

1. While Great Britain was investing heavily in mechanization, her manufacturing class as a whole had little interest in the arts. If they had any leisure time at all, the excess energy of the new millionaires of Manchester and Leeds, in the north of England, went into politics.

2. By 1890 America had outstripped England and France in their output of iron and steel, manufacturing more than one third of the world's total production (Charles A. and Mary R. Beard, *The Rise of American Civilization*, Macmillan, New York, 1966, Vol.2, p. 175.) According to one estimate, there were only three millionaires in the United States in 1861, but at least 3,800 at the close of the century (Beard, op. cit., Vol. 2, p. 384).

3. Though they did not give even as much as a nod in the direction of the art of their own country, there were some sophisticated eyes among plutocratic businessmen such as John Pierpoint Morgan (steel), Henry Clay Frick (coke), Henry Walters (railroad), Andrew Carnegie (steel), John D. Rockefeller (oil) and Andrew Mellon (business). The eventual bequest of their art treasures to public institutions has provided a reservoir of inspiration to the majority of Americans, artists among them, who did not have the opportunity to go abroad for a proper art education.

4. Most American tycoons sought to accrue cultural status not only by amassing collections of naively selected European art but by building their homes with portions of sumptuous palaces that they shipped wholesale to America. Publishing scion William Randolph Hearst's 265,000–acre San Simeon in California was the ultimate in parvenu phantasmagoria. Hearst moved there in 1925, amid the "awesome and the awful" art treasures plucked from Europe and assembled by period throughout the 146-room castle.
 The only son of a Missouri farmer and mining expert, Hearst indiscriminately mined the world for treasures from the past in places with a past. Insistently referring to San Simeon as "the ranch," he entertained there the whole of Hollywood society. Solidifying the image of art as the ultimate in corruptness on a scale that rivaled Louis XIV's Versailles (without exquisite taste as the saving grace), American satirist Dorothy Parker was inspired to jot down in the San Simeon guest book: "Upon my honor, I saw a Madonna, over the door of the private whore of the world's worst son-of-a-bitch." The Madonna to which she was referring was by the Italian Renaissance master, Lucca della Robbia. The "private whore" was Marian Davies, movie queen of the silents and early talkies, and the constant companion of Hearst, "the world's worst son-of-a-bitch."

5. Lucienne Bloch, "On Location with Diego Rivera," *Art in America*, February 1986, p. 106.

6. It is well known that Rivera changed all the rules and dallied with the limits of his artistic freedom until he was ordered to stop work on the project. After about a year, during which time some attempt was made to remove the mural from the lobby and donate it to the Museum of Modern Art, the fresco was hacked off the walls in unsalvageable chunks. If we are to arrive at a point where we have public masterpieces, monuments to civilization in and of our own time and place, we must provide a syntax for artistic freedom in the public realm. A voice of enlightenment does not pander to the middle ground. The Rivera mural is lost as masterpiece, cultural icon and historical record (even though a reconstruction made by Rivera when he returned to Mexico in 1934–35 can be seen at the Instituto Nacional de Bellas Artes in Mexico City).

7. *Selected Works from the IBM Collection*, exhibition pamphlet, IBM Gallery of Science and Art, New York, November 5, 1985–January 4, 1986.

8. Craig Smith, "The IBM Story," *Corporate Philanthropy Report*, December/January 1991, p. 1.

9. Paul Goldberger, "Corporate Design That Stays on the Safe Side," *The New York Times*, May 13, 1990, Arts and Leisure, p. 37.

10. Too numerous adequately to recount, the major attractions at the IBM Gallery have included: *Oskar Schlemmer* (1986); *Out of the Mists: Northwest Coast Art* (1984); *Postmodern Visions: Contemporary Architecture 1960–1985* (1987); *Pre-Modern Art of Vienna: 1848–1898* (1987); *The Hyde Collection* (1989); *Manet to Matisse: The Maurice Wertheim Collection* (1985); *American Paintings from the Toledo Museum of Art* (1986); *Highlights from the Smith College Museum of Art* (1990); *Graphic Design in America: A Visual Language History* (1990); *German Drawings and Watercolors from the Detroit Institute of Arts* (1990); *Pleasures of Paris: Daumier to Picasso* (1991); *Theatre in Revolution: Russian Avant-Garde Stage Design 1913–1935* (1992); and *Korean Costumes and Textiles* (1992).

11. In 1941 Roosevelt appointed him Chairman of the National Week of Art, instituted by the government to stimulate the livelihood of artists.

12. Thomas Graham Belden and Marva Robins Belden, *The Lengthening Shadow*, Little, Brown & Company, Inc., Boston and Toronto, 1962, p. 269.

13. Ibid., p. 198.

14. Ibid., p. 267

15. *Against Nature: Japanese Art in the Eighties*, exhibition catalogue, Grey Art Gallery and Study Center, New York University, the MIT List Visual Arts Center, The Japan Foundation, 1989, p. 17.

16. Deborah Solomon, "The Cologne Challenge: Is New York's Art Monopoly Kaput?" *The New York Times Magazine*, September 6 1992, pp. 20–23, 30, 45, 49.

17. Peter Paret, the German art history scholar now at Princeton's Institute for Advanced Study, defined the *Kunsthalle* (art hall) as a paraphrase of *Markethalle*. The *Markethalle* was a popular form of international display hall where industrial wares and scientific paraphernalia were put on view. Sometimes art was included in these *Markethallen* and often annual art exhibitions were presented in what came to be known as *Kunsthallen*. Toward the end of the nineteenth century, the term began to be applied to museums (Hamburg is the first place recorded as having called its museum the "*Kunsthalle*"). Paret thinks that the terms began to be used interchangeably, "either to avoid a duplication of names with other museums in the area or for political reasons. For example, a city with a tradition of self-government like Hamburg might want to call its major museum *Kunsthalle*, which is certainly a non-aristocratic term." (Letter to the author from Peter Paret, September 1991).

18. Each year a "monument prize" of DM50,000 is awarded to the property owners who have contributed most significantly to the preservation of their historic monuments.

19. Among the works purchased between 1985 and 1989 were a Harold Klingelholler sculpture for the Krefeldermuseen; a Werner Buttner for the Landesmuseum Darmstadt; a Hubert Kiecol for the Kunstmuseum Bonn; a Stephan Huber for the Von der Heydt Museum Wuppertal; a Bernhard Blume for the Museum Ludwig, Köln; a Walter Dahn for the Rheinisches Landesmuseum, Bonn; and an Anna and Bernhard Blume photographic series for the Sprengel-Museum in Hannover.

20. Catherine David, "Curators: Bernard Ceysson," *Galeries Magazine*, January 1990, pp. 103–9, 146.

21. Robert Atkins, "Scene & Heard," *Village Voice*, January 7, 1992, p. 87.

22. Sandra d'Aboville, "Interview: Alain-Dominique Perrin, le mécénat français," *Galeries Magazine*, October/November 1986, p. 76.

23. Brigitte Cornand, "Telegrams: France," *Galeries Magazine*, December 1989–January 1990, p. 19.

24. Corporate collecting in France is relatively new and, as of autumn 1992, no donation under this legislation had been made.

25. Georgina Adam, "The Fine Art of the Tax Break," *ARTnews*, April 1990, p. 53.

26. In the mid-1960's, while American artists were making icons of the products of a consumer culture, a group based in northern Italy was constructing assemblages not with the cast-offs of their country's newly exalted industrial boom, but with raw natural elements, living things and elementary science. Although the Italians often referred to nature and archaeology, the materials they used were generally not associated with high art, and their work thus became known as arte povera (poor art). The seminal members of the original group, which gathered in Milan and Turin, were Jannis Kounellis, Pino Pascali, Alighieri Boetti, Mario Merz, Marisa Merz,

Giuseppe Penone, Pier Paolo Calzolari, Gilberto Zorio, Luciano Fabro, Michelangelo Pistoletto and Giovanni Anselmo.

27. Count Panza attempted to arrange for his collection to be housed at the Castello di Rivoli in Turin, and also made inquiries in Lombardy and Tuscany, and in Rome and Venice. The prospect of negative financial repercussions led him to disperse parts of his collection to the Los Angeles Museum of Contemporary Art and to the Guggenheim Museum in New York.

28. Marcia E. Vetrocq, "Palaexpo Opens in Downtown Rome," *Art in America*, January 1991, p. 39.

29. Marcia Vetrocq, "Culture by Fiat," *Art in America*, July 1990, p. 69. The Palazzo Grassi opened to the public in 1986 under the direction of the peripatetic Swedish museum maestro Pontus Hulten, who has held founding directorships at the Centre Pompidou in Paris and at the Los Angeles Museum of Contemporary Art. Hulten, who left in 1990 to plan the new Kunst und Ausstellungshalle der Bundersrepublik Deutschland in Bonn, was succeeded by Paolo Vitti, who was the pioneering cultural affairs mastermind for Olivetti. Vitti, unlike Hulten, has a background in business and public relations rather than art and is employed directly by Fiat.

30. American investment in defense operations in Asia, beginning with the Korean War, was most profitable for the Japanese economy. By the end of the Vietnam War, the Japanese had achieved an historic record of economic ascendency.

31. In contrast to the consensus of mainstream Asian economic scholars that post-war Japan operates much like a Western democracy, the basic tenet of revisionist theory is that Japanese government institutions do not play a regulatory role; instead they are partners with business in the development of economic and social goals.

32. Patrick Smith, "Letter from Tokyo," *The New Yorker*, October 14, 1991, p. 118.

33. Dr. Thomas W. Bechtler, *Unternehmer und Künstler im Dialog: Qualität durch Kompetenz und Engagement (Entrepreneurs and Artists in Dialogue: Quality through Competence and Engagement)*, speech given at Basel Art Fair, June 1989, p. 11.

Chapter 2
Maecenas, Mécénat, Mäzenatentum

1. Alain-Dominique Perrin, quoted by Sandra d'Aboville, "Interview: Alain-Dominique Perrin, le mécénat français," *Galeries Magazine*, October/November 1986, p. 75.

2. Lewis Mumford, *Faith for Living*, New York, Harcourt, Brace and Company, 1940.

3. Interview with the author, May 1991.

4. Dennis Evans introduces the art program to employees in *First Press*, First Bank System's newspaper, 1983, reprinted in *Talkback-Listen: The Visual Arts Program at First Bank System 1980–1990*, published by Winnipeg Art Gallery in conjunction with the exhibition "Challenge in the Workplace" at Winnipeg Art Gallery, June 13–August 20, 1989, p. 48.

5. Interview with the author, May 1991.

6. Ibid.

7. *Talkback-Listen . . .*, op. cit., p. 98.

8. The results of the Employee Art Survey were enlightening if contradictory. The 30 percent response (820 out of 2700) was in itself unusually high. Although a third of respondents felt the art collection improved their working environment, most said they did not like the kind of art that was being collected. Almost all respondents read, liked and found the explanatory labels informative, yet most said that they had not learned more about art or become more curious to find out.

9. A complete account of First Bank System's visual arts undertakings appears in *Talkback-Listen . . .* op. cit.

10. Interview with the author, May 1991.

11. This was an urban reclamation project for Les Minguettes, a troubled ghetto where highrise public housing was in scandalous decay. Raynaud proposed to cover the entire surface of one of the abandoned structures with his signature tiles and to render it usable again as "inhabited" sculpture.

12. Catherine Francblin, "Raynaud's Psycho-Objects," *Art In America*, June 1991, p. 77.

13. Patricia C. Phillips, "Alfredo Jaar: The Body Maps the Other," *Artforum*, April 1990, p. 138.

14. See *Collection Caisse des dépôts et consignations, Acquisitions, 1989–1991*, Groupe Caisse des dépôts, Paris 1992.

15. Interview with the author, October 1990.

16. Paul Taylor, "The Golden Underground," *Village Voice*, July 10, 1990, p. 85.

17. As at 1994, a second Fondation Cartier is planned on the old site of the American Center on Boulevard Raspail, designed by French architect Jean Nouvel.

18. "The more I knew about the natural sciences, the more I saw that they were too narrow for me." Laib in an interview with Klaus Ottmann, "Wolfgang Laib," *Journal of Contemporary Art*, Vol.1, no.1, spring 1988, p. 90. See also interview with Suzanne Page in *Wolfgang Laib*, exhibition catalogue, ARC Musée d'Art Moderne de la Ville de Paris, October 11–November 30, 1986, p. 21.

19. Bernhard Starkmann in a letter to the author, July 15, 1991: "Our son is going to study at the University of British Columbia in Vancouver and he met Rodney Graham, Jeff Wall and Ken Lum during a recent trip there. I told him to continue his science studies, but to learn from the artists, whose ideas are so much ahead of the scientists'. I hope my son was listening!"

20. René Viau, adapted from the French by Colette Tougas, "The Crex Collection (an interview with Urs Raussmüller)," *Parachute*, no. 54, March–June 1989, p. 24.

Chapter 3 The Pantheon

1. Interview with the author, June 1991.

2. Kuh was hired by the First National Bank of Chicago in 1968 to select works for the bank's new Chicago headquarters, which were then under construction. (Walter McQuade, "First National of Chicago Banks on Art," *Fortune*, July 1974, pp. 104–11.)

3. In 1955, Chase National and the Bank of Manhattan merged to become Chase Manhattan Bank. The combined interest and intervention of David Rockefeller (youngest son of John D. Rockefeller, Jr. and Nelson Rockefeller's brother) and Skidmore, Owings & Merrill (SOM) architect Gordon Bunshaft (who was hired as partner in charge of a new headquarters they were planning in the financial district) launched the art program. SOM had by that time become known as a commissioner of blue-chip art to enhance their buildings. In the late 1940's, for a hotel owned by industrialist John Emery, who was also President of the Cincinnati Museum board, Alexander Calder was engaged to make a mobile for the lobby; Saul Steinberg painted a mural for the dining room and Joan Miró a mural for the penthouse restaurant. In 1952, a painting by Stuart Davis was installed in the lobby of the Heinz Research Laboratory in Pittsburgh. In 1954, a sculpture by Harry Bertoia was sited at Manufacturers Hanover in New York; and SOM promoted a Noguchi sculpture and garden courts at Connecticut General Life Insurance Company.

4. The founding art committee initially discussed the donation of judicious choices to the Museum of Modern Art, with tax-benefit proceeds to be used to buy work by new young artists. The bank subsequently made it a policy to keep all works. See *Art at Work: The Chase Manhattan Collection*, ed. Marshall Lee, E. P. Dutton, Inc., New York, 1984.

5. Quoted by Leonard Sloane in "Collecting at the Chase: Fine Arts Stands for Good Business," *ARTnews*, May 1979, p. 49.

6. The original committee included Alfred Barr; James John Sweeney of the Guggenheim Museum; Robert Beverly Hale, head of the department of contemporary American art at the Metropolitan Museum; Perry Rathbone, director of the Boston Museum of Fine Arts; Dorothy Miller, curator at the Museum of Modern Art; Gordon Bunshaft of Skidmore, Owings & Merrill; and David Rockefeller.

7. Calvin Tomkins, "Medicis, Inc.," *The New Yorker*, April 14, 1986, p. 89.

8. Amy Virshup, "The $2 Million Man," *ARTnews*, September 1987, p. 114.

9. "In the five years since exhibitions were introduced, the Branch's balances are up 300% and its loan portfolio has increased 500%." Manuel Gonzalez, "The Bank-as-Gallery: Chase Manhattan's SoHo Branch Celebrates a Marriage Between Commerce and Art," *BCA News*, May/June 1990, p. 5. Recently the branch moved a few doors away to Broadway, just above Houston, but the art programming continues unaltered.

10. Chase Manhattan is the only bank to operate a branch at MetroTech, a 16-acre commercial and academic complex that will house nearly 30,000 workers when completed in 1995.

11. The room is an example of early collaborative work by Gordon Bunshaft and Max Gordon, who was a member of the Skidmore Owings & Merrill team working on the building project. Max Gordon went on to become the guru of architectural spaces conceived for art.

12. Interview with Trevor Fairbrother, *The BiNATIONAL: American Art of the Late 80s*, 1988, pp. 96–97.

13. Amy Virshup, op. cit.

14. Manuel Gonzalez, unpublished speech given to the Executive Council of the Museum of Modern Art, New York, 1990.

15. Interview with the author, June 1991.

16. Joan Simon, *Susan Rothenberg*, Harry N. Abrams, Inc., New York, 1991, p. 176.

17. Charles A. Riley II, "The Confidence Game," *Art & Auction*, June 1991, p. 118.

18. Ibid., p. 120.

19. Interview with the author, April 1991.

20. Nexus catalogue. The project was called Nexus, a modification of "Next Us" and certainly a provocative slogan.

21. Arata Isozaki used the prototype of the International Building Exhibition in Berlin (IBA), in which he had participated. IBA was a German government-sponsored joint venture with developers that brought an international roster of architects to Berlin to design new urban dwelling complexes as well as to renovate housing all over the city. Fukuoka Jisho said it wanted to build a Japanese IBA in Fukuoka as an experiment in improved future urban living.

22. In a symposium on the future of museums sponsored by the Japan Foundation in early 1991, Isozaki had underscored the issue: ". . . shells pre-empting the *concept* of a museum are one of the main problems that we face here in Japan," a situation he did not encounter with Nexus.

23. The motive force behind the standardized apartments that emerged in the late 1950's in Japan was the government's need to supply an enormous volume of new dwellings to replace the substandard living quarters that commonly existed as well as those destroyed in the war.

24. Hiroshi Watanabe and Sally B. Woodbridge, "A Cross Cultural Concert in the Far East (Nexus World Kashii)," *Progressive Architecture*, August 1991, p. 79.

25. Excerpt from descriptive text by Martha Schwartz regarding *International Housing Exhibition in Kashii-Fukuoka '89*, p. 1.

26. Hiroshi Watanabe and Sally B. Woodbridge, op. cit., p. 148.

Chapter 4
The New Museums of the Magnates

1. Interview with the author, January 1991.

2. The facility is in the genre of the country "open-air" museum tradition established in Japan in 1969 by the Hakone Open-Air Museum, which was founded by Fujisankei Communications Group's Nobutaka Shikanai. Shikanai, a passionate devotee of large-scale sculpture, combined his love of art with a shrewd business decision to take advantage of the leisure time newly available to the modern Japanese worker. Visiting open-air museums with amusement parks and performance centers has since become a popular summer weekend jaunt in Japan.

3. *A Primal Spirit: Ten Contemporary Japanese Sculptors*, exhibition catalogue, Hara Museum of Contemporary Art, Tokyo and Los Angeles County Museum of Art, distributed by Harry N. Abrams, Inc., New York, p. 11.

4. *Against Nature: Japanese Art in the Eighties*, p. 15. The exhibition, co-curated by Kathy Halbreich and Thomas Sokolowski of the United States and Shinji Kohmoto and Fumio Nanjo of Japan, traveled to seven American museums before reaching its final venue at the ICA in Nagoya. The artists in this show represented a decisive turning point in the development of a new Japanese aesthetic, neither Western nor traditionally Japanese but an imaginative aesthetic investigation of a changing society.

5. William Wilson, "Japanese Art Exhibition: A Rare Find," *Los Angeles Times Calendar*, June 17, 1990, p. 89.

6. Michael Gibson, "Japan's Impresario of New Art," *International Herald Tribune*, October 1–2, 1988, Arts/Leisure, p. 7.

7. The only exceptions are three government foundations devoted to the arts, to which Japanese corporations can make tax-allowable donations, but without the liquid accessibility a private museum provides: The Japan Foundation, established in 1972 under the auspices of the Ministry of Foreign Affairs (budget $2 million); the Japan Art and Culture Foundation, inaugurated in 1989 under the Ministry of Education's Agency of Cultural Affairs; and the Ministry of Finance, which has an arts-promotion agency similar to the National Endowment for the Arts in the United States. In 1989, the Japanese budget was $420 million compared to the National Endowment for the Arts' $171,255 million.

8. Interview with the author, April 1991.

9. *Selected Works from Kawamura Memorial Museum of Art*, exhibition catalogue, Kawamura Memorial Museum of Art, 1990, p. 7.

10. *Mark Rothko*, exhibition catalogue, Kunsthalle Basel, 1989.

11. Nonie Niesewand, "Seat of Learning," *Vogue*, February 1990, p. 171.

12. Statement by Rolf Fehlbaum at the opening of the Vitra Design Museum, Vitra press information, November 1989.

13. Ibid.

14. Interview with the author, January 1991.

15. The idea of a contemporary exhibition hall in a fully operational winery is a radical approach to product-related marketing and the fine arts. The most celebrated precedent is probably the Mouton Museum in the Médoc, France. In 1922, twenty-year-old Philippe de Rothschild took over the management of one of the family vineyards and over the years cultivated a collection of wines and amassed a collection of artworks whose theme was "wine in art." The distinction of the collection was the exceedingly high quality of the chosen objects as well as the formidable relationship they forged between the finest wine and great works of art. Decorative arts in precious metals and china, votive statuary, furniture, tapestries and other mostly historic objects from many cultures and civilizations are displayed in appropriately appointed surroundings. Soon after Rothschild took over the business, he instituted the practice of bottling on the premises, a revolutionary procedure at the time. Embracing the art of his own era from 1946 on, Rothschild used the fine arts to draw attention to his business by asking illustrious contemporary artists to design distinctive labels for his wine collection. The impressive list of artists included: Jean Cocteau, Georges Braque, Salvador Dalí, Joan Miró, Marc Chagall, Matta, Pierre Alechinsky, Cesar, Richard Lippold, Henry Moore, Dorothea Tanning, Pablo Picasso, Wassily Kandinsky, Robert Motherwell, Andy Warhol, Pierre Soulages, Jacques Villon and Pavel Tchelitchew. Many of the designs were original works conceived for the labels according to specific requirements established by Mouton; some labels were coopted from sketches either owned by Rothschild, or lent by the artist or his estate. The program resulted in a minor collection of palatable designs and a major boost for business sales. In this

tradition, many other well-known brewers and liquor companies such as Absolut Vodka, Becks Beer and Heineken have followed suit.

16. Interview with the author, January 1991.

17. Ibid.

18. Ibid. "In between, I set up a foundation in Switzerland and I strongly urged our local banks to participate," said Hess. "I blackmailed them, actually, into giving me money, saying they would lose our business. So there are three people. They can be art historians, or collectors or art writers, none of them over 32, and they buy the art and every three years they're changed so the buyers are always young."

19. Other charter members included Bernhard Hahnloser, Ulrich Loock (Director of the Kunsthalle Bern), Paul Jolles, Eberhard Kornfeld and Hans-Christoph von Tavel.

20. Kunsthalle Bern has had a number of illustrious directors over the years who have helped launch the careers of a high percentage of younger artists who later received world recognition.

21. Interview with the author, January 1991.

Chapter 5 The Corporate Kunsthallen

1. Reprinted in "Ramifications: Whitney Museum of American Art Fairfield County," *Whitney Museum of American Art News*, Vol.2, No.2, July 1984, p. 7.

2. Other illustrious European *Kunsthallen* include that of Bayerische Hypotheken- und Wechsel-Bank, Munich (see p. 120), La Caixa de Pensions, Madrid and Barcelona (see p. 22), Caisse des Dépôts et Consignations, Paris (see p. 27) and Cartier International, Paris (see p. 34).

3. The Touko Museum hosted several excellent exhibitions from 1989 to 1991, among them "Strange Abstractions," featuring Americans Robert Gober, Cady Noland, Christopher Wool and Philip Taaffe and curated by Jeffrey Deitch in 1991; "Toshikatsu Endo" in 1991; "Pleats Please" (Issey Miyake) in 1990; and "Selections from the Stedelijk Museum, Amsterdam" in 1989. Supported by Touko Haus Co. Ltd., a real estate corporation, and directed by contemporary art dealer Masami Shirashi, the facility was a critical venue for exposing new global art trends in Japan. Because of its quasi-commercial structure, it is not included in the main discussion.

4. Before "Against Nature: Japanese Art in the Eighties" ended its two-year tour of American museums with a final showing at the ICA, Fumio Nanjo had left to become an independent curator.

5. Interview with the author, April 1991.

6. Koichi Tsukamoto, "Setting Spiral in Motion," from *Spiral Book*, Wacoal Art Center, Tokyo, 1988, unpaginated.

7. "Scholars, cultural figures and specialists were consulted for their expertise," reads the Introduction to the *Spiral Book* on the development and realization of Spiral. In addition to Kimindo Kusaka, the table of contents lists an illustrious cast of contributors and includes essays by Jack Lang, French Minister of Culture, on "Culture and Economy;" Daniel J. Boorstin, Pulitzer Prize-winning historian, on "Backing for the Arts;" and Masakazu Yamazaki, professor at Osaka University, on "The Role of Corporations in the Cultural Environment."

8. Letter to the author from Akiko Mizoguchi of Spiral, June 1991.

9. Curated by Hiroshi Kawanishi, the exhibition included work by Philip Taaffe, Kenji Fujita, Terry Winters, Kenny Scharf, Carroll Dunham, Nancy Graves, R.M. Fischer, Ross Bleckner, Peter Schuyff, Jonathan Lasker, Stephen Mueller and Sherrie Levine. Judy Pfaff made the only installation.

10. Essay by Roberta Smith in *Judy Pfaff: Autonomous Objects*, Knight Gallery/Spirit Square Center for the Arts, Charlotte, North Carolina, September 12–November 8, 1986, p. 14.

11. In the case of Equitable, all exhibition organization costs were covered by the corporation and a contribution of $100,000 per year was made to the main Whitney Museum exhibition program.

12. The standard contract provided by the Whitney Museum to the author states that the branch hosts "invite" the Whitney Museum "in furtherance of its [the museum's] efforts to make American art more readily accessible to the public." The corporation must agree to provide a designated exhibition area to be called "Whitney Museum of American Art at . . .," to construct and furnish that space for exhibition, storage and offices according to the plans provided by the Museum. The programming and full operation of the facility are in the control of the Museum as well. An "Initial Costs Budget" covers interior architects' fees; construction; gallery furniture and fixtures; office furniture and equipment; signage; publicity; opening receptions; and Whitney Museum overhead. A "Fiscal Year Operating Budget" covers branch staff salaries and benefits; office expenses; exhibition generation, organization and maintenance; publicity; opening receptions; educational programs; performances; manned security; maintenance; and Whitney Museum overhead.

13. Interview with the author, July 1992.

14. *The New Criterion Reader: The First Five Years*, edited with an introduction by Hilton Kramer, The Foundation for Cultural Review, Inc., The Free Press Division of Macmillan, 1988, p. 67.

15. Part of the issue may be that it was the former head of the real estate operation, Ben Holloway, who courted the Whitney to come to 7th Avenue as part of his grand scheme for billing the Equitable Center as the culture center of the future in order to lure high-rolling tenants to the slightly off-center

location. The plan failed, and many square feet of the rental space above the ten floors that Equitable occupied remained empty as much because of the real-estate slump of the late 1980's as due to the unrealistic rents.

Chapter 6 Collaborations

1. Dr. Eberhard Martini, *Oswald Mathias Ungers Gerhard Richter Sol LeWitt*, catalogue, Bayerische Hypotheken- und Wechsel-Bank AG, Munich, 1991, p. 5.

2. Stacy Paleologos Harris, ed. *Insights/On Sites: Perspectives on Art in Public Places*, Partners for Livable Places, Washington, DC, 1984, p. 34.

3. Public discussion between Siah Armajani and Cesar Pelli at the San Francisco Museum of Modern Art, January 1986, printed in *Siah Armajani*, exhibition catalogue, Kunsthalle Basel, Stedelijk Museum Amsterdam, 1987, unpaginated. In another visual venue, Dennis Potter, the iconoclastic English playwright, argued the case for the cultural potential of television, a medium that has profoundly recast the possible boundaries of the public space: "It's that chance that you carry, that sense of what pictures can do, which jumps over all the hierarchies of print that say 'You're a bum, you're uneducated,' or 'You're educated, how wonderful.' The fact that all kinds and conditions of human beings can be watching the same thing at the same time made the hairs on the back of my neck prickle." (William Grimes, "A Feast of Wit? Not Quite. Bile Flows," *The New York Times*, January 18, 1992, Section 1, pp. 13–18.)

4. By early 1981, the modern theory of "collaboration" had taken shape sufficiently to be the subject of an important exhibition, "Collaboration: Artists and Architects," organized for the Architectural League of New York by Barbaralee Diamonstein. The show featured various degrees of partnership between twelve architects and artists. In all cases but one, where artist Alice Aycock chose architect James Freed to be her collaborator, the architects selected the artists, as is the usual situation. The teams were commissioned by the league to submit proposals that could theoretically be built should an angel patron appear. Writing in the afterword of the catalogue, Jane Livingston, a curator with a sensitive sympathy for the integrated environment, assumed that future support would continue to be a government-funded mandate, although she parenthetically mentioned that the role of corporations and private foundations had attained some visibility but no clear definition. Although certainly nothing like a mass movement, the collaborative dialogue was significantly explored in these few projects. (Barbaralee Diamonsten, ed., *Collaboration: Artists & Architects*, Whitney Library of Design, New York, 1981, p. 160.)
 In actuality, the full-scale collaboration prototype of the modern age (between artists, technicians, architects and corporations) can be traced to "Art and Technology," a three-year interchange between a number of California artists and corporations, organized through the Los Angeles County Museum

by the curator Maurice Tuchman in the late 1960's. An exhibition at the museum in 1971 examined the project and provided a painstaking summary of the attempt to involve business more closely in lending technical and financial support to the artist rather than inviting the artist to contribute the concept of spacemaking. These auspicious beginnings prompted predictably mixed and frustrated reactions. Even ten years later, Livingston could still only wish that "such catalytic acts of patronage might eventually result in an actual tradition of permanent works of art that are integral to their sites—works which use both natural and artificial light, building materials, acoustical properties, furnishings and spaces themselves in ways which convey the best thought of the artist and, by influence, the best thought of the architect." (Diamondstein, op. cit., p. 160)

Looking back at "Collaboration," the League's presentation of unrealized but realizable projects, there were a few where the bonds of tradition were sufficiently loosened to signal the future. There were, for example, Richard Serra's and Frank Gehry's *Connections*; Alice Aycock's and James Freed's *Mythical Waterworks*; the *Ellis Island* piece by Susana Torre and Charles Simonds; *The Four Gates to Columbus* by Emilio Ambasz and Michael Meritet; and even the more classically grounded *Hexagonal Room* by Cesar Pelli and William Bailey. "It was the intention of William Bailey and Cesar Pelli to produce a work of art not merely sympathetic to the paintings of Bailey, or the architecture of Pelli but to create a work . . . which is a synthesis of each. The formal and aesthetic qualities of the architecture and the paintings should be mutually reinforcing, each responsive to the other in precise ways." (Diamonstein, op. cit., p. 118.) For Ambasz and Meritet, the inspiration of Columbus, Indiana, where J. Irwin Miller, mogul patron and Chairman of Cummings Engine Company, spawned a laboratory for new architecture, produced a scheme for four processional entry routes to the city where trees in different orders supplanted statuary.

5. Armajani's relationship with architect Cesar Pelli had grown closer as a result of their collaboration on Battery Park City Financial Towers and subsequently led to other private-sector projects with Pelli. Yerba Buena Tower (1989), a downtown office building in San Francisco, and Skybridge (1988), which connects Minneapolis's downtown office buildings and stores, were two projects on which Armajani and Pelli collaborated. The juncture of art and architecture for the Yerba Buena Tower was at the skyline of the building. "One thing that this is not, this is not a sculpture on a building," was Pelli's observation. "This is all one building from the ground until the very tip of the building top . . . Here the functional requirements are slight and the formal opportunities are great so this is a very good area for collaboration where the architect can stretch the natural boundaries of architecture and the public artist can stretch the natural boundaries of public art until we create an area of commonality." (From a public discussion between Siah Armajani and Cesar Pelli at the San Francisco Museum of Modern Art, January 1986, printed in *Siah Armajani*, exhibition catalogue, Kunsthalle Basel/Stedelijk Museum Amsterdam, 1987, unpaginated.)

6. Michael Brenson, "Battery Park Plaza Design Unveiled," *The New York Times,* December 1, 1983, p. 28. In December 1982, seven artists were formally invited to take part in the competition: Athena Tacha, Robert Morris, Robert Irwin, Richard Fleischner, Harriet Feigenbaum, Scott Burton and Siah Armajani. They were asked to consider working as a team. In April 1983 they made their proposals to the Fine Arts Committee; Pelli was asked to participate but had no final vote.

7. Cesar Pelli and Nancy Rosen, "The Chemistry of Collaboration: An Architect's View," *Insights/On Sites: Perspectives on Art in Public Places*, op. cit. pp. 36–37.

8. *Artists and Architects Collaborate: Designing the Wiesner Building*, Massachusetts Institute of Technology Committee on the Visual Arts, 1985, p. 52.

9. I interviewed Michael McKinnell in his office, Michael Singer at mine, and Richard Fleischner in his Providence, Rhode Island, studio.

10. Interview with the author, April 1991.

11. Ibid.

12. Jean E. Feinberg, "Michael Singer: Ritual Series," *Arts Magazine*, June 1983, p. 69.

13. Interview with the author, April 1991.

14. Ibid.

15. Ibid.

16. Roger Kimball, "Art & architecture at the Equitable Center," *The New Criterion*, November 1986, p. 24.

17. Michael Brenson, "Museum and Corporation – A Delicate Balance," *The New York Times*, February 23, 1986, Section 2, p. 1.

18. Ibid, p. 28.

19. Kimball, op. cit., p. 27.

20. At the time of its unveiling at the New School, Benton's mural received international exposure in the media as an optimistic portrayal of American life, a reaffirmation of Realism in the wake of the Abstractionist movement that was engulfing the liberal intelligentsia and a rebuttal to the Socialist manifesto. The critical and political avant-garde, at the time solidly behind abstract art and revolutionary Marxism, reviled the work and its maker as "chauvinistic," "reactionary," "opportunist" and "anti-Semitic," calling Benton a "jingoist son-of-a-bitch who whitewashed his Socialist leanings and sold out to the capitalists." In one of his memoirs Benton retaliated: "When I began answering criticism of our joint movement with the same smear techniques, Reginald Marsh said of me, 'It was Tom Benton who made the enemies of American Realism.'" (Thomas Hart Benton, *An American in Art*, University Press of Kansas, 1969, p. 173.)

21. David Whitney, Whitney Museum curator, was consulted on this and the Burton commission.

22. Bernice Rose, *The Drawings of Roy Lichtenstein*, The Museum of Modern Art, New York, p. 177, n. 54. See listing of other mural proposals and commissions.

23. Douglas C. McGill, "Art People: Public Space But is it Art?" *The New York Times*, February 7, 1986, p. C30.

24. Since his early performances in the 1970's Burton has been experimenting with spatial perception based on various theories, as well as his own observations, of behavioral psychology. At first, he worked with real actors moving around in spaces sparsely furnished with readymade furniture. In these tableaux there was already an implication of positive and negative volumes that led Burton to make his own furniture. Reversing the equation, Burton omitted the actors and worked on the issue of configuring the furniture as behavioral/sculpture, "enlarging our idea of what art may be to its audience, and what it may mean in the world." (Elizabeth C. Baker, "Scott Burton: 1939–1989," *Art in America*, February 1990, p. 163.)

25. Douglas C. McGill, op. cit.

26. Named for the Classical front of the bombed public library, a "relic" that König kept for the facade of the exhibition space he had built behind.

27. Interview with the author, June 1991.

28. For a discussion of Fritsch's *Die Gelbe Madonna (The Yellow Madonna)* for the Münster Skulptur Projekte in 1987 and several designs for public areas, see Julian Heynen, trans. Catherine Schelbert, "Speculations on Trucks, Cemeteries, Foxes and Other Images," *Parkett* (no. 25, 1990). The Münster Skulptur Projekte was a city-wide public art event for which sixty-four artists representing the international avant-garde were invited to make new works in the context of sites around the city they chose themselves. In the words of organizer Kasper König: "The close interrelation between the city and the artist's project, upon which the organizers insisted and which was accepted by nearly all artists, does not facilitate the understanding of the exhibition, neither for foreigners unfamiliar with the city and its history, nor for the population of Münster who is induced to view its city with new eyes. So the ideal visitor to this exhibition is not the participant in international art tourism though we welcome him as well . . . but the 'flaneur' who idly walks through Münster and follows the interplay of art and city."

29. "Even if they could, by nature, belong where they are, their actual, unexpected appearance isolates them, even dislodges them . . .," Julian Heynen, op. cit., p. 54.

30. In earlier work for which he has been praised, Schütte had made temporary public sculpture/buildings exploring how the shape of space affects perception, a fully developed example of which is *Eis* (1987), his functioning refreshment stand for Documenta VIII.

31. Of *Kirschensäule* (*Cherry Column*), which he made for the Münster Skulptur Projekte in 1987, Schütte said: "The cherries I made on a column—I could just transplant it and mass produce it five times for five different cities. Yet it was made for a specific place. And the situation this piece was specially made for also changed afterwards. I placed a kitsch sculpture in the middle of a car park. But it's not a car park anymore. Now there's an interesting sculpture in the middle of a kitsch place!" (*Possible Worlds: Sculpture from Europe*, exhibition catalogue, Institute of Contemporary Arts, London, November 9, 1990–January 6, 1991, p. 71.)

32. Letter to the author, February 1992.

33. Essay by Michael Newman in *The Analytical Theatre: New Art From Britain*, Independent Curators Incorporated, New York, 1987, guest curators Milena Kalinovska and Michael Newman, p. 51.

34. Dr. Eberhard Martini, op. cit.

35. Statement by Oswald Mathias Ungers on his being awarded the BDA (Bund Deutscher Architekten) grand prize for 1987, published in "When one deals with architecture," *Lotus International*, No.57, 1988, p. 35.

36. *Gerhard Richter 1988/89*, exhibition catalogue. Texts by Anna Tilroe and Benjamin H.D. Buchloh. Museum Boymans-van Beuningen Rotterdam, 1989, p. 29.

37. Gerhard Richter was born in Dresden in 1931, emigrated to Düsseldorf in 1961 and showed his work in Western European capitals from that time on. Sol LeWitt is American, born in Hartford, Connecticut, and has been exhibiting professionally in New York City since the early 1960's. Both were forming their aesthetic politic during the 1960's, when Pop Art and Minimalism were in the vanguard. Whereas Richter went through, and continues to practice, a number of exercises in figuration and in geometric and expressive abstraction, with the photograph as image source, LeWitt, immersed in the vocabulary of Minimalism, identified and codified the Conceptual movement.

LeWitt not only defined Conceptual art in widely read articles that he wrote in 1967 and 1969, but also assigned to his brand of Conceptualism a kind of purist ethic. If LeWitt came across the work of Richter in the late 1960's in Germany (which he may well have), he would undoubtedly have approved. Indeed, back in 1967 he had written: "Ideas may also be stated with numbers, photographs or words, or any way the artist chooses, the form being unimportant." Richter and LeWitt, although seemingly at opposite poles, share a significant common turf. They both approach the craft of visual art on a highly conceptual basis and each has made a notable contribution to the artistic discourse on the issue of space. Never before the Düsseldorf commission have LeWitt and Richter invited such provocative comparison.

38. Partners in the San Francisco project include the member agencies of the San Francisco Domestic Violence Consortium and its advisory council, Gannett Outdoor, the City of San Francisco through the Commission on the Status of Women, Marin Abused Women's Services, the San Francisco Child Abuse Prevention Center, Manalive and MOVE (Men Overcoming Violence).

39. Interview with the author, November 1991.

40. For a study of corporate bias imposed on cultural information, see Herbert I. Schiller, *Culture, Inc*.

41. Interview with the author, November 1991.

Chapter 7 Beyond the Sculpture Gardens of the Tycoons

1. Interview with the author, May 1991.

2. Noguchi is an often unacknowledged primary source of the sculptor's garden, which has become the staple of the public artmakers in America now.

3. See *In the Mountains of Japan*, text by Sam Hunter, photographs by David Finn, Abbeville Press, New York, 1988.

4. Everett Potter, "A Forgotten Art: A Conversation with Ian Hamilton Finlay at Stonypath, Scotland," *Arts Magazine*, September 1987, p. 83.

5. Ibid.

6. Paul Goldberger, "Public Space Gets a New Cachet in New York," *The New York Times*, May 22, 1988, p. 35.

7. Ibid.

8. Bartlett pointed out during interviews with the commission that the specific components of the garden were under continuous discussion and that the maintenance cost of the piece would be "perpetually" due to its nature. The artist reiterated that if BPCA could not ensure its maintenance, it was best not done and another artist be selected. (Letter to the author, October 1992.)

9. Although Bartlett was influenced by Monet's garden at Giverny, she might also have been paraphrasing Cézanne. "One must make an optic," he said, "one must see nature as no one has seen it before." The nature that Bartlett saw for the South Garden at Battery Park City had been seen many times before, by the artist herself. "It is just exactly the same old song," she said, referring to the elements of the South Garden, which uses her standard vocabulary of the grid, obsessiveness with detail, voracious research and wild appropriation of motifs from the history of modern art—in this case of earlier landscape models. The typical follower of the art scene in the 1980's would be familiar with the rise to fame of Jennifer Bartlett, the American artist whose "In the Garden" corps d'oeuvre became her signature format. The garden and its accompanying elements of nature had been instigators in two series of Bartlett's work since the mid-1970's. In terms of garden architecture, she was inspired by Lawrence Johnston's Hidcote Manor in England. Her use of small spaces has its origins in the Japanese garden type. (Letter to the author, October 1992)

10. Paul Goldberger, "Exclamation Point for Battery Park City," *The New York Times*, March 11, 1990, Architecture/Design, p. 41.

11. Jennifer Bartlett, talk given at Harvard Graduate School of Design, February 1987.

12. Carol Vogel, "Again: South Garden," *The New York Times*, February 14, 1992, p. C17.

13. Technical know-how and contributions in kind were committed by the Atlanta Department of Parks, Recreation and Cultural Affairs, the Atlanta Housing Authority, Gibralter Land Inc., the Atlanta Botanical Gardens, and the Mayor's Office and the Urban Gardening Program of Atlanta. Staffing organization was centered around a resident master gardener and community volunteers.

14. Interview with the author, April 1992.

15. Interview with the author, July 1992.

16. Webster had made two smaller garden-derived sculptures that were, in retrospect, precursors to the evolution of the Atlanta Garden Project. The most recent was *Glen* (1988), a commission for the Minneapolis Sculpture Garden and the Walker Art Center. It is site-specific to the surrounding landscape and consists of a circular pit excavated in the side of a slope with interior tiers of specifically chosen and arranged flowering plants. The exterior, resembling a ritualistic mound, consists of packed earth bisected by a wedged steel entryway. *Hollow* (1985), for the Nassau County Museum, was an earlier version of *Glen*, with its severe exterior, single access and lush interior. Since her graduate years in sculpture at Yale and her first "coming out" exhibition at Art Galaxy Gallery in 1985, Webster has used sand, soil, hay, seedling and other plantings to make architectural sculptures, many enterable, and meant to enter into conversation with nature. If you could not actually go into the structures, you could lie on them or perceive them as usable in some way or another. Enclosure was either implicit or implied. Many reviewers called them landscape sculptures, a linear outgrowth of the earthworks and Minimalist experiments of her predecessors.

17. Interview with the author, July 1992.

18. Interview with Trevor Fairbrother, *The BiNATIONAL: American Art of the late 80s*, pp. 214–15.

19. Letter from Claiborne's art consultant to the author, October 1992.

20. Interview with the author, May 1991.

21. Interview with the author, May 1991.

22. The opportunities available to these artists came mainly through the Federal Government's 1%-for-Art program; university campus projects, most notably the Manilow Sculpture Park at the University of Illinois; the Stuart Collection at the University of San Diego; and a handful of public parks privately endowed (by individual and corporate funding), like Laumeier Park, Wave Hill, Art Park and Storm King.

23. *Sitting/Stance* (1984–86), Artschwager's first fully realized outdoor ensemble, was an important contribution to the annals of public art. Artschwager furnished the patio, a triangular outdoor room carpeted with hexagonal stone pavers, with chairs, picnic tables, lighting and a potted tree (Halka honey locust). There are four oversized chair types: two lounge chairs of purple heart on stainless steel frames and two Egyptoid thrones of granite, two stainless steel picnic tables, whose "umbrellas" are a lamppost, and a tree.
The cerebral content of *Sitting/Stance* is described by Herbert Muschamp as drawing on "the architectural context and thinking that shaped it [Battery Park City]." "The design guidelines sought to create by executive control the kind of environment that once developed without it, and it has that look of the artificially natural, the planned spontaneous, the authoritarian casual," Muschamp thought. "The work as a whole projects an oddly suburban mood, a summertime air of odds and ends thrown together for seating at a backyard barbecue." (Herbert Muschamp, "Between Art and Cars," *Richard Artschwager: PUBLIC (Public)*, exhibition catalogue, Elvehjem Museum of Art, University of Wisconsin-Madison, September 14-November 10, 1991, p. 77).

24. The piece was fabricated in the Minneapolis region using indigenous materials. Artschwager's scheme called for a large tree, but the building and grounds people and a local nursery decided that a smaller, slow-growing species would acclimate to the space best. When Artschwager came to visit, he reiterated that the whole entity was determined not only by the inclusion of the tree but by its scale. "I'm an old man. I don't have time to wait," he said. "Go out and buy a big tree, If it dies, I'll pay for it!" (Don McNeil, interview with the author, May 1991).

25. In 1970, Siah Armajani had also built a structure around a tree in Minneapolis, a temporary installation called *Bridge Over a Tree*. Whereas Artschwager uses the language of furniture to locate a site, Armajani settled on the transformation of basic architecture and building types (the very existence of which depends on a public purpose) to enrich the experience of access, passage and assembly. All are functions of a public place. As a rhetorical exercise, *Bridge Over a Tree* spoke of the need for architecture to accommodate itself to its surroundings. In another parody of reversal like Artschwager's *Oasis*, the bridge steps aside rather than trammeling nature. After about 1978, Armajani developed an interest in making "gathering spots"

and was commissioned to design a number of outdoor garden rooms for reading, musical events and even picnicking.

26. In the main, Ferrara's most successful outdoor pieces had been executed in wood, the material with which she was most comfortable. During the 1970's, Ferrara had developed methods of stacking and piling wooden planks to make objects recalling ancient architectural forms like pyramids, ziggurats and mastabas. Most of them were constructed in the studio in two-dimensional graphs and small-scale models. "I didn't think I was doing something radically different in the studio, or in the conceptual part of the studio work when I was working on something for public placement or on an object," Ferrara has said. "The way I approach it, the way I work it out (in any scale) is exactly the same." Nancy Princenthal, "Placemakers: Jackie Ferrara's Sculpture," *Jackie Ferrara Sculpture: A Retrospective*, exhibition catalogue, The John and Mable Ringling Museum of Art, Sarasota, Florida, February 7–May 31, 1992, p. 63

27. Michael Klein, *Jackie Ferrara*, exhibition catalogue, The University Gallery, University of Massachusetts at Amherst, September 13–November 2, 1980.

28. Interview with the author, May 1991.

29. Paul Parker, *The Role of Art in the Corporate Culture,* Association of Corporate Art Curators, Chicago, May 9, 1984.

30. Jolles was chief negotiator and policy maker for Swiss trade and foreign economic relations and was often caught in political crossfire, nationally and internationally, experience relevant for the director of an art program.

31. Father of Bernard Tschumi, the leading Deconstructivist architect and the author of the distinguished Parc de La Villette (1982–85) in Paris.

32. On that committee were: Maurice Besset, Professor of Art History and Architecture of the Twentieth-Century at the University of Geneva; Franz Meyer, former director of the Kunstmuseums in Basel; Jean-Christophe Ammann, director of the Museum of Contemporary Art in Frankfurt; and Kasper König. The group met a number of times with Jolles, and sometimes with Nestlé's Chief Executive Officer Helmut O. Maucher, to formulate the overall strategy of selecting artists who would make specific works in the context of the building and the city.

33. "The impression of creating a sculpture garden was carefully avoided. The works form a coherent group and are related to each other. They are not chosen to act by themselves in a neutral space, but to respond to the architectural and environmental context in which they are placed." Claudia Jolles on the Nestlé Sculpture Project, in a letter to the author from Dr. Paul R. Jolles, October 1992.

34. Ibid.

35. Ulrich Rückriem, born in Düsseldorf in 1938 and trained as a stonemason, is perhaps Germany's most celebrated post-war Modernist sculptor. (Rückriem has exhibited in almost every important institution and exhibition in his country, as well as in the Venice Biennale, Documenta VII, VIII, & IX and the Münster Skulptur Projekte (see Chapter 6, note 28). On the surface, his work may seem disarmingly retrograde; his medium is stone, his method is carving—the most traditional of sculptural languages. The shapes he employs are basic geometry (the circle, the square, the rectangle) and the results are three-dimensional volumes, vertical or horizontal in orientation, evoking the primordial atavism one might experience in the architecture of Stonehenge or in the ruins of pre-Classical Knossos or Mycenae. As a Modernist, Rückriem is steeped in Minimalism, process and seriality—the movements that had international currency during his formative years. After considering the site for an installation, Rückriem goes to the quarry, chooses the blocks, returns to the studio and generates drawings, mapping the cuts and the types of markings he wishes to be evidenced. "Most often the sculptures are made by professional workers at the quarry. My work is to watch over the process in order to obtain exactly what I want. Making drawings, organizing, negotiating, deciding, rejecting has become my real work . . ." (Rückriem quoted by Daniel Soutif, "Sculpting the Interior of the Volume," excerpt from an essay originally published in French in *Artstudio*, no.3, winter 1986–87, pp. 104–15; and translated by Donald Young in *Ulrich Rückriem*, Donald Young Gallery, Chicago, Illinois, 1987, unpaginated.)

36. English translation of Benjamin Buchloh, "The Petrification of Progress: Notes on the Sculpture of Ulrich Rückriem," in *Ulrich Rückriem*, Donald Young Gallery, Chicago, Illinois, 1987, unpaginated.

37. A revealing insight into Kirkeby's sculptural pursuits is given in *Nachbilder*: "Am sitting in a room. Rereading Loos. 1910 architecture. 'A house must please everyone, as distinguished from a work of art which does not have to please anyone . . . Only a small part of architecture belongs to art: mausoleums and monuments. Everything else, everything that serves a purpose, must be excluded from the realm of art.' So I am sitting on the fifth floor in the shadow of my huge, useless block of stone, feeling good. The television is on. But what about my tower for the tramway inspector in Bremen? There they are working on the basement. Can I sit and write there? Would that serve a purpose?" (*Nachbilder*, text by Per Kirkeby, Verlag Gachnang & Springer, Bern/Berlin, 1991, trans. Annette Mester for *Documenta IX*, exhibition catalogue, Edition Cantz, Kassel, 1992, Vol.2, p. 309.)

38. Bice Curiger, trans. Catherine Schelbert, "With Kirkeby against 'The Affectation of Academic Dispassion,'" *Parkett*, No.4, 1985, p. 70.

39. Kelly spent his formative years in Paris (1949–54), where his mentors included Kasimir Malevich, Piet Mondrian and Henri Matisse. Kelly's imagery always derives from the observed world of nature and architecture, with figure as shape and ground as

surrounding space. Silhouettes, contours and edges, the abutting of two planes, unarticulated planes of flat color or black and white are carefully situated to call attention to the essential language of form. An established original in the United States, Kelly has been showing his paintings and sculpture liberally in New York since the early 1960's when the "new abstraction" came into vogue. There has recently been a new-found reverence for Kelly on the international scene, and his work has been included in most of the important biennials and global surveys.

40. Jennifer Bartlett, talk given at Harvard Graduate School of Design, February 1987.

41. The subject of Modernism and landscape architecture was explored in a forum, a transcript of which was published in "A Convergence of 'isms'," *Landscape Architecture*, January 1990, pp. 56–61. Moderator Peter Jacobs, ASLA, is professor of landscape architecture at the University of Montreal. Elizabeth Meyer is assistant professor of landscape architecture at Harvard University's Graduate School of Design. Martha Schwartz is principal of Martha Schwartz, Inc., in Cambridge, Massachusetts.

42. Ibid, p. 59.

Chapter 8
Not Just Another Canvas On The Wall

1. Letter to the author, July 1991.

2. Mario Diacono, an Italian writer who taught Italian literature at Berkeley and Sarah Lawrence College in the 1960's and 1970's, had always been involved at the critical edge of the visual arts. He returned to Italy in 1976 and opened an art gallery first in Bologna (1977–78) and then in Rome (1980–84) to exhibit the work of the emerging trans-avantgarde, arte povera artists and American artists who followed that aesthetic. In the early 1980's in Rome, Diacono showed the work of Americans Julian Schnabel, David Salle, Eric Fischl and Jean-Michel Basquiat. When Diacono later moved to Boston, Massachusetts, he continued to apprise Maramotti of new trends and inflections. As a result, the collection has become a serious reckoning of international scope, always exploring the seeds of the next wave.

3. As a member of a family of intellectuals whose father, a professor of Roman philology, was close to the Futurists, Maramotti himself was drawn to art and literature. His mother, on the other hand, operated a dressmaking school, which was clearly the impetus for his decision to become a clothing manufacturer.

4. Interview with the author, fall 1991.

5. Alliance Capital's London office has a collection of about 150 modern British prints that is particularly strong in the Bloomsbury School, Claude Flight and his circle, and includes important examples of Stanley W. Hayter and the group of English printmakers who were influenced by his *Atelier 17*.

6. Interview with the author, October 1990.

7. Dave Williams, "Why Prints?" a speech given at the Cosmopolitan Club, New York, March 8, 1988.

8. Both Reba and Dave Williams have MBAs from Harvard University. Mrs. Williams, a former securities analyst, left the business world and is in the process of studying for a doctorate in art history.

9. Dave Williams, op. cit.

10. Ibid.

11. Interview with the author, October 1990.

12. Interview with the author, March 1991.

13. At last count, the collection numbered approximately 500 works, and a complete catalogue, to replace the earlier documentation of the collection produced in 1982 and now of course very out of date, was being prepared.

14. Interview with the author, March 1991.

15. Ibid.

16. Ibid.

17. David Oates, "Gaining a Competitive Advantage—Highlights from The BOC Group's International Executive Development Programme," *BOC Group Management Magazine*, April 1987, p. 1.

18. In the 1970's, after an auspicious beginning with prints, multiples and books by all the American Pop Art group (Oldenburg, Warhol, Rosenquist, Rauschenberg and others), Goodman began to incorporate into her Pop stable publishing projects with the younger Conceptualists, artists such as Dennis Oppenheim, Ed Ruscha and Sol LeWitt, who were often employing photography in their work. During the first part of the decade, Goodman's introduction to the European scene came by way of the Fluxus artists and the editions she co-produced with Rene Block, the legendary figure in post-1950's European print publishing. Up to the early 1970's, American art had dominated the international scene and post-Second World War European art had little exposure in America. By the end of the 1970's, Marian Goodman had developed an exhibition program for her gallery in America that concentrated in primary market works by many of the major artists of the European avant-garde. She continued to publish major prints, but less frequently.

19. Craig-Martin studied at Yale in the 1960's with a group of artists who went on to achieve significant recognition: Brice Marden, Jennifer Bartlett and Chuck Close. Until recently lesser known than his classmates, Craig-Martin has been a revered teacher at the Goldsmiths College of Art.

20. Roberta Smith, "Wholesome Enough for Children," *The New York Times*, March 15, 1991, p. C26.

21. *Commersant* was founded in 1908, suspended in 1917 and revived in January 1990 as a joint project with Refco. The trade newspaper, which is still in publication, provides the English-speaking business world in Canada, Europe and the Far East with news of current events, political analysis and law and information on new business ventures in Russia.

22. In her acknowledgments, Frances Dittmer singled out the Chicago art dealer Rhona Hoffman as an influential aesthetic mentor in the development of the Refco collection.

23. Interview with the author, June 1991.

24. Werner Döttinger, foreword to *Gerhard Merz: Tivoli*, text by Laszlo Glozer and Vittorio Magnago Lampugnani, Verlag der Buchhandlung Walther König, Köln, 1986, p. 1.

25. Some of these works are now located in the offices of Döttinger/Straubinger Vermögensverwaltung GmbH, a newly founded asset management firm, also in Munich.

Chapter 9 Entrepreneurship and Culture

1. Dr. Thomas Bechtler, *Unternehmer und Künstler im Dialog: Qualität durch Kompetenz und Engagement* (*Entrepreneurs and Artists in Dialogue: Quality through Competence and Engagement*), speech given at Basel Art Fair, June 1989, p. 8.

2. Their diversified interests include telecommunications and traffic control electronics, safety and environment electronics, office communications and business administration equipment, industrial ventilation and air conditioning technology.

3. The book, entitled *Management und Intuition*, was published in German in 1987 by Verlag moderne industrie, Zürich, and translated into Japanese and Dutch. The English summary used here was provided by Bechtler for this study.

4. Tinguely died in August 1991, almost immediately after the piece was finished. The Bechtler family has had a long association with Tinguely; they helped to finance his public works in Zürich, and have an estimable collection of his sculptures and drawings, many of which hang in the halls of the corporations. Hesta Properties also uses a Tinguely drawing for its mailing labels.

5. Dr. Thomas Bechtler, op. cit., p. 9.

6. Ibid., pp. 11–12.

7. Lecturers included Andrea Miller Keller, Senior Curator at the Wadsworth Atheneum in Hartford, Connecticut, and a LeWitt scholar; Philip Yenawine, of the Education Department of the Museum of Modern Art, New York; and architects Thompson, Ventulett, Stainback & Associates.

8. Jerry Peart, a Chicago artist/entrepreneur of the

younger generation, who is active in the arena of sculpture for public spaces, makes colorful abstract painted steel sculptures. Competent, yet commonplace in the corporate landscape, the work cannot compete with the level of talent, imagination and innovation of LeWitt and Tinguely. Peart's selection, made by group decision with the input of the architects and a Hesta representative rather than imposed from Zürich, points to the virtue of informed curatorial choice versus unquantifiable taste. "We went through a lot of review and observation of what seemed to be attractive for a 'park like' atmosphere and would also be pleasant to look at." (Harry Trimakas, Treasurer and Vice-President of Finance, interview with the author, July 1991.)

9. An informative catalogue was published for the exhibition, and included an essay by art critic Kim Levin.

10. Focusing on the bank of three elevators interrupting the LeWitt wall, Mallozzi was reminded of disconnection, and of the real experience of taking the elevators to the parking garage: "It's the idea of puncturing the work, or fragmenting it in some way at points. I figured out the approximate halfway point of each sentence and interrupted it with three sounds that are completely out of context and have nothing really to do with anything that is going on in the text. They are a harpsichord, some kind of scratching sound and a recording of the elevator bell tone which I then lowered one octave . . . So there is the first half of the text with the background and then the whole thing is interrupted by these three sounds which form a kind of mechanical rhythm of their own . . . I thought that would work particularly well in this elevator. The piece in some ways is very much an interruption of what one expects to have in an elevator. In a given elevator ride you are only going to hear maybe one sentence from any of this text, which is eight sentences long—just because of the time it takes to ride the elevator. Your listening is essentially being interrupted by your own travel . . . It seems like a lot of my work recently has to do with memory, different ways we remember, interpreting memory, remembering things for other people, forcing people to remember things in a certain way . . . I have worked a lot with a [little] girl from Chicago who has performed several of my pieces and done recordings for me, she is the girl voice of this piece, too. I use the child as receptacle for adult language and experience and put that child in some kind of context as conveyor of that material." (Interview with Ann L. Shengold in *RSVP: Six Artists Respond*, exhibition catalogue, The Hans and Walter Bechtler Gallery, "A Place for the Arts," Carillon, Charlotte, North Carolina, May 1, 1992–January 24, 1993, pp. 16, 17, 19.)

11. It was never clearly established as to whom the art amassed by Charles Saatchi belonged—to himself, his family or his business. As the 1980's closed, Saatchi & Saatchi became one of the business casualties of the decade, and much of the international collection was sold. Many young artists of considerable talent were affected as the fair market value of their work, buoyed up by Saatchi's voracious habit of buying out whole exhibitions, was

deflated soon thereafter on the auction block. As the 1990's unfold, Charles Saatchi has turned to emerging artists in England, an undeniably precocious group just ripe enough for a princely patron to support. The Saatchi Collection, a private museum reinvented from a warehouse in Lisson Grove, is an influential showcase for the presentation of young British art, and Saatchi's investment in the new culture of his own country is highly professional and laudable.

12. "Frank Gehry Furnishes Vision for New Chiat/Day Headquarters," press release isssued on the inauguration of the new Chiat/Day/Mojo headquarters in Venice, California (no date).

13. The artists invited were Mike Kelley, Tony Berlant, George Hermes, Eric Orr, Peter Alexander, Chuck Arnoldi, Billy Al Bengston, Jim Ganzer, John McCracken, Ed Moses, Ken Price and Alexis Smith.

14. Francesca Garcia-Marques, "Frank O. Gehry & Associates/Claes Oldenburg & Coosje van Bruggen: Office Building, Venice/California," *Domus*, February 1992, p. XXII.

15. Michael Webb, "A Monument to Vision," *L.A. Style*, January 1992, pp. 70–75.

16. Mike Kelley is the American *enfant terrible* of the post-1980's generation of artists, the guru of the next wave of the avant-garde. He studied at the California Institute of the Arts in Los Angeles under John Baldessari, Jonathan Borofsky and Douglas Huebler—all Conceptualists in their individual ways. Kelley stayed in Los Angeles to work and began to be noticed in the early 1980's for installations and performances. Although he now has a considerable following all over the United States, he is especially adored in Europe for his typically American art-smart debunks of all sorts of myths. Through an odd blend of domestic objects like soiled yarn and cloth dolls and ragged blankets, Kelley, in irreverent references to the few remaining ineffables in the world—religion, sex and even childhood—seeks to expose the raw edges of society's frailties. Besides the toys, the vocabulary of images Kelley uses is often mined from the popular American youth culture of comic strips, graffiti and commercial advertising; yet, the taboos he defuses psychologically are common ones the world over. Best known for those soiled yarn dolls and worn crocheted afghans he transforms into sculptures really of an adult's inner view of childhood, fusing the pre-conscious states of exploring sexual and bodily functions with a grown-up loss of innocence, or the crudely fashioned drawings and photomurals, and acrylics on felt that depict in text and image the dark underbelly of creativity, Kelley is quite the social critic.

17. Letter from Mike Kelley to Aleks Istanbullu, May 17, 1990.

18. Ibid.

19. The original architectural detail and construction were preserved but covered over with modern materials such as steel, glass and cement (all

new elements were installed in such a way as to allow for their easy removal). The combination of the richly ornamented rooms of the castle and the spare modernism of the Manica Lunga makes a challenging and handsome site for the exhibition of art.

20. Guido Curto, "Rivoli Fills a Castle with Art," *The Journal of Art*, April 1991, p. 25. Now well into her second year, Ida Gianelli (the Italian curator who was assistant curator to Pontus Hulten at the Palazzo Grassi in Venice) has stepped up the international profile of the program.

21. *Aldo Rossi: Casa Aurora*, text by Roberto Gabetti, Luigi Uva, Aldo Rossi, P. Groenendijk, P. Vollaard and Umberto Barbieri, Gruppo GFT, (no date, unpaginated).

22. Ibid.

23. Experts generally identify the period 1875–1945, from the Arts and Crafts Movement in England, through Art Nouveau, the Wiener Werkstätte, de Stijl, the Bauhaus and Art Deco in Europe and America, as the parameters of the Modernism movement.

24. Lloyd P. Johnson, *Modernism at Norwest Minneapolis,* inaugural brochure, January 1989.

25. The "regional bank" period of Sullivan's career spanned the years 1906 to 1920 and was the last phase for the great American pioneer of Modernism in architecture. Sullivan received very few commissions after 1895. Chicago, where he and his partner Dankmar Adler had become the leading designers of urban commercial buildings from 1881 to 1895 (e.g. the Wainwright Building, 1890; the Guaranty Building, 1894–95, and the Transportation Building for the Chicago World's Fair, 1893) was suddenly infatuated with a Beaux Arts classicism introduced at the World's Fair of '93, a style that surely ennobled those rich entrepreneurs anxious to acquire an instant coat of arms. Instead of reverting back to the old world, Sullivan was reaching for an authentic American style in his work. Far from providing a meager income or a marginal inspiration to the suddenly demoted architect, the opportunity allowed him fully to meld his philosophy with the function of the banking community. An emerging Midwestern rural capitalist culture, anxious to separate its economic goals and ethical standards from the image of big-city-slicker materialist, found in Sullivan, and he in them, a perfect match. Overall, Sullivan held the profound belief that architecture (and all the visual arts) had a moral obligation to maintain a balance between man's desire for material gains and his need for spiritual growth. The architectural elements and materials, and the ornamentation Sullivan designed were metaphors for metaphysical truths. In his previous highrise and mercantile commissions, Sullivan had experimented with what he called the "democratic plan." With the rural bank projects, he was able to come closest to achieving the full extent of the idea: "The highpoint of interest is the interior. It was designed, with all its adjuncts, strictly as a banking room. Its plan may be called democratic, in that the

prospect is open and the offices are in plain view and easily apprehended. This may be called the modern 'human' element of the plan, as it tends to promote a feeling of ease, confidence and friendship between officers, employees and customers."

26. Norwest acquired a second Sullivan bank, The People's Savings Bank in Cedar Rapids, Iowa (completed in 1911), which was also carefully restored and opened to the public as a modern banking facility in 1991.

27. John Russell Wheeler, founder of another early Sullivan branch bank, the Farmers and Merchants National Bank in Winona, Minnesota, and in retrospect a man of uncommon vision (or was it his wife who was the real visionary?), articulated the ambivalence of all entrepreneurs of his rank when faced with a high-risk decision. He had hired architect Louis Sullivan in 1906, at a time when Sullivan was generally considered to have become a has-been, economically bankrupt and bereft of ideas as well, to design his new bank: "I was scared to death . . . I was supposed to be a conservative man, a fairly distinguished member of a conservative profession and I was being asked to build a building that looked to me flamboyantly radical. And I was sure I would terrify the natives . . . it was Mrs. Wheeler who soothed my feathers and talked me into going ahead." (John Szarkowski, *The Idea of Louis Sullivan*, University of Minnesota Press, Minneapolis, 1956, reprinted in Lauren S. Weingarden, *Louis H. Sullivan: The Banks*, The MIT Press, Cambridge, Massachusetts, 1987.)

28. Bernd O. Ludwig, in *Carl Emanuel Wolff, Frankfurter Hof Zimmer 152*, exhibition catalogue, published by Portikus and the Galerie Luis Campaña, Frankfurt, unpaginated.

29. I tried to track down a conventional hotel guest to hear their story, but this proved fruitless. Furthermore, I ultimately felt that the conceptual premise of the "piece" was the primary content. Again, raising the questions was the underlying motivation for Wolff's refurnishing of Zimmer 152.

30. Bernd O. Ludwig, op. cit.

31. Wolff had studied at the Düsseldorf Art Academy, occupied a studio at P.S. 1 in New York in 1981, and was showing in a number of interesting galleries in Germany including Galerie Luis Campaña in Frankfurt.

32. Introduction by Kasper König and Ulrich Wilmes to *Carl Emanuel Wolff, Frankfurter Hof Zimmer 152*, op. cit.

33. Previously, Sugimoto had shown other thematic photographic projects which were also time related. He is well known for a series depicting movie theater interiors where his exposures lasted two to two-and-a-half hours, after which all that remained of the screen images was a burning white light. Even earlier he did a group of dioramas that involved time exposures of about forty minutes. See John Yau, "Hiroshi Sugimoto: No Such Thing as Time," *Artforum*, April 1984.

34. Interview with the author, June 1991.

35. Ibid.

36. *Carnegie International 1991*, Vol.I, The Carnegie Museum of Art, Pittsburgh, Rizzoli, New York, p. 128.

37. Andrew L. Yarrow, "A New Stage for High Art and High Finance," *The New York Times*, May 19, 1989, p. C19.

38. Anita Contini quoted by Karin Lipson, "Splashy Performances," *Newsday*, July 13, 1990, Part II, p. 5.

39. For example, Steve Reich and Musicians have appeared in the Winter Garden along with the St. Luke's Chamber Ensemble and the Kronos Quartet. The Winter Garden has also been host to previews or excerpts of several new works scheduled to be performed at concert halls and theaters like the Brooklyn Academy, City Center and the Joyce Theater. Most ambitious was a plan to commission five works a year beginning with Connie Beckley's *Replay*, Brian Eno's sound installation *Tropical Rainforest*, *Anggrek* by choreographer Alice Farley, and *Articles of Faith* by choreographer Susan Marshall.

40. The exhibition/education committee included Gary Garrels, Peter Nagy, Lisa Phillips, Valerie Smith and Philip Yenawine, and the Board of Advisors consisted of David Childs, Mildred Friedman, Frank Gehry, Richard Koshalek, Richard Martin, Cesar Pelli and Andree Putman. Although Olympia and York was the principal underwriter, much of the work was installed in the unfinished lobby space of Merrill Lynch, at 2 Financial Center.

41. Allan Schwartzman, "Corporate Trophies," *Art in America*, February 1989, p. 37.

42. Scott Gutterman interviews Frank Gehry in "The Architect as Artist," *View*, supplement to *The Journal of Art*, April 1991, p. 42.

SELECT BIBLIOGRAPHY

(see Notes, pp.207-216, for additional references)

Books

Beard, Miriam, *A History of Business*. Vol. I: *From Babylon to the Monopolists*, Vol. II: *From the Monopolists to the Organization Man*. The University of Michigan Press, Ann Arbor, 1963.

Bechtler, Dr. Thomas, *Management und Intuition*, Verlag moderne industrie AG, Zürich, 1987.

Chagy, Gideon, *Business in the Arts*, Paul S. Eriksson, New York, 1970.

—— *The New Patrons of the Arts*, Harry N. Abrams, Inc., New York, 1973.

—— *The State of the Arts and Corporate Support*, Paul S. Eriksson, New York, 1973.

Crane, Diana, *The Transformation of the Avant Garde: The New York Art World, 1940–1985*, University of Chicago Press, Chicago, 1987.

Eells, Richard Sedric Fox, *The Corporation and the Arts*, Macmillan, New York, 1967.

Halberstam, David. *The Next Century*, William Morrow and Company, Inc., New York, 1991.

Hauser, Arnold, *The Social History of Art*, 4 vols., Vintage Books, New York, 1985.

—— *The Sociology of Art*, University of Chicago Press, Chicago and London, 1982.

Havens, Thomas R.H., *Artist and Patron in Postwar Japan*, Princeton University Press, Princeton, New Jersey, 1982.

Hunter, Sam, *Art in Business: The Philip Morris Story*, Harry N. Abrams, Inc., New York, 1979.

—— *In the Mountains of Japan: The Open Air Museums Hakone and Utsukushi-ga-hara*, Abbeville Press, New York, 1988.

Larkin, Oliver, *Art and Life in America*, Holt, Rinehart and Winston, New York, 1960.

Lippert, Werner, *Corporate Collecting: Manager— Die Neuen Medici*, ECON Verlag, Düsseldorf, Vienna and New York, 1990.

Makela, Maria, *The Munich Secession: Art and Artists in Turn of the Century Munich*, Princeton University Press, Princeton, New Jersey, 1990.

Martorella, Roseanne, *Corporate Art*, Rutgers University Press, New Brunswick, New Jersey, 1990.

Meyer, Karl. E., *The Art Museum: Power, Money, Ethics*, William Morrow and Company, Inc., New York, 1979.

Mosser, Monique, and Georges Teyssot, *The Architecture of Western Gardens: A Design History from the Renaissance to the Present Day*, Thames and Hudson, London, and The MIT Press, Cambridge, Massachusetts, 1991.

Moulin, Raymonde, trans. Arthur Goldhammer, *The French Art Market: A Sociological View*, Rutgers University Press, New Brunswick, New Jersey, 1987.

New British Art in the Saatchi Collection, Thames & Hudson, London, 1989.

Paret, Peter, *The Berlin Secession: Modernism and its Enemies in Imperial Germany*, The Belknap Press, Harvard University Press, Cambridge, Massachusetts, 1980.

Pevsner, Nikolaus, *A History of Building Types*, Thames and Hudson, London, and Princeton University Press, Princeton, New Jersey, 1976.

Porter, Robert A., ed., *Guide to Corporate Giving in the Arts*, American Council for the Arts, New York, 1987.

Pusateri, C. Joseph, *A History of American Business*, Harlan Davidson, Inc., Arlington Heights, Illinois, 1984.

Reiss, Alvin, *Culture and Company: A Critical Study of an Improbable Alliance*, Twayne, New York, 1972.

Saarinen, Aline B., *The Proud Possessors*, Vintage Books, New York, 1968.

Sandler, Irving, *American Art of the 1960s*, Harper & Row, New York, 1988:

—— *The New York School: The Painters & Sculptors of the Fifties*, Harper & Row, New York, 1978.

Schiller, Herbert I., *Culture, Inc.: The Corporate Takeover of Public Expression*, Oxford University Press, New York, 1989.

Seligman, Germain, *Merchants of Art: 1880–1960*, Appleton-Century, New York, 1961.

Toffler, Alvin, *The Culture Consumers: A Study of Art and Affluence in America*, St. Martins Press, New York, 1964.

Tomkins, Calvin, *Merchants and Masterpieces*, E.P. Dutton, New York, 1970.

Articles, Exhibition Catalogues and Brochures

1. General

A Report on the Art and Technology Program of the Los Angeles County Museum of Art 1967–71. Maurice Tuchman. Los Angeles County Museum, Los Angeles, California, 1971.

"The Bottom Line: A Conversation with Stephen Stamas of Exxon and Edward M. Block of AT&T," *American Arts*, November 1982, pp. 16–21.

Brenson, Michael, "Museum and Corporation—A Delicate Balance," *The New York Times*, February 23, 1986, Section 2, pp. 1, 28.

Brooks, Valerie F., "The Billion-Dollar Merger," *ARTnews* advertising supplement, January 1987, pp. 21–46.

—— "Corporate Art Patronage," *ARTnews* advertising supplement, December 1989, pp. 57–78.

Burger, Ruth, "The Corporation as Art Collector," *Across the Board*, January 1983, pp. 42–50.

BCA News, various eds., Business Committee for the Arts., Inc., New York, 1968–present.

Chambres d'amis. Essay by Jan Hoet. Museum van Hedendaagse Kunst, Ghent, June 21–September 21, 1986.

Chapman, Christine, "Power and Patronage," *ARTnews*, March 1990, pp. 139–41.

Chira, Susan, "Art Inc.: Japanese Businessmen Pay Top Yen All Over the World to Stock their Corporate Collections," *The New York Times Business World Magazine*, May 3, 1987, pp. 38–56.

Collaboration: Artists & Architects, ed. Barbaralee Diamonstein, The Architectural League, New York; the Whitney Library of Design, New York, 1981.

Corporate ARTnews, various eds., a division of *ARTnews*, New York, 1984–present.

"Corporate Collecting 1988," *Art & Auction*, October 1988, pp. 167–87.

"Corporate Collecting Goes International," *Art & Auction*, October 1989, pp. 210–39.

"Corporate Collections 1987," *Art & Auction*, October 1987, pp. 166–87.

"Corporations and the Arts in America Today," *Art & Auction*, October 1984, pp. 117–59.

Danto, Ginger, "France: Let Them Have Art," *ARTnews*, November 1989, pp. 136–39.

Danzinger, Charles, "Turning Profits Into Paintings: Japanese Corporate Art Investment," *Tokyo Business Today*, October 1989, pp. 28–29.

de Bruyn, Gerd, "Braucht der öffenliche Raum Kunst: Ein Gespräch mit Kasper König," *Baukultur*, June 1990, pp. 23–28.

Elicker, Paul H., "Why Corporations Give Money to the Arts," *The Wall Street Journal*, March 31, 1978, p. 51.

Galloway, David, "From Bankfurt to Frankfurt: A Cash and Carry Renaissance," *Art in America*, September 1987, pp. 152–59.

Gambrell, Jamey, "Report From Spain: Gearing Up," *Art in America*, September 1988, pp. 37–47.

Gibson, Michael, "Japan's Impresario of New Art," *International Herald Tribune*, October 1–2, 1988, Arts/Leisure, p. 7.

Glueck, Grace, "Are the Whitney's Satellite Museums on the Right Course?" *The New York Times*, June 9, 1985, Section 2, pp. 31, 34.

—— "For Japanese Art Collectors, Acquisition Begins at Home," *The New York Times*, June 24, 1990, Section 4, p. 5.

—— "What Big Business Sees in Fine Art," *The New York Times*, May 26, 1985, Section 2, pp. 1, 20.

Godfrey, Tony, "Decline and Fall?" *Art in America* February 1990, pp. 63–65.

Goldberger, Paul, "Corporate Design That Stays on the Safe Side," *The New York Times*, May 13, 1990, pp. 37, 38.

Grossberg, Shelley Jane, "Artful Management," *Art & Auction*, October 1987, pp. 160–65.

Hans Haacke: Unfinished Business (1971–1986), ed. Brian Wallis. Essay by Rosalyn Deutsche. New Museum of Contemporary Art, New York; The MIT Press, Cambridge, Massachusetts, 1986.

Harris, Stacy Paleologos, ed., *Insights/On Sites: Perspectives on Art in Public Places*, Partners for Livable Places, Washington, DC, 1984.

Hawthorne, Don, "Saatchi & Saatchi Go Public," *ARTnews*, May 1985, pp. 72–81.

Howarth, Shirley Reiff, "Corporate Art: The International Partnership," *ARTnews* advertising supplement, December 1988, pp. 47–48.

Involving the Arts in Public Relations: A Business Strategy, Business Committee for the Arts, Inc., New York, 1986.

Jedlicka, Judith, *America's Eclectic Collector: A History of Corporate Art Collection*, Executive Viewpoints; Business Committee for the Arts, Inc., New York, 1985.

Kawashima, Nobuko, "The Relationship between Private Corporations and the Arts in Japan," Dentsu Institute for Human Studies, 6th Conference on Cultural Economics, Tokyo, June 1990.

Kimball, Roger, "Art & Architecture at the Equitable Center," *The New Criterion*, November 1986, pp. 24–32.

König, Kasper, and Hans-Ulrich Obrist, eds., *Jahresring 38: Der öffentliche Blick*, Verlag Silke Schreiber, Munich, 1991.

Kramer, Jane, "Letter from Europe," *The New Yorker*, August 6, 1984, pp. 74–84.

Larson, Kay, "Art [Battery Park City]," *New York*, December 26, 1983–January 2, 1984, p. 117.

Laskin, Bill, *Motivations Behind Corporate Support of Arts*, doctoral thesis, Harvard University, 1982.

Lewis, Michael, "Pic-ah-so," *The New Republic*, November 26, 1990, pp. 17–18.

Lipson, Karen, "New Directions in Corporate Collecting," *ARTnews*, November 1983, pp. 140–62.

—— "Splashy Performances," *Newsweek*, July 13, 1990, Part II, pp. 4–5.

Lueck, Thomas J., "More Corporations Becoming Working Museums," *The New York Times*, September 15, 1985, Section 1, p. 60.

Marmer, Nancy, "Paris Culture Budget Tops Billion Francs," *Art in America*, February 1990, p. 37.

McGuigan, Cathleen, comp., "A Word from Our Sponsor," *Newsweek*, November 25, 1985, pp. 96–98.

Nanjo, Fumio, "The Economic Structure of the Japanese Art World," *The Journal of Art*, December 1989, p. 8. (Excerpt from "Situation in Japan," originally published in *Les Cahiers du Musée d'Art Moderne*, No.28, Editions du Centre Pompidou, Paris.)

"New Traditions in the Old Country," *The Economist*, February 7, 1987, pp. 85–86.

Niesewand, Nonie, "Seat of Learning," *Vogue*, February 1990, pp. 170–73.

Ono, Yumiko and Marcus W. Brauchli, "Big Japanese Art Collector Face Squeeze," *The Wall Street Journal*, February 21, 1991, pp. C1, C8.

Parker, Paul, "The Role of Art in the Corporate Culture," unpublished transcript of talk given to the Association of Corporate Art Curators, Chicago, Illinois, May 9, 1984.

Pears, Iain, "In Sum: Corporate Support for the Arts," *Art in America*, July 1988, pp. 55–59.

Princenthal, Nancy, "Report from Minneapolis: Corporate Pleasures," *Art in America*, December 1988, pp. 39–41.

Rice, Faye, "The Big Payoff in Corporate Art," *Fortune*, May 25, 1987, pp. 106–12.

Riley, Charles A. II, "The Confidence Game," *Art & Auction*, June 1991, pp. 118–23.

Rohr-Bongard, Linde, "Geltungsbereich," *Capital*, June 1990, pp. 259–66.

Rosenbaum, Lee, "Money and Culture," *Horizon 21*, May 1978, pp. 24–29.

Mark Rothko: The Seagram Mural Project. Preface by Alan Bowness; introduction by Michael Compton. The Tate Gallery, Liverpool, 1988.

Russell, John, "Where City Meets Sea to Become Art," *The New York Times*, December 11, 1983, Section 2, pp. 1, 31.

Sculpture Inside Outside, Walker Art Center, Minneapolis, Minnesota; Rizzoli International Publications, New York, 1988.

Serlen, Bruce, "What's New in Corporate Art," *The*

New York Times, February 12, 1989, Section 3, p. 13.

Smith, Patrick, "Letter from Tokyo," *The New Yorker*, October 14, 1991, pp. 105–18.

Span, Paula, "Making a Business out of Art for the Office," *The Wall Street Journal*, July 11, 1985, p. 22.

Stephens, Suzanne, "An Equitable Relationship?" *Art in America*, May 1986, pp. 117–23.

Tomkins, Calvin, "Medicis, Inc.," *The New Yorker*, April 14, 1986, pp. 87–90.

Vetrocq, Marcia E., "Culture by Fiat," *Art in America*, July 1990, pp. 67–71.

Viau, René, trans. Colette Tougas, "The Crex Collection (An Interview with Urs Raussmüller)," *Parachute*, No.54, March–June 1989, pp. 22–27.

Wallach, Amei, "Lobbying for Art," *Newsday*, February 9, 1986, pp. 4–29.

Woodbridge, Sally B., and Hiroshi Watanabe, "A Cross Cultural Concert in the Far East [Nexus World Kashii]," *Progressive Architecture*, August 1991, pp. 60–79, 148.

Yarrow, Andrew L., "A New Stage for High Art and High Finance," *The New York Times*, May 19, 1989, pp. C1, C19.

2. Corporate Art Projects

Akademierundgang 1950–1988: Eine Ausstellung zeitgenössicher Kunst in der Bank. Introduction by Herbert Zapp; text by Karl Ruhrberg. Deutsche Bank AG, Düsseldorf, September 1988.

Alcoa Collection of Contemporary Art: An Exhibition of Works Acquired from the G. David Thompson Collection. Forewords by David Rockefeller, President, Chase Manhattan Bank; John D. Harper, President, Alcoa; and Frederick J. Close, Chairman, Alcoa. The American Federation of Arts, New York, and Special Services Section, Aluminium Company of America, Pittsburgh, Pennsylvania (no date).

Art at Work: The Chase Manhattan Collection, ed. Marshall Lee. Forewords by David Rockefeller and Willard C. Butcher; texts by J. Walter Severinghaus, Dorothy C. Miller and Robert Rosenblum. E.P. Dutton, Inc., New York, 1984.

The Art Collection of Fried, Frank, Harris, Shriver & Jacobson. Text by Amy Simon. Fried, Frank, Harris, Shriver & Jacobson, New York, 1982.

Art from Corporate Collections, Union Carbide Corporation Gallery, New York, 1979. Exhibition organized by Marjory Jacobson.

Art Inc.: American Paintings from Corporate Collections. Forewords by Winton M. Blount and Henry Flood Robert, Jr.; text by Mitchell Douglas Kahan. Montgomery Museum of Fine Arts, Brandywine Press, Alabama, 1979.

Art of Our Time: The Saatchi Collection. Book 1: text by Peter Schjeldahl. Book 2: texts by Jean-Christophe Ammann, Michael Auping, Robert Rosenblum and Peter Schjeldahl. Book 3: texts by Rudi Fuchs, Hilton Kramer and Peter Schjeldahl. Book 4: texts by Michael Auping, Prudence Carlson, Lynne Cooke, Hilton Kramer, Kim Levin, Mark Rosenthal and Phyllis Tuchman. Lund Humphries Ltd., London, 1984.

Art of the 80s from the Collection of Chemical Bank. Text by Janice Oresman. The Montclair Art Museum, Montclair, New Jersey, January 29–April 9, 1989.

El Arte de Coleccionar. Fundación Arco: 1987/1991, Centro Atlántico de Arte Moderno; Las Palmas de Gran Canaria, March 14–April 28, 1991.

Artists and Architects Collaborate: Designing the Wiesner Building, Massachusetts Institute of Technology Committee on the Visual Arts, Cambridge, 1985, in collaboration with and supported by the National Endowment for the Arts.

BankAmerica Corporation Art Program Acquisitions 1982–1983. Introduction by Bonnie Earls-Solari. Bank of America, San Francisco, California (no date).

Thomas Hart Benton: The America Today Murals, catalogue of exhibition presented at Williams College Museum of Art, February 2–August 25, 1985. Text by Emily Braun and Thomas Branchick. The Equitable, New York, 1985.

Castello di Rivoli Museo d'Arte Contemporanea, Regione Piemonte, Banca CRT, Fiat and Gruppo GFT, Turin, 1989.

Chemical Bank: An Art Collection in Perspective. Introduction by Walter V. Shipley; texts by Karen Alphin, Kenneth Baker and Janice C. Oresman. Chemical Bank, New York, 1981.

Collection Caisse des Dépôts et Consignations: Acquisitions 1989.1991, Groupe Caisse des Dépôts, Paris, 1992.

Collection Catalogue, The Saison Foundation; The Museum of Modern Art, Takanawa, 1990.

Une Collection pour la Grande Arche, AXA; Caisse des Dépôts et Consignations, Paris (no date).

The Consolidated Freightways, Inc. Collection. Introduction by Rod Slemmons; text by Kristen Paulson with statements by Raymond F. O'Brien and Judy Kay. Consolidated Freightways, Inc., Palo Alto, California, 1985.

The Consolidated Freightways, Inc, Collection. Foreword by Raymond F. O'Brien; text by Susan Ehrens with statement by Judy Kay. Consolidated Freightways, Inc., Palo Alto, California, 1988.

Contemporary Prints and Drawings from the Mellon Bank Collection, Allegheny College, Meadville, Pennsylvania, 1989.

Controversy Corridor: The Second Year, Division of Visual Arts, First Bank System, Inc., Minneapolis, Minnesota, 1989.

Coopers & Lybrand/Boston. Text by Marjory Jacobson. Coopers & Lybrand, Boston, Massachusetts, 1984.

Facets of the Collection. Foreword by Don Guinn and Sam Ginn; introduction by Judy Kay; text by John Bloom and Mark Levy. Pacific Telesis Group, San Francisco, 1988.

Europa/L'Europe/Europe: Kunst en Bedrijf, special fortieth anniversary issue/*Kunst en Bedrijf*, Amsterdam, May 31, 1990.

Fifty Years of Collecting: Art at IBM, IBM Gallery of Science and Art, New York, 1989.

Foundation Activities 1987–88, Fundacio Caixa de Pensions, Barcelona, 1989.

Foundation Activities 1988–89, Fundacio Caixa de Pensions, Barcelona, 1990.

Jean-Louis Garnell, Stadtwerke Saarbrücken AG, Saarbrücken, 1992. Published in connection with the exhibition "Jean-Louis Garnell: Arbeiten von 1987–92," at the Stadtgalerie, November 15–December 6, 1992.

Frank O. Gehry: Design Museum Vitra, Weil am Rhein, Aedes: Galerie für Architektur, Berlin, July 19–August 17, 1989.

The Goldman Sachs Art Program Brochure 1987, Goldman, Sachs & Co., New York, 1986.

Great Ideas of Western Art, Container Corporation of America; Brooks Memorial Art Gallery, Memphis, Tennessee, August 14–September 8, 1968.

Gruppo GFT Consolidated Financial Statements 1989, GFT S.p.A., Turin, 1990.

Hara Museum of Contemporary Art, Hara Museum of Contemporary Art, Tokyo, 1985.

The Hess Collection. Text by Dieter Ronte. Harry N. Abrams, Inc., New York, 1989.

Howarth, Shirley Reiff, ed., *International Directory of Corporate Art Collections*, 1990–91 edition, ARTnews Associates & International Art Alliance, Inc., New York, 1990.

Hypo Art: London, selections from the collection located at Hypo-Bank's London branch. Foreword by Dr. Eberhard Martini. Bayerische Hypotheken- und Wechsel-Bank AG, Munich, 1990.

Kunst aus Frankfurt. Text by Ingrid Mössinger. Degussa AG, Frankfurt am Main, 1989.

Kunst in der IBM Deutschland, IBM Deutschland, Stuttgart, 2d edition, 1991.

Kunstprojekt Heizkraftwerk Römerbrücke, Stadtwerke Saarbrücken AG, Saarbrücken, 1992.

Die Kunstsammlung der Bayerischen Hypotheken- und Wechsel-Bank AG, Munich, 2d edition (no date).

Late Twentieth Century Art from the Sydney and Frances Lewis Foundation. Texts by Frederick R. Brandt and Susan L. Butler. Sydney and Frances Lewis Foundation, Richmond, Virginia, 1981.

Lehman Brothers Kuhn Loeb Incorporated Art Collection. Introduction by Janice C. Oresman. Lehman Brothers Kuhn Loeb Incorporated, New York, 1982.

LeWitt, Tinguely, Peart: Counterbalance, The Hans and Walter Bechtler Gallery, "A Place for the Arts," Carillon, Charlotte, North Carolina, September 6, 1991–March 20, 1992. Sponsored by Hesta Properties, Inc., developer of Carillon, and organized by Curators' Forum, Charlotte.

Gerhard Merz: Tivoli. Foreword by Werner Döttinger; texts by Laszlo Glozer and Vittorio Magnano Lampugnani. Verlag der Buchhandlung Walther König, Köln, 1986.

Moderne Kunst Sehen und Erleben. Text by Dr. Klaus Gallwitz and Dr. Dietrich Mahlow. Deutsche Bank AG, Düsseldorf, 1985.

The New Urban Landscape, ed. Richard Martin. Introduction by Anita Contini; essays by Nancy Princenthal and David McGlynn. Olympia & York (USA) and Drenttel Doyle Partners, New York, 1990; distributed by Rizzoli International.

Nexus [Momochi]: architect Michael Graves, architect Stanley Tigerman, Fukuoka Jisho Design Room, Fukuoka, August, 1990.

Nexus World, Fukuoka Jisho Co. Ltd., Fukuoka, 1991.

The Progressive Corporation: Annual Report, The Progressive Corporation, Mayfield Heights, Ohio, 1987, 1988, 1989.

The Refco Collection, ed. Sue Taylor. Introduction by Judith Russi Kirshner; essays by Eleanor Heartney, Anne Rorimer and James Yood. Organized by Adam Brooks. Refco Group Ltd., Chicago, Illinois, 1990.

Aldo Rossi: Casa Aurora. Texts by Roberto Gabetti, Luigi Uva, Aldo Rossi, P. Groenendijk, P. Vollard and Umberto Barbieri. Gruppo GFT, Turin (no date).

Rothschild, Philippine de, *Mouton Rothschild: Paintings for the Labels, 1945–1981*, Little, Brown and Company, Boston, Massachusetts, 1983.

RSVP: Six Artists Respond, The Hans and Walter Bechtler Gallery, "A Place for the Arts," Carillon, Charlotte, North Carolina, May 1, 1992–January 24, 1993. Sponsored by Hesta Properties, Inc., developer of Carillon, and organized by Curators' Forum, Charlotte.

Sammlungen Hans und Walter Bechtler, Kunsthaus Zürich, August 8–October 3, 1982, Waser Verlag, Zürich, 1982.

The Security Pacific Collection 1970–1985: Selected Works. Foreword by Richard J. Flamson III; overview by Tressa Ruslander Miller; texts by Susan C. Larsen, Jan Butterfield, Van Deren Coke, Richard H. Axsom, Mary Hunt Kahlenberg and

Joan Marter. Security Pacific Corporation, Los Angeles, California, 1985.

The Security Pacific Collection: Twenty Years 1970–1990: Prints. Foreword by Richard J. Flamson III; texts by Tressa Ruslander Miller and Bonnie Rae Pomeranz. Security Pacific Corporation, Los Angeles, California, 1990.

The Seibu Museum of Art Biennial Review 1986–87, Seibu Museum of Art, Tokyo, 1988.

Selected Works from Kawamura Memorial Museum of Art, Kawamura Memorial Museum of Art, Sakura, 1990.

Siemens Kulturprogramm 1989/90. Introduction by Florian Müller. Siemens AG, Berlin and Munich, 1990.

Siemens Kulturprogramm 1990/91. Introduction by Florian Müller. Siemens AG, Berlin and Munich, 1991.

Southeast Bank Collects: A Corporation Views Contemporary Art, The Norton Gallery of Art, West Palm Beach, Florida, 1990.

Spiral Book, Wacoal Art Center, Tokyo, 1988.

TalkBack—Listen: The Visual Arts Program at First Bank System 1980–1990, eds. Bruce Ferguson, Jane Swingle and Kobi Conaway. Introduction by Lynne Sowder and Nathan Braulick. Winnipeg Art Gallery, Winnipeg, Manitoba, in conjunction with the exhibition "Challenge in the Workplace," June 13–August 20, 1989.

Oswald Mathias Ungers, Gerhard Richter, Sol LeWitt. Introduction by Dr. Eberhard Martini. Bayerische Hypotheken- und Wechsel-Bank AG, Munich, 1991.

Carl Emanuel Wolff: Frankfurter Hof Zimmer 152. Introductions by Kasper König and Ulrich Wilmes, and Bernd O. Ludwig; text by Martin Bochynek. Portikus, Frankfurt am Main; Galerie Luis Campaña, Frankfurt am Main, 1990.

Works from the Crex Collection, catalogue of a traveling exhibition shown at Ink, Zürich; the Louisiana Museum, Humlebaek; Städt. Galerie im Lenbachhaus, Munich; and Stedelijk Van Abbe-museum, Eindhoven. Sammlung Crex, Zürich, 1978.

Zeitgenössische Kunst in der Deutschen Bank Frankfurt. Introduction by Dr. Herbert Zapp; text by Klaus Gallwitz. Deutsche Bank AG, Ernst Klett Verlag GmbH, Stuttgart, 1987.

ACKNOWLEDGMENTS

For a first-time author (and perhaps for every time) the process of writing a book seems an impossible ordeal, and the support and encouragement of valued colleagues is an essential start–up step. Whitney Chadwick said "you know more about this topic than anyone," and recommended me to the publisher. Whitney, your trust in my abilities is a gift of confidence that I cherish. Thank you, too, Kathy Halbreich, for assuaging my interminable doubts and for sharing with me your preeminent professional expertise. "You have to do it," you insisted. And that was that. A fond salute to you, too, Barbara Krakow, for your wise counsel, and for always being there.

In the corporate sphere, the cooperation was remarkable. As witnessed by the extensive interviews recorded herein, busy executives made the time to talk to me candidly, and to supply to my exact specifications photographs of the art in its surroundings. Along the research road, I met many extraordinary people, and even made new friends. Bernhard Starkmann, although he may not realize it, is *the model* businessman art patron—and my favorite rebel. I would also like to make personal note of Paul Jolles and George Loudon, who exerted extra efforts to help out. My text readers, who probably will never respond to my phone messages again, deserve trophies for their willingness, endurance and exacting comments: Joan Nissman and Morton Abromson; Phyllis Andersen; Patricia Fuller; Dana Friis-Hansen (researcher, too); Junko Iwabuchi and Fumio Nanjo. I am obliged as well to all the interviewees, the corporate curators and their staffs who took the time to see me and to sift through their portions of the material for errors and omissions.

Wherever I traveled, so many, many artists, dealers and other art world figures willingly came to my aid. I am grateful to them all, especially to Brooke Alexander, Roland Augustine, Douglas Baxter, Azby Brown, Richard Flood, Eric Franck, Gary Garrels, Barbara Gladstone, Arthur Goldberg, Marge Goldwater, John Good, Yoshiko Isshiki, Jörg Johnen, Claudia Jolles, Michael Klein, Kasper König, Doris Lockhart, Ulrich Loock, Lawrence Luhring, Carol Lutfy, Lewis Manilow, Karen McCready, Lorcan O'Neill, Eva Pressenhuber, Stuart Regen, Thomas Schulte, Larry Shopmaker and Glenn Scott Wright.

Thames and Hudson, through sheer publishing wizardry, transformed a mere manuscript into a book. We survived the experience relatively unscathed and with warm feelings (I think), and I am forever appreciative. The editors at Harvard Business School Press were early supporters and I thank them for their enthusiasm. Liz Boyle, Helena Ghez, Becky Hunt, Denise Joseph and Caren Yusem made valuable contributions early on, and Sharon Lee Ryder lent perspective and shape to the material with her heroic long-distance conceptual editing in the interim stages.

All in all, the project was three splendid years in the making from research to publication. Like any self–respecting author, I had difficulty letting go, perhaps more so because of the people involved. The experience had become a lifestyle, the participants comfortable friends. The pleasure of getting to know so many talented individuals during one project is a unique and treasured experience.

PHOTO CREDITS

Jon Abbott 193 bottom; Nick Arroyo 196, 197; Bruna Biamino 181 bottom; Richard Bryant 76, 77; Bruno and Eric Bührer 47 right, top and bottom; Barbara Burg + Oliver Schuh 182 top; Sheldon Collins 96 center; D. James Dee 152, 153; Ian Dobbie 11, 38 bottom, 39, 40, 41 top and bottom, 154, 155, 156, 157; Pierre Dupuy 94 top; Steve Elmore 162–63 center; J. Fessy 28 top; Brian Forrest 151 bottom; Kazuo Fukuhaga 89; Olivier Gaeng and Philippe Prêtre 140, 142, 143; Lynton Gardiner 55 top; Claude Gaspari 37 bottom; P. Goetlen 37 top; Mark Gulezian 151 top; Hara Museum of Contemporary Art 69; George Hirose 93; Tim Hursley 111, 112; Interim Art 38 top; Bill Jacobson 95; Mitchell Kearney *frontispiece*, 171, 172–73, 174, 175, 176, 177; Soichi Kondo 91; Klaus Kinold 166, 167 top and center, 168; Joseph Loderer 167 bottom, 169; C. Mauss, Esto 158, 159, 160, 161 top; Ian McKinnel 79; David Mohney 55 bottom; Andre Morain 35 top and bottom, 36 bottom; Gary Mortensen 185, 186, 187; Wallace Murray 81, 83; Rita Nannini 195; Sakae Oguma 90 bottom; Susan Ormerod 161 bottom; Alan S. Orling 94 bottom; P. Pellion 182 bottom; John Pottle 129 bottom; Robert Raussmüller 46, 48, 49; Christoph Schenker 42 top; Hans Schlegel 82; Jeremy Speer 53; Jerry L. Thompson 92, 96, 99; Brad Trayser 125 top; Michael Tropea 163 top and bottom, 164, 165 top and bottom; Peter Vanderwalken 104, 105; William Waldron 110 bottom; Werner Wunderlich 114 top, 115 top, 118; Masao Yamamoto 88–89, 90 top; Tadasu Yamamoto 71; Dorothy Zeidman 178.

INDEX